DAY IN THE LIFE

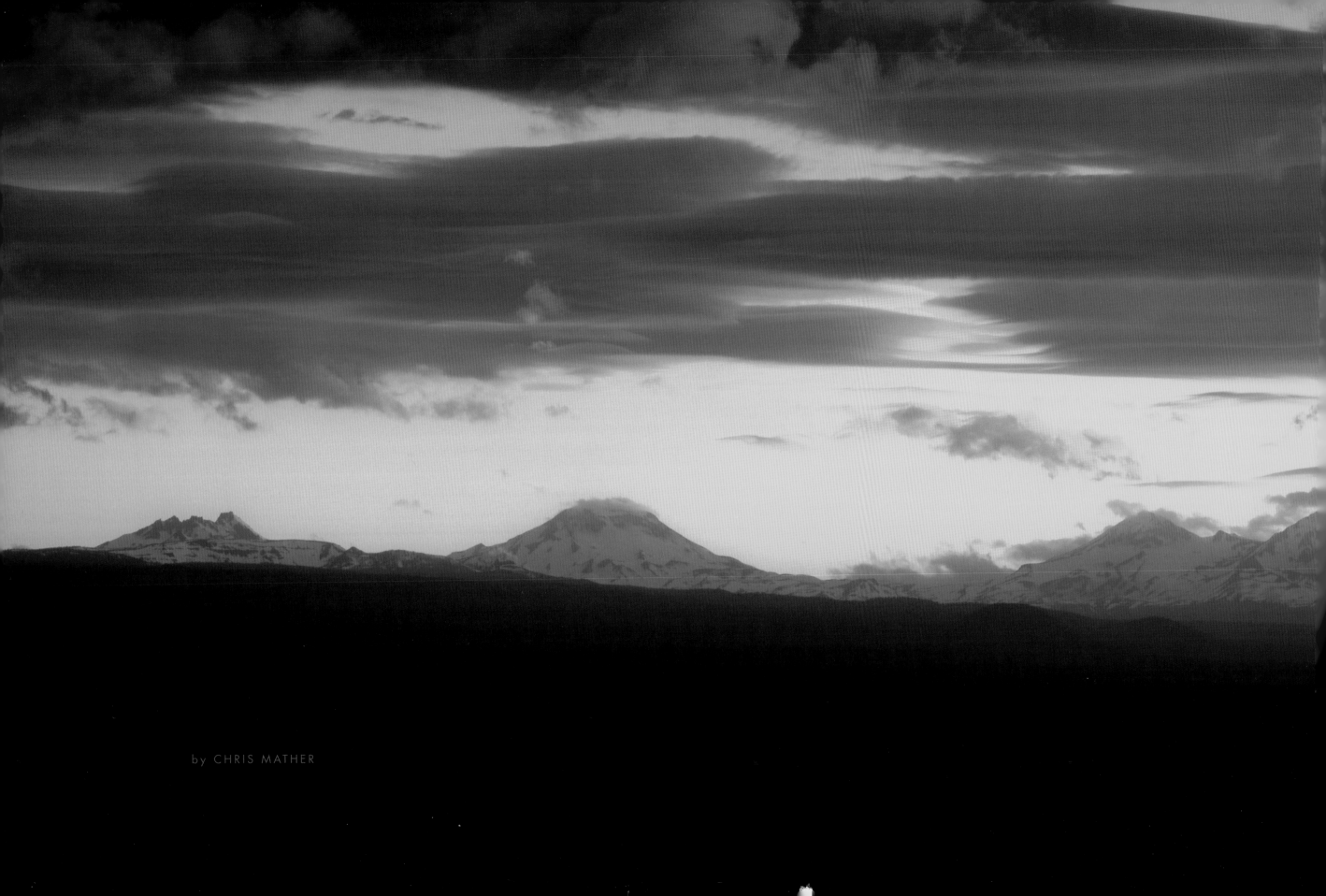

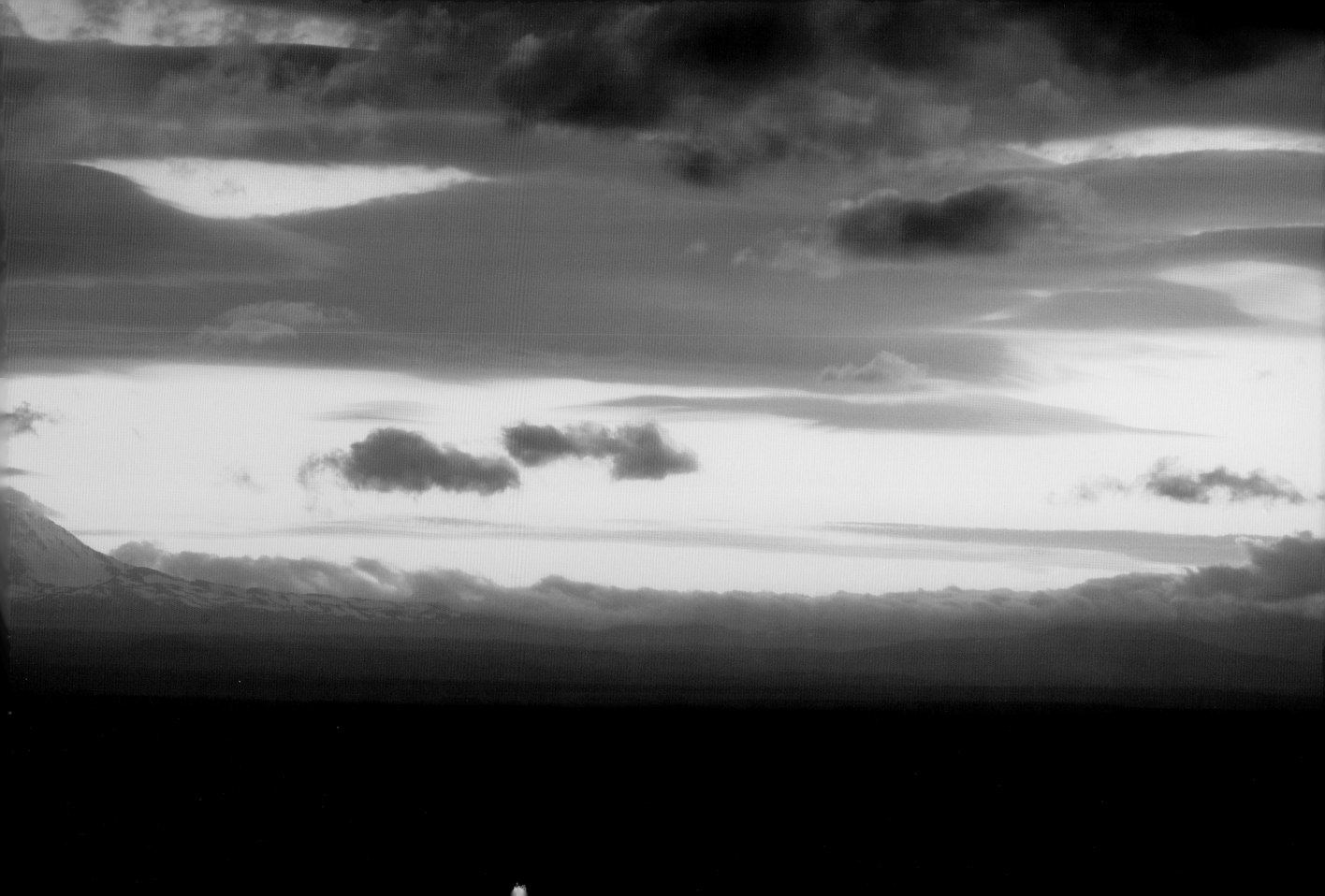

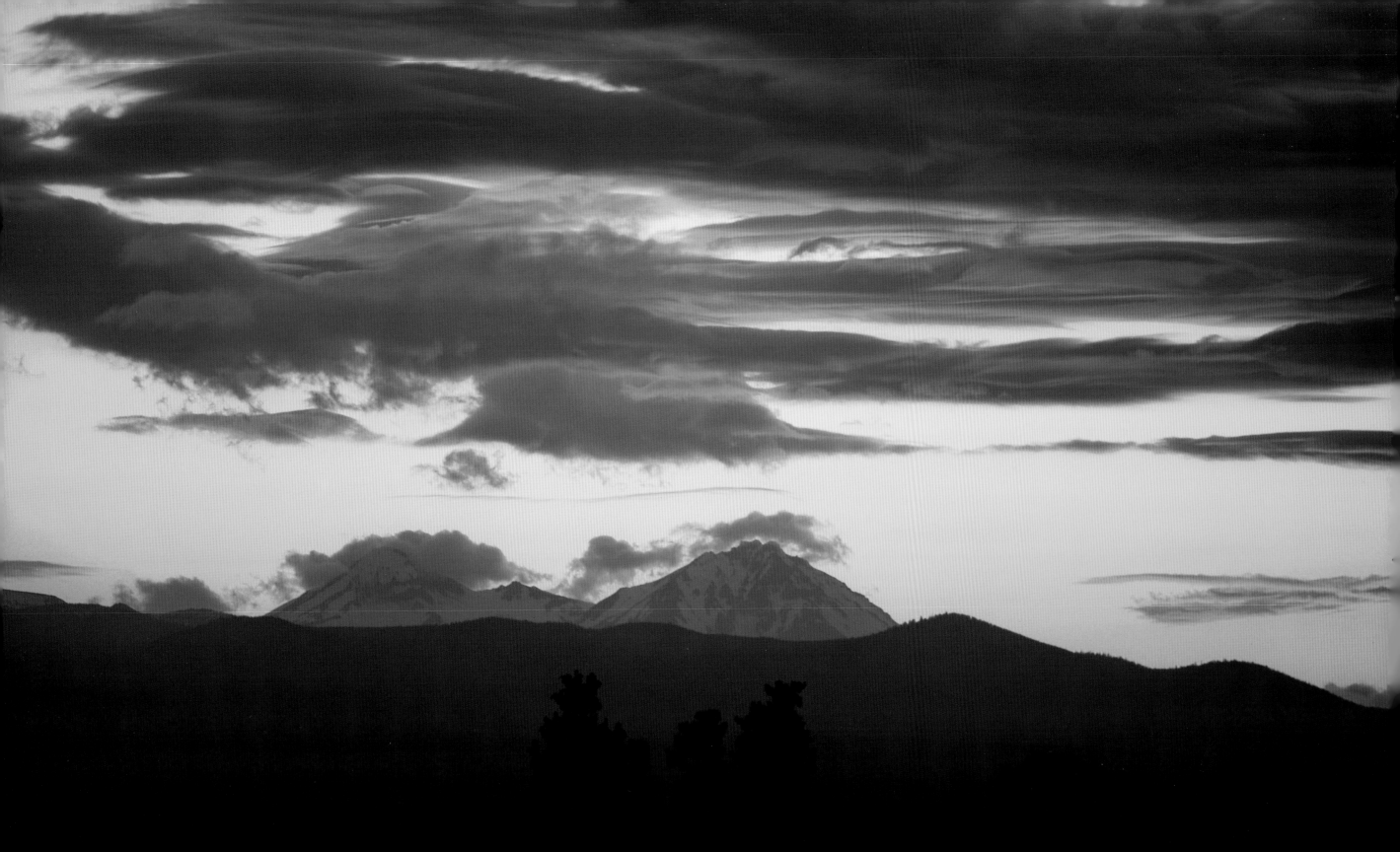

Cutter Communications
408 NE Hawthorne Ave.
Bend, OR 97701

www.bendliving.com

cover photo: Chris Mather

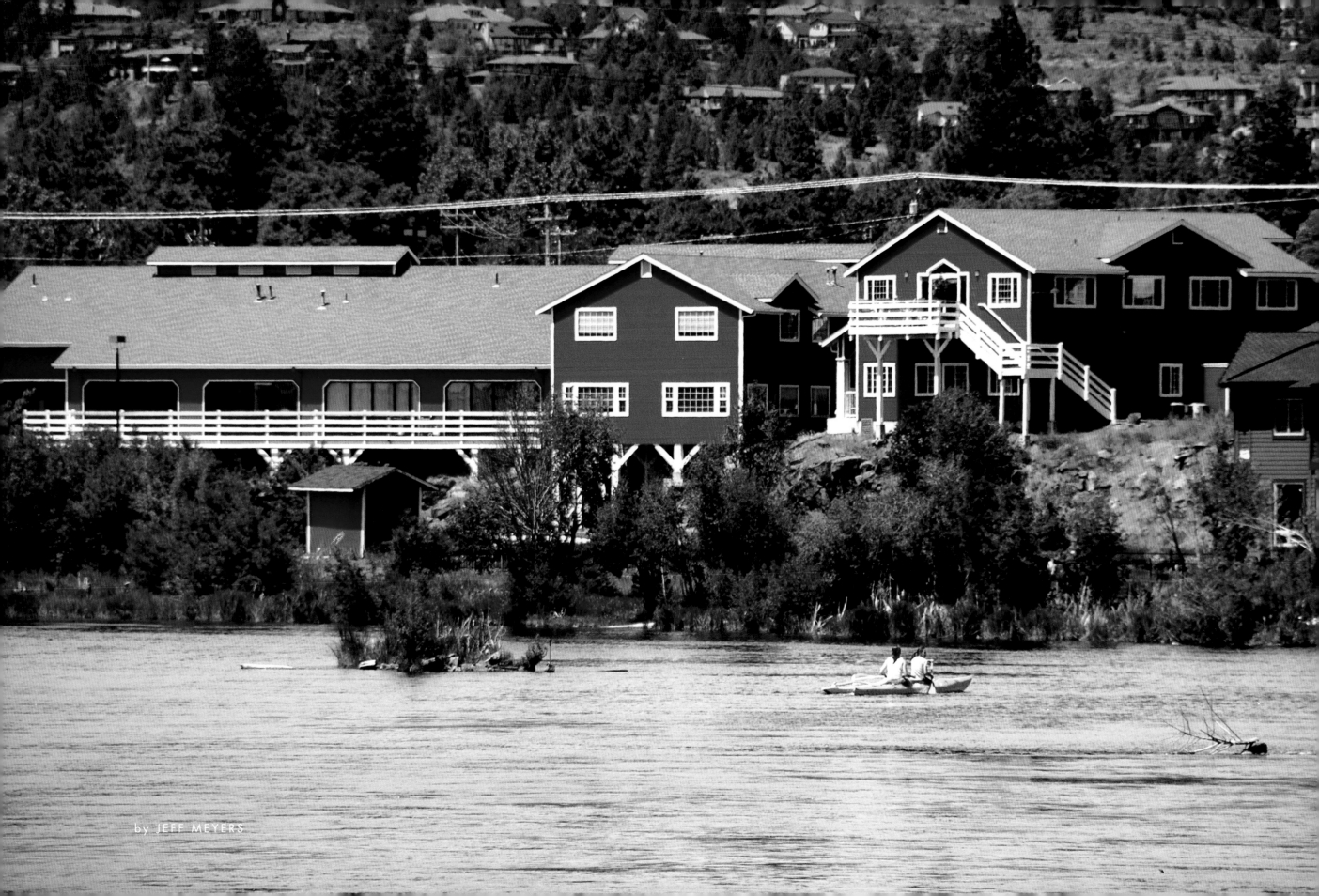

the project

At noon on June 9, 2006, 27 professional photographers gathered at Bend's Pine Tavern restaurant to begin a visual adventure the likes of which had never before been seen in Central Oregon. Twenty-four hours and more than 9,000 images later, they completed their mission of shooting a day in the life of Central Oregon.

Along the way, the photographers covered everything from landscapes to theatrical performances, baseball games to high-school graduations, farmers' markets to rodeos. They visited schools and churches, barber shops and recreation centers. They rode with firefighters and police officers. They climbed into the mountains to track late-season skiers, followed whitewater kayakers on the Deschutes River and extreme climbers at Smith Rock. Working day and night, into the wee hours of the morning, their shutters snapped at a rate of more than once every 10 seconds. And along the way, they captured the soul of Central Oregon.

And they did it all for charity, as proceeds from the sale of this book will benefit the Bethlehem Inn homeless shelter. Thank you for joining us on this magnificent journey.

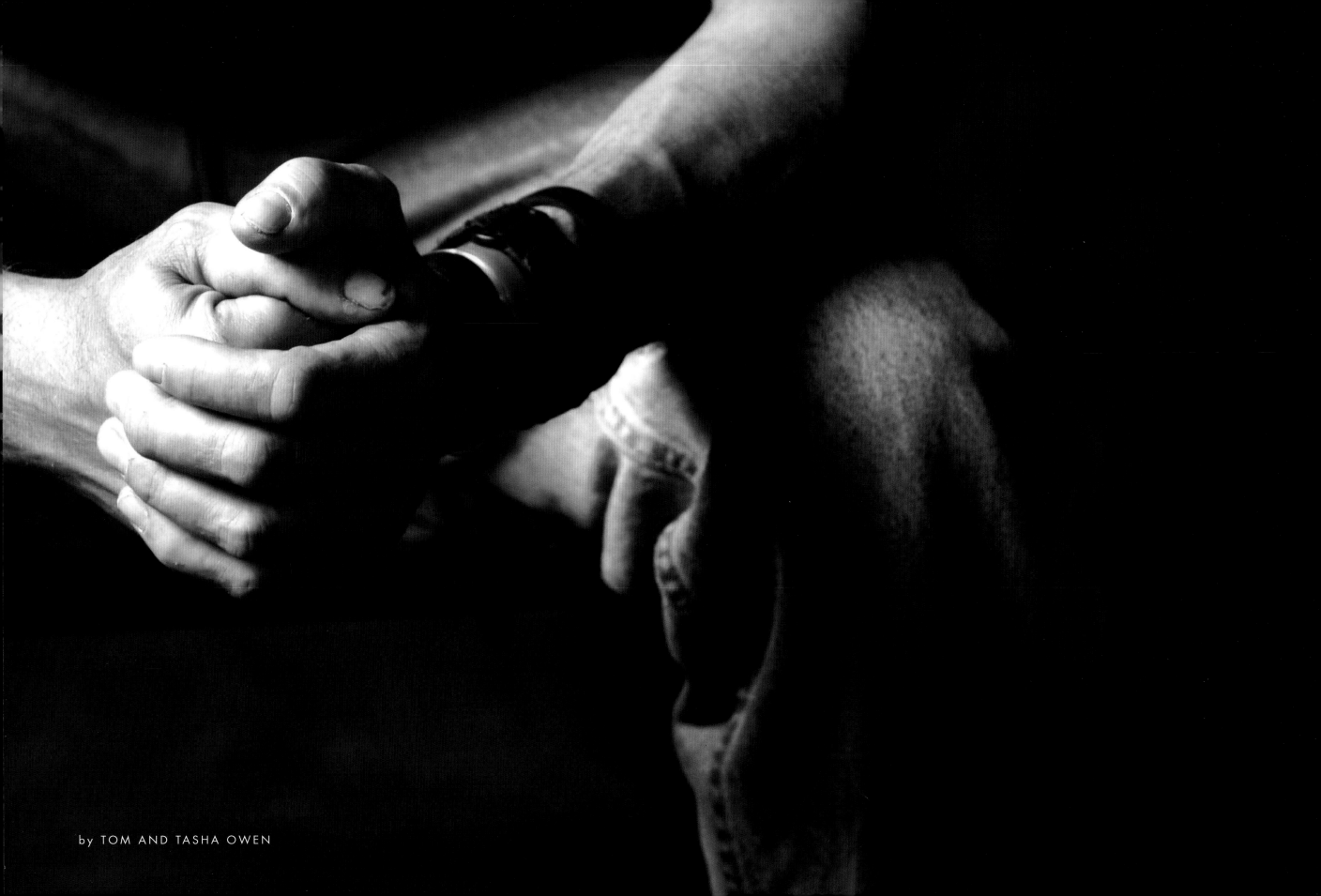

by TOM AND TASHA OWEN

When clients arrive at the Bethlehem Inn, they are often in a state of shock. "For many, it's the first time they have found themselves without a home," says executive director Liz Hitt. "They don't know how to be homeless."

Emergency homeless shelters are the triage units of homelessness, Hitt says. "Like the ER room at a hospital, our job is to stabilize, assess and move forward. We are the first brick on the road out of homelessness and into self-sustainable living."

Founded in 1999 as a temporary shelter open only during the cold winter months, the Bethlehem Inn's location rotated for five years among churches and organizations willing to share their spaces. In 2004, when the Inn moved to its current location, it was able to expand its beds-and-meals services to include case management, mental-health support, drug testing, laundry facilities, transportation and assistance in obtaining education and employment.

Those services are supported by the efforts of more than 4,000 dedicated community volunteers. In addition to serving meals and manning the front desk, they make a substantial impact on residents simply with their presence. "Our clients have a much better time of it when there are a lot of volunteers around," says Hitt. "They feel very cared about."

The Bethlehem Inn's services have never been in higher demand in Central Oregon. A January 2006 survey counted 1,344 homeless persons in Deschutes, Crook and Jefferson counties. Forty-one percent were children; 153 were younger than six.

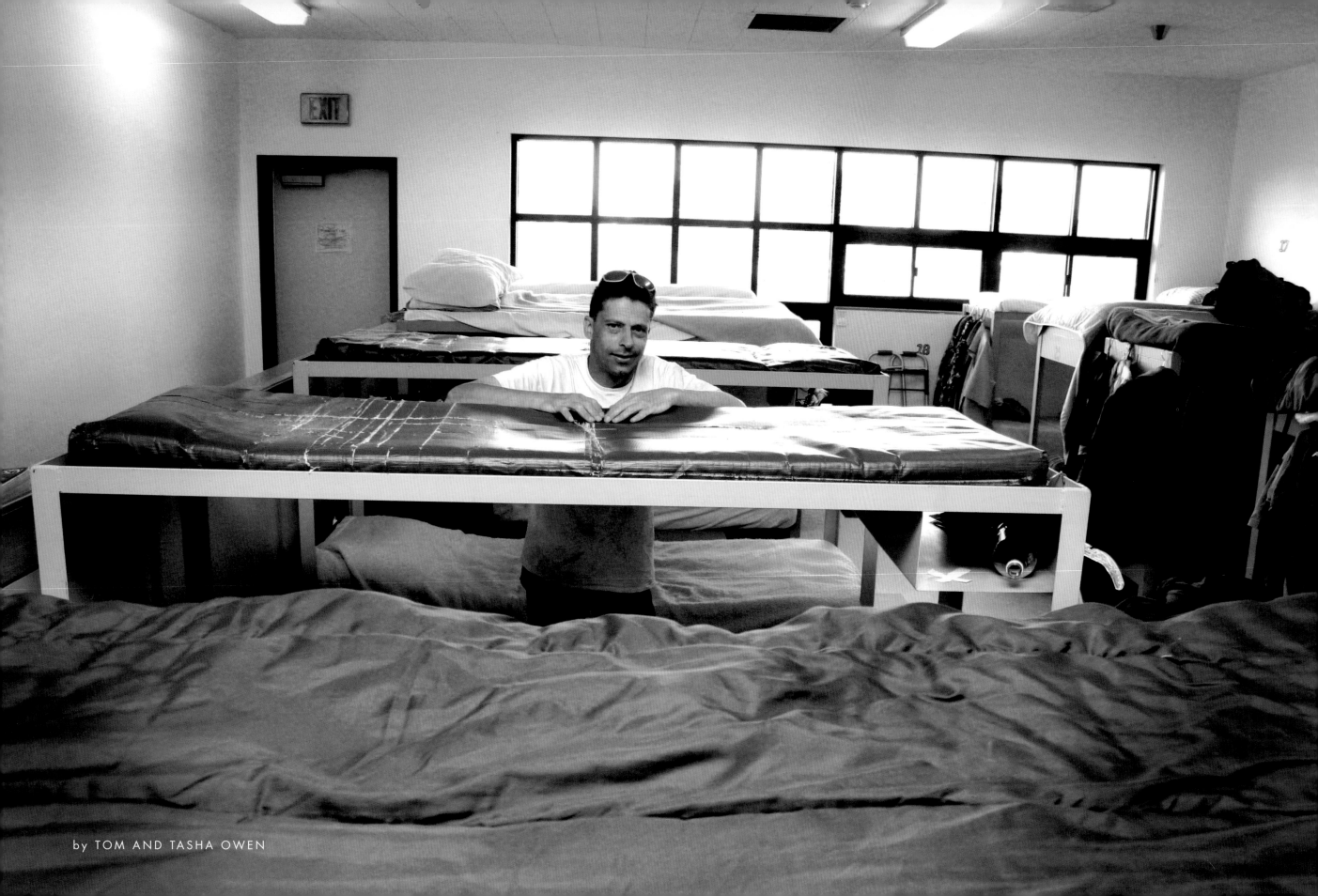

"Our mission is to break the cycle of homelessness," says Hitt. Bethlehem staffers know that accomplishing that goal takes hard work and persistence. The Inn has an open-door policy—with caveats. Clients deemed employable are required to find and maintain work, while those unable to be employed help with daily shelter activities. All clients are asked to pay $5 a day. "Paying gives residents a sense of accomplishment and pride," Hitt says.

The Bethlehem Inn is the largest emergency shelter for single adults and families in Central Oregon. It operates on a budget of just over $400,000, only 14 percent of which is publicly funded. The Inn provides about 80,000 meals and 30,000 bed-nights per year.

Hitt feels the entire community is accountable for the homeless population. "We have a responsibility that we are not meeting," she says. "There is nothing more important than shelter—if we can't make that happen, then we've failed as a community."

—Kim Cooper Findling

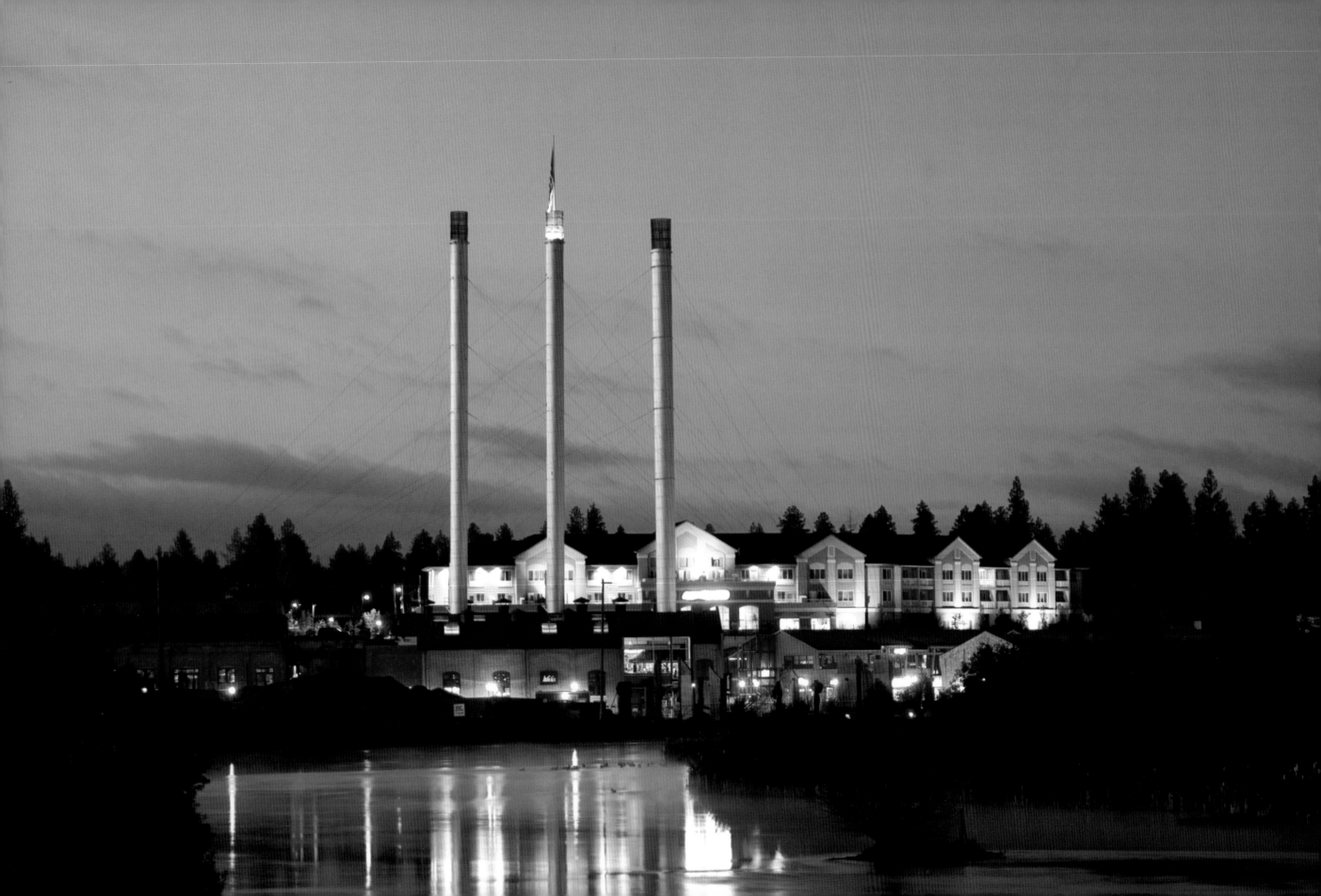

ROBERT AGLI

Robert Agli was hooked on photography even before he took an evening college photography course at the age of 15. An industrial-design graduate of Michigan State University, he escaped the automotive corporate world to move to Bend. "I'm a visual-communication problem solver," he says. "Subject matter is secondary."

www.robertagliphotography.com

LEFT:
Early morning light, Old Mill District, Bend

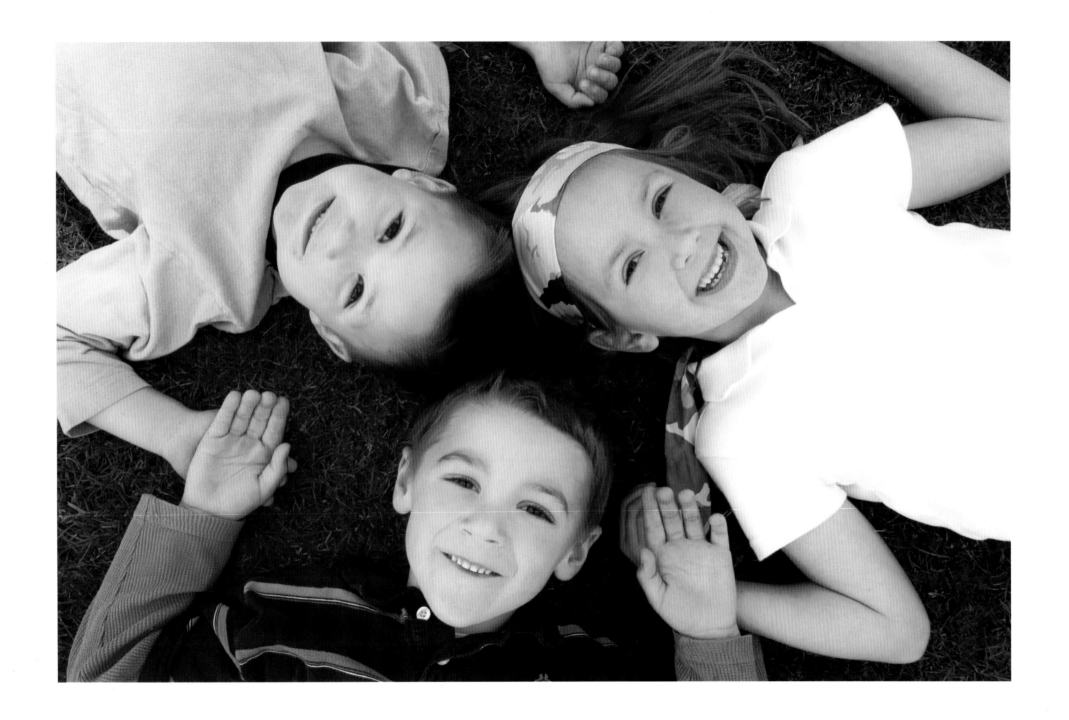

PAULA AUE WATTS

Paula Aue Watts is a graduate of the famed Brooks Institute of Photography in Santa Barbara, California. Passionate about architectural photography, she also enjoys shooting food, people and adventure. Her work has been published locally and nationally, and she has shot professionally in multiple countries

www.paulaauephoto.com

LEFT:
Meeting of the minds: Clockwise from left, Javan, Rachel and Kainoa Hedges

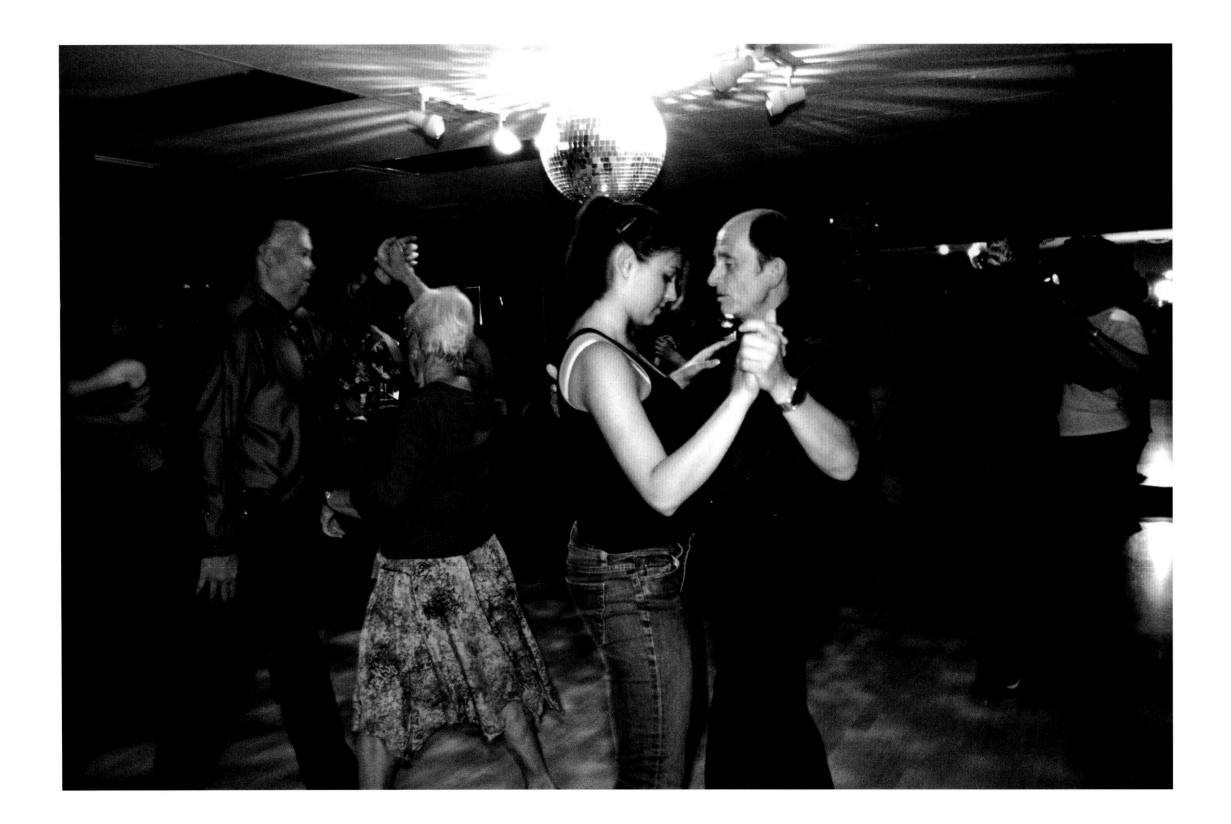

KAREN CAMMACK

Karen Cammack returned to her native Bend in 2003 after living in Seattle and Montana for 12 years. Her work has appeared in *The New York Times*, *Fortune* and *Fly Fisherman*. Karen also works as a fundus angiographer for the Retina Clinic of the Cascades.

LEFT:
Taking the lead, Deschutes County Ballroom Dance Club

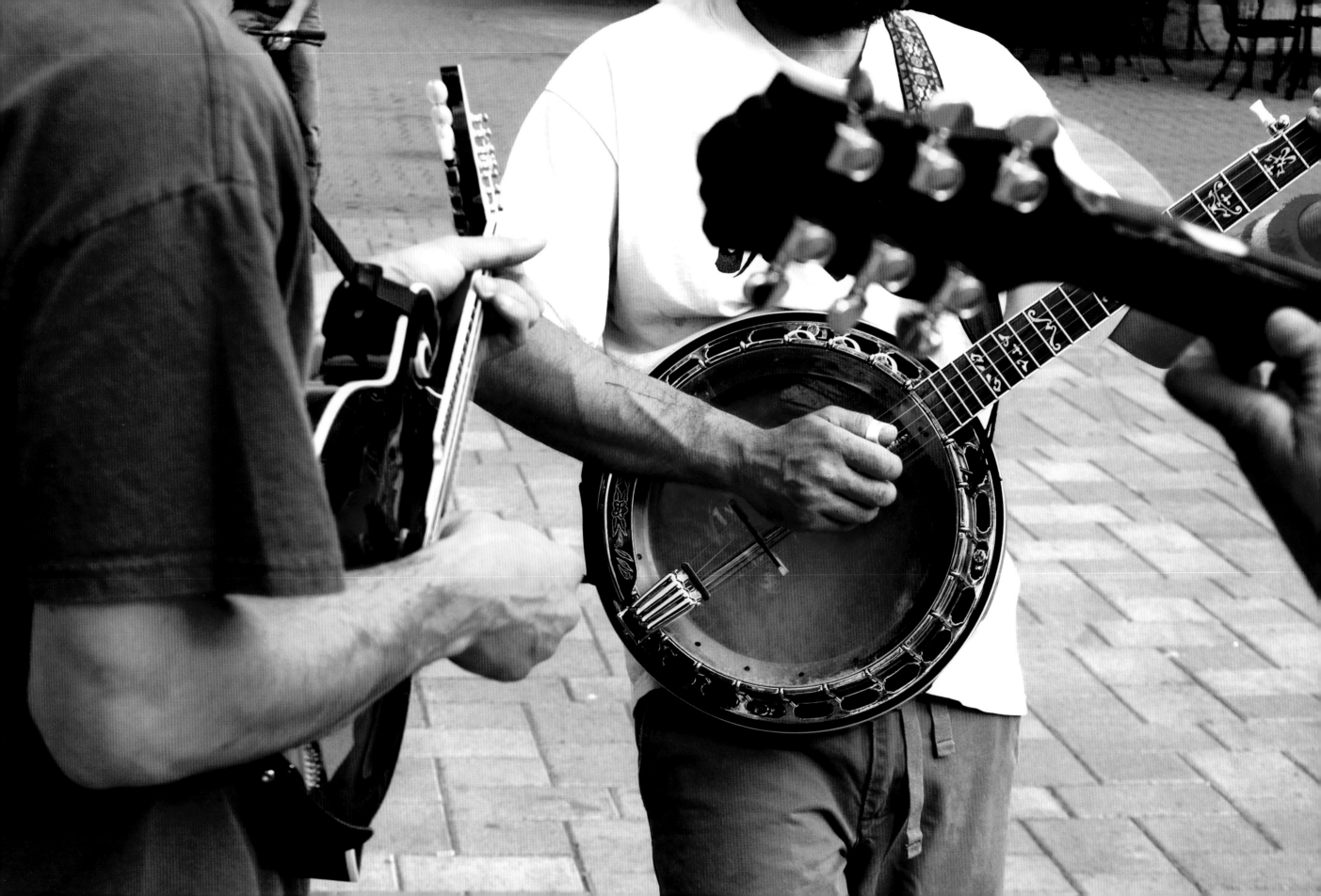

MARISA CHAPPELL

Marisa Chappell is a Bend native who was born with a traveling soul. After living and working in France and Australia and nearly filling a passport with stamps, she returned home to pursue a career in photography. When she is not holding a camera, the University of Oregon graduate works for the law firm of Karnopp Petersen.

www.marisachappell.com

LEFT:
Jam session, Mirror Pond Plaza, Bend

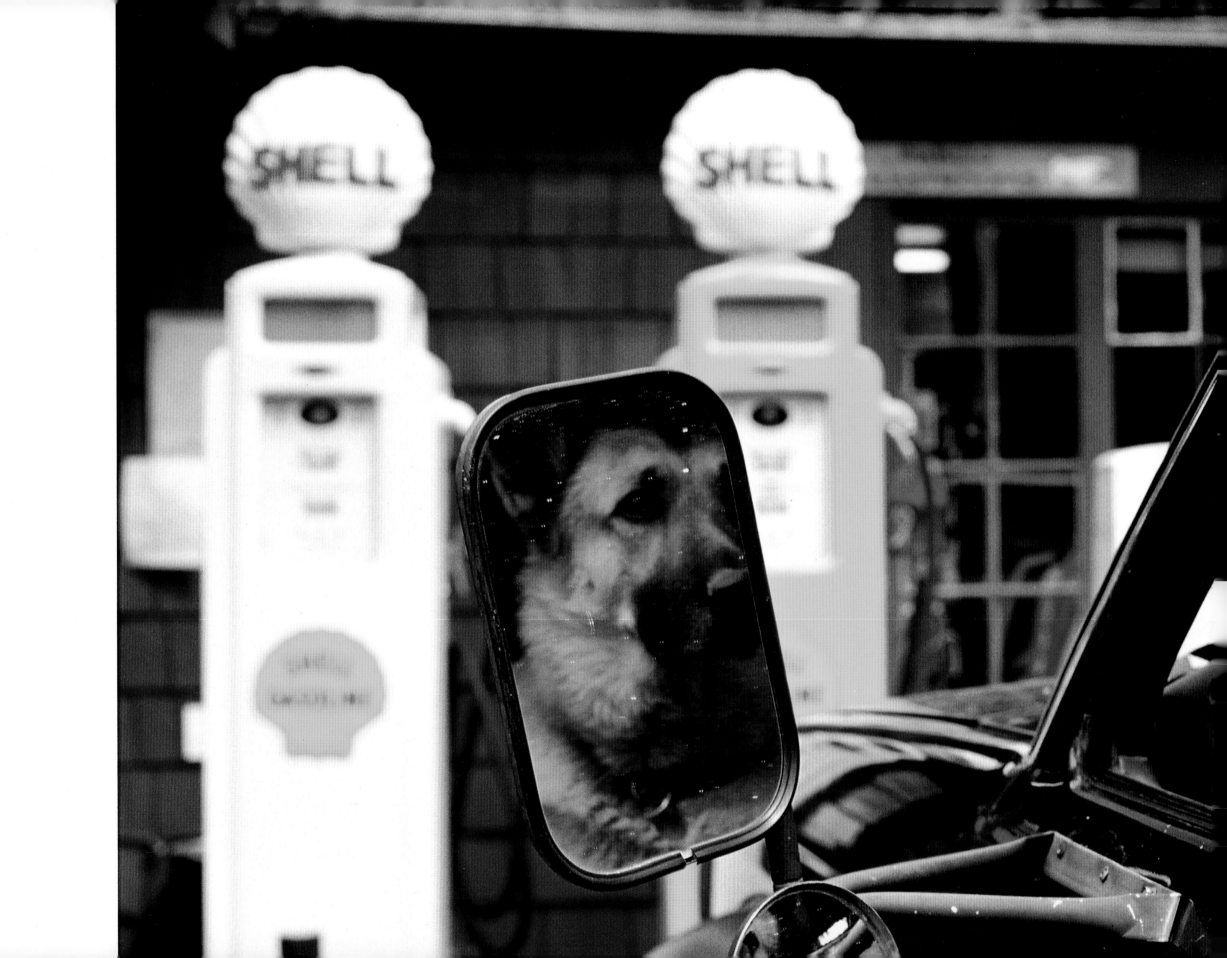

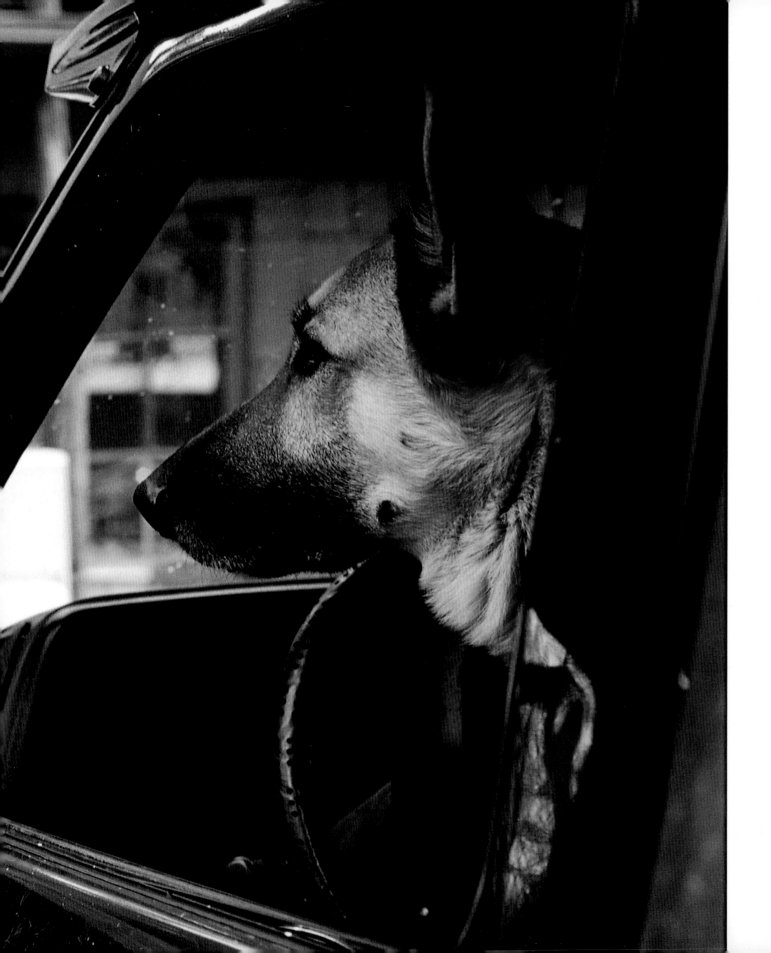

BYRON DUDLEY

Landscape photographer Byron Dudley moved to Sisters in 2002 with his wife, Nancy, from Eugene, where he was a high-school administrator for more than 20 years. His work has appeared in such publications as *Sierra, Sunset, Oregon Home* and *Bend Living*, and his photographs have been displayed at the White Oak Gallery in Eugene since 1980.

LEFT:
Mirror image, Camp Sherman Store

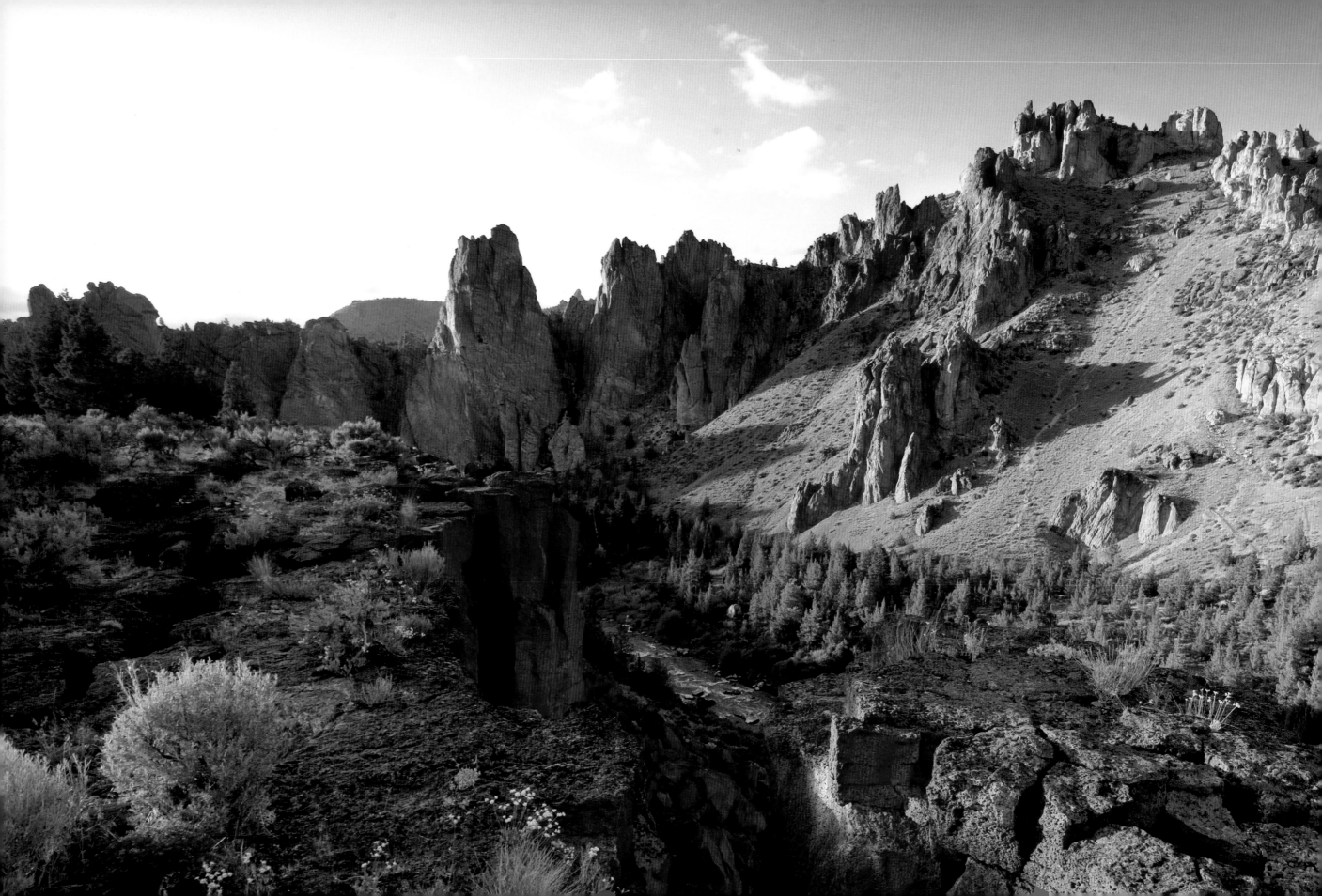

RIC ERGENBRIGHT

Ric Ergenbright has lived in Bend since 1983, when he moved from California with his wife, Jill, and their three daughters. Ric has a stock-photography business that has grown to 250,000 worldwide images, and he has produced five books, including *The Art of God* and *The Image of God*. Ergenbright's work has been honored nationally by the National Geographic Society and the Smithsonian Institution.

www.ricergenbright.com

LEFT:
Smith Rock State Park

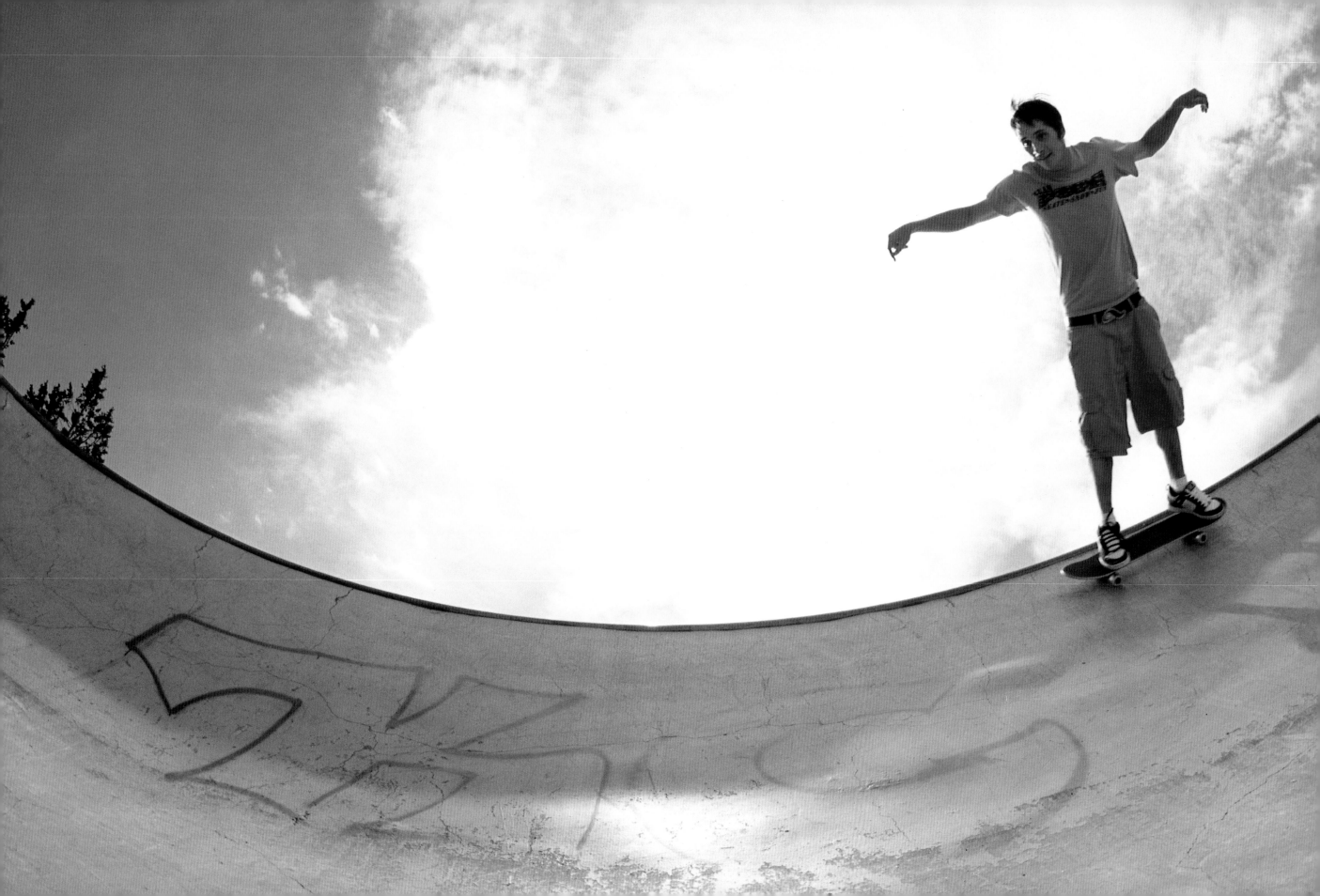

MARK GAMBA

A Colorado native, Mark Gamba has developed a national reputation for his shots of extreme sports and athletes. His long list of publications—many of which have featured his work on their covers—includes *Skiing*, *Sports Illustrated*, *Outside*, *Sunset*, *Men's Journal*, *Newsweek*, *People*, *Esquire* and *National Geographic Adventure*. A resident of Bend from 1994 to 2004, he now lives near Portland with his wife and three children.

www.markgamba.com

LEFT:
Houston Chet carves the bowl,
Ponderosa Skate Park

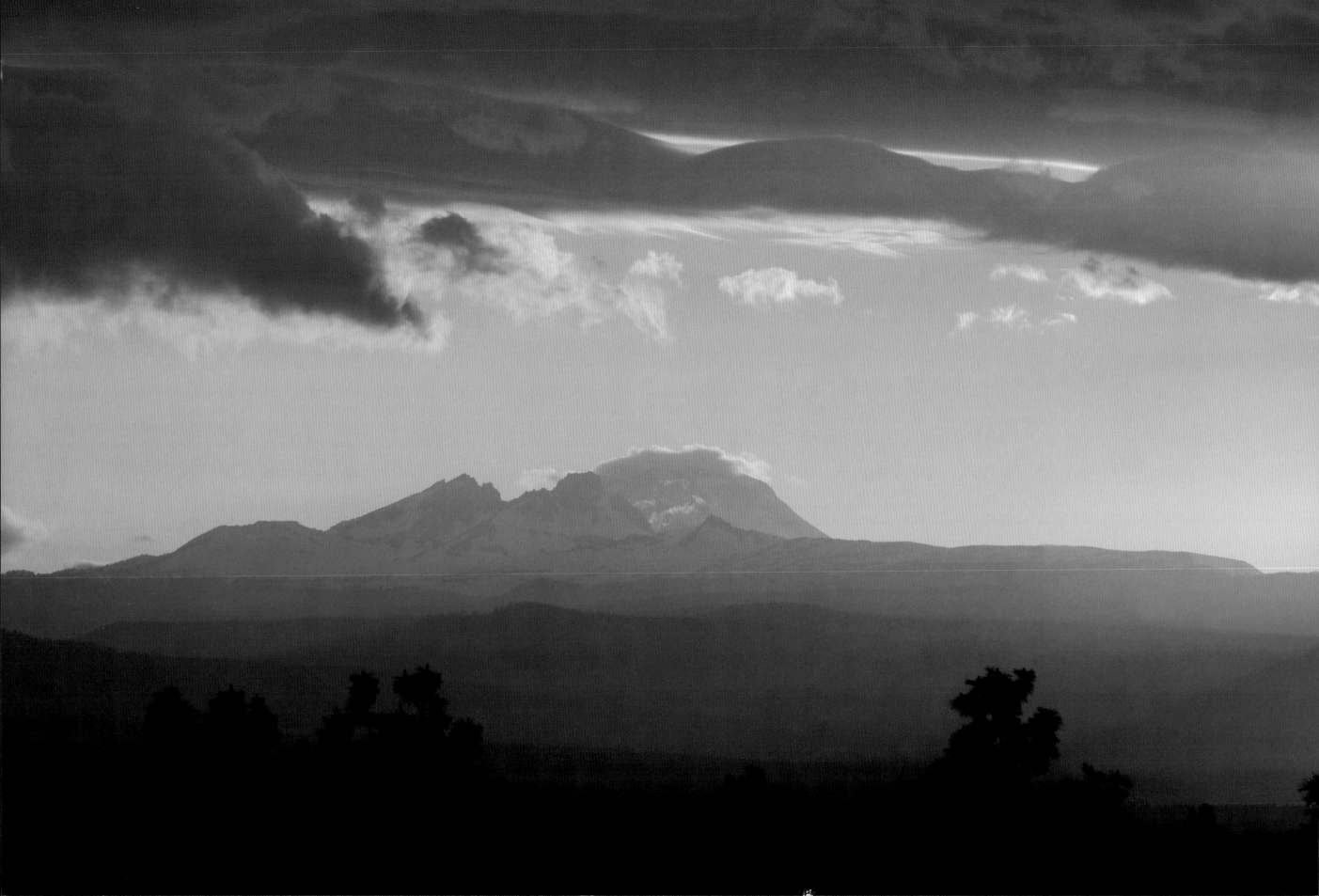

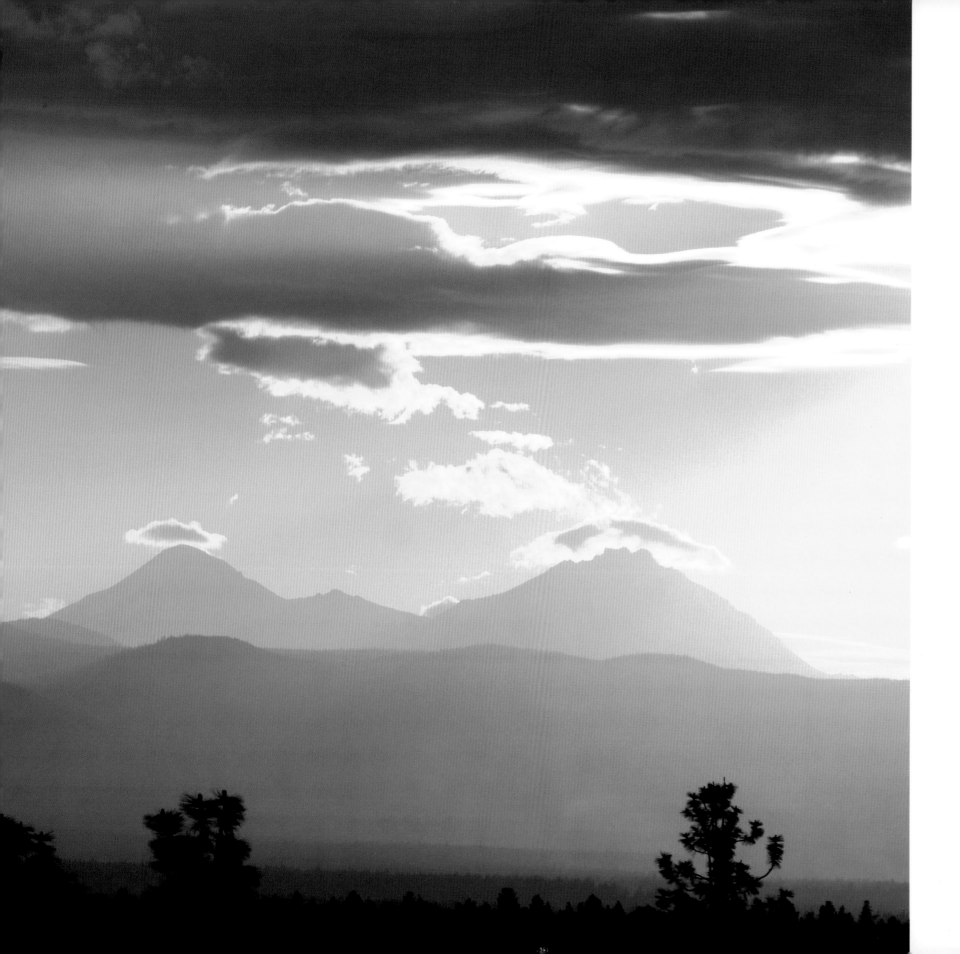

CHRISTIAN HEEB

Christian Heeb is an internationally known travel photographer who works out of Bend and St. Gallen, Switzerland. His images of scenic locations worldwide have appeared on the covers of magazines (including *National Geographic Traveler* and *Rolling Stone*) published in nine different countries, and more than 100 books feature his photos. He has written about his profession in such magazines as *American Journal* and *Color Foto*.

www.heebphoto.com

LEFT:
Cascade mountainscape:
Broken Top and the Three Sisters

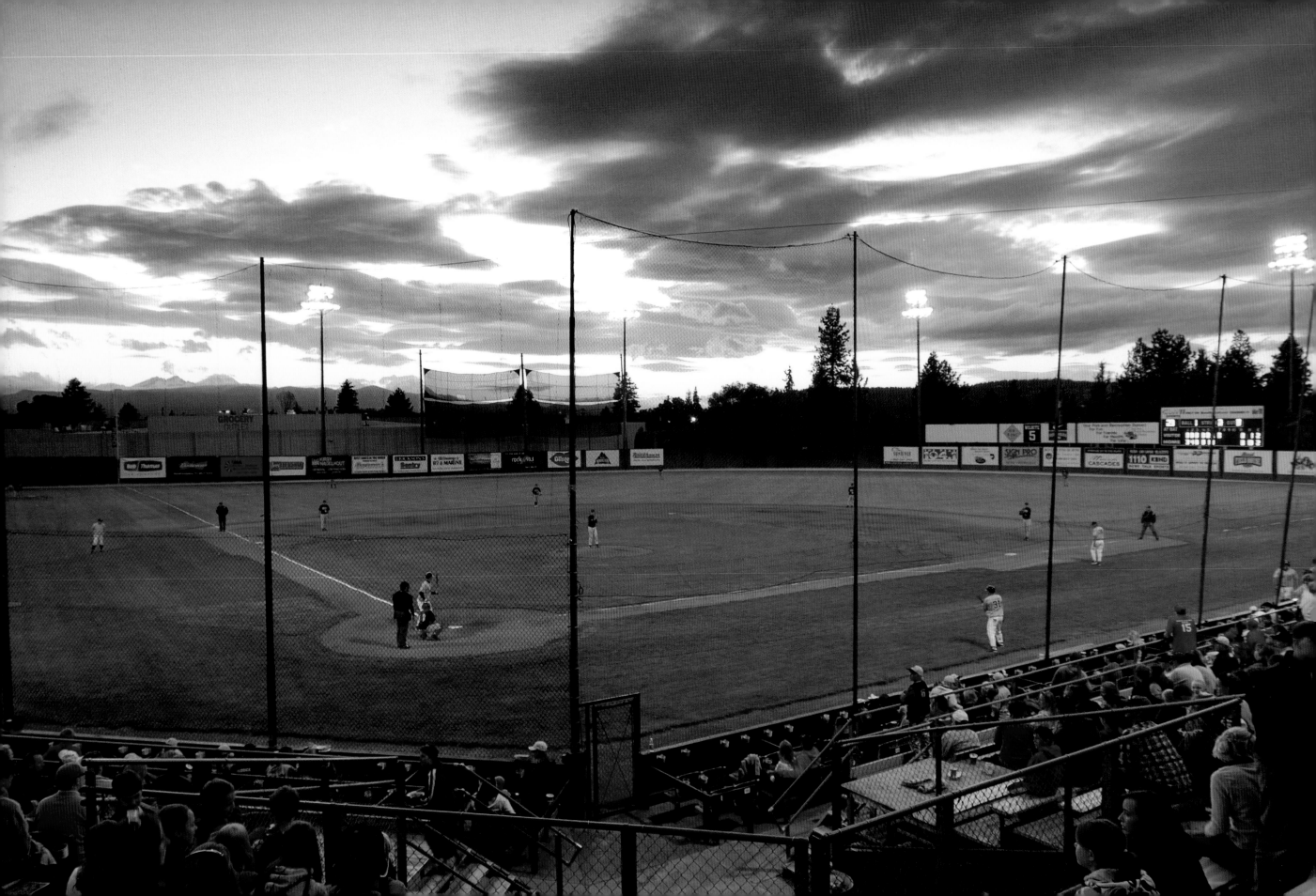

MIKE HOUSKA

Mike Houska is a Bend-based commercial and advertising photographer who specializes in shooting for clients in the resort, travel and recreation industries. When he is not armed with a camera, Mike and his wife, Meaghan, are kept hopping by their children, Sam and Johanna.

www.doglegstudios.com

LEFT:
Time for baseball, Vince Genna Park, Bend

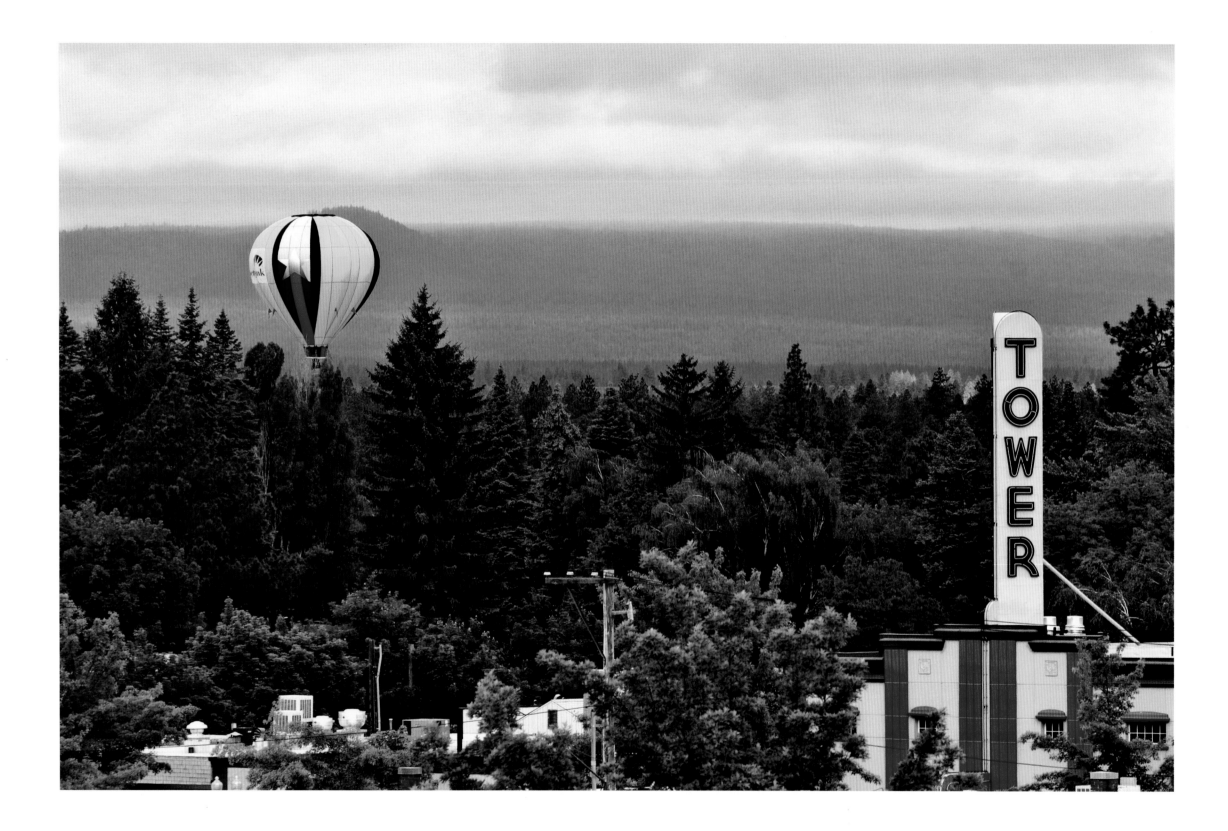

JEFF KENNEDY

Jeff Kennedy is a second-generation Bend native who—with the exception of six years in Colorado—has lived all his life in Central Oregon. Jeff owns his own photography business, specializing in contemporary portraiture.

www.imagesbyjeffkennedy.com

LEFT:
Towering above Bend

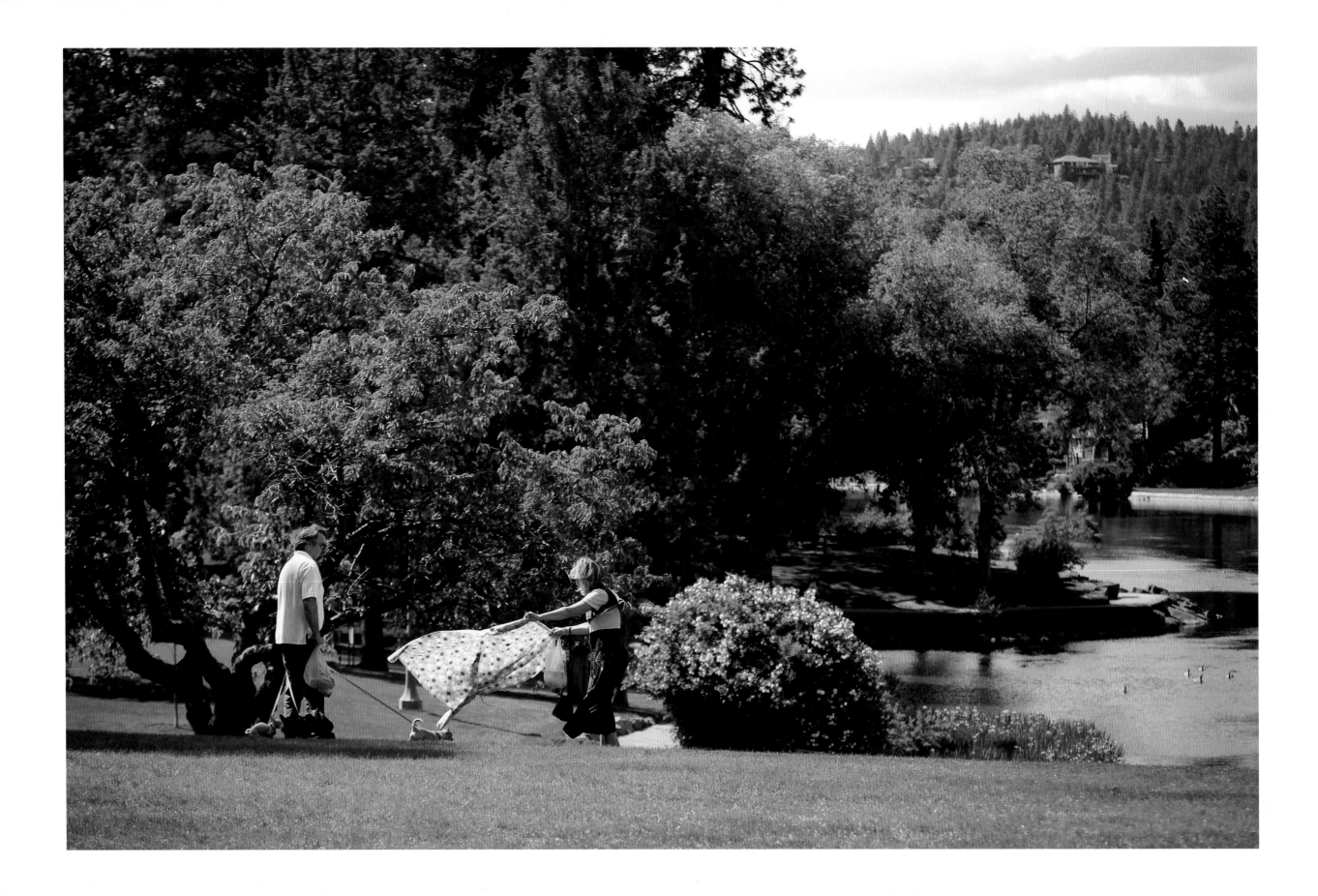

KEVIN KUBOTA

Kevin Kubota lives in Bend with his wife and business partner, Clare. The Hawaii natives have made their home here since 1996 and operate a thriving wedding, portrait and commercial studio, Kubota Photo Design. Their business has expanded to include digital workshops and training for professional photographers nationwide as well as in Canada and Italy.

www.kkphoto-design.com

LEFT:
Dogs love a picnic, Drake Park, Bend

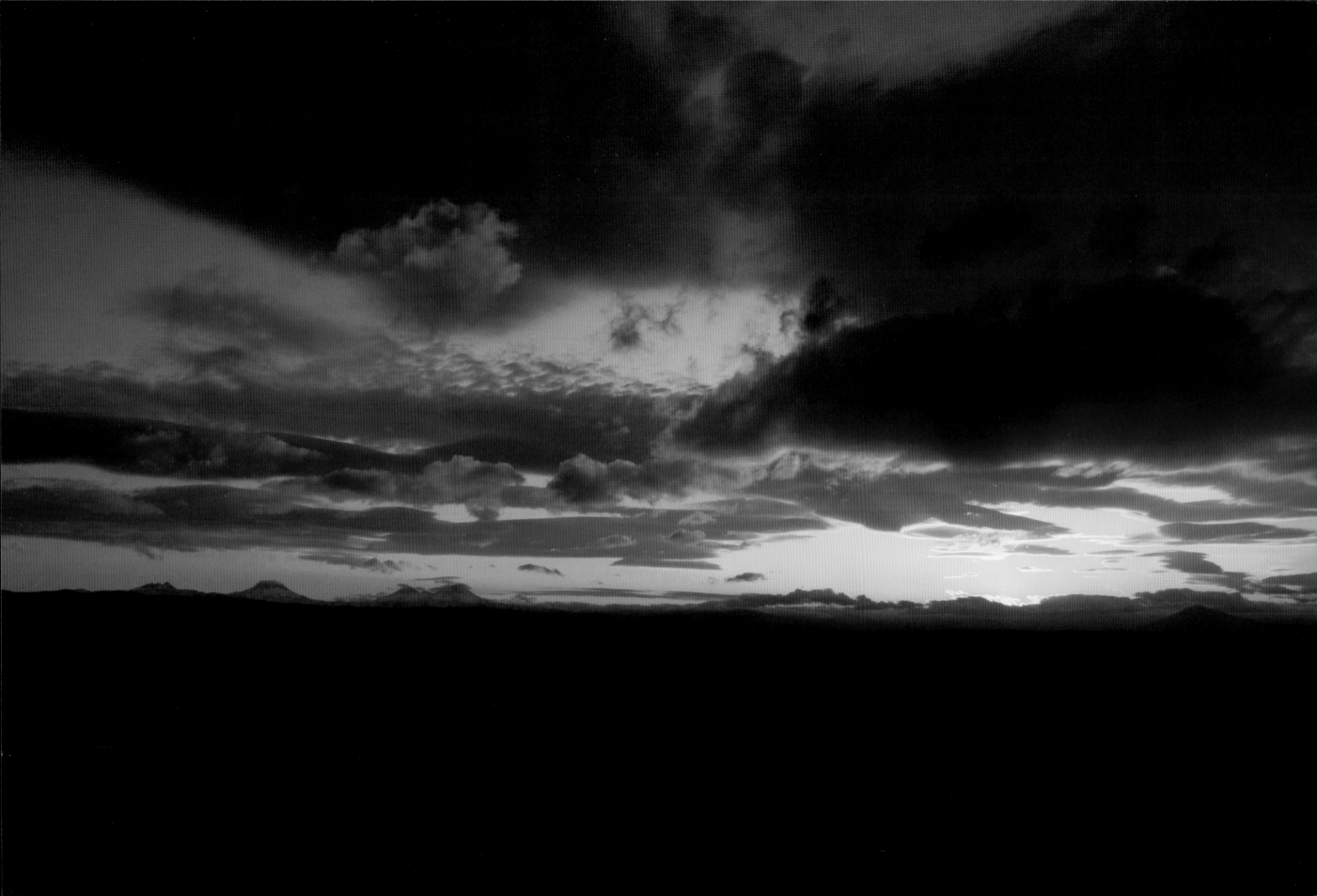

CHRIS MATHER

Chris Mather has worked as a photographer for more than a dozen years, with clients in the music, entertainment, education, health-care and advertising industries. Originally from the East Coast, Chris has settled into the Central Oregon lifestyle with his wife, Dana, and their daughters, Cassidy and Madison.

www.doglegstudios.com

LEFT:
Cascade sunset

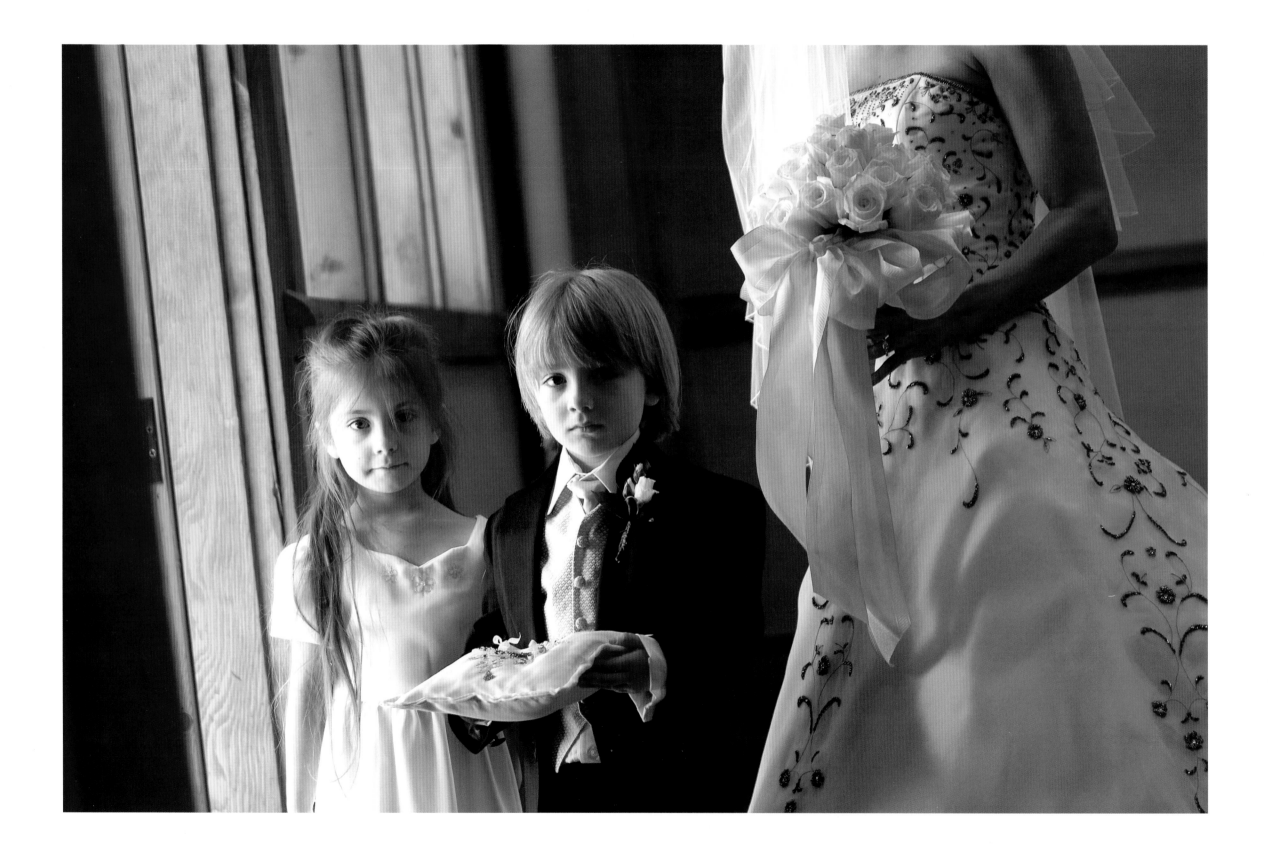

TODD MARTYN-JONES

A native of Sydney, Australia, where he worked as a photojournalist for *The Daily Telegraph* and other newspapers, Martyn-Jones now makes his home in Bend with his wife, Debra, and their dog, Foster. Todd's wide-ranging portfolio ranges from outdoor sports and wildlife to music and wedding photography.

www.tmjphotography.com

LEFT:
Ringbearer and flower girl,
wedding ceremony, Sunriver

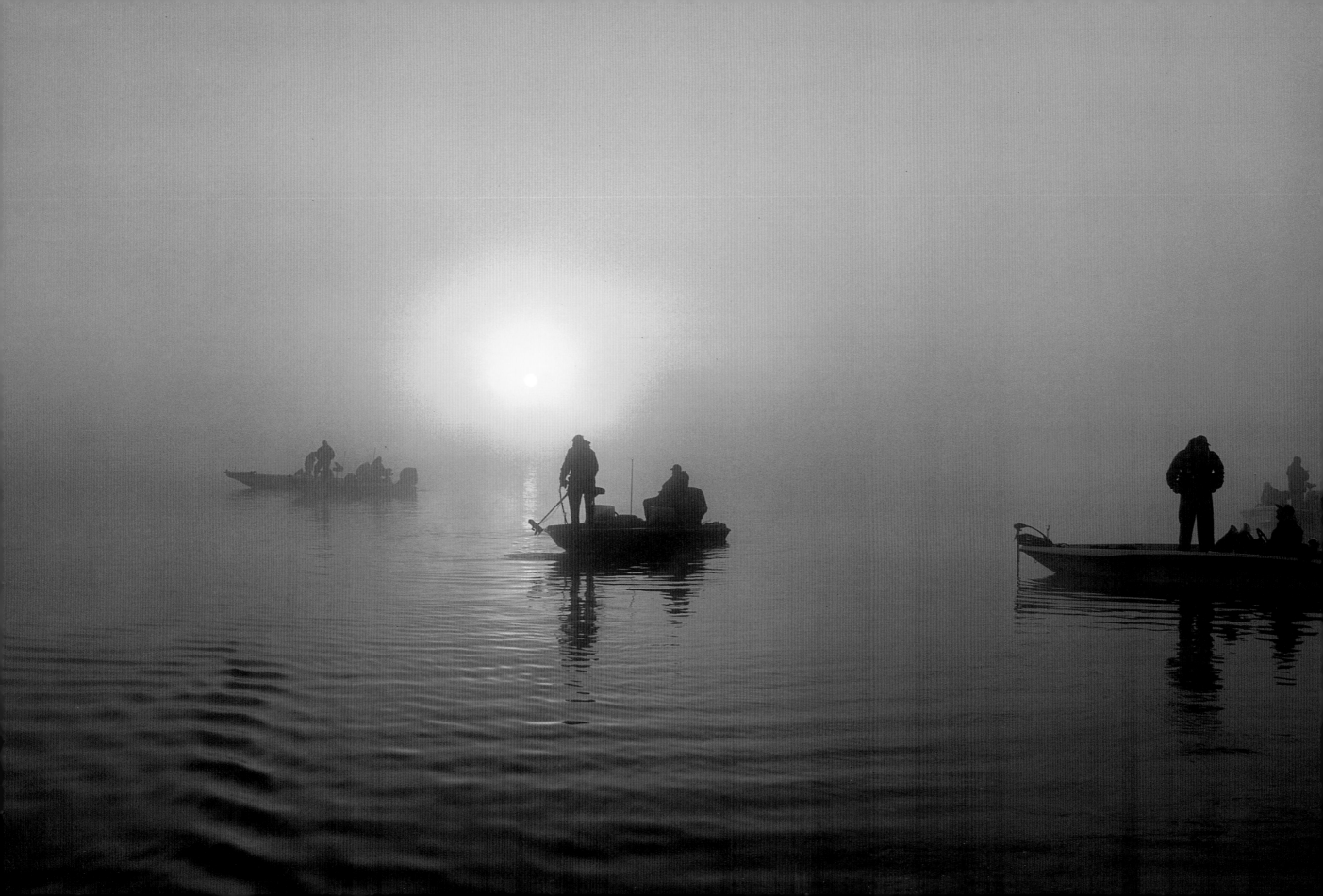

BUDDY MAYS

Buddy Mays has lived in Bend with his wife, Stephanie, and daughter, Crosby, since 1996. His color images, taken on six continents, regularly appear in such publications as *National Geographic Adventure*, *Outside*, *Business Week* and *Condé Nast Traveler*.

www.buddymays.com

LEFT:
Bass fishermen at dawn,
Crane Prairie Reservoir

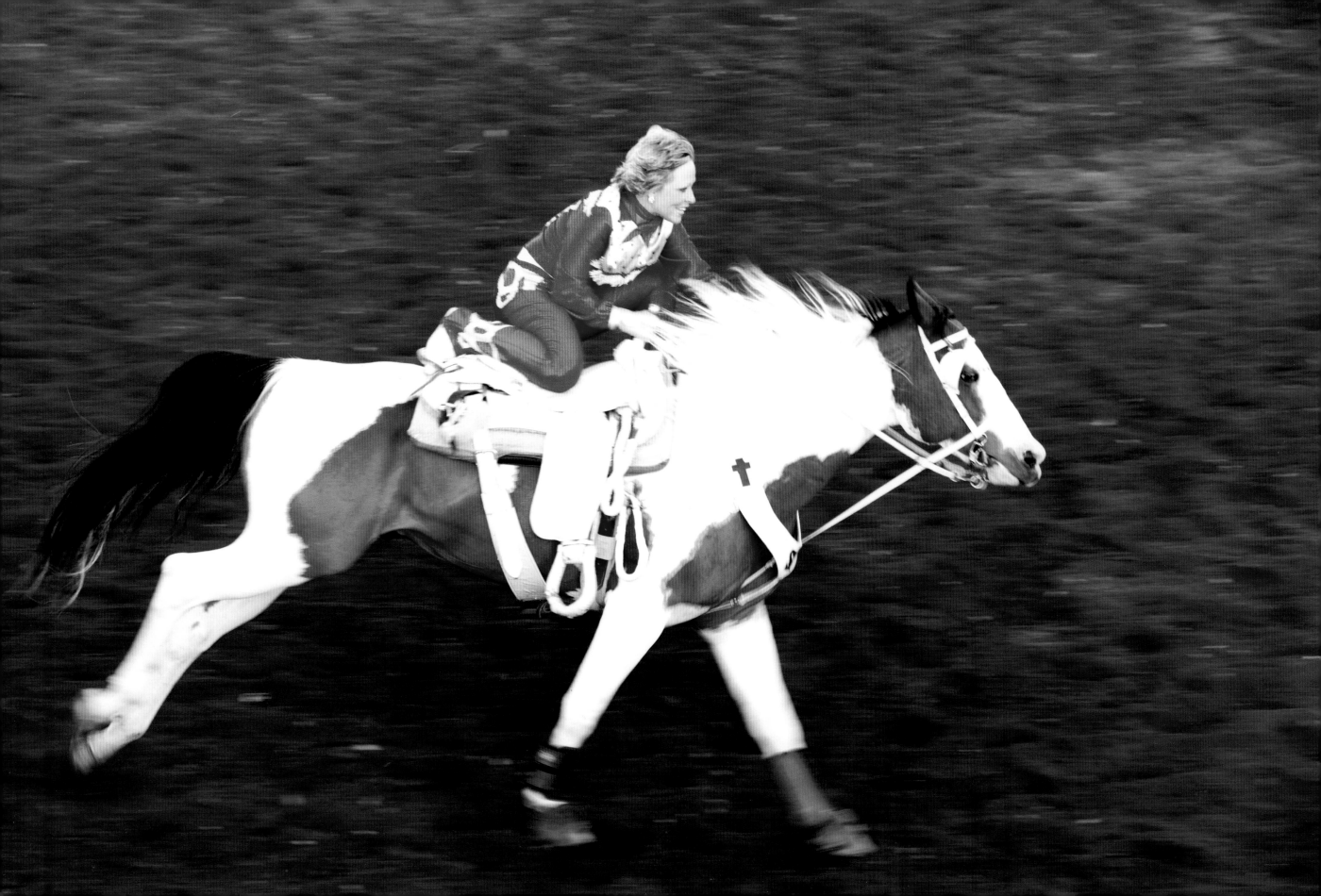

HADLEY McCANN

Native Oregonian Hadley McCann settled in Sisters after retiring from a long career as a special agent for the FBI. A photographer for more than 40 years, he has been recently published in such magazines as *Portland Monthly* and *Seattle Magazine*, and is the official photographer for the Sisters Rodeo, Sisters Folk Festival and Oregon High Desert Classic horse show.

www.hadleymccan.com

LEFT:
Equestrian acrobat, Sisters Rodeo

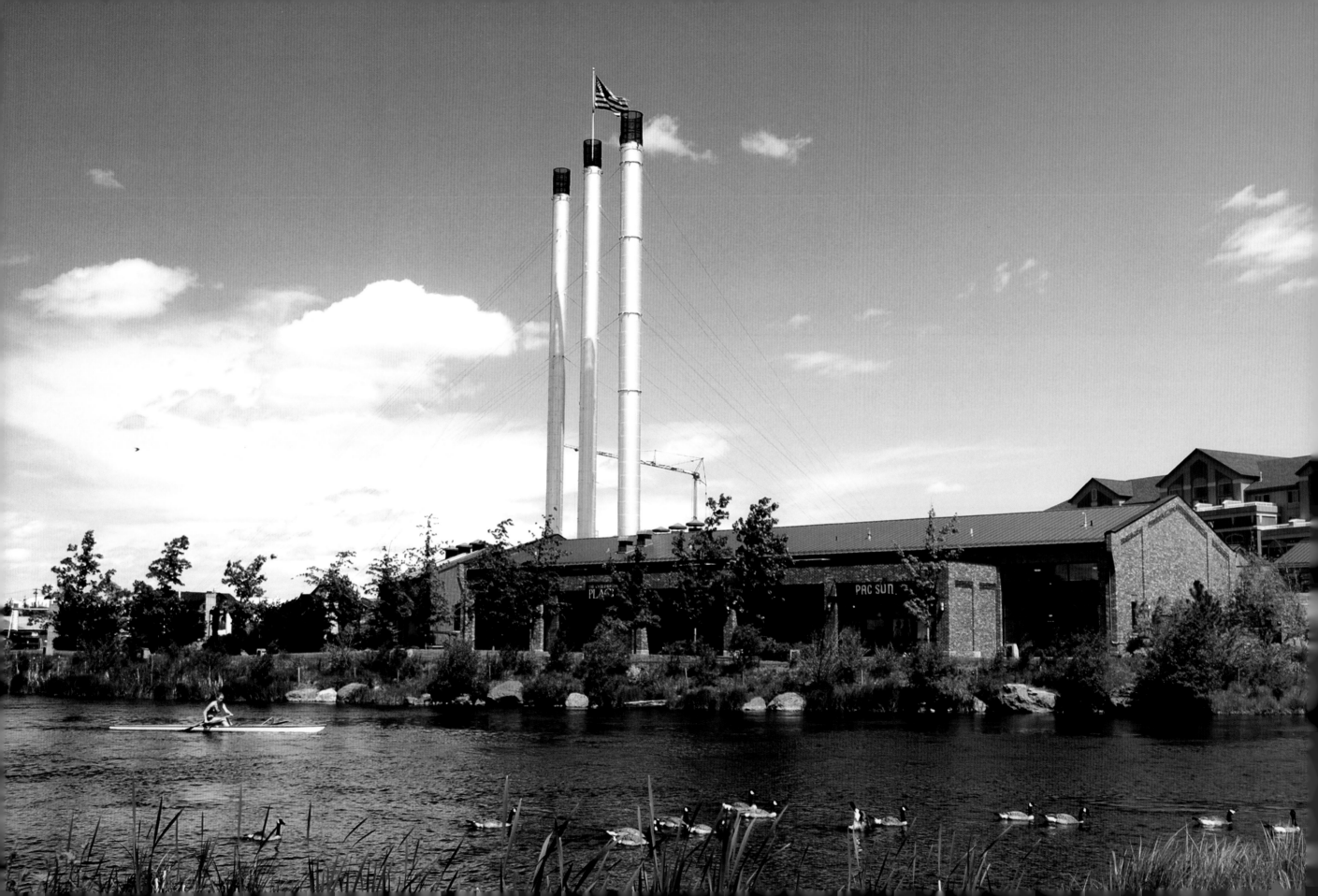

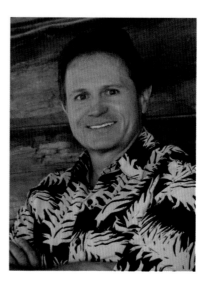

JEFF MEYERS

Redmond native Jeff Meyers started his photography career in 1980. After 12 years of wedding photography and wine tasting in the Napa Valley, he returned to his hometown with his wife, Julianne. "I needed more ski days at Bachelor," he explains. Today the Meyerses have a studio specializing in family portraits and wedding photography.

www.cascadephotography.com

LEFT:
The Shops at the Old Mill District, Deschutes River, Bend

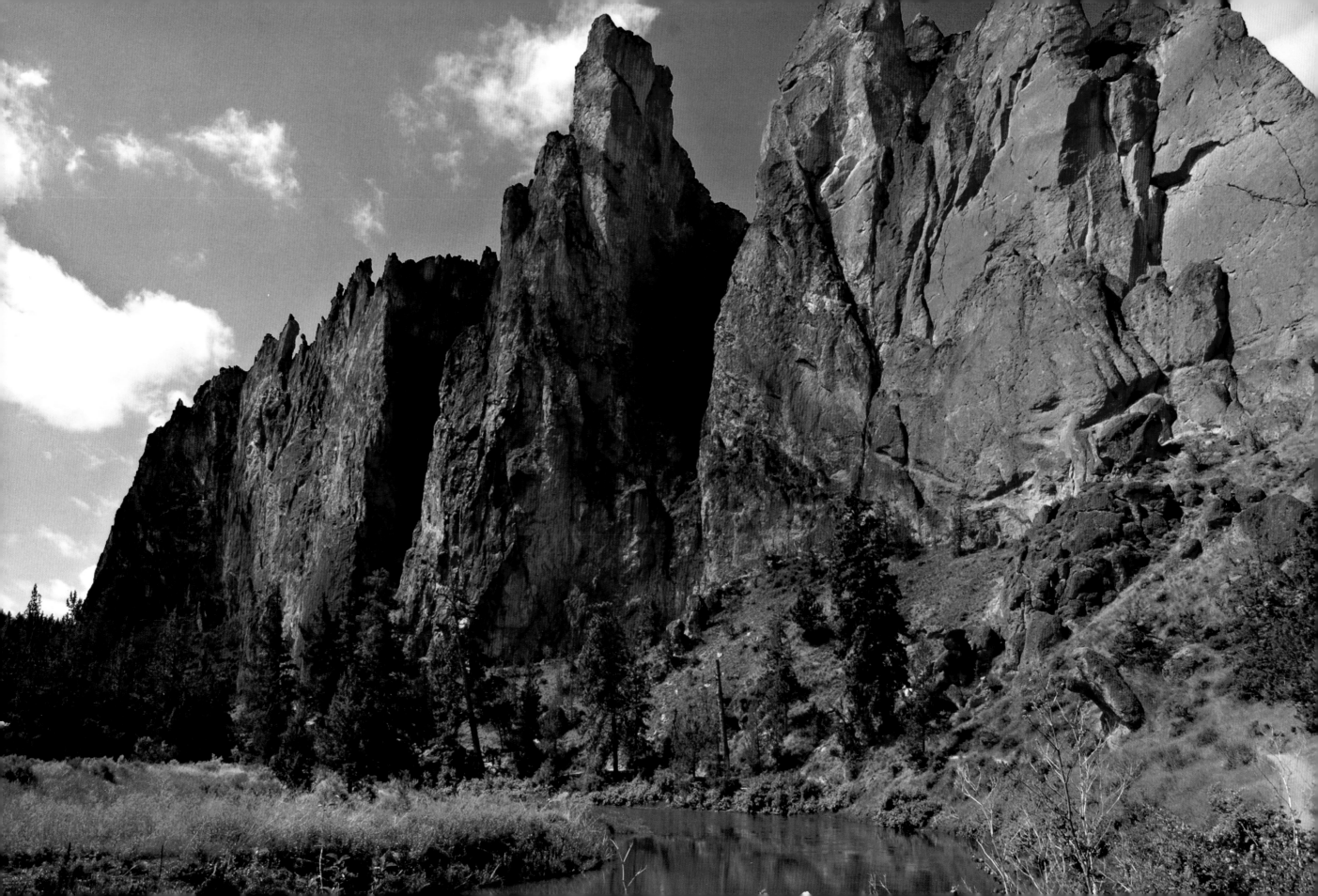

JULIANNE MEYERS

Julianne Meyers traveled from her native Wisconsin to the San Francisco Bay Area, where she met her life and business partner, Jeff. Their work has been published in *Town & Country* magazine and in publications of *Modern Bride* and *Country Magazine.* Julianne enjoys hiking and traveling with Jeff and their two dogs, Mickie and Minnie.

www.cascadephotography.com

LEFT:
Crooked River, Smith Rock State Park

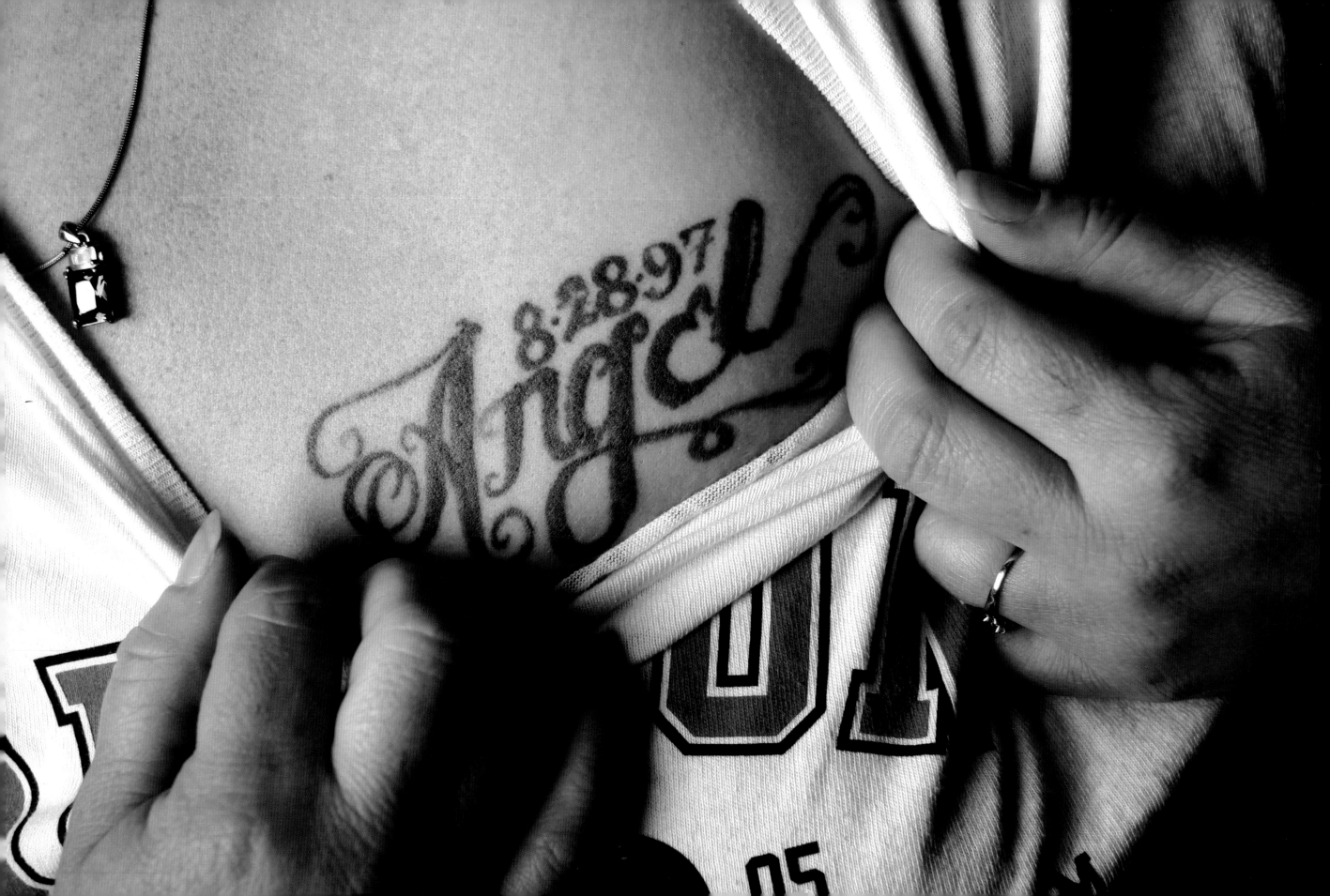

TASHA OWEN

Tasha Owen lives in Tacoma, Washington, with her photographer husband, Tom, where she specializes in editorial portraiture and wedding photography. A former entertainment-industry photographer in Los Angeles, she is a frequent *Bend Living* contributor, and her work has also appeared in *Glamour* and *Interview Magazine*. The December 2006 issue of *The Knot* features a portfolio of her work.

www.tashaowen.com

LEFT:
Revelation, Bethlehem Inn, Bend

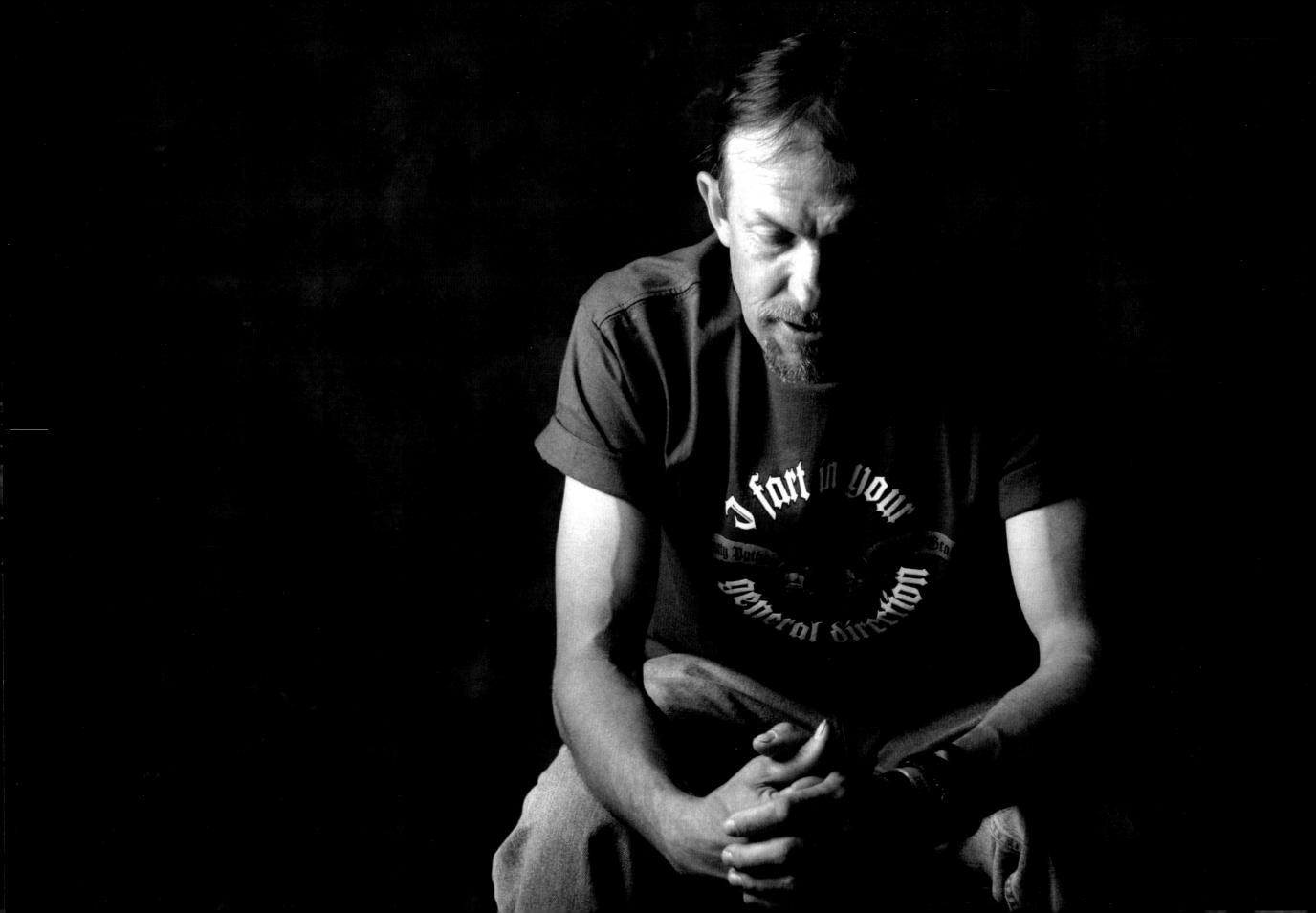

TOM OWEN

Tom Owen lives in Tacoma, where he operates a
commercial and advertising photography business.
He and his wife, Tasha, his college sweetheart from
Iowa, moved to Los Angeles after graduating from pho-
tography school in 1980, then relocated to the Pacific
Northwest. His corporate clients include Breedlove
Guitars, Brown & Haley and NASCAR.

www.owenphoto.com

LEFT:
Reflection, Bethlehem Inn, Bend

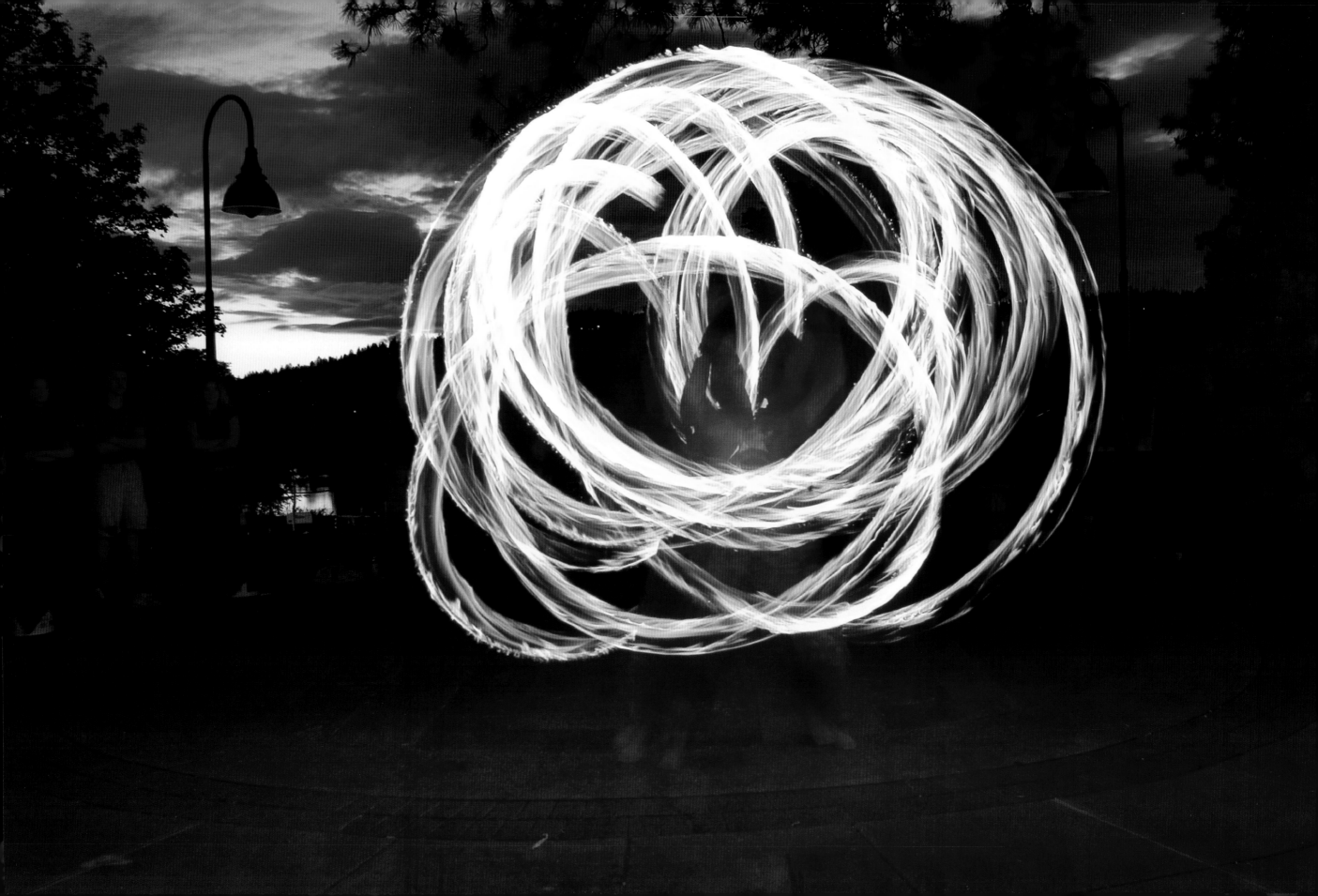

SIMONE PADDOCK

Simone Paddock, who specializes in architectural photography, was educated in Switzerland and traveled the world before settling in La Pine in 2002. She covers subjects from travel to food, and has written about food photography for O'Reilly Media.

www.emeraldbayphoto.com

LEFT:
Fire dancer, Mirror Pond Plaza, Bend

TIFFANY PAULIN

Tiffany Paulin is *Bend Living*'s photo editor and production manager—and the creative mind behind *Day in the Life: Central Oregon*. Her work is regularly published in *Bend Living*. Raised in southwestern Washington, she has lived in Bend since 2000. In addition to photography, she has worked as a marketing director, a graphic designer, an entrepreneur and a musician.

LEFT:
Whispering winds

BRIAN ROBB

A lifelong Oregonian, Brian Robb graduated from Bend High School in 1968 and Oregon State University in 1972. He got his first camera at the age of 25 and ever since has focused on his passion for skiing and ski racing—from the Pacific Northwest to the Alps and around the world. He has covered two Winter Olympics as well as a Super Bowl. Brian has been a resident of Hood River since 1987.

www.brianrobbphoto.com

LEFT:
From the tee, Juniper Golf Club

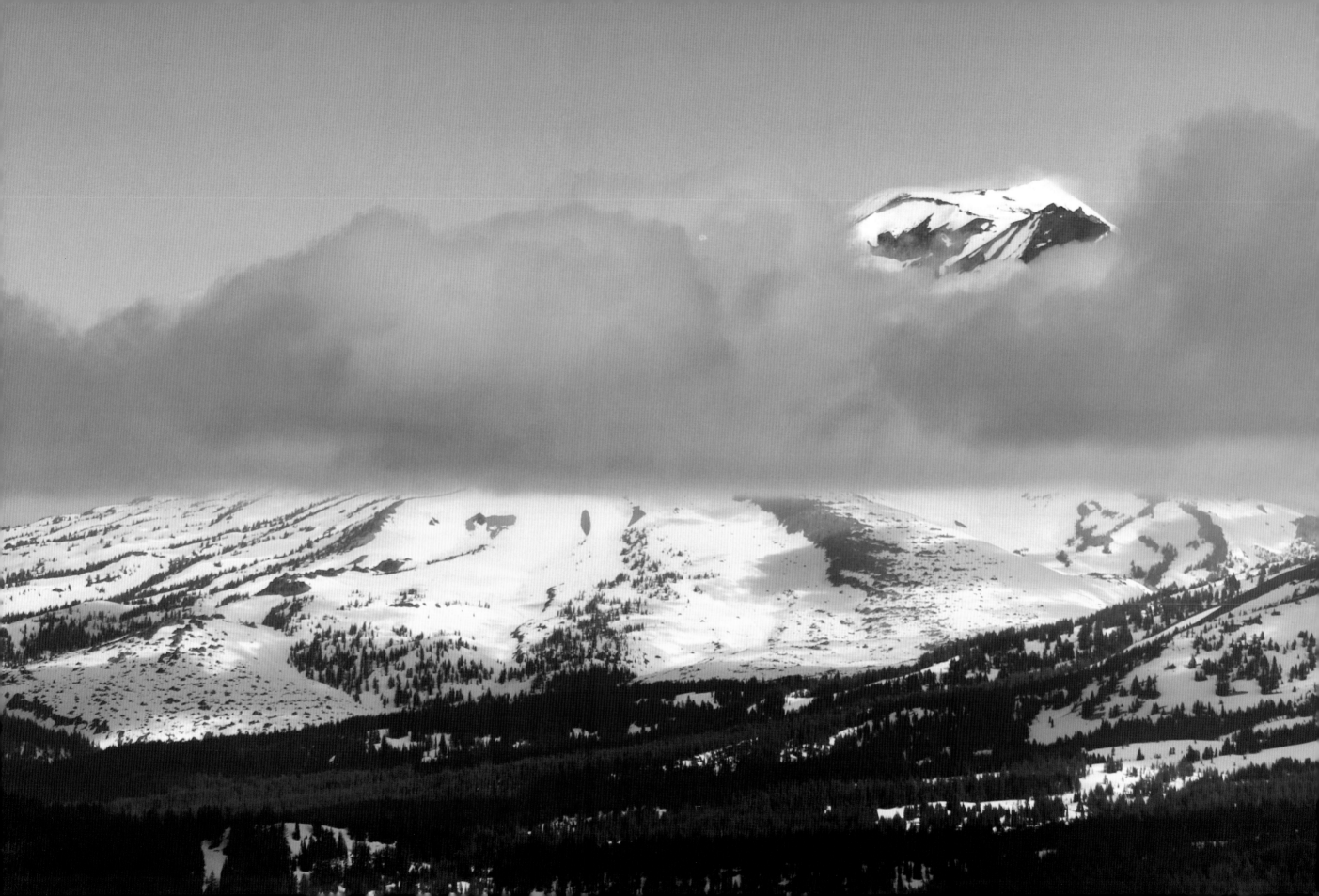

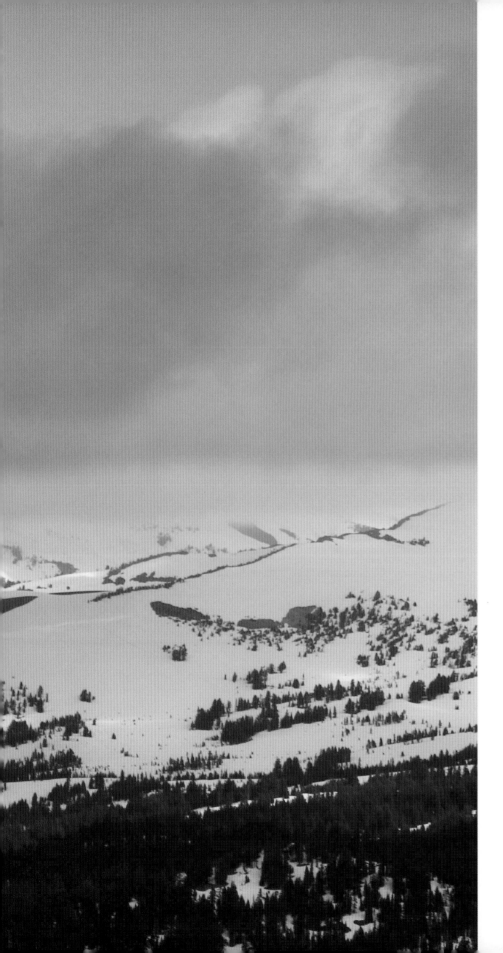

ZACH SCOTT

Zach Scott, who has been taking pictures since he could hold his grandfather's old Pentax, published his first photo at age 11. Born in Ojai, California, he has lived in Bend for a decade.

www.zachscottphoto.com

LEFT:
South Sister from Tumalo Mountain

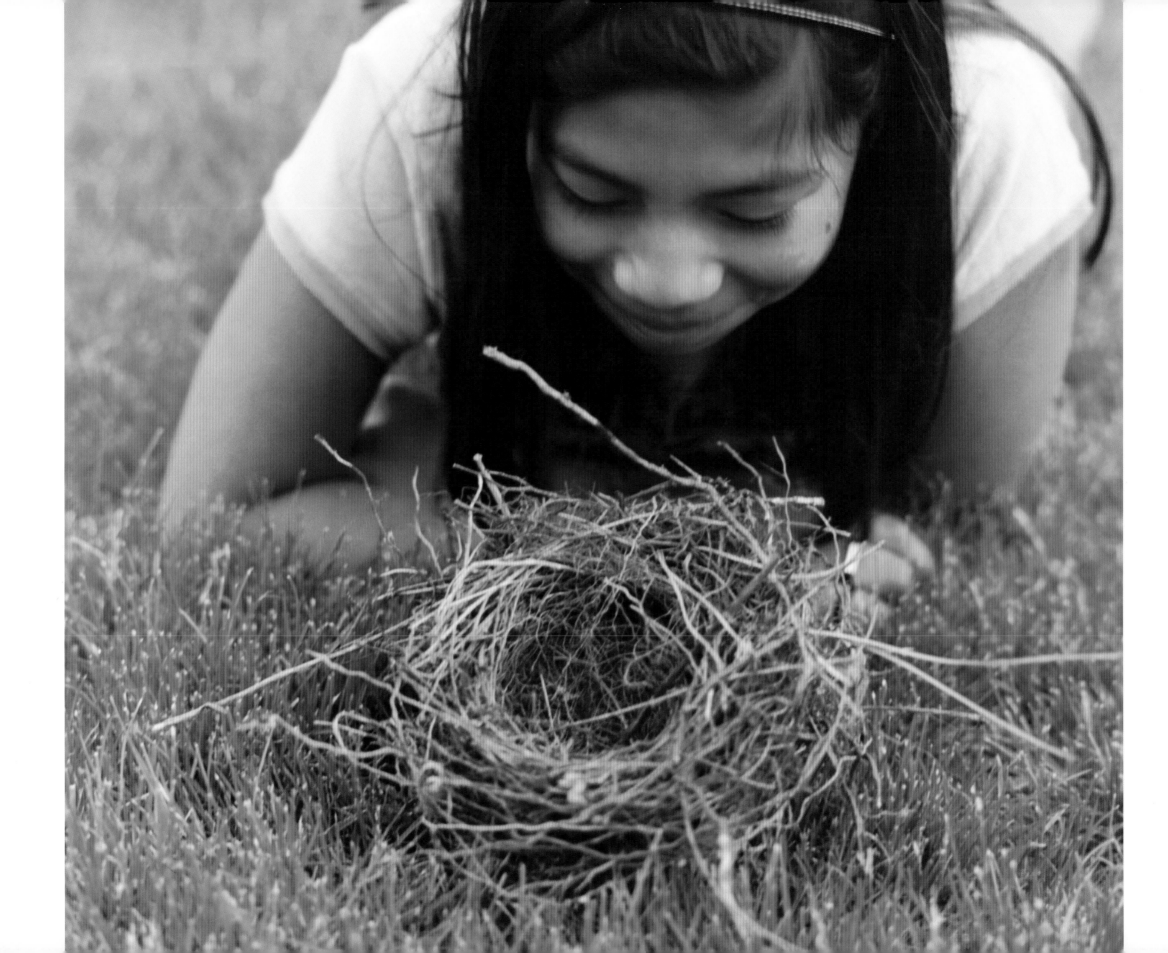

CAROL STERNKOPF

Carol Sternkopf, who studied at Wisconsin's Milwaukee Institute of Art and Design, moved to Bend nine years ago and has worked since as a portrait photographer. Carol's photos have appeared in numerous magazines and gallery shows, in the Aperture online gallery and in *The Sun*.

www.carolsternkopf.com

LEFT:
Childhood wonder

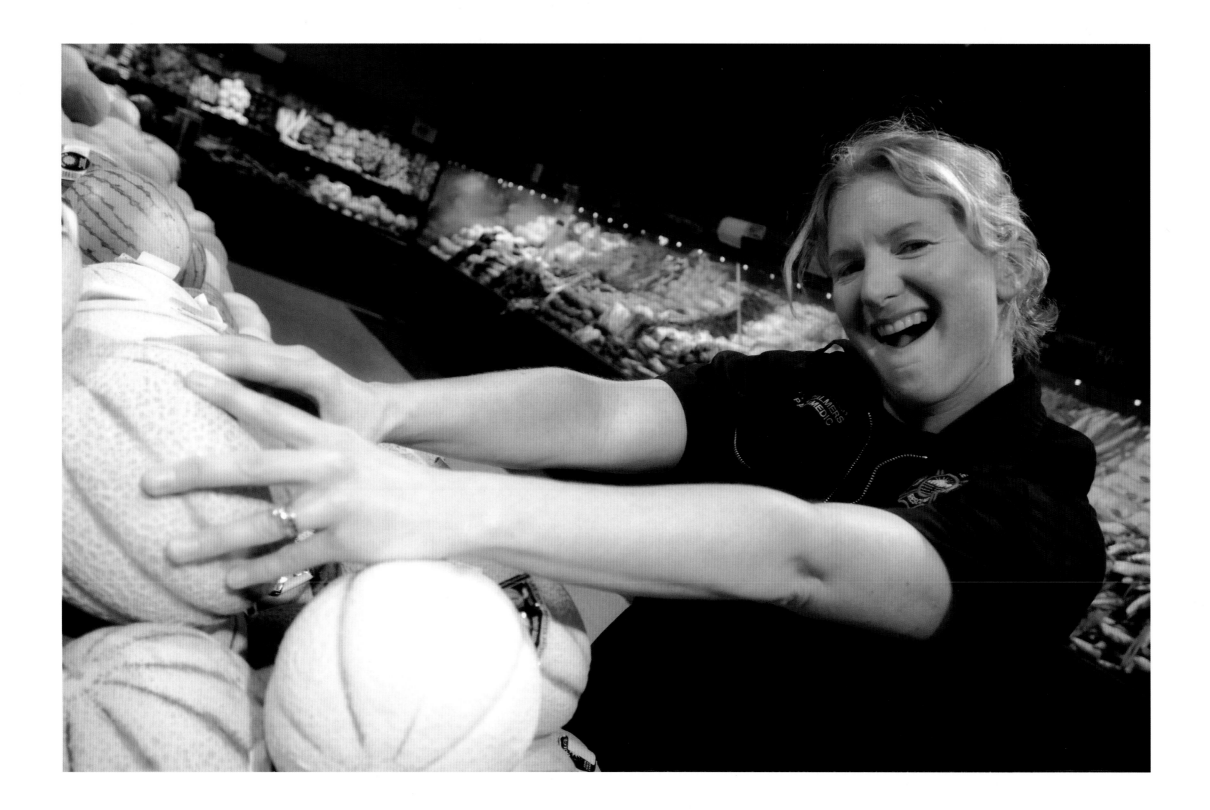

STEVE TAGUE

Steve Tague appreciates the calm pace of Central Oregon after years of working in New York city. He specializes in product and home photography, and his list of past clients ranges from IBM to *House Beautiful* magazine. Steve lives in Bend with his two favorite assistants: his sons, Max and Dakota.

www.stevetague.com

LEFT:
A fruitful frolic, Bend

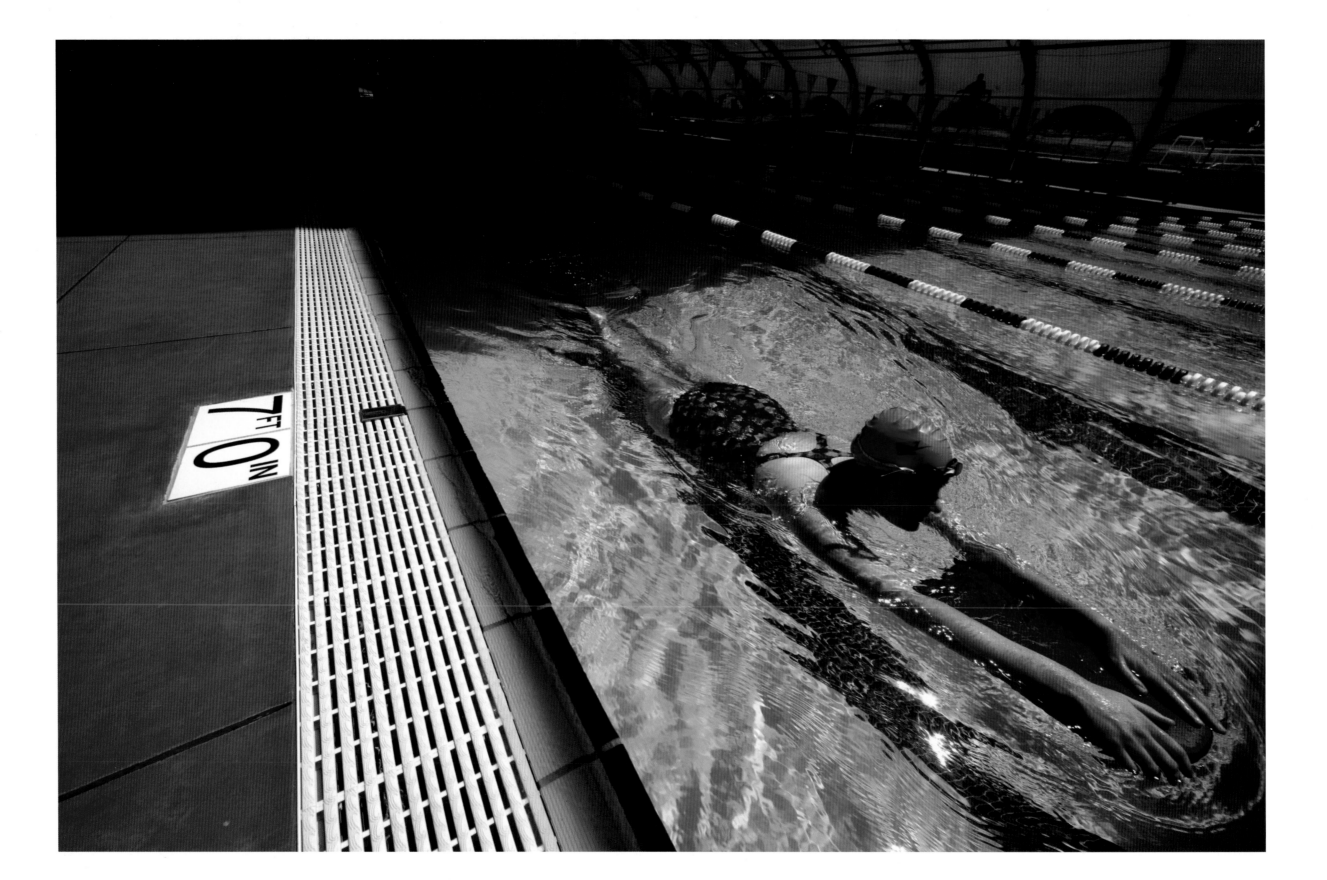

BOB WOODWARD

Writer-photographer Bob Woodward, a Bend resident since the 1970s, was mayor in 1997-99. A former editor for *Times Mirror* and *New York Times* magazines in New York, Woodward specializes in covering outdoor sports. He now serves on the Bend Metro Park and Recreation District board, writes a column for *the Source Weekly* and is a regular *Bend Living* contributor.

LEFT:

Morning swim, Juniper Swim and Fitness Center

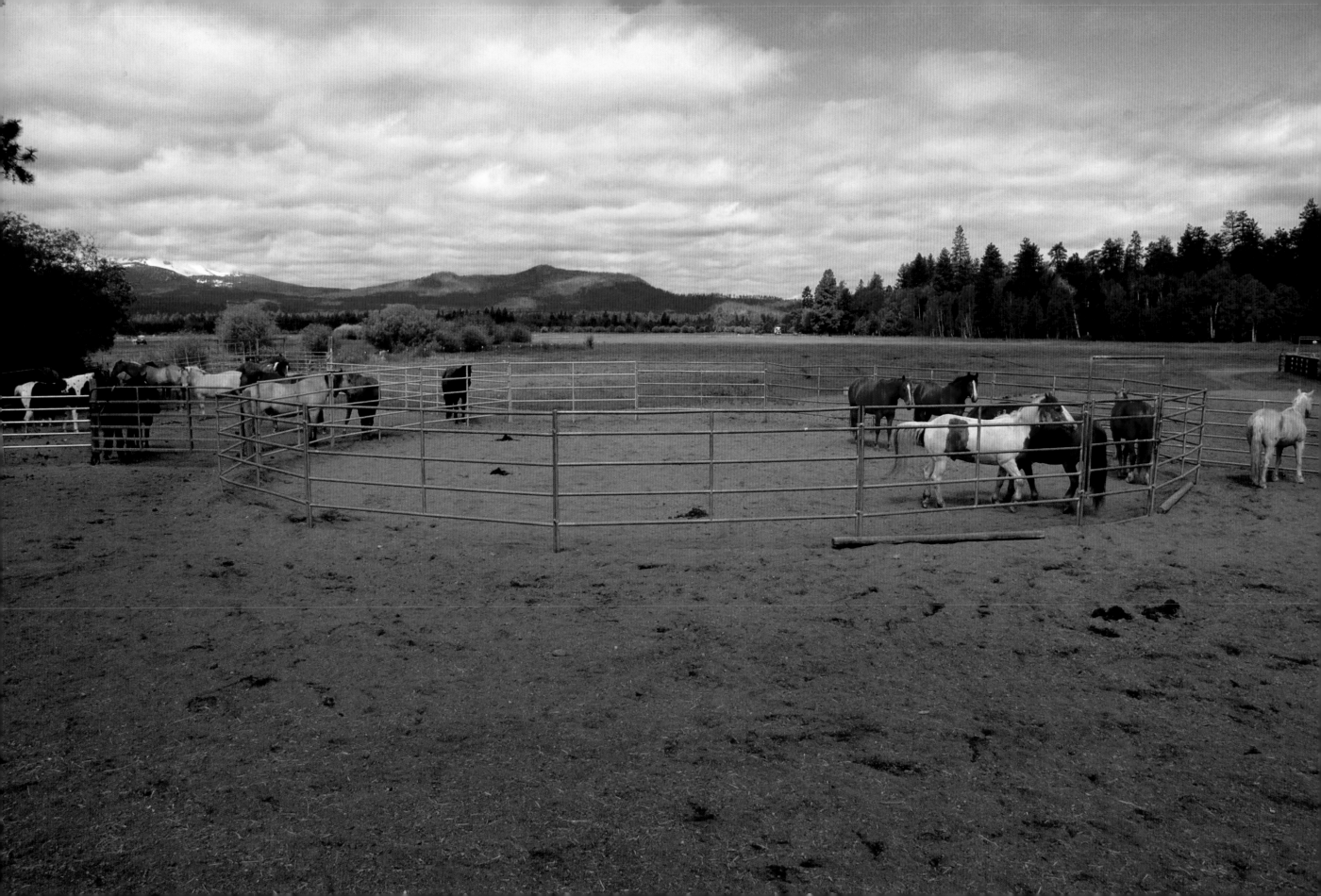

JIM YUSKAVITCH

Jim Yuskavitch has been covering the Pacific North-west with a special focus on the environment for the past 30 years. His work has appeared in *Bend Living*, *German Geo*, *Time*, *National Wildlife*, *Backpacker*, *Sierra*, *Travel+Leisure*, *Fly Fisherman* and many other publica-tions. He lives in Sisters.

www.agpix.com/jimyuskavitch

LEFT:
Corral, Black Butte Ranch

by CHRISTIAN HEEB

Sunset over the Cascades

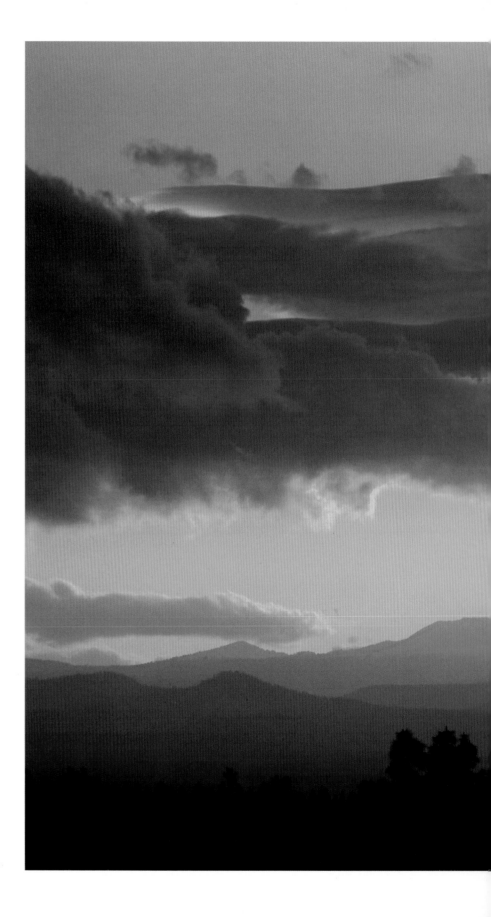

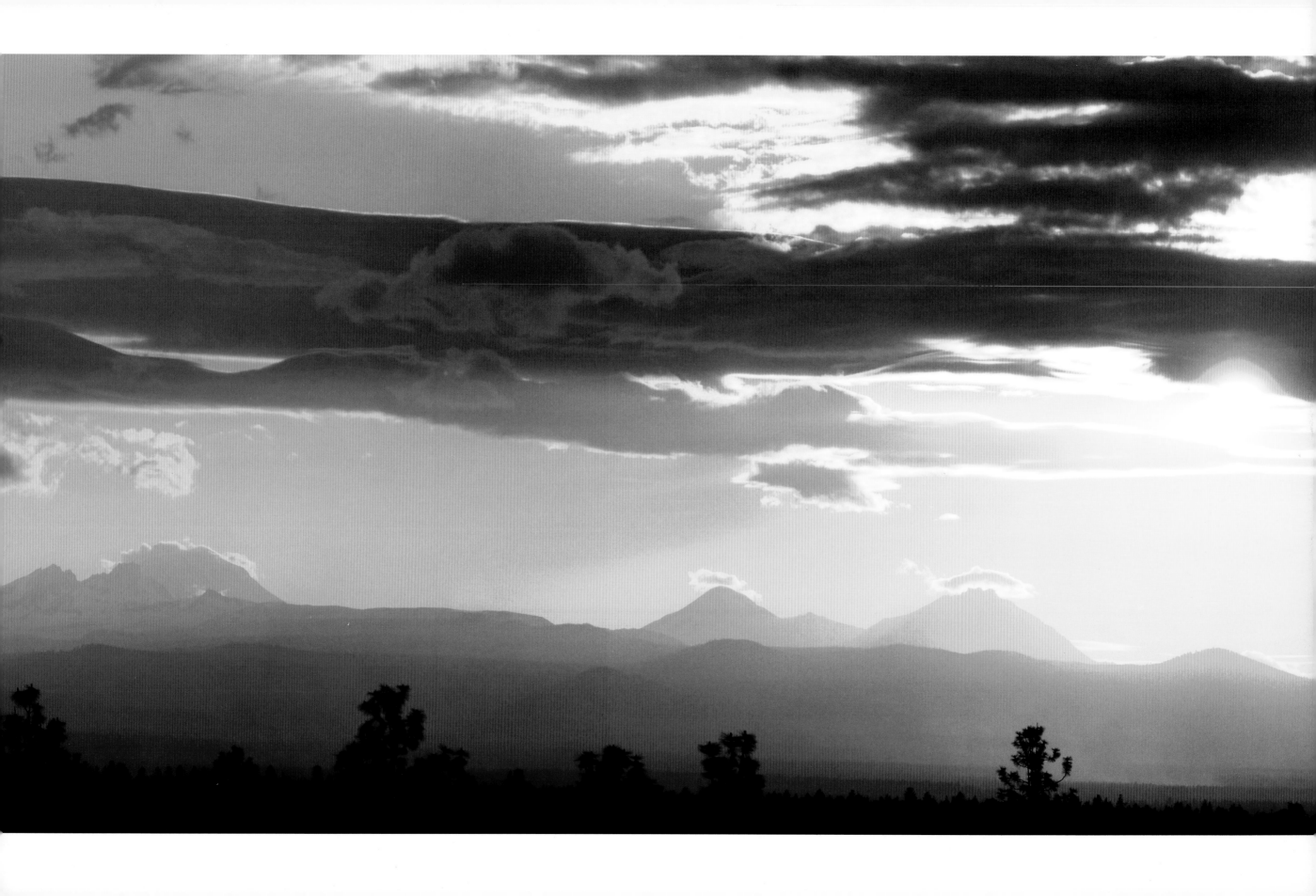

by RIC ERGENBRIGHT

Sunrise moonset, Smith Rock State Park

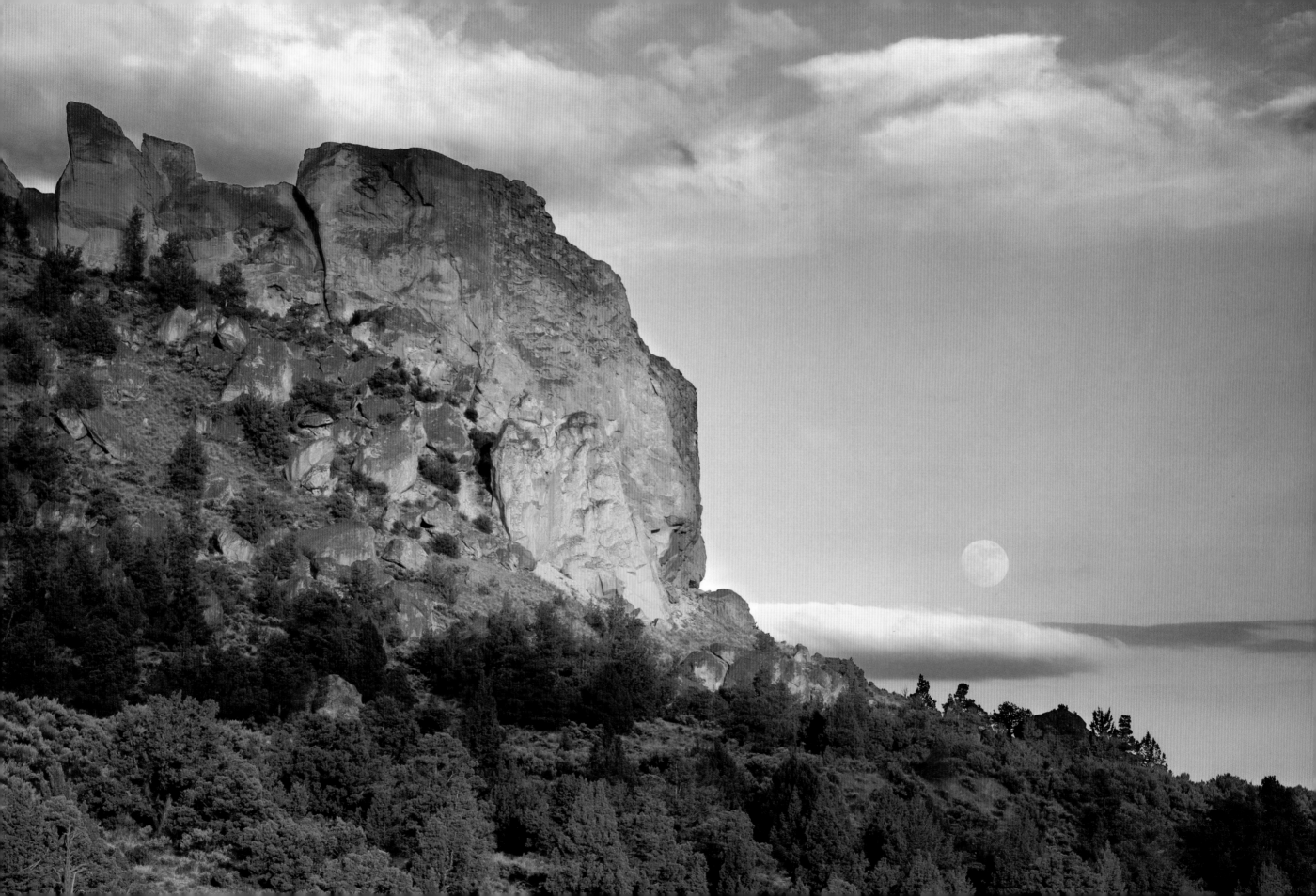

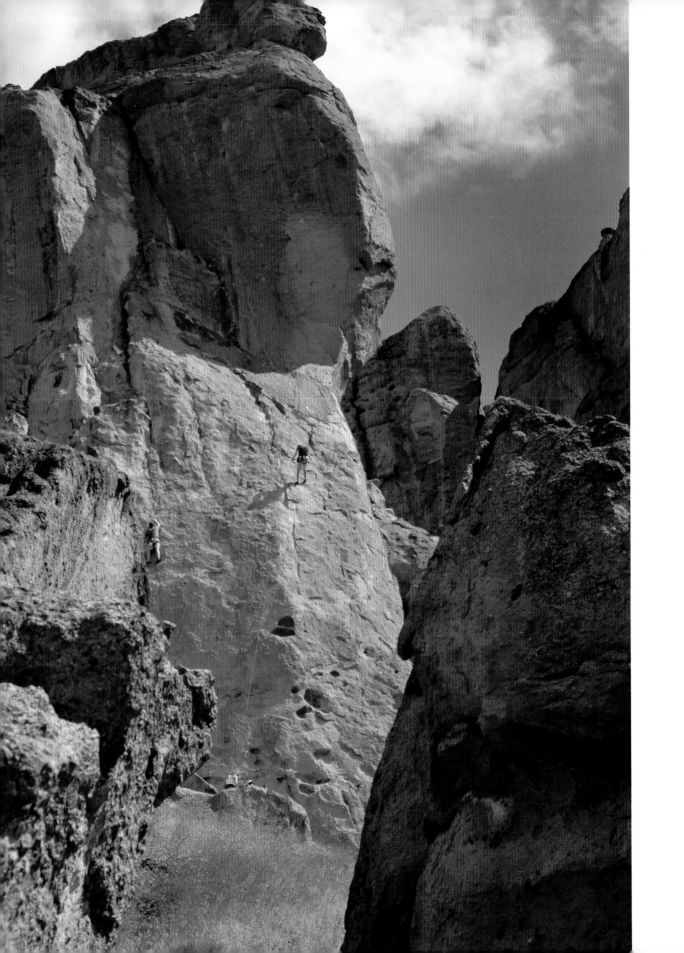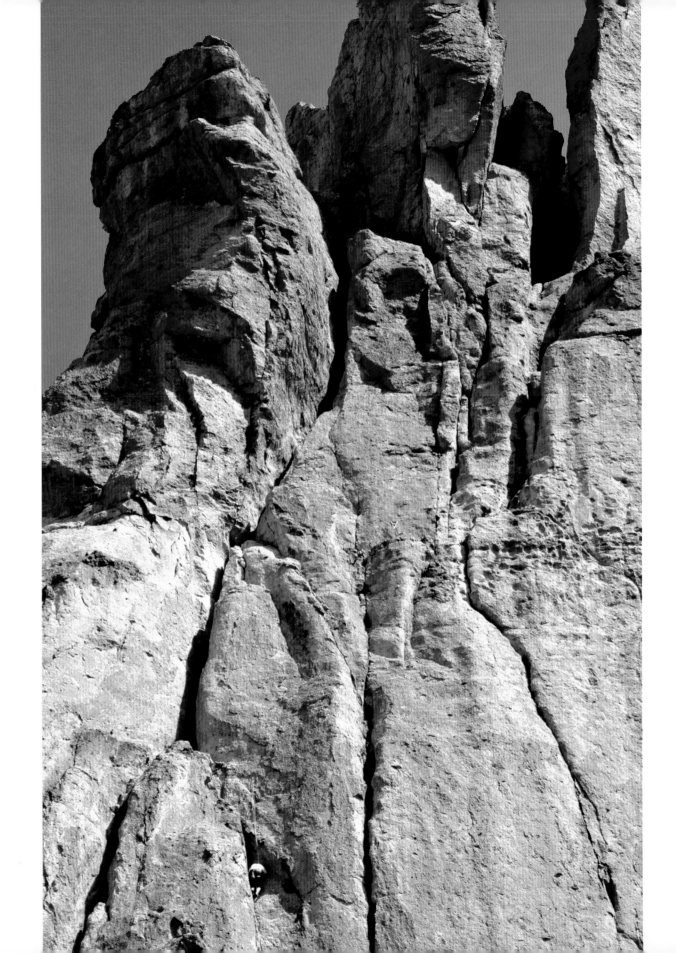

by JULIANNE MEYERS

Morning ascents, Smith Rock State Park

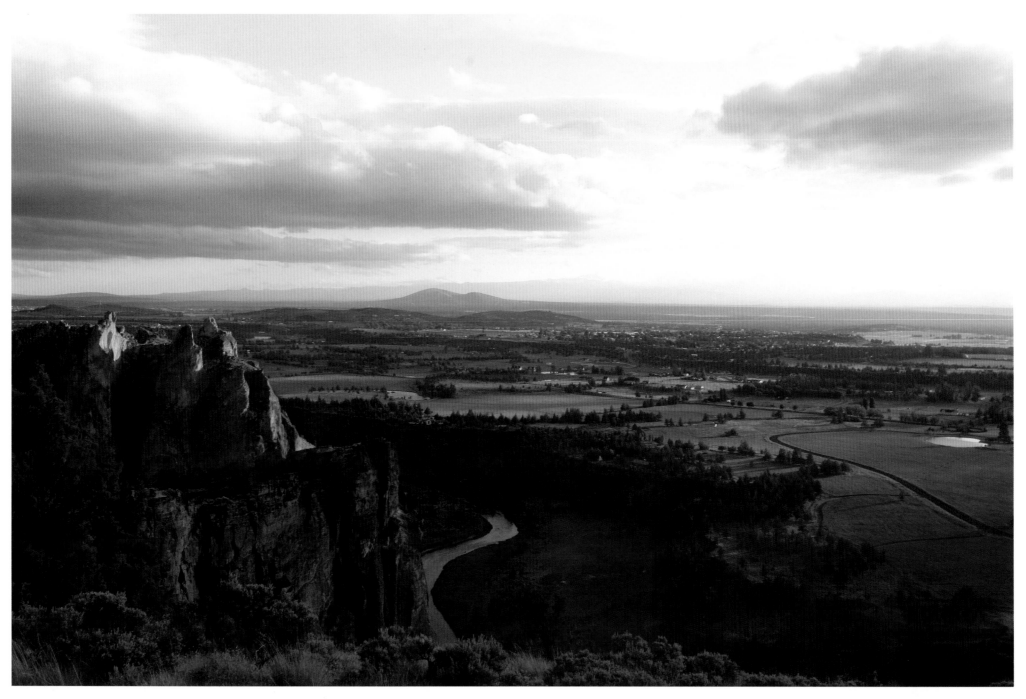

by BRIAN ROBB

Summit views, Smith Rock State Park

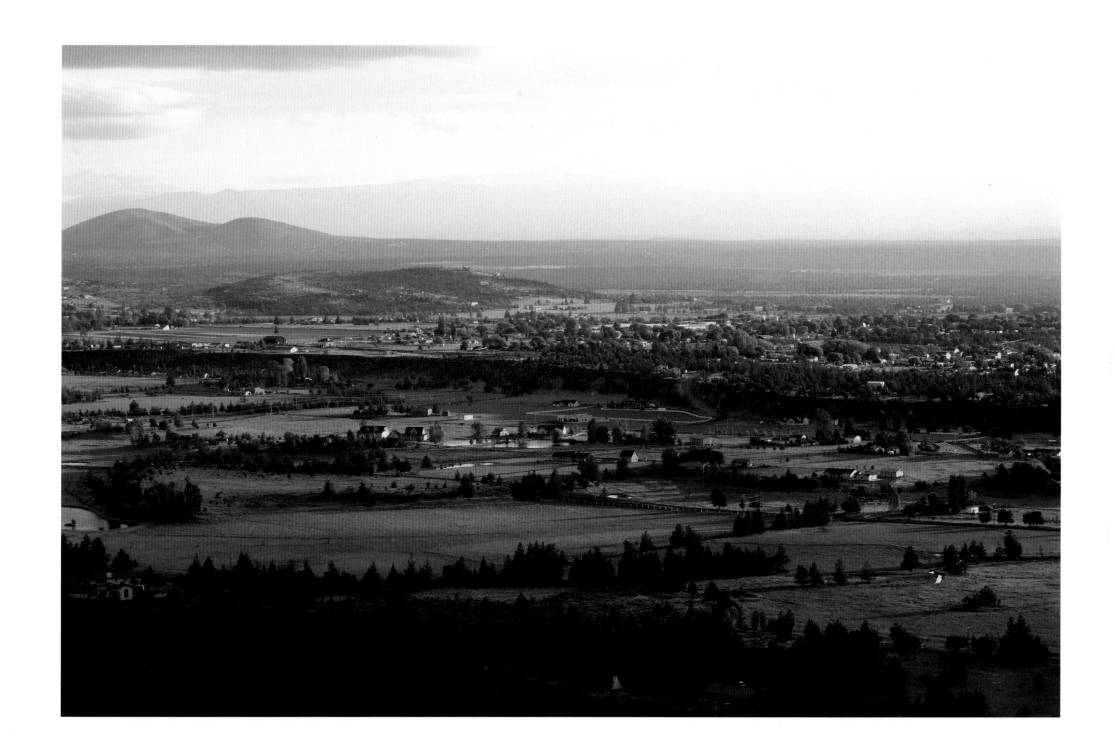

by JEFF MEYERS

Terrebonne ranch near Gray Butte and Smith Rock

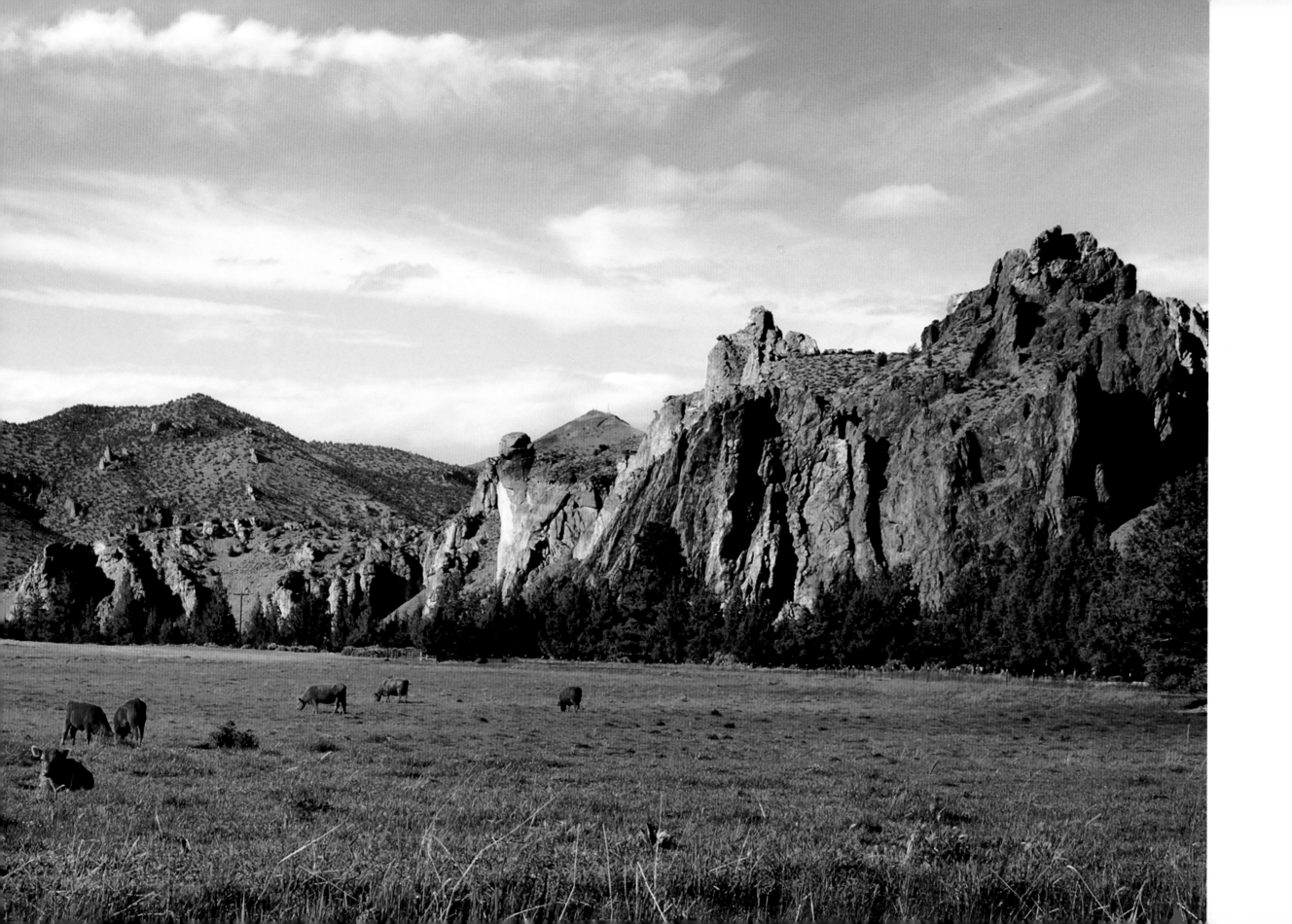

by BRIAN ROBB

Storm front

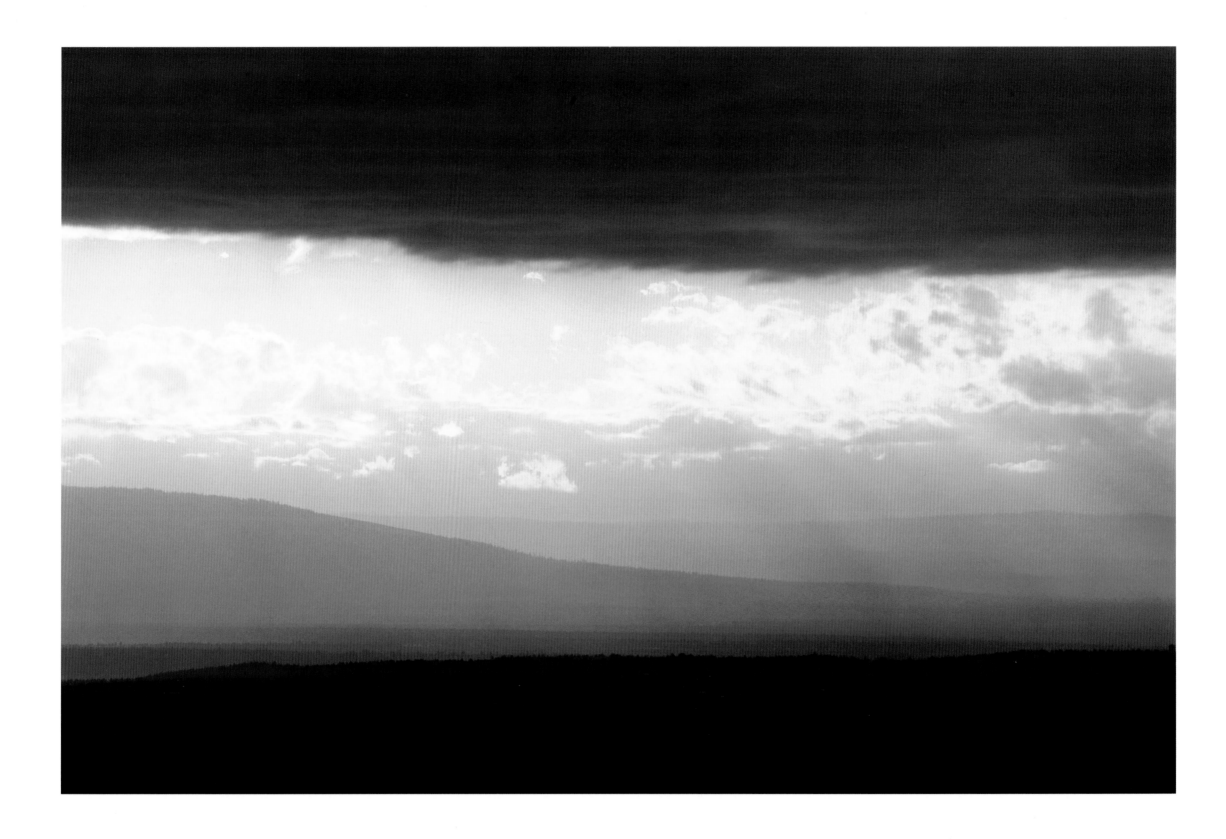

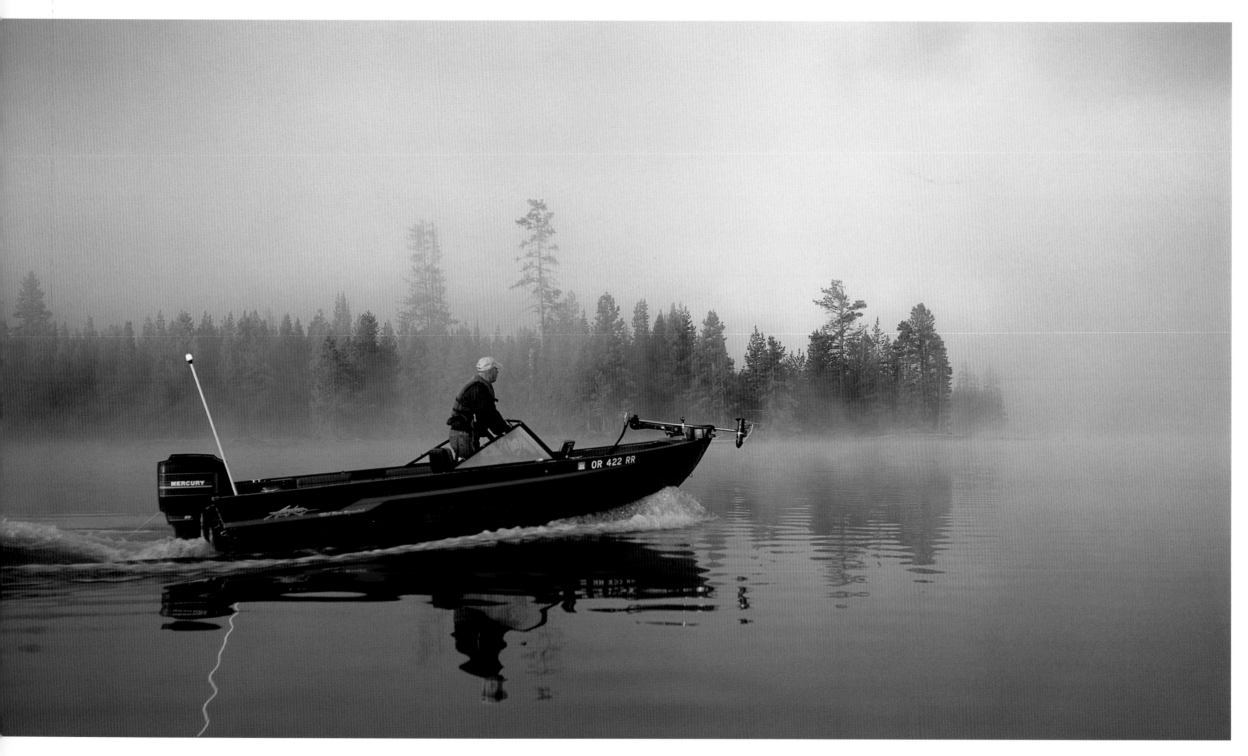

by BUDDY MAYS

Bass fisherman at dawn

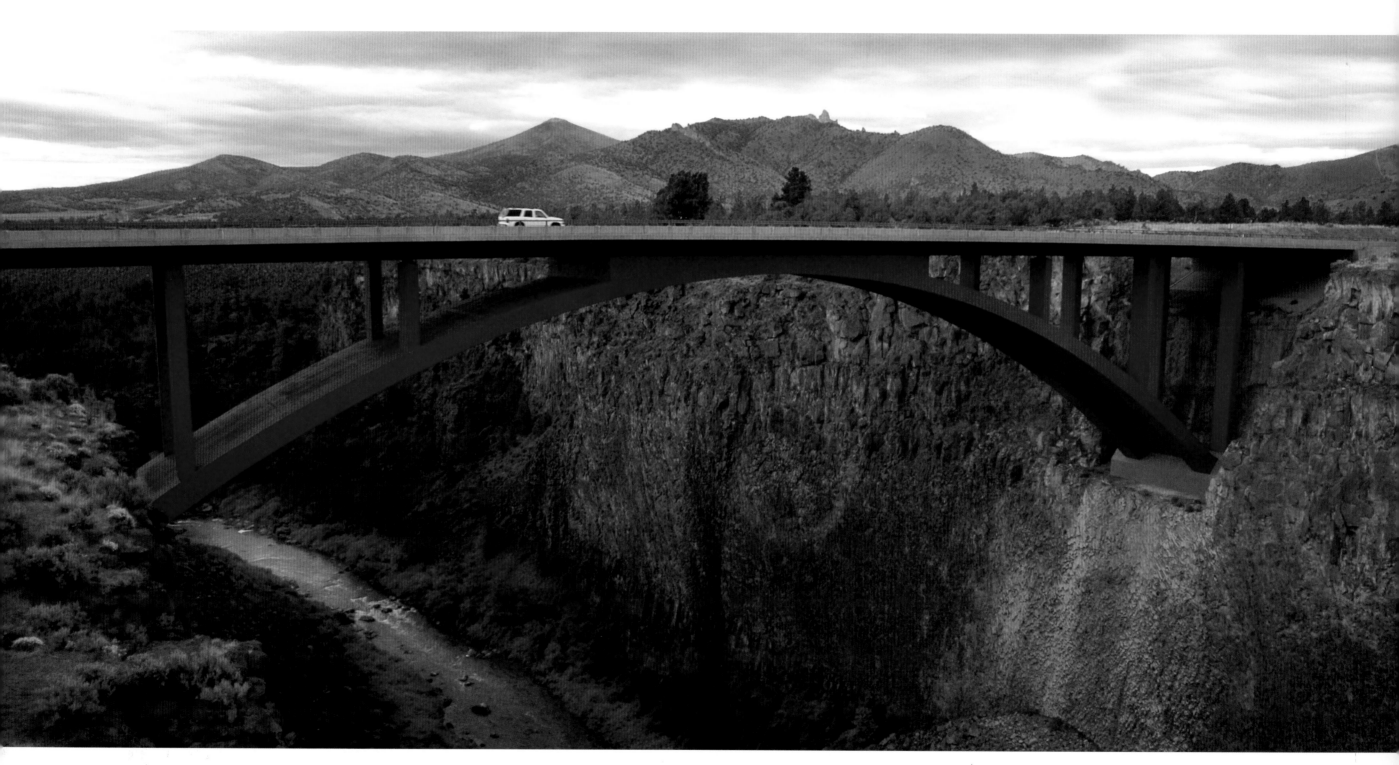

by JEFF MEYERS

Crooked River Gorge

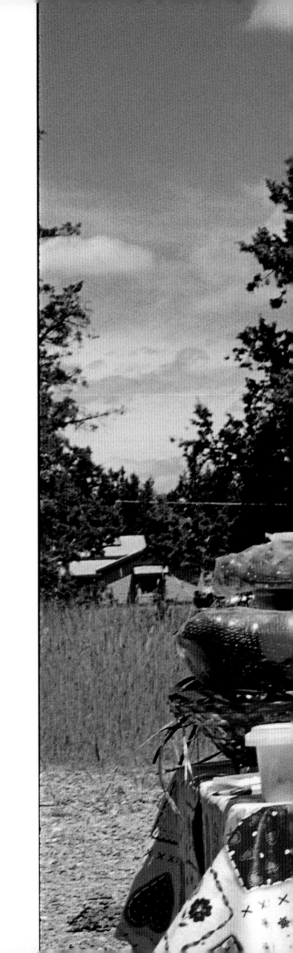

by BYRON DUDLEY

The Berg sisters—Shella Sohn and Carolyn
Schmidt—have a yard sale in Tumalo

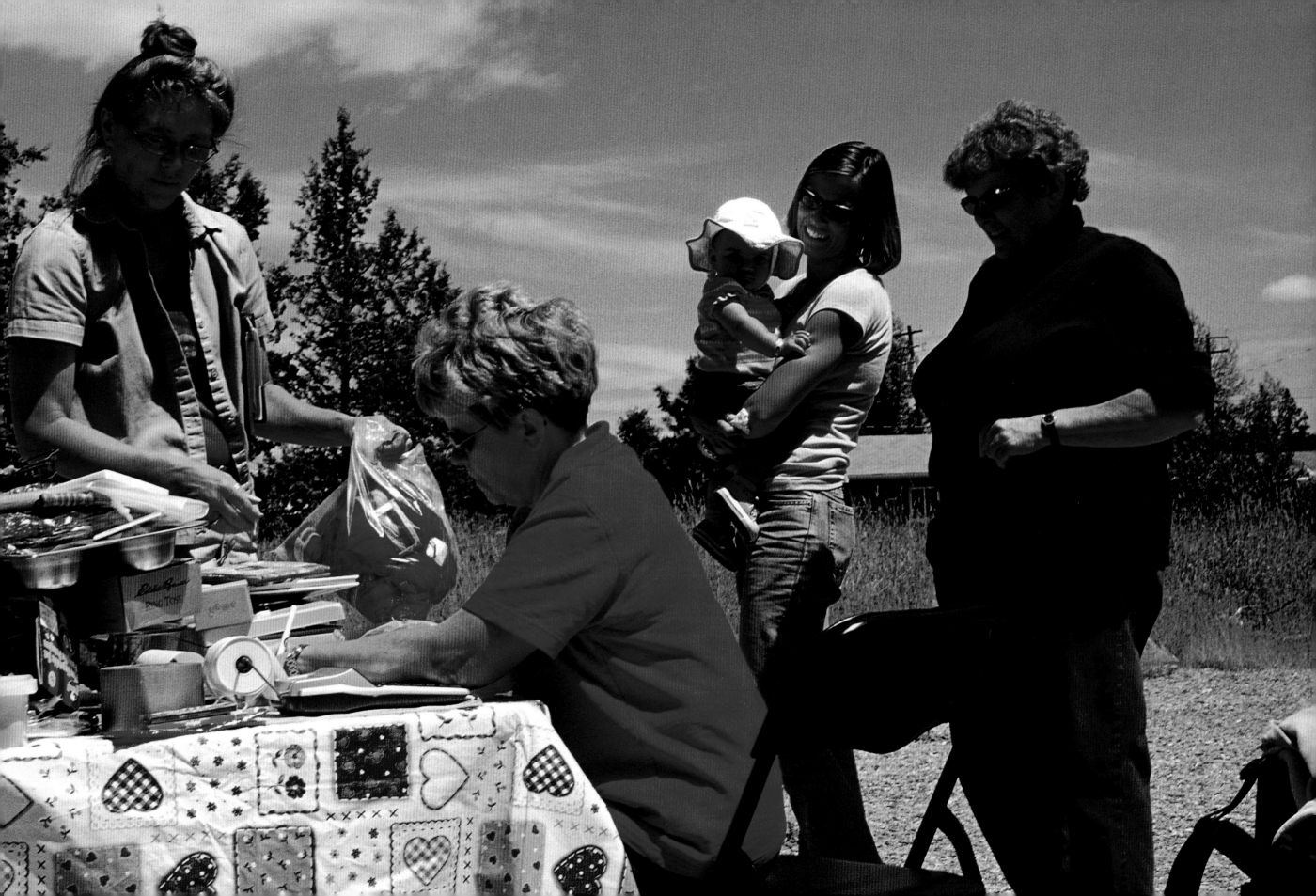

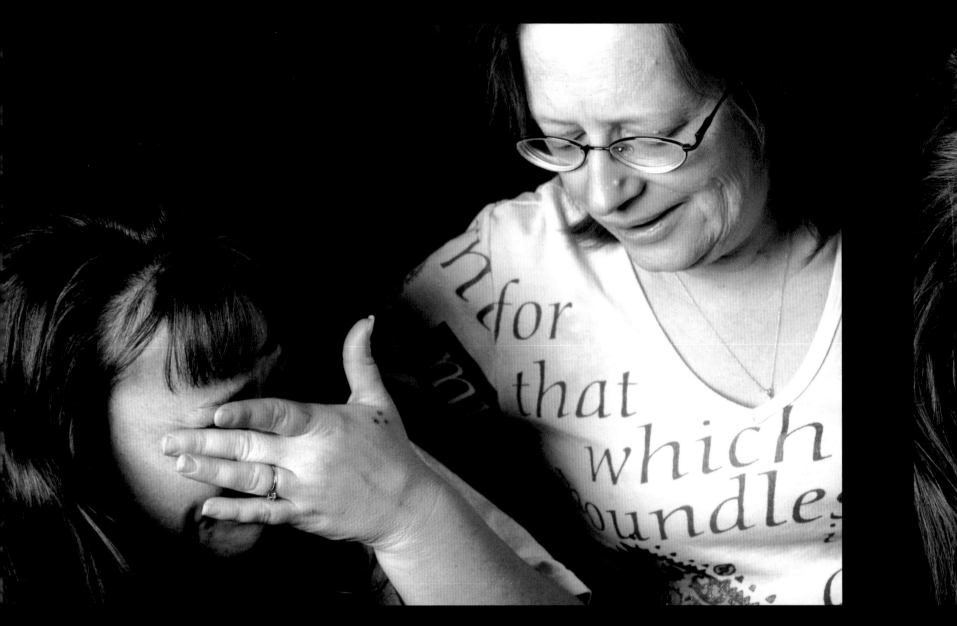
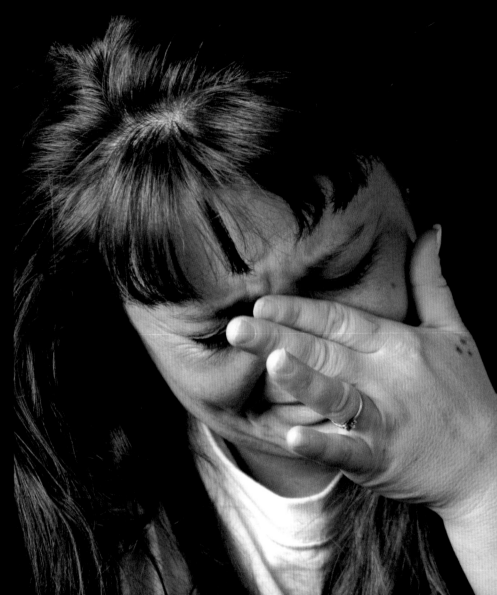

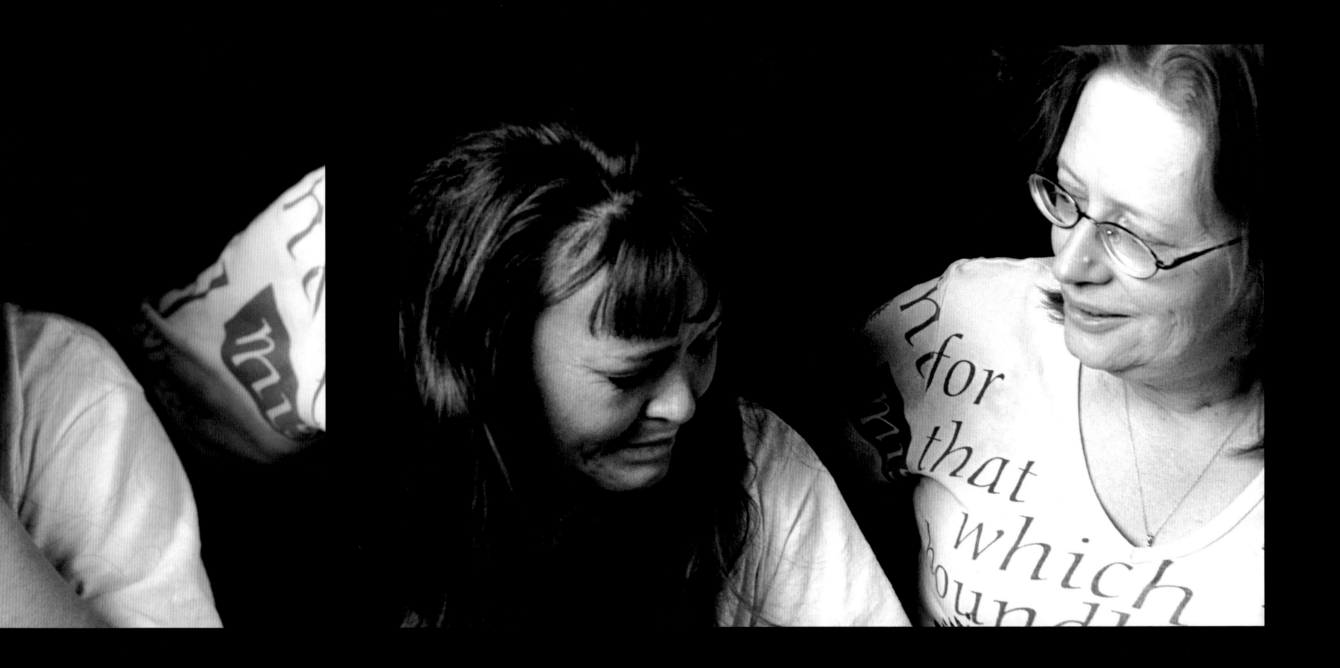

"Sometimes you have to lose everything ... to gain everything."
Bethlehem Inn resident paraphrases Matthew 10:39

by SIMONE PADDOCK

Street vendor David Conas and Donner Flower Shop owner Doris Dilday prepare for the work day.

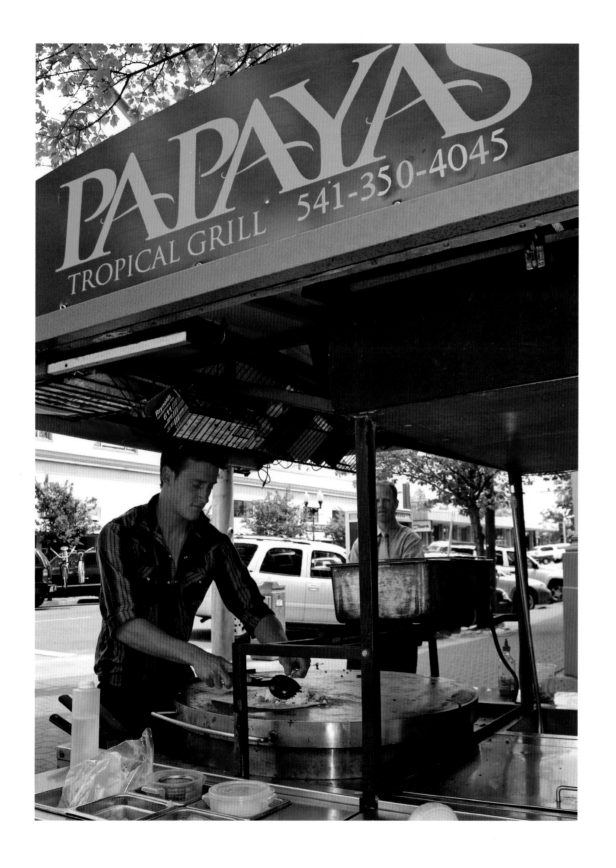
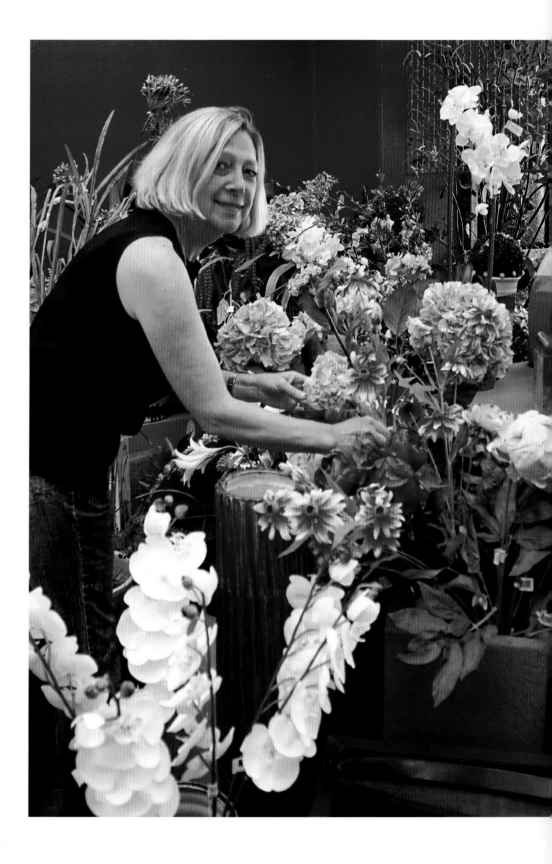

by JEFF KENNEDY

Night falls on Wall Street

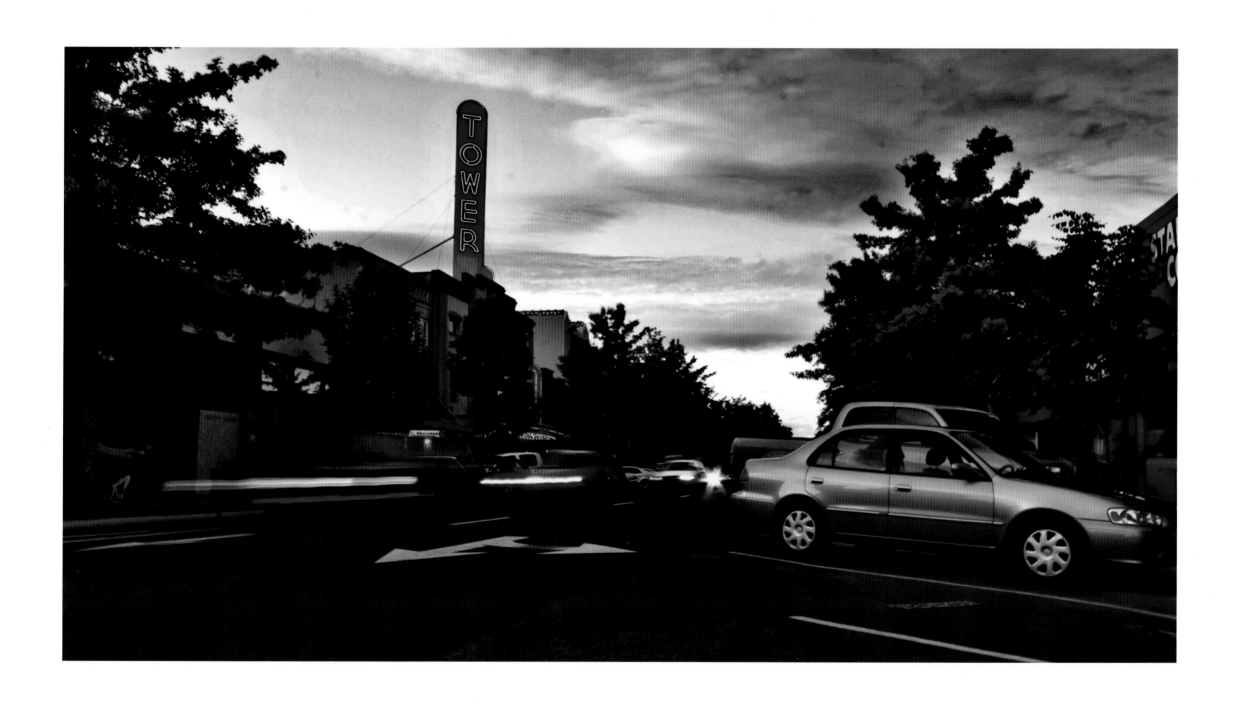

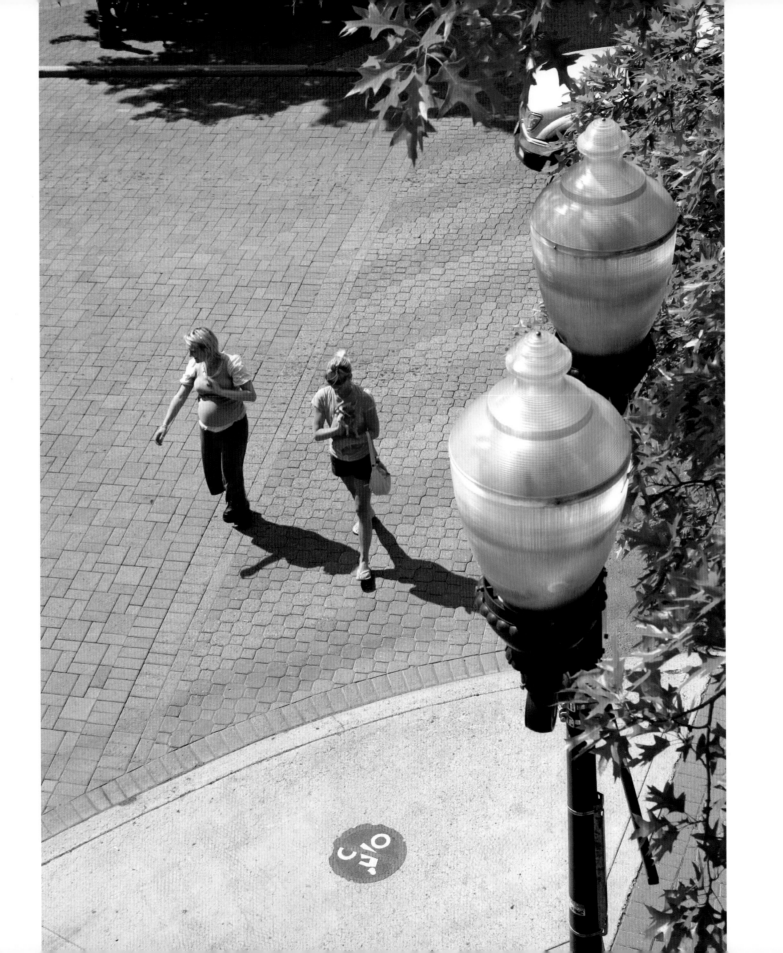

by SIMONE PADDOCK

Wall Street, downtown Bend

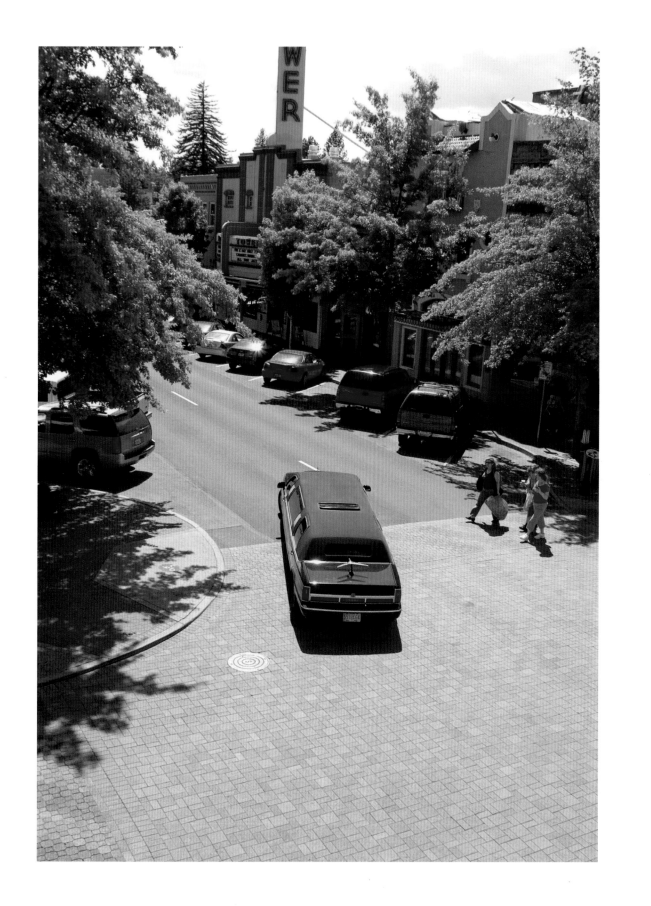
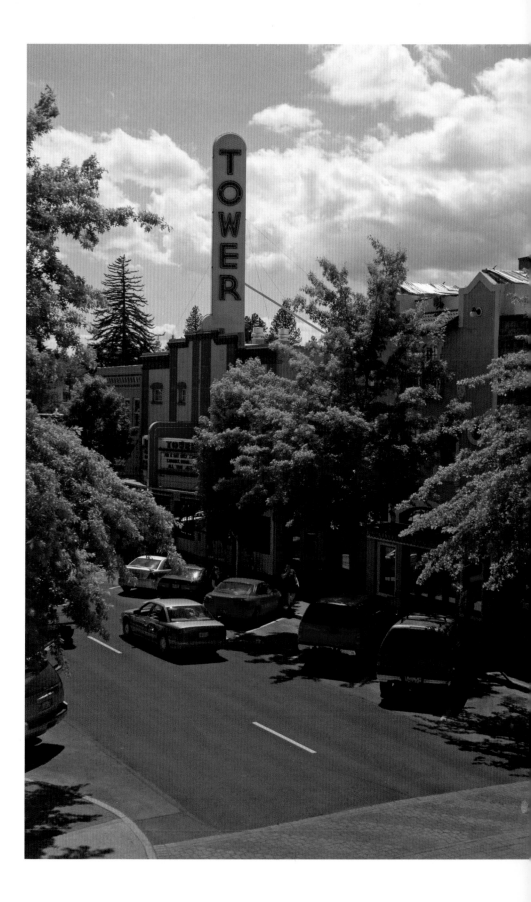

by JEFF KENNEDY

Art meets commerce, downtown Bend

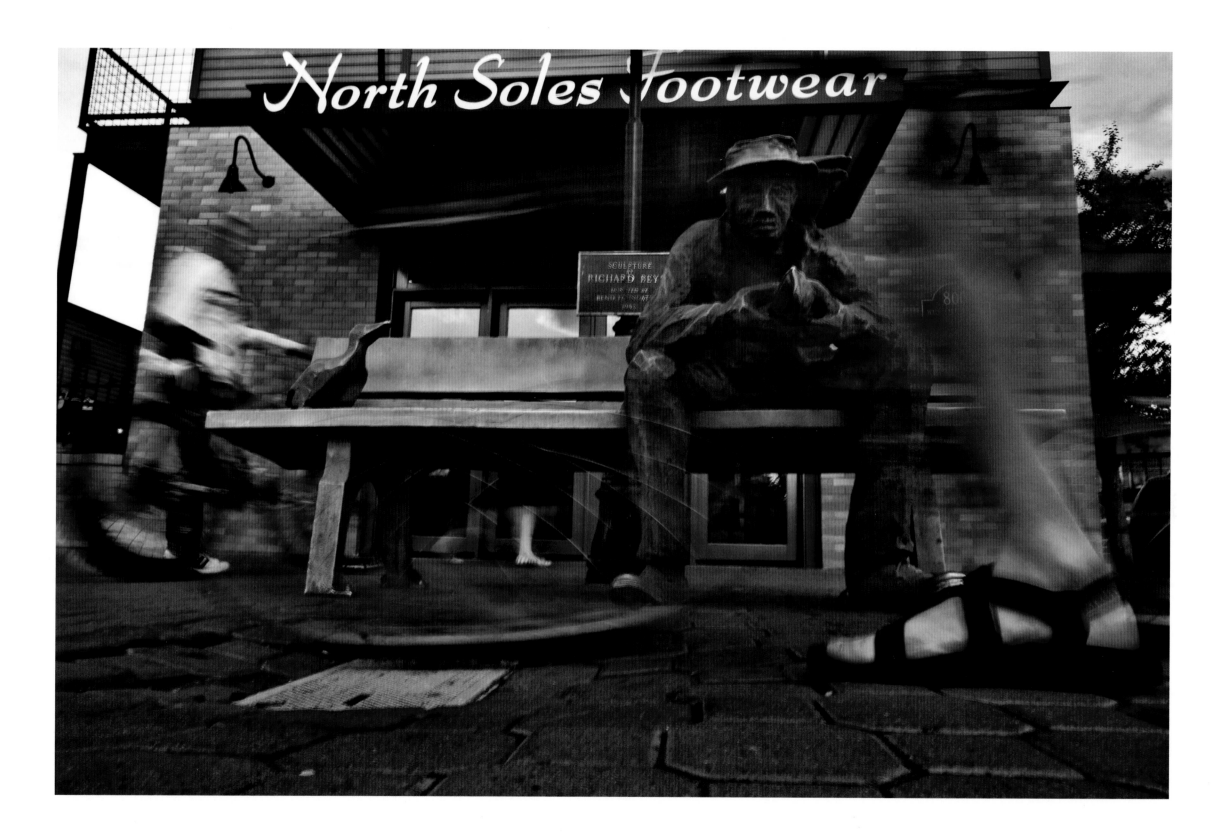

by TIFFANY PAULIN

Floral ride

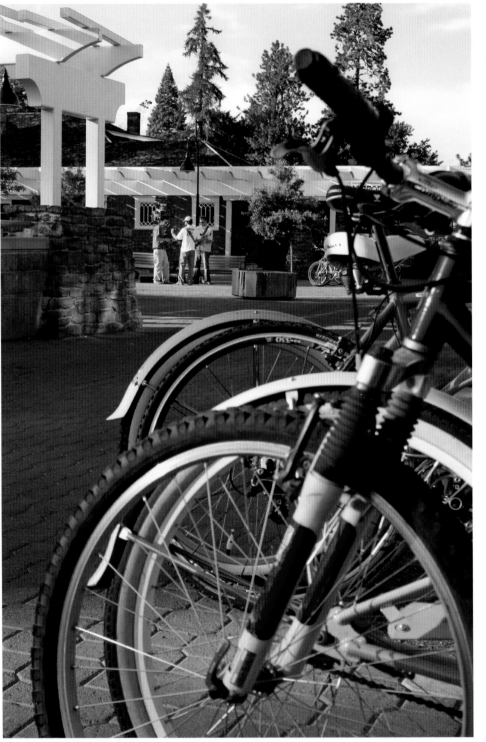

by SIMONE PADDOCK

Plaza parking

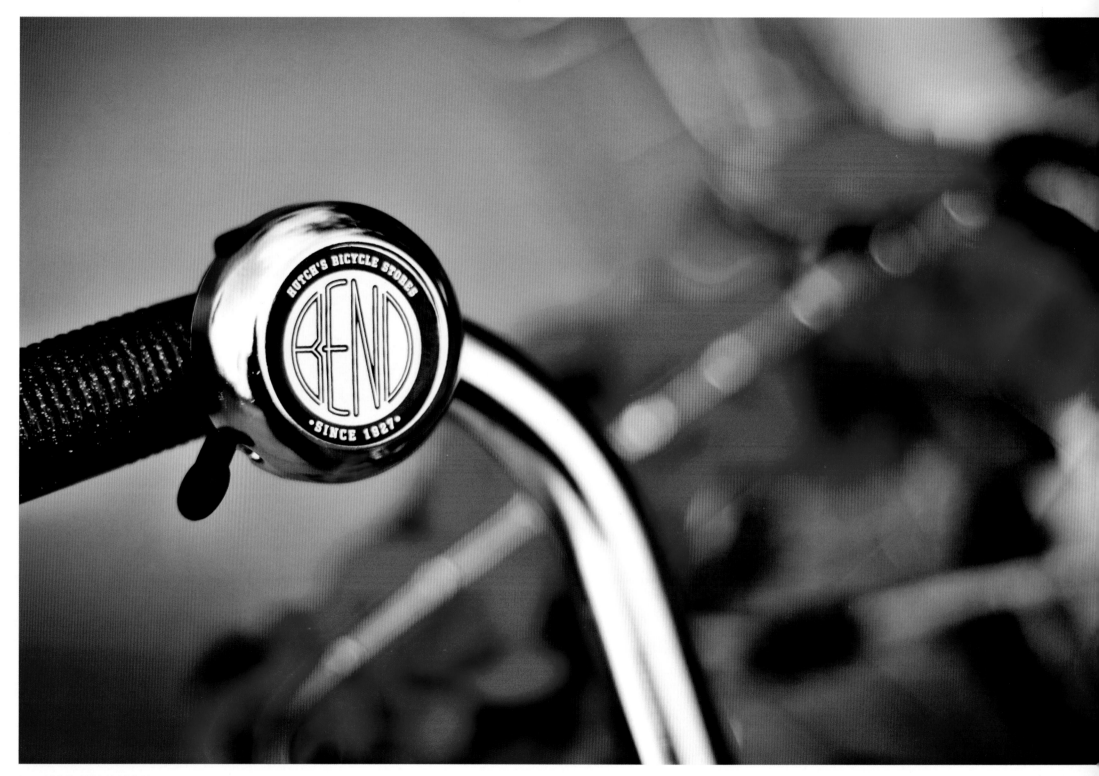

by JEFF KENNEDY

Bike-friendly town

by TIFFANY PAULIN

A two-wheeled classic

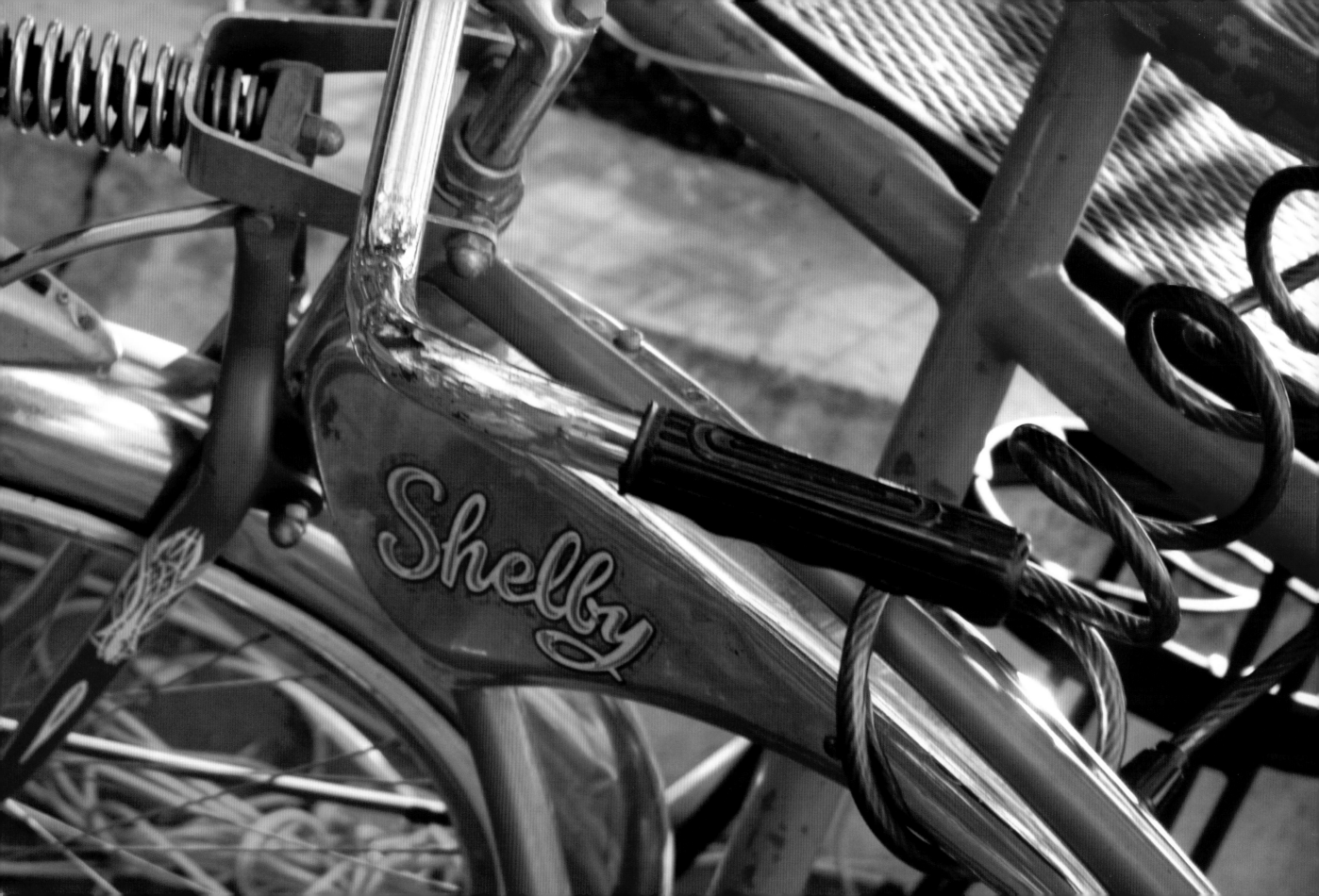

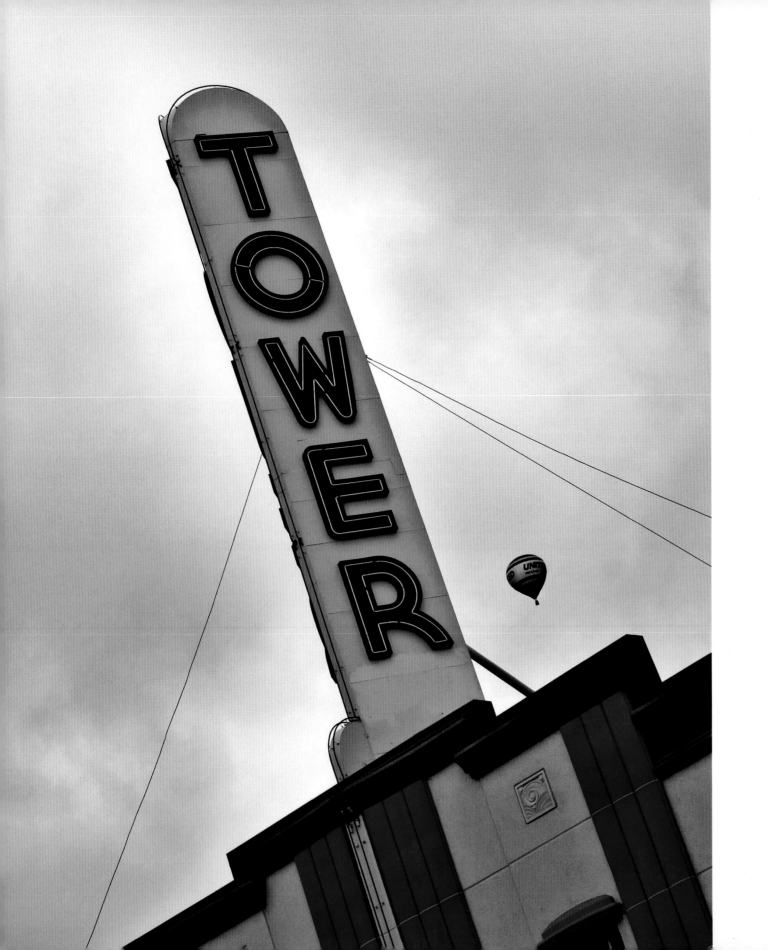

by JEFF KENNEDY

Balloons above the Tower

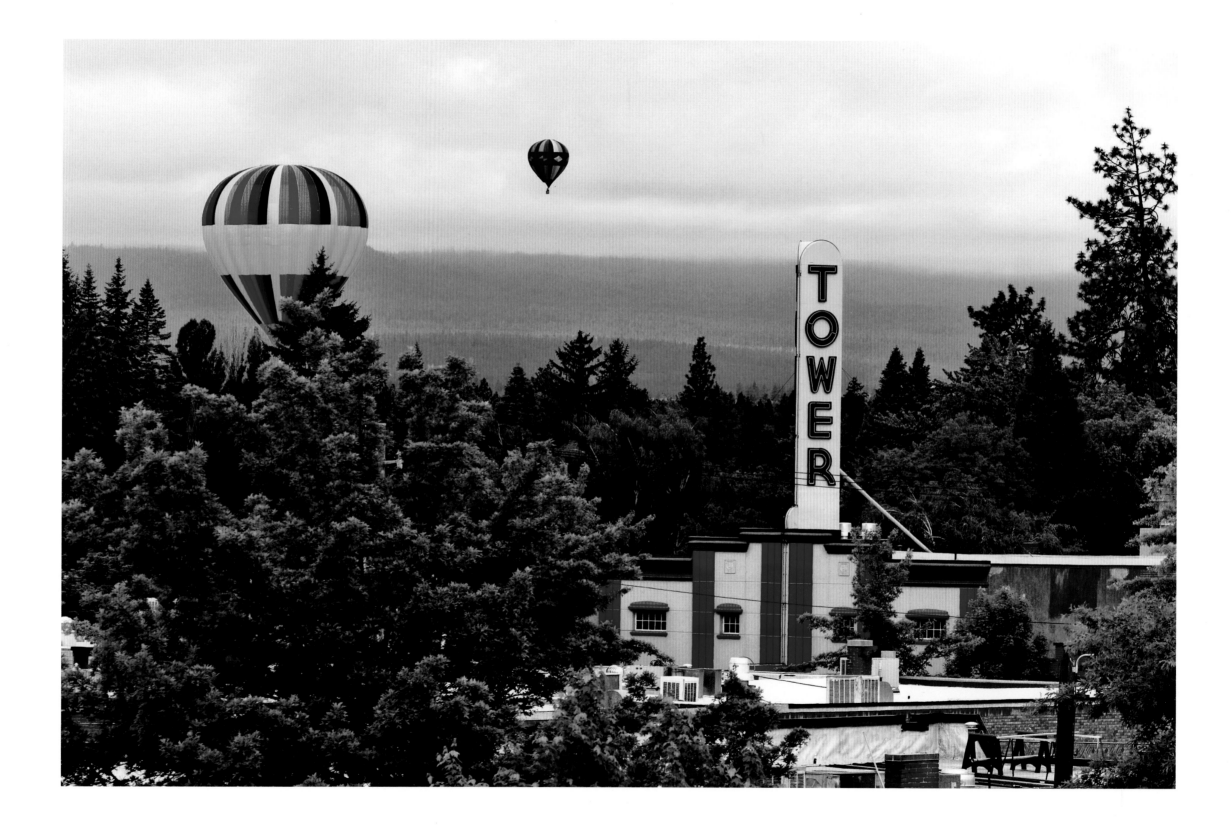

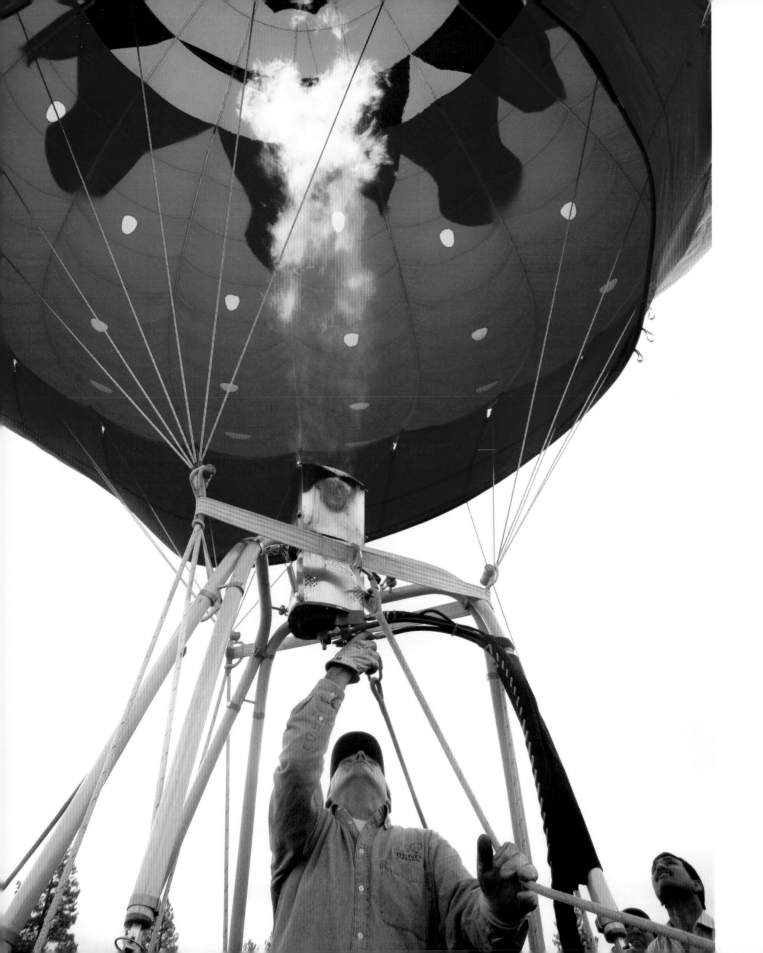

by BRIAN ROBB

Up, up and away

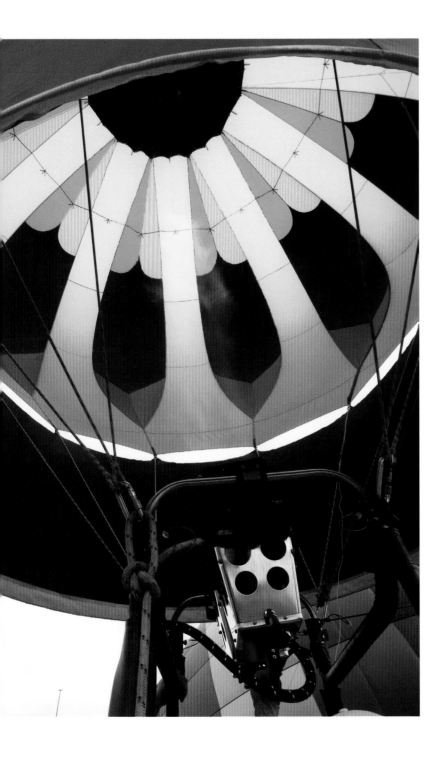
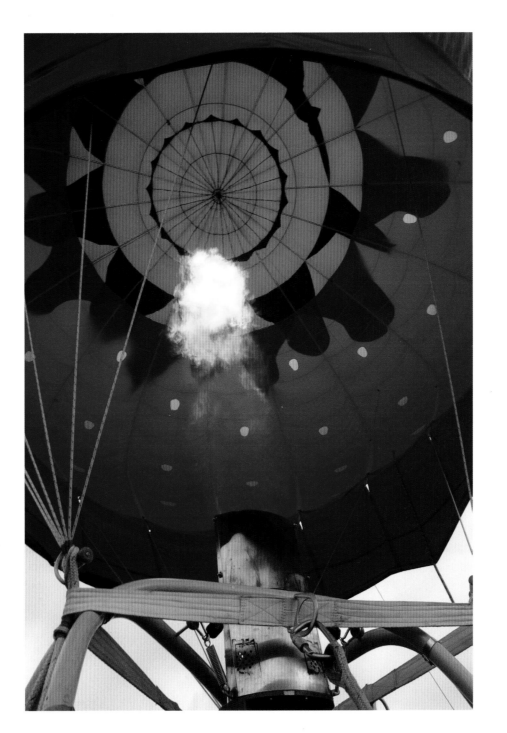
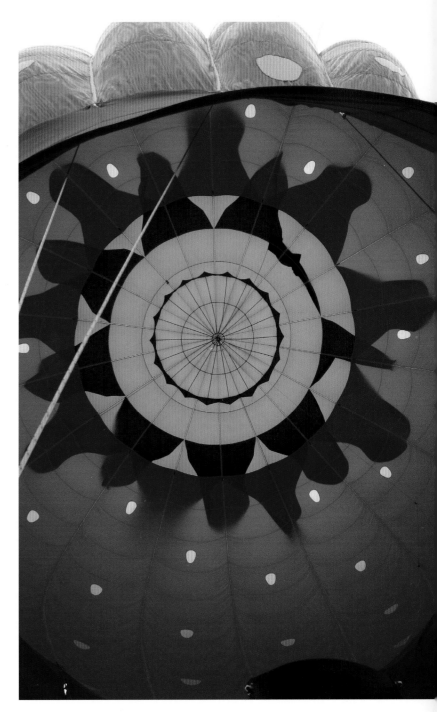

by BRIAN ROBB

Balloons over Bend

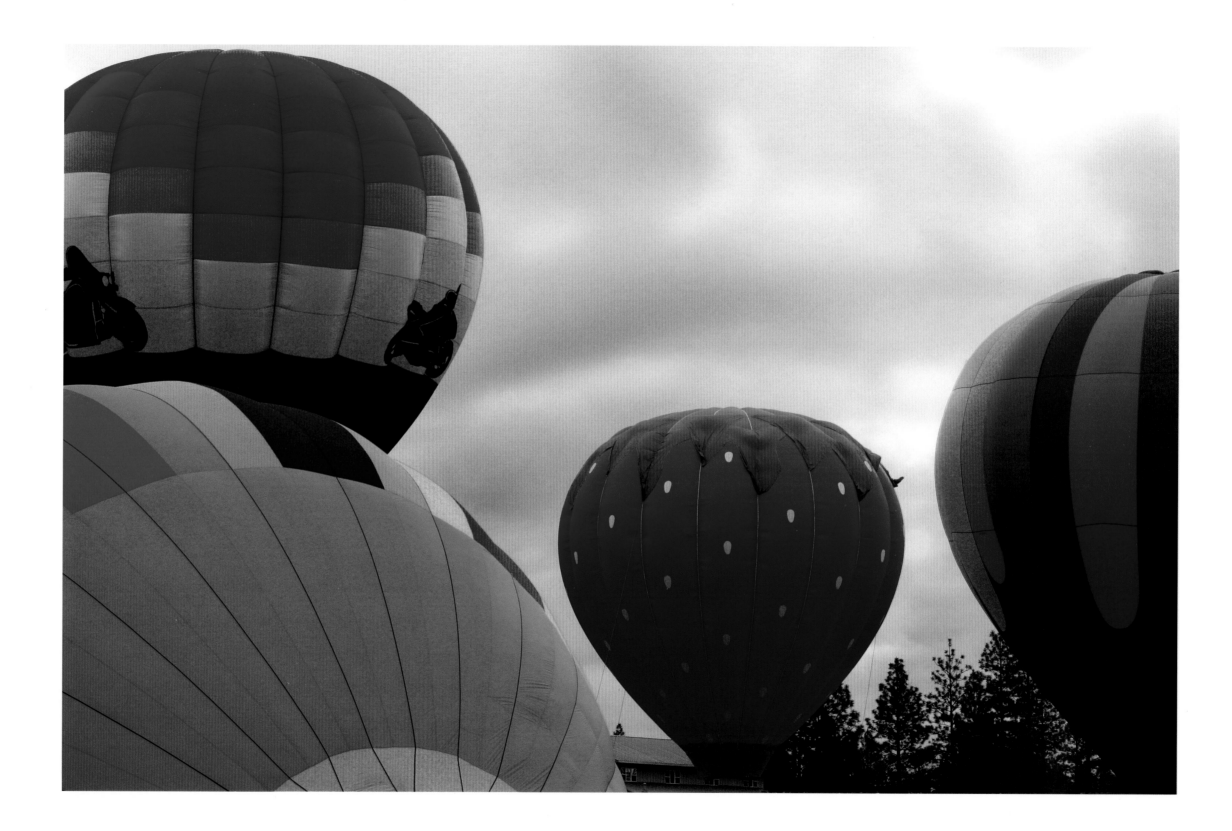

by JEFF MEYERS

Outrigger paddlers glide through the Old Mill District

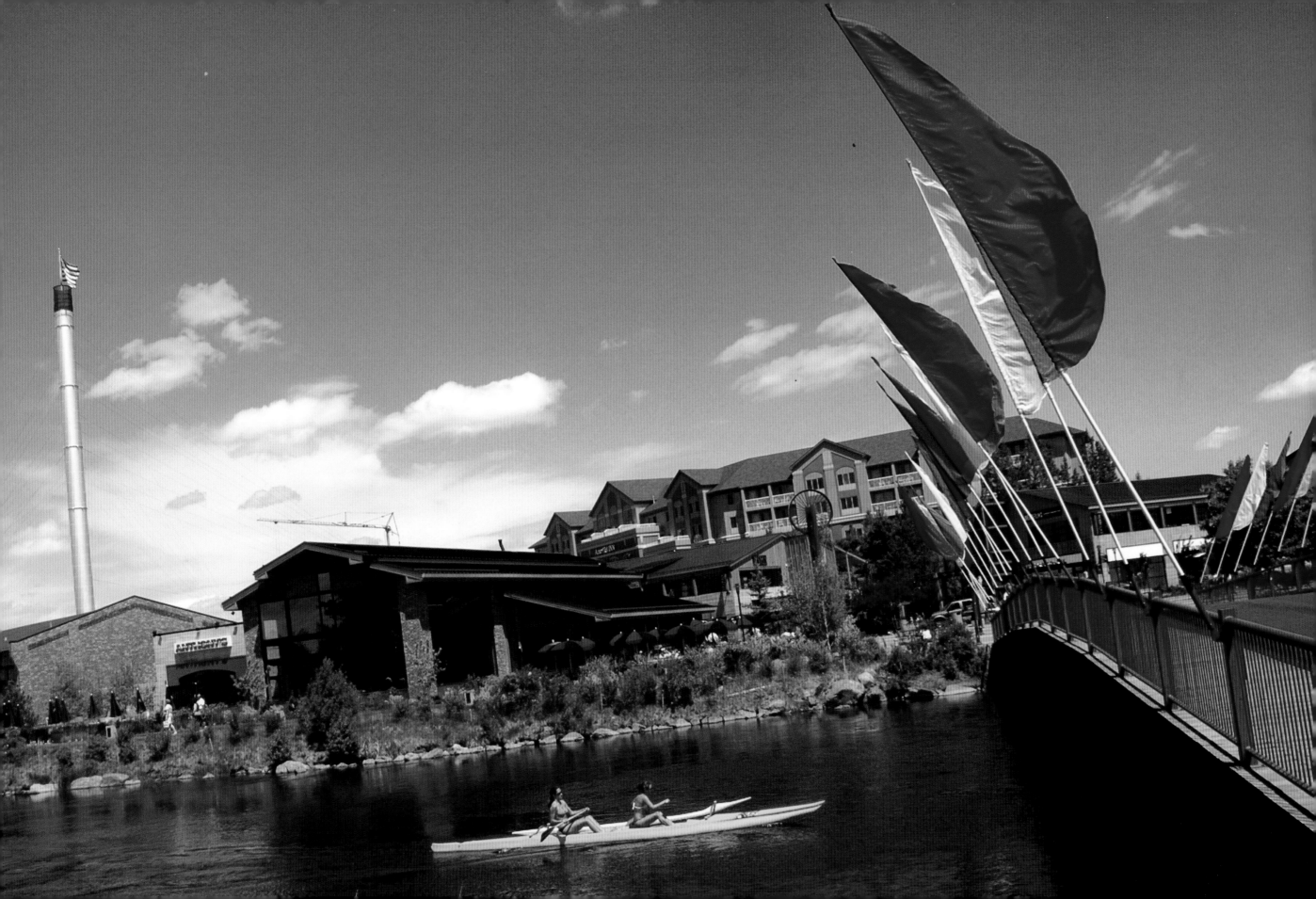

LEFT:

by BOB WOODWARD

Jennifer Seitz's morning workout,
Juniper Swim & Fitness Center

RIGHT:

by ROBERT AGLI

Lap swimmers at Juniper pool

FROM LEFT TO RIGHT:

by BOB WOODWARD

Roxanne Fera, Phil's Trail

by MARISA CHAPPELL

Amy Petersen, Shevlin Park

by BOB WOODWARD

Eiji Daniel, Phil's Trail

by BOB WOODWARD

Tyge Shelby and Bridger,
Deschutes River Trail

by MARK GAMBA

Young BMX riders, Big Sky Park

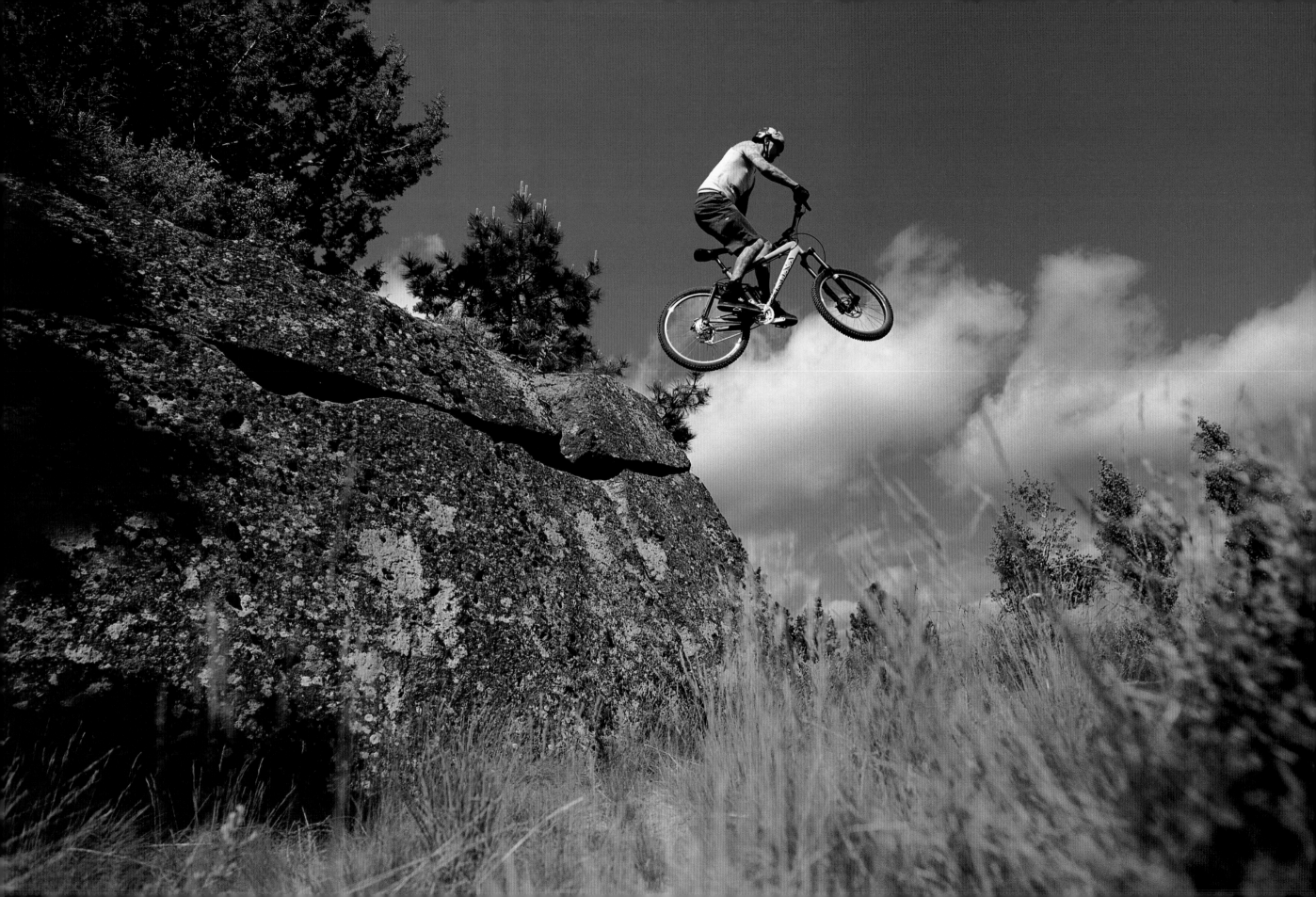

by MARK GAMBA

LEFT:
Big rock, big air
Bend Cyclery owner Eric Smith

RIGHT:
Can leap trucks in a single bound

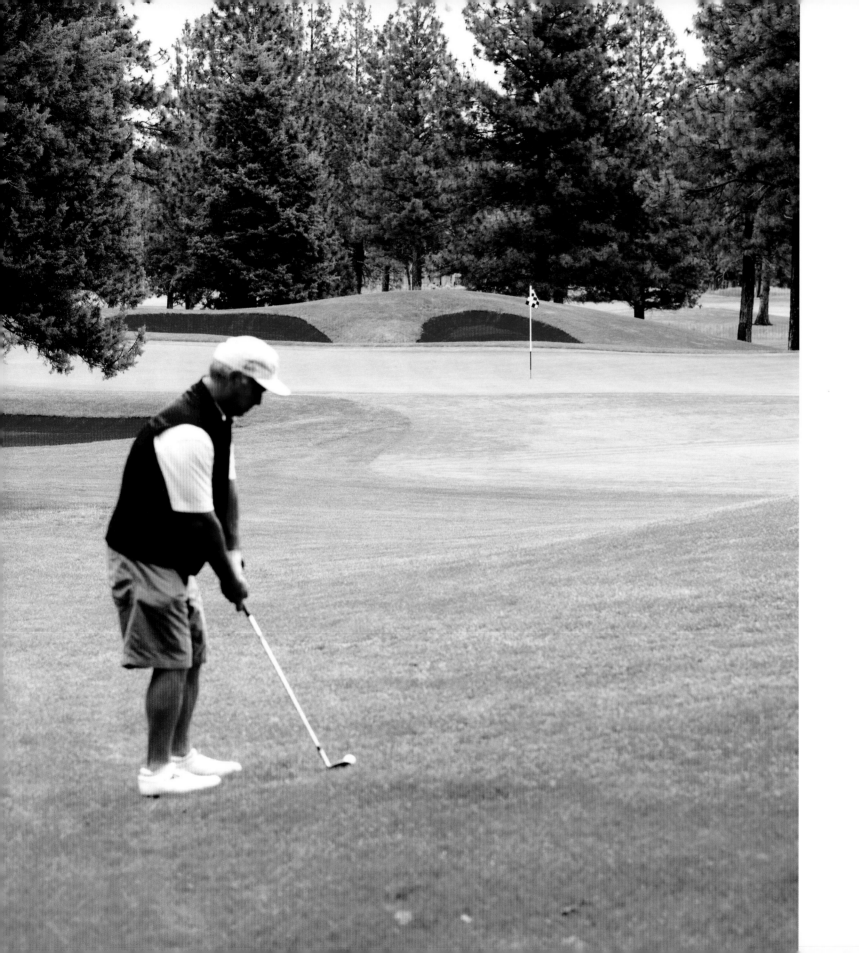

by JIM YUSKAVITCH

A half-wedge to stick it,
Aspen Lakes Golf Course

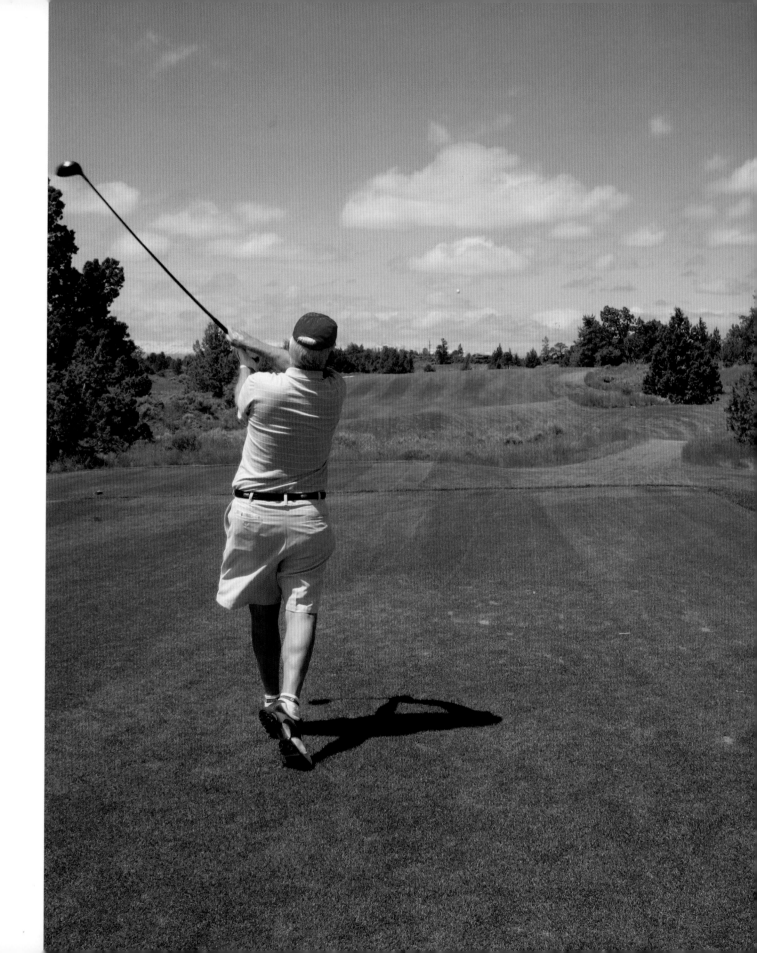

by BRIAN ROBB

Three wood down the 10th fairway,
Juniper Golf Club

by JEFF KENNEDY

Spike it! One, two, three

by JEFF KENNEDY

Flag football game, Prineville

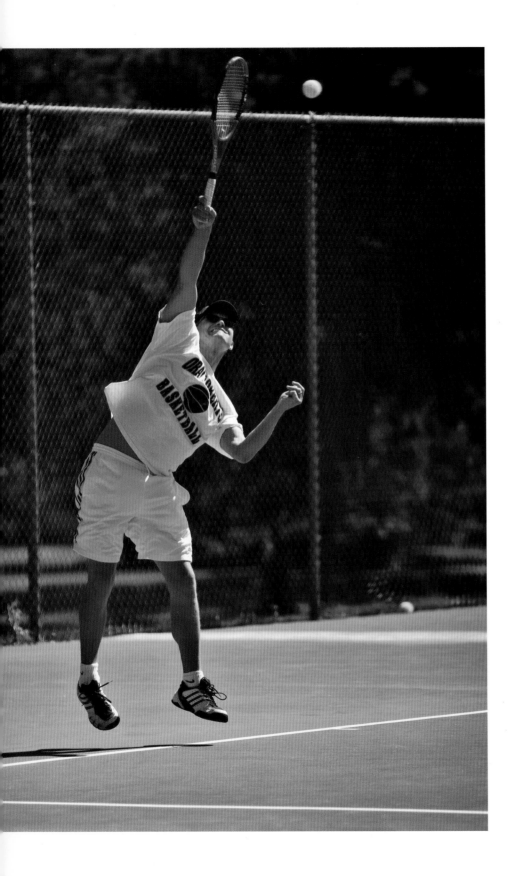

by JEFF KENNEDY

LEFT:
Serving an ace

RIGHT:
Kevin Collier, recreation specialist,
Bend Metro Parks

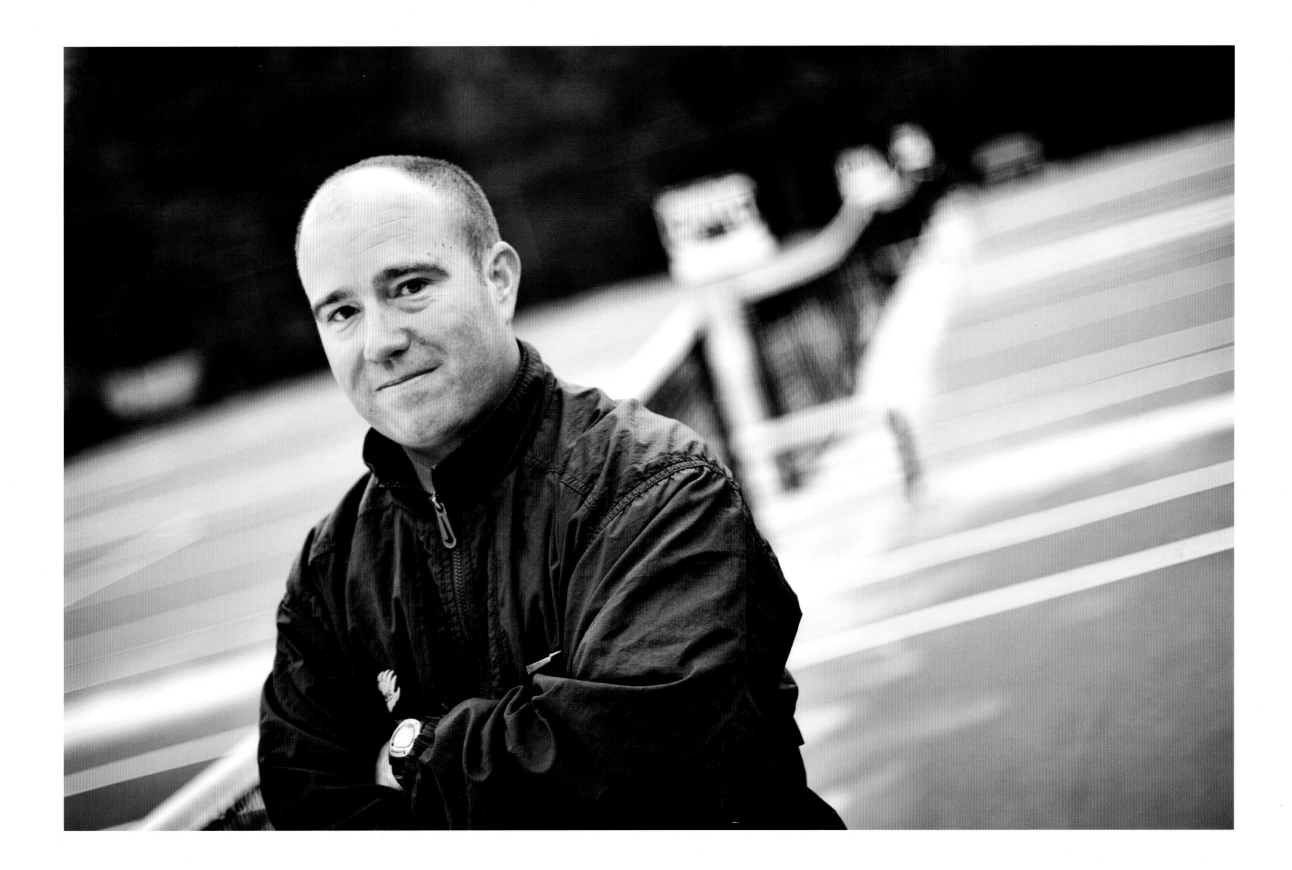

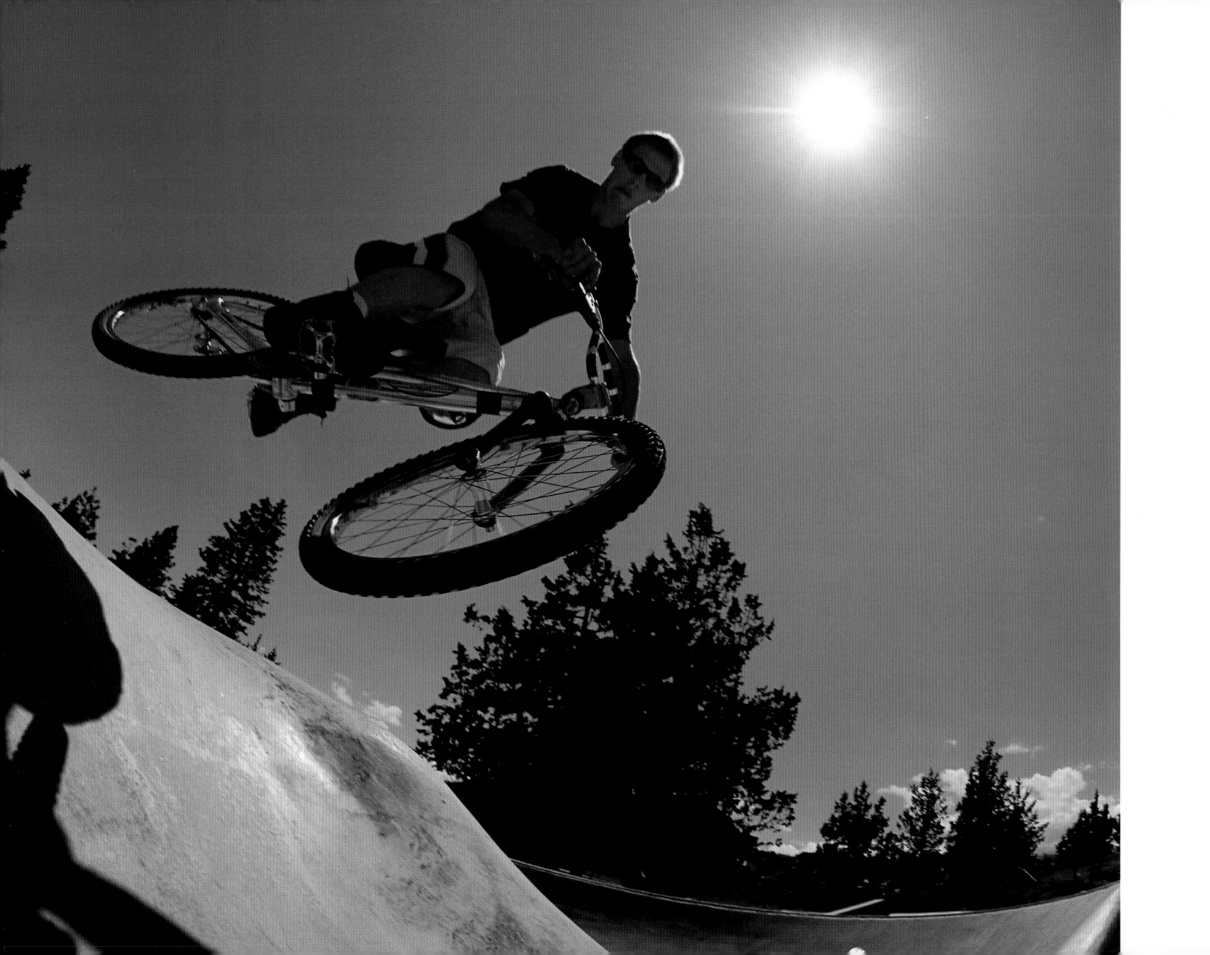

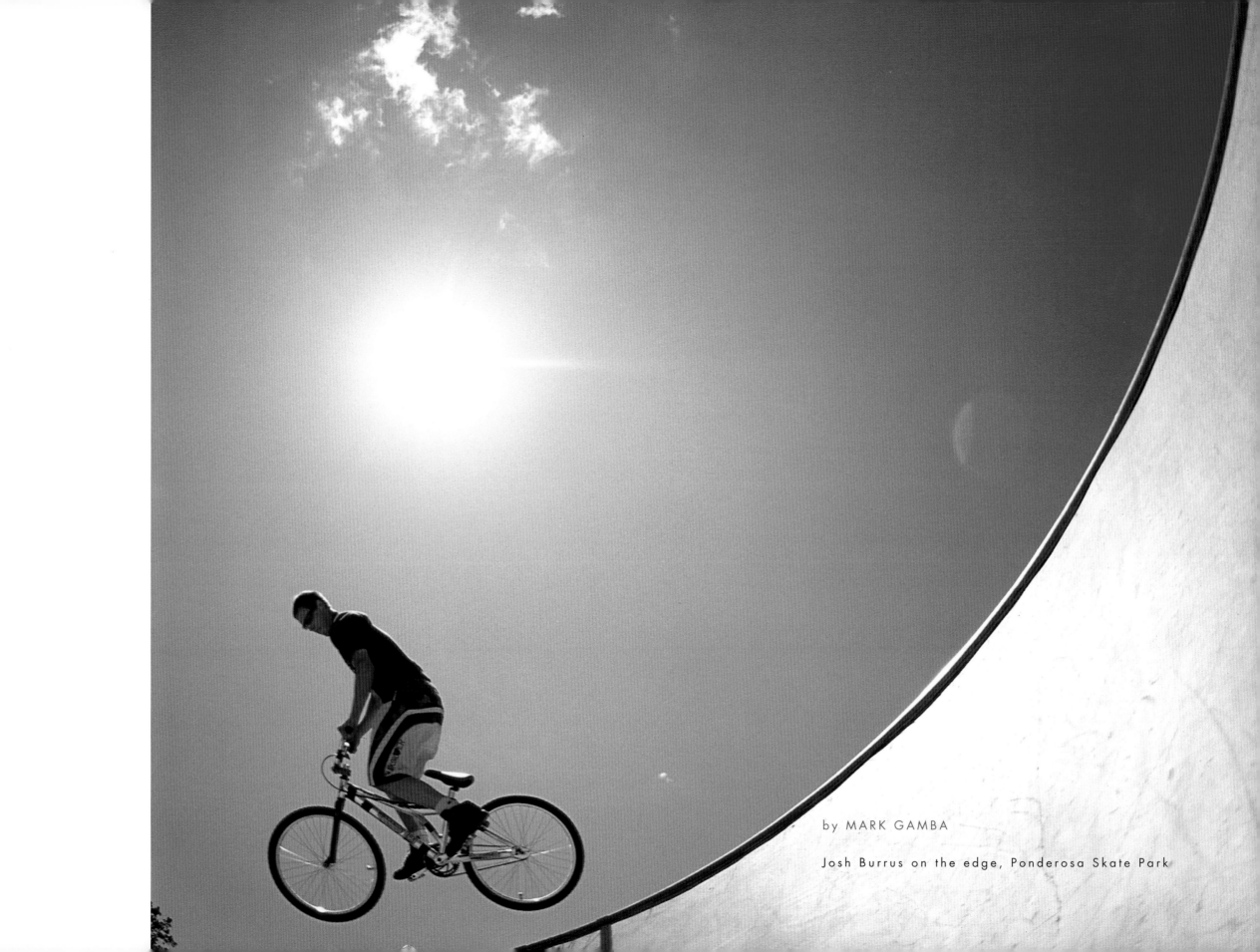

by MARK GAMBA

Josh Burrus on the edge, Ponderosa Skate Park

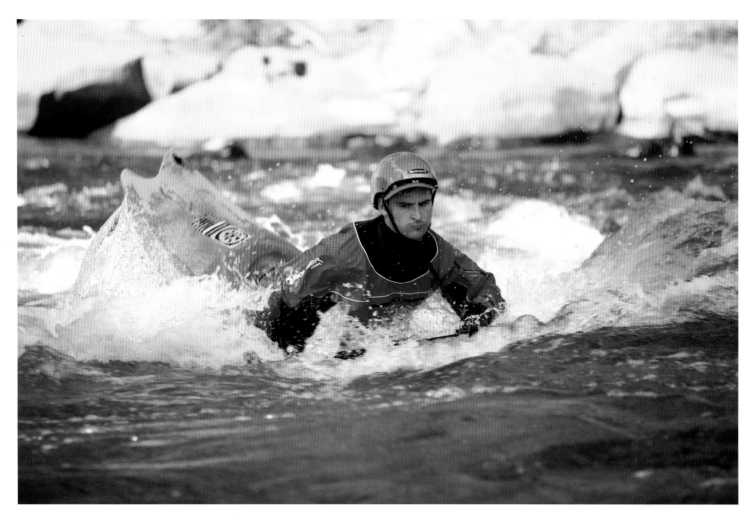

by BOB WOODWARD

Kayaker Christopher Brown,
First Street Rapids

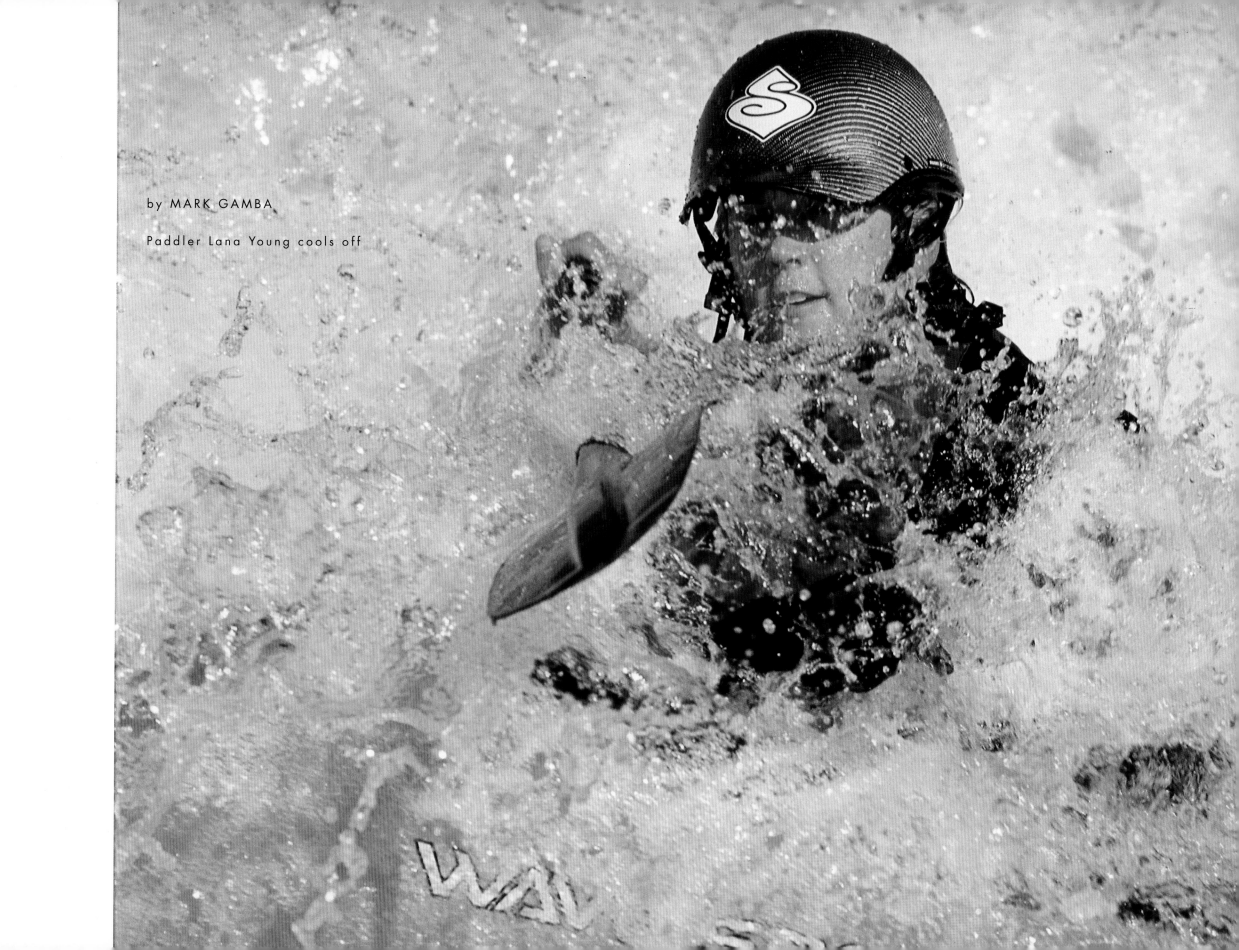

by MARK GAMBA

Paddler Lana Young cools off

by MARK GAMBA

Desperado: Kayaker rides the canal

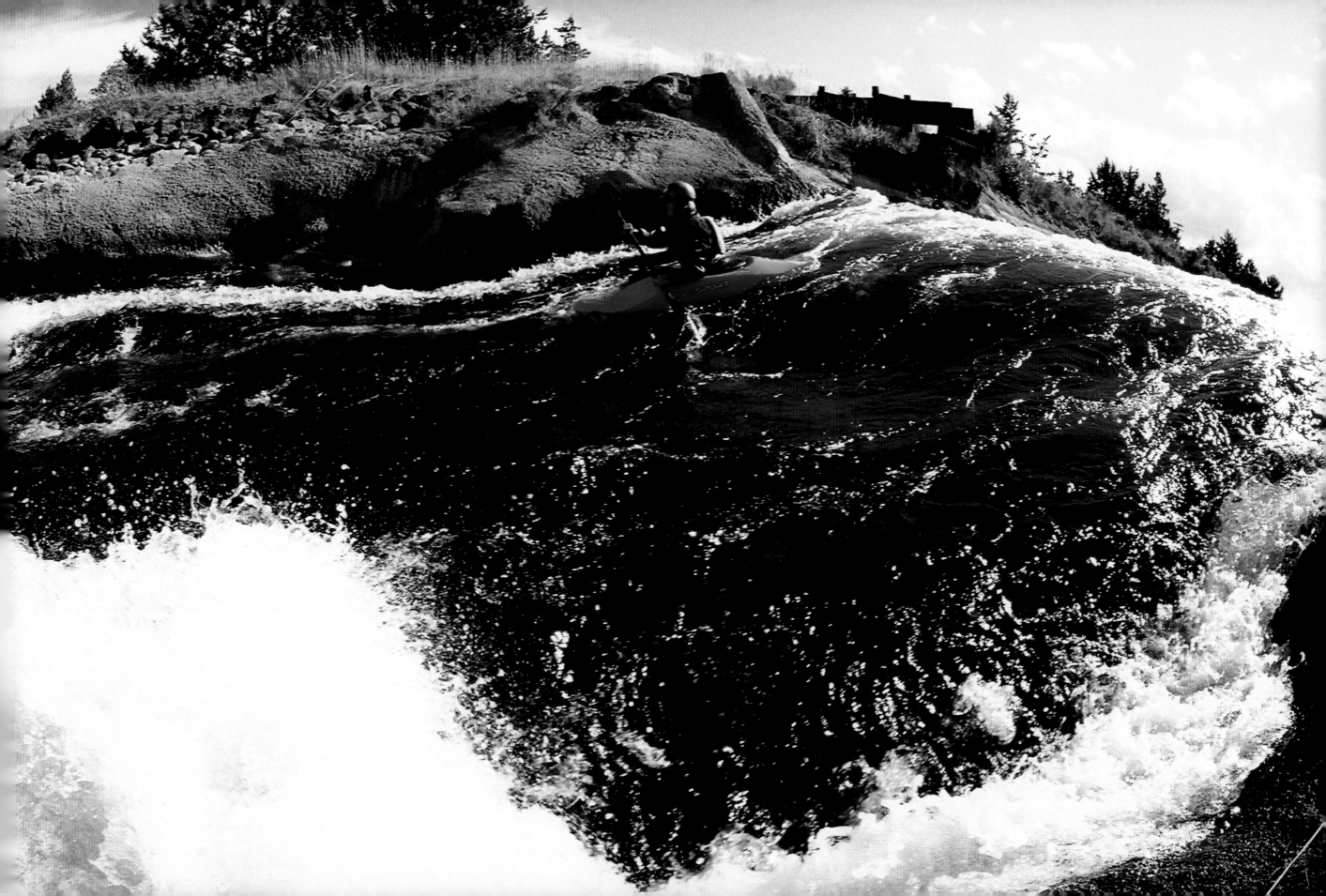

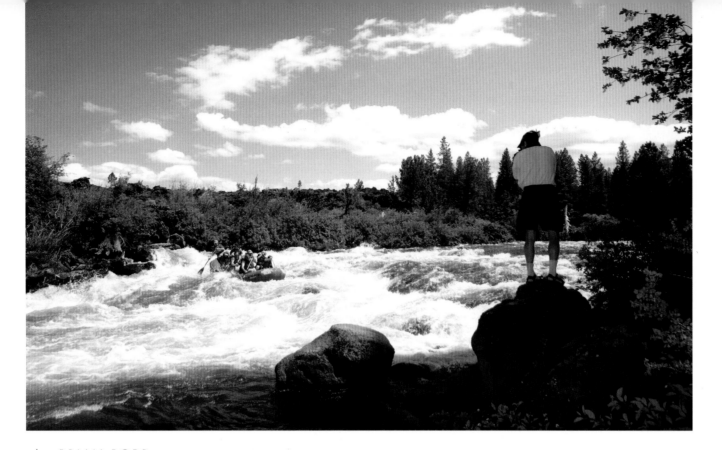

by BRIAN ROBB

Rafting Big Eddy, Upper Deschutes River

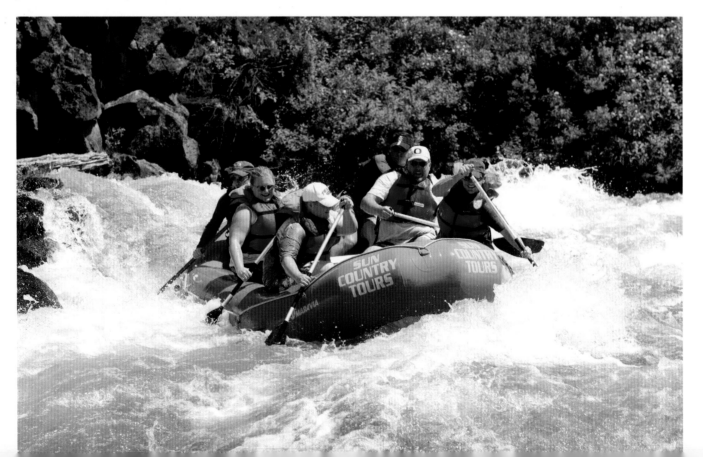

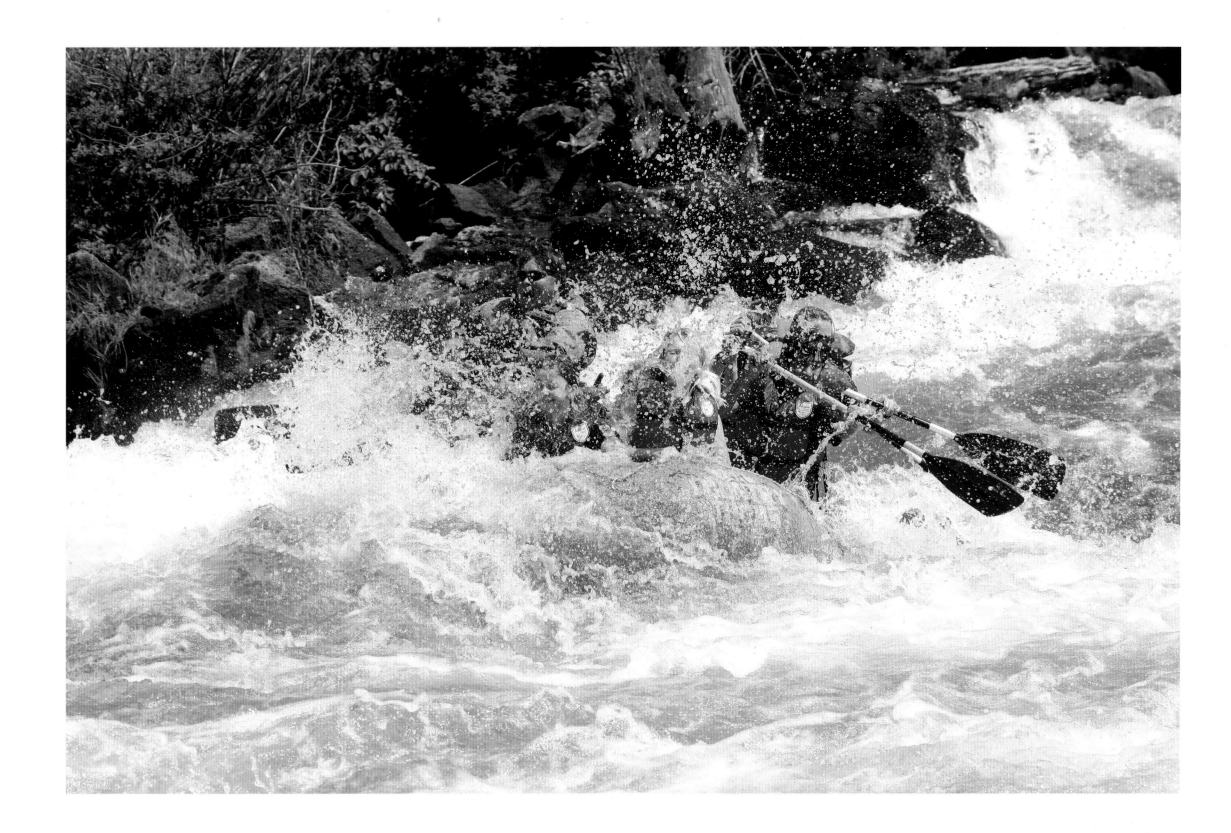

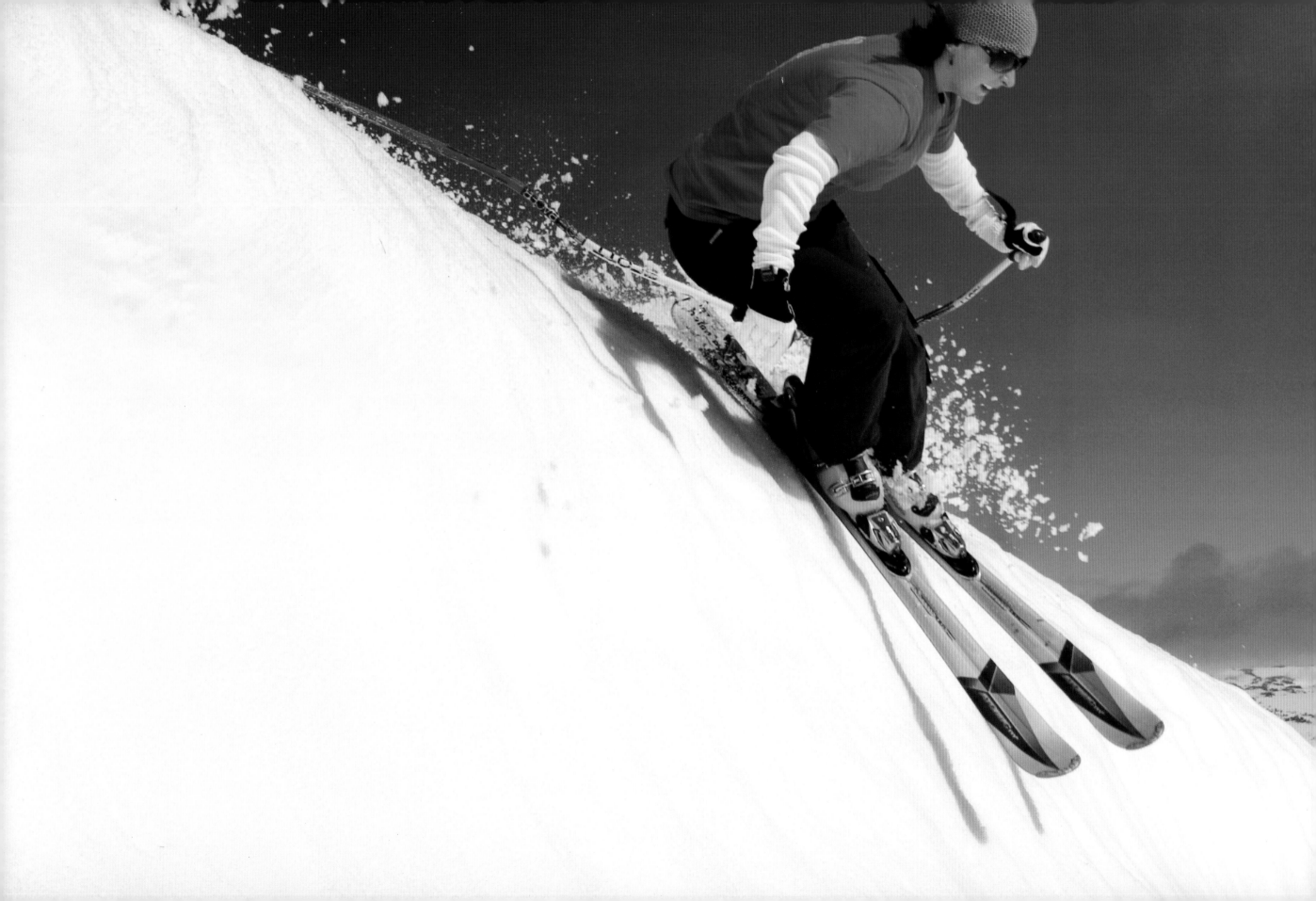

by ZACH SCOTT

Lauren Wilson crests the cornice atop Tumalo Mountain

by ZACH SCOTT

Kyle Schmid and Rachel Hanis cartwheel
through the Cascades

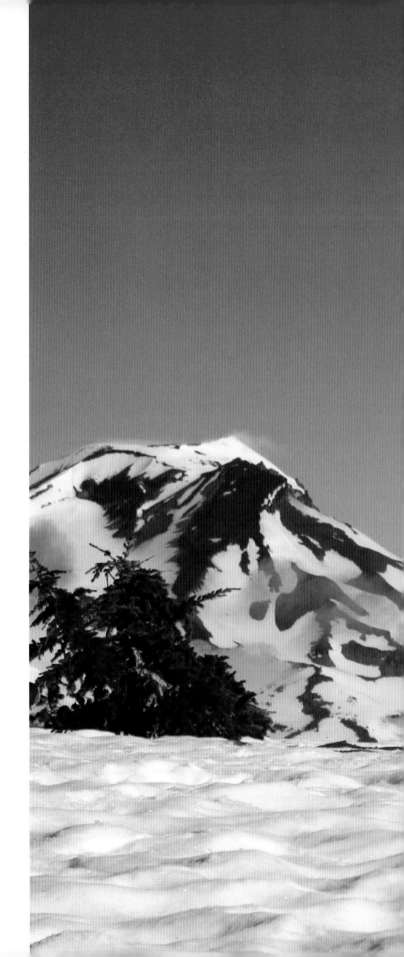

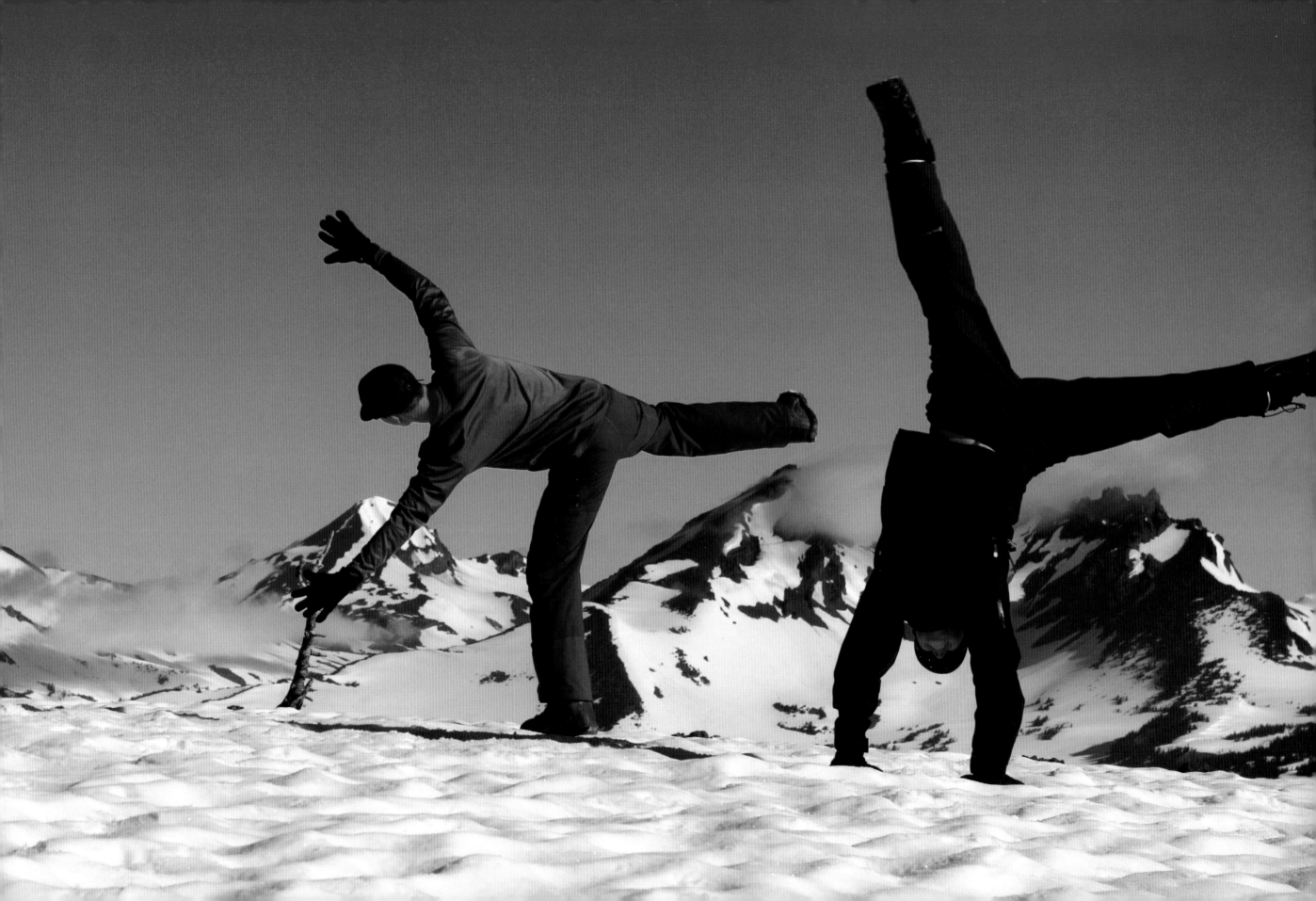

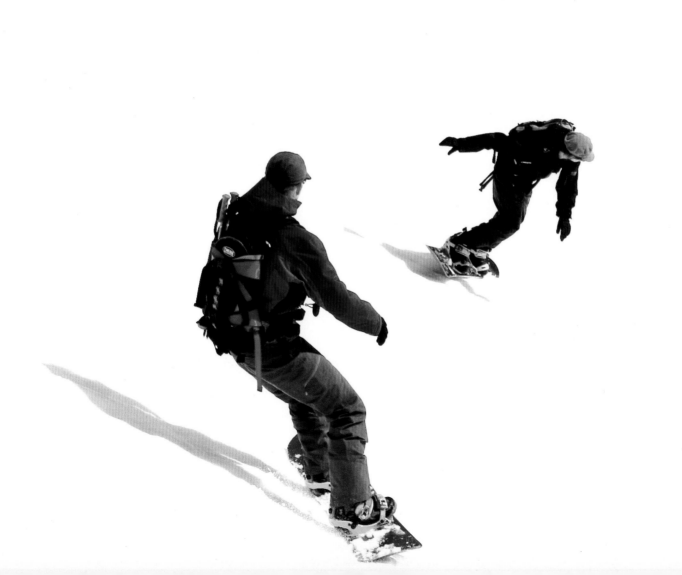

by ZACH SCOTT

Snowboarders ride down Tumalo Mountain

by ZACH SCOTT

The photographer grabs some air: Zach Scott set up his camera and convinced his wife, Rachel Hanis, to snap the photo, as he joined in the fun.

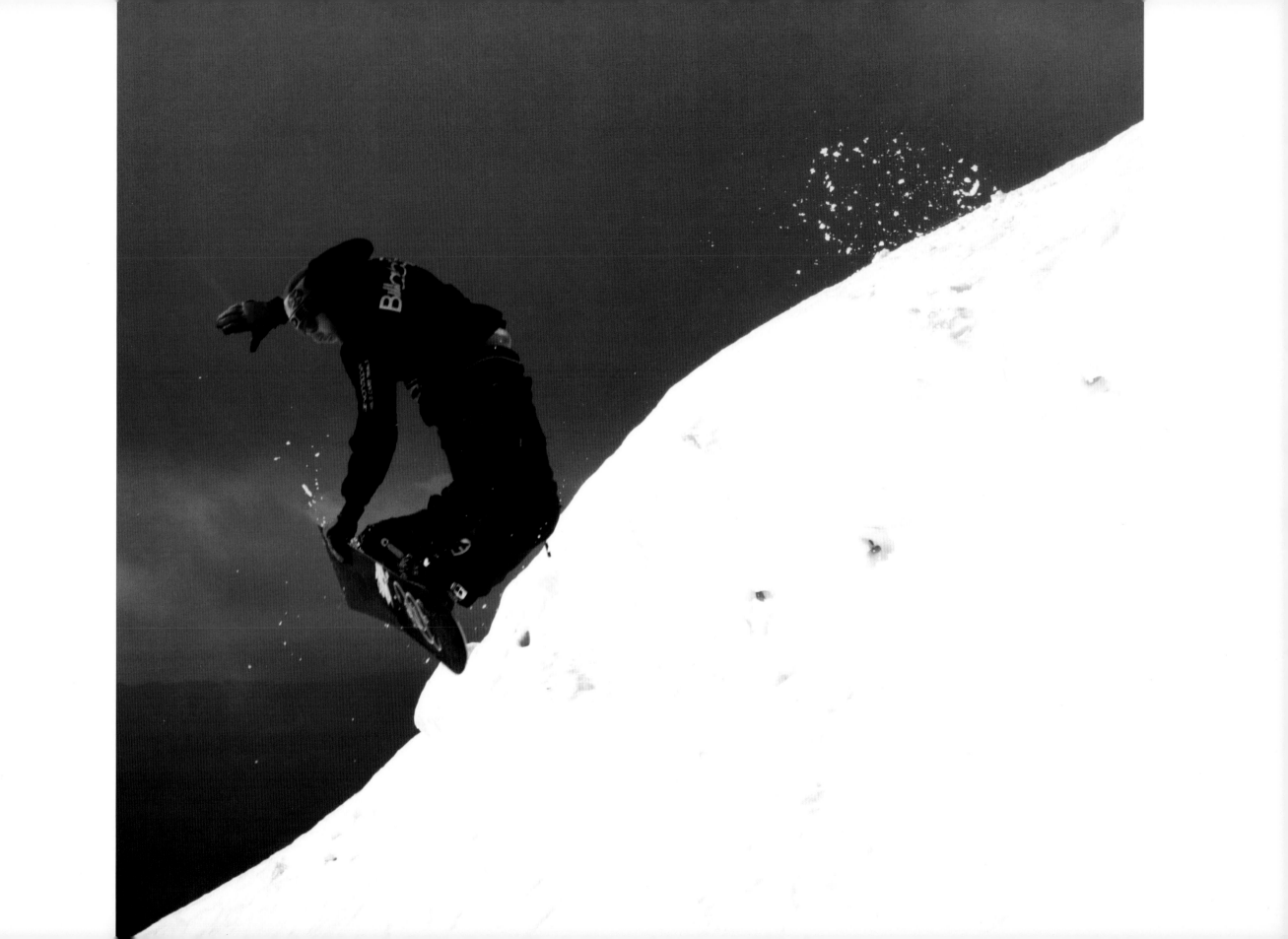

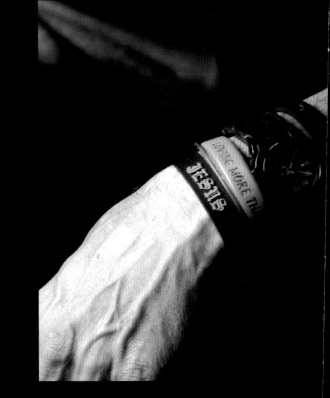

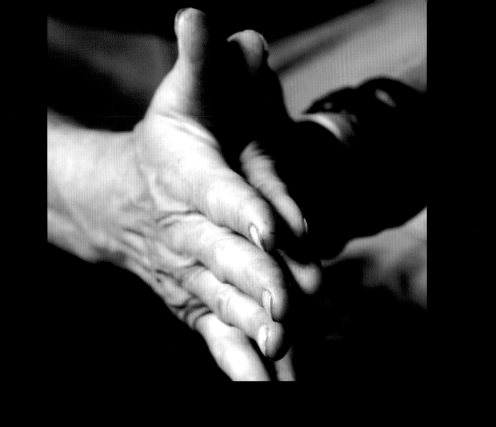
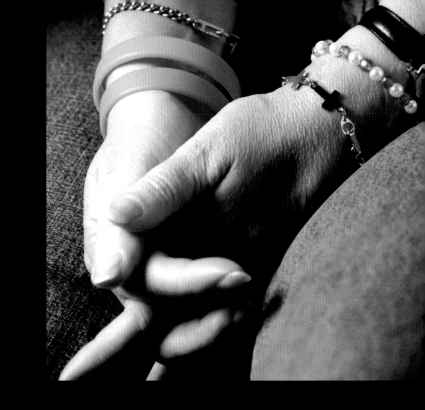

Hands of the homeless
The Bethlehem Inn offers a hand up, not a hand out

by MIKE HOUSKA

National anthem on the Bend Elks' opening day

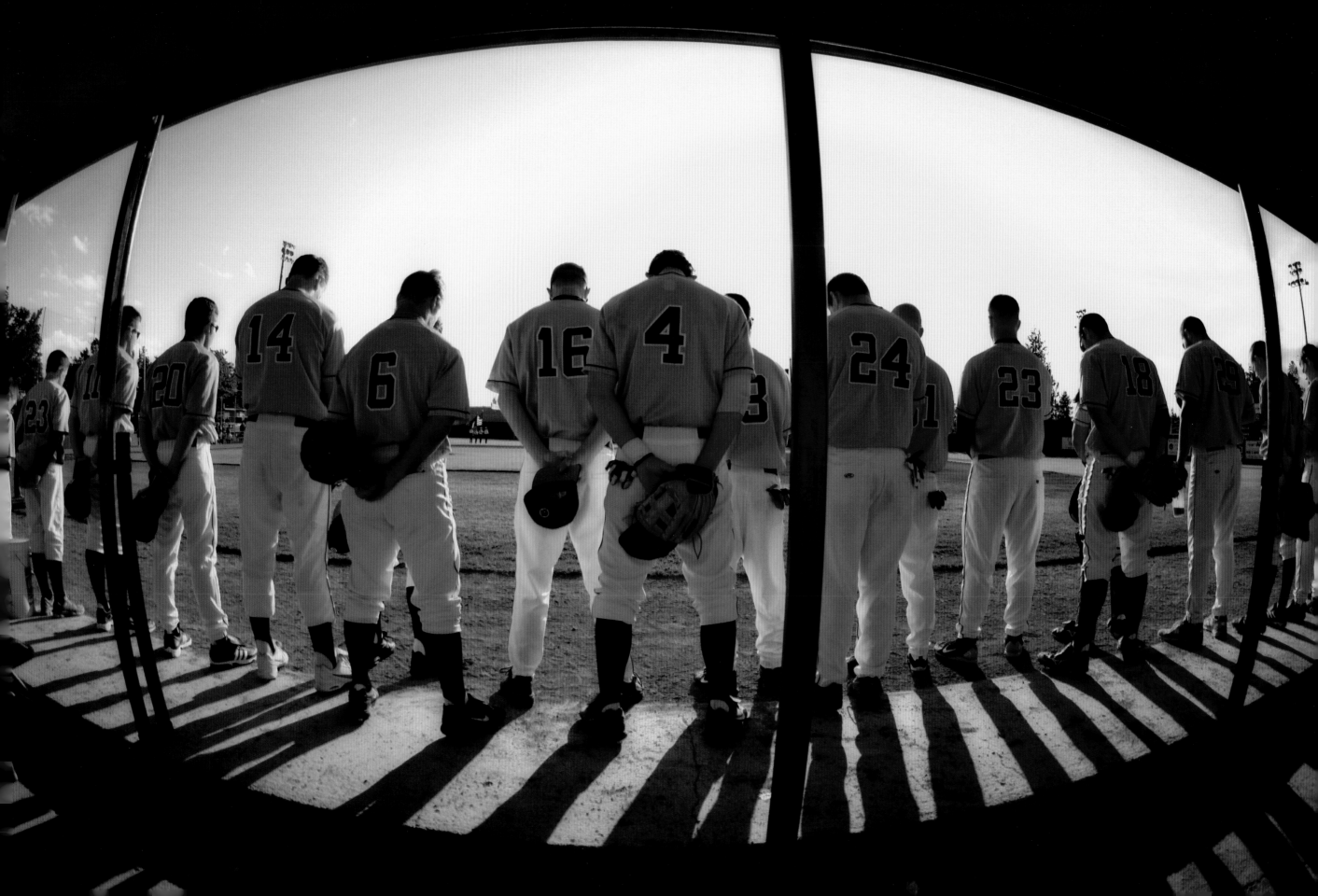

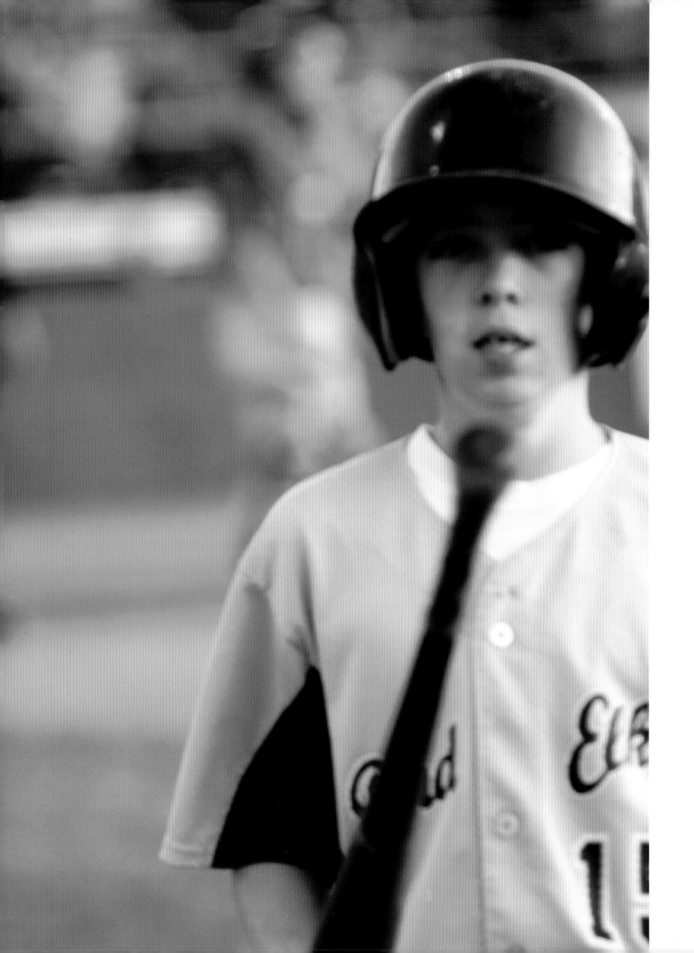

by MIKE HOUSKA

LEFT:
Today a batboy, someday a star

RIGHT:
Hosing down the infield, a pre-game ritual

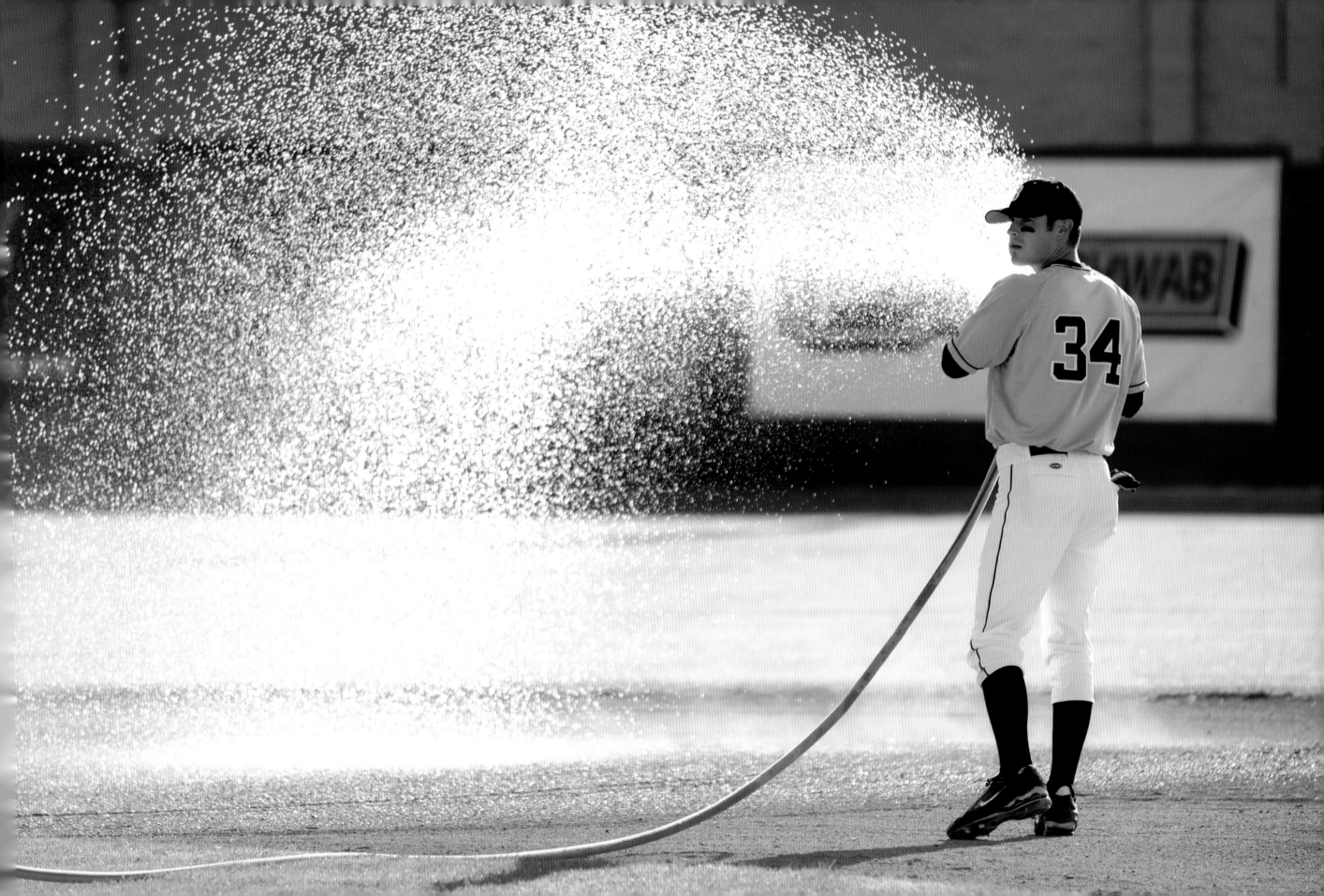

by MIKE HOUSKA

Warming up for the season's first official pitch

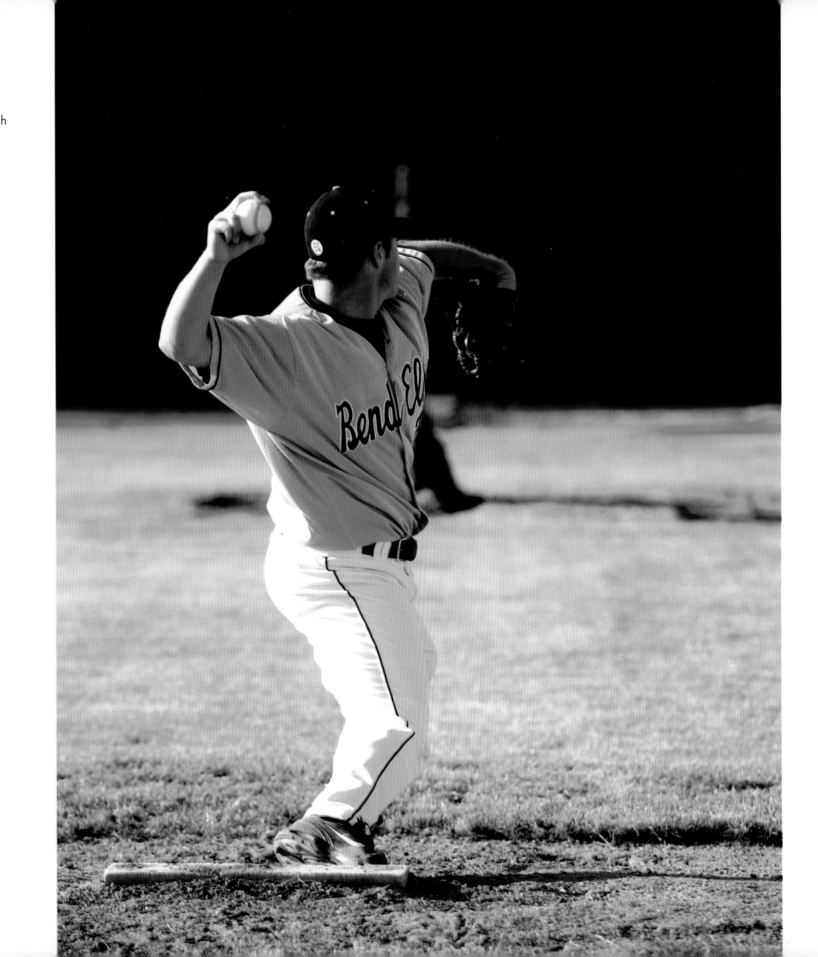

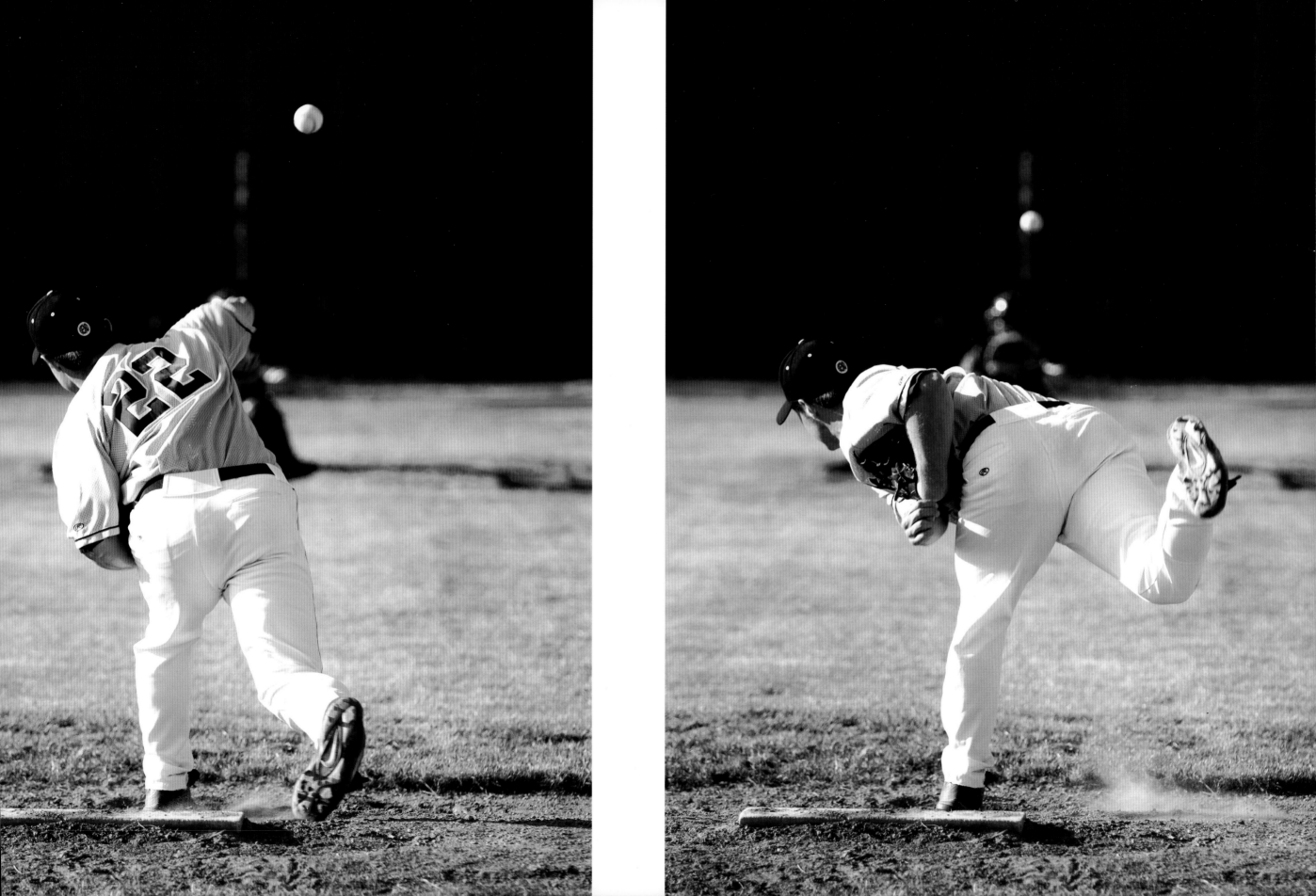

by MIKE HOUSKA

LEFT:
Baseball fan Sam Houska

RIGHT:
Take us out to the ballgame

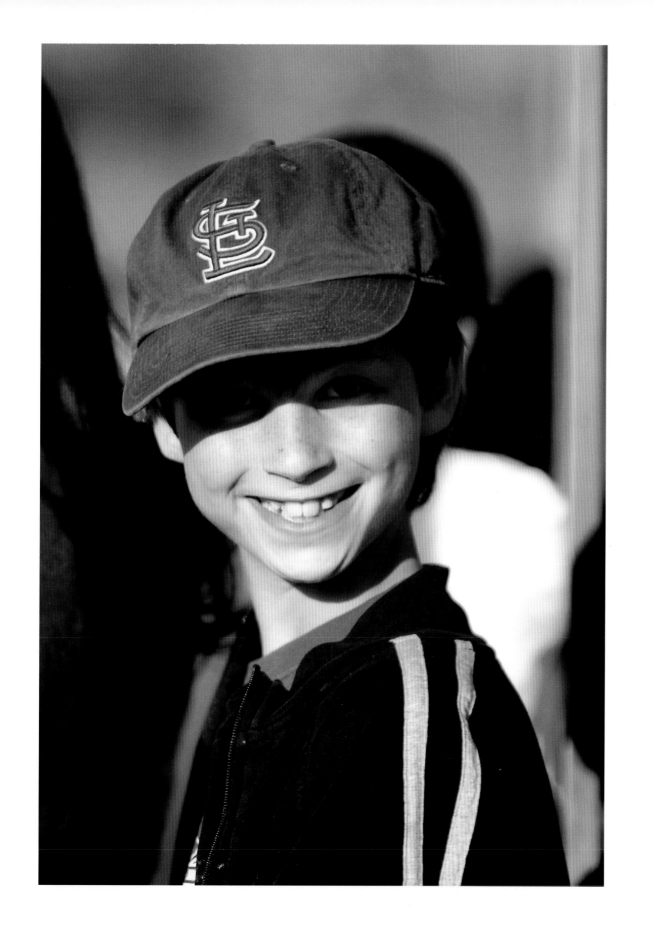

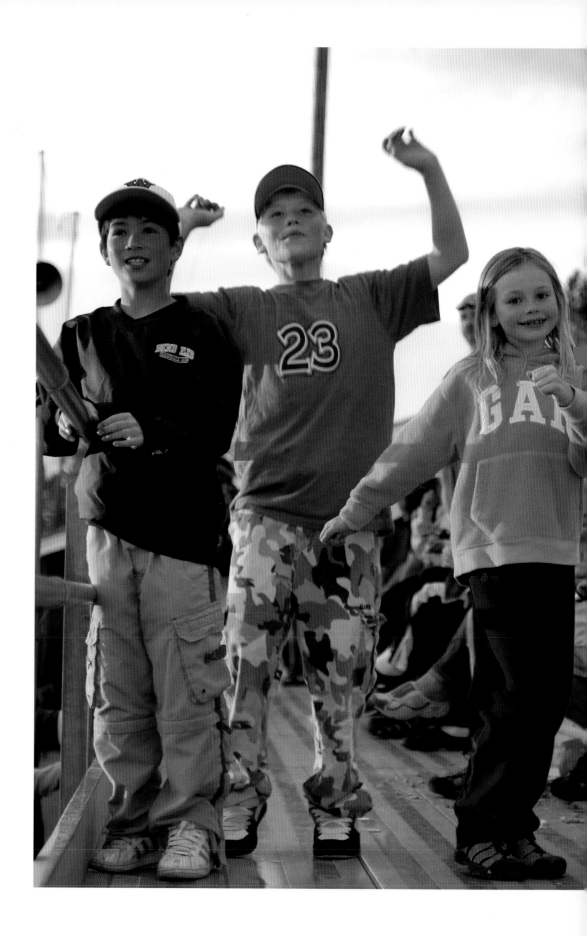

by KEVIN KUBOTA

Recess time, Amity Creek Magnet School

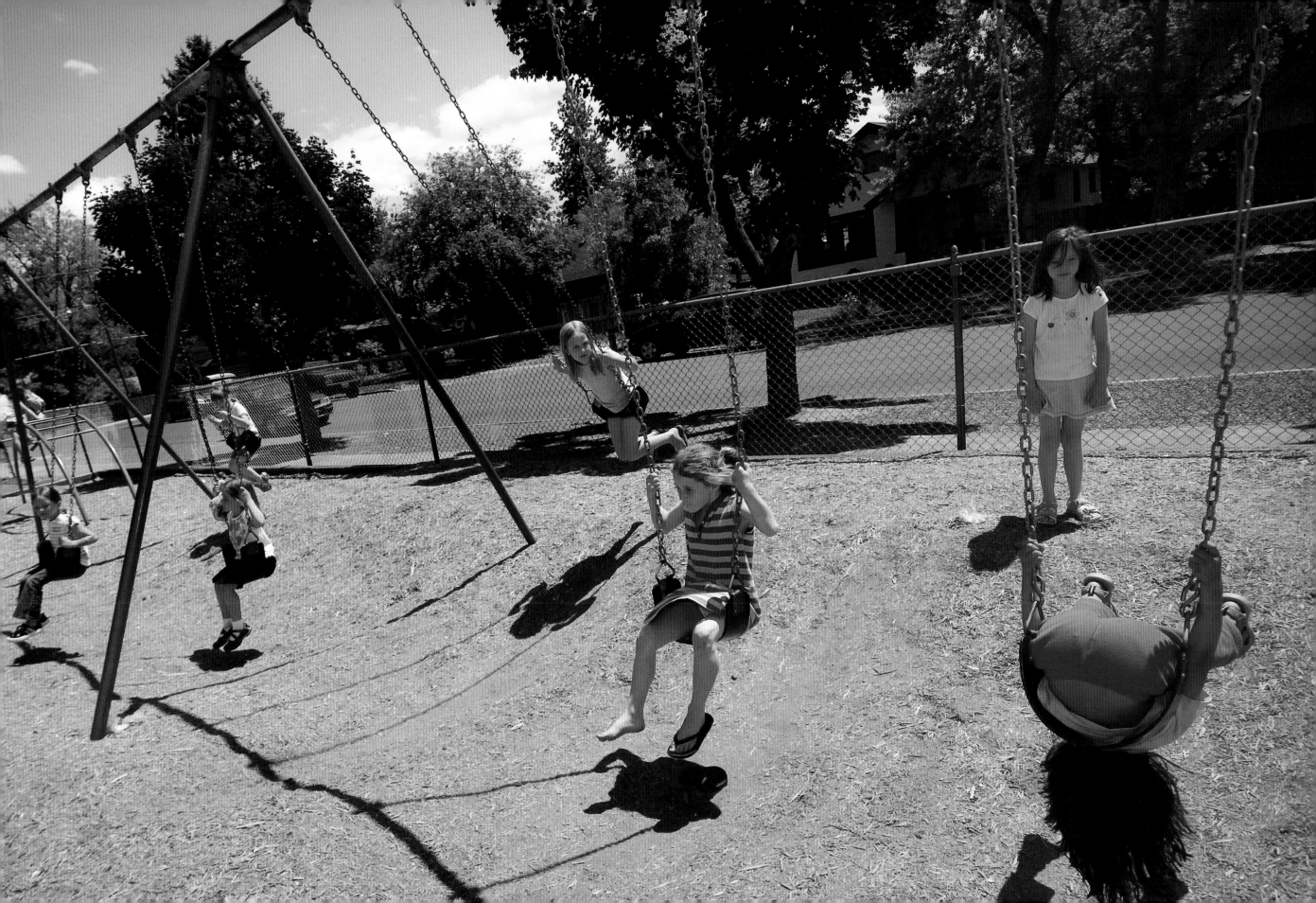

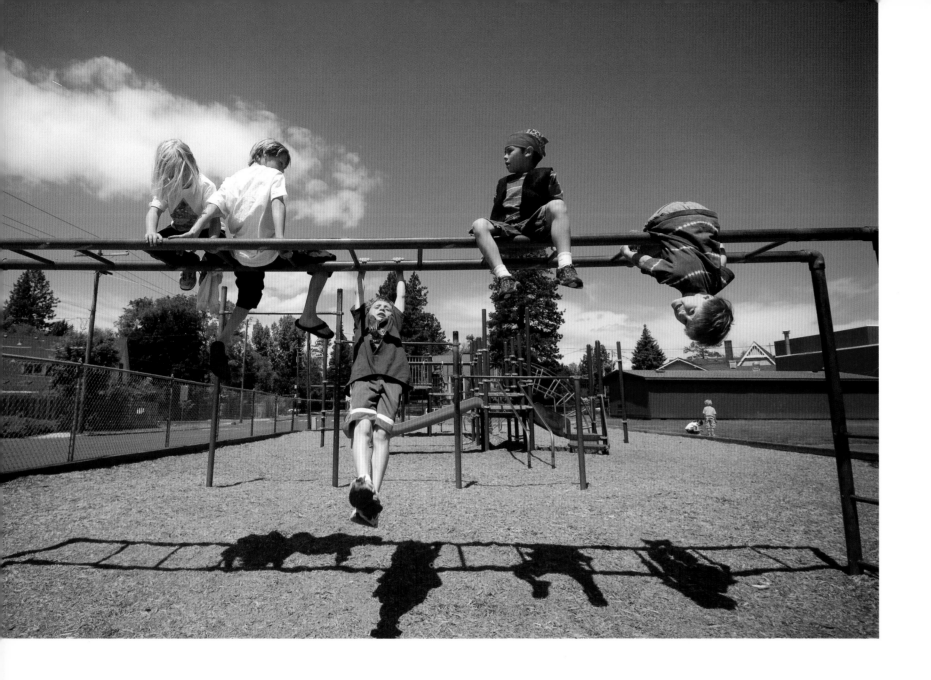
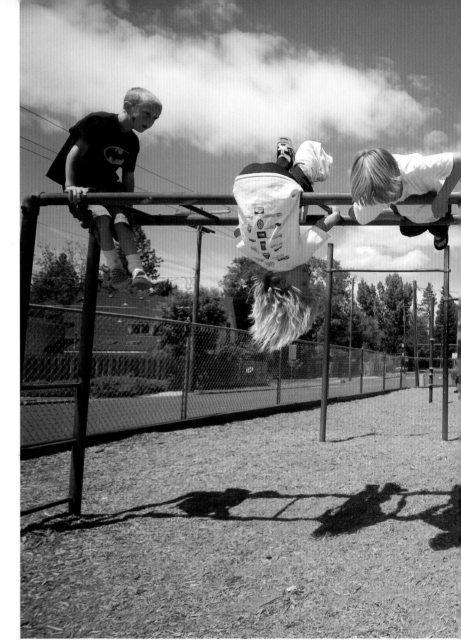

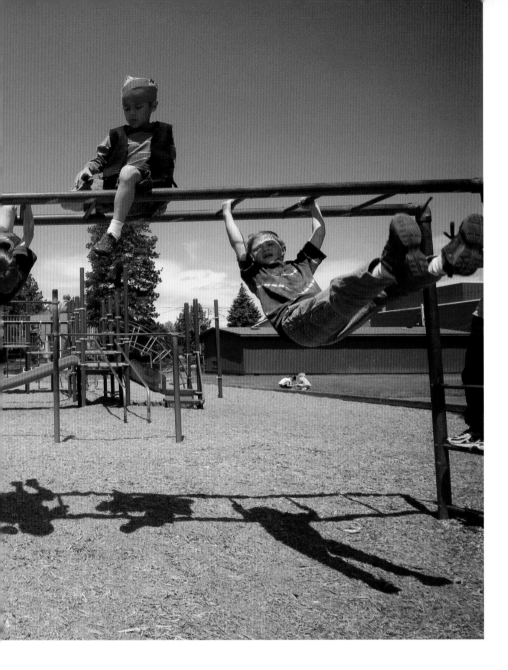

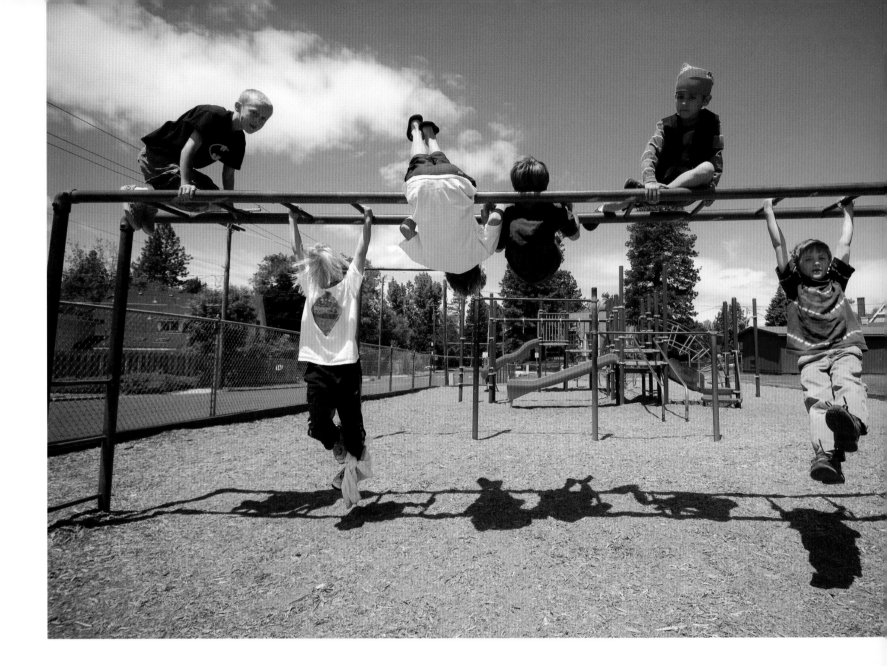

by KEVIN KUBOTA

Just hanging out at Amity Creek

by KEVIN KUBOTA

Chad Rogers is upside down and inside out

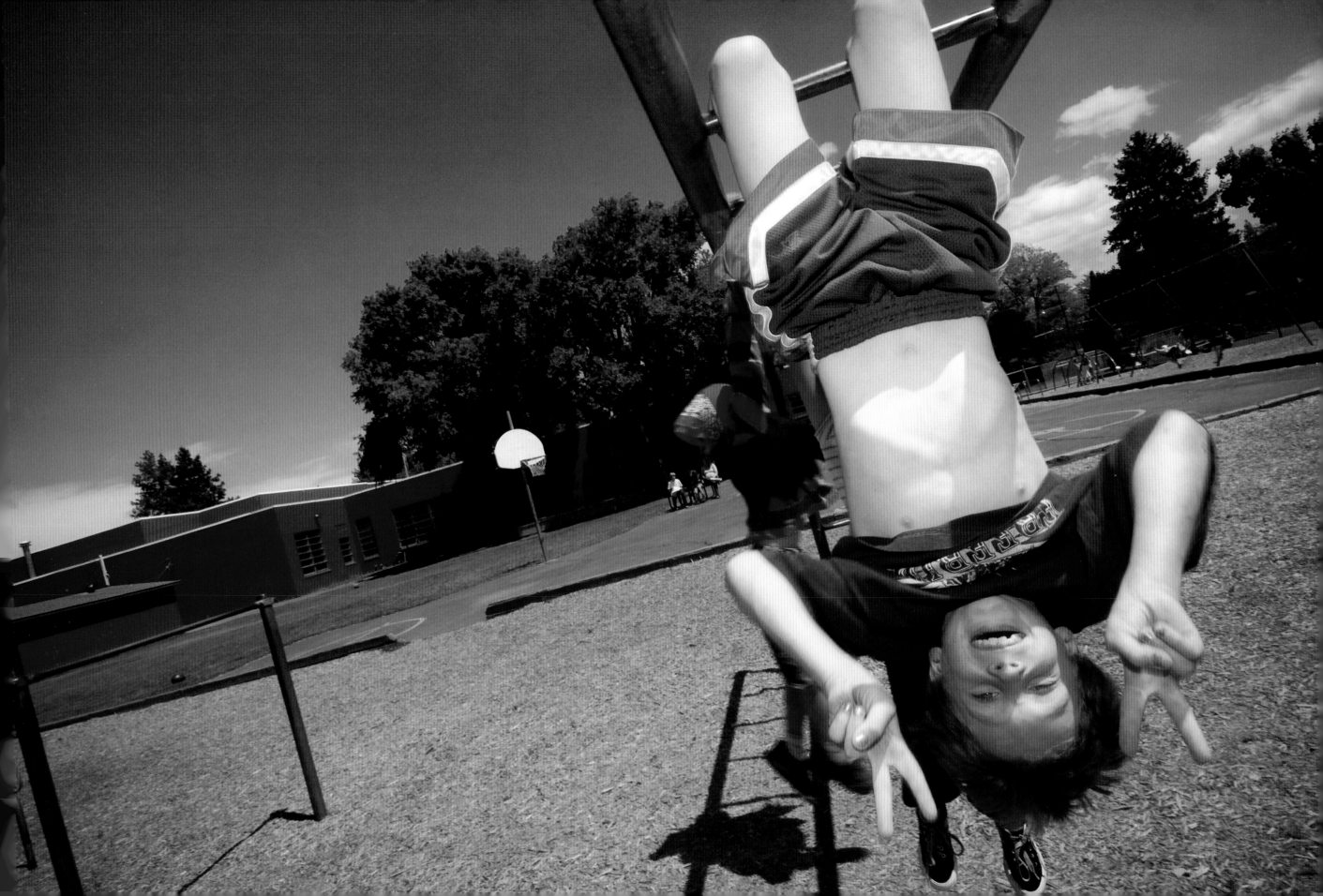

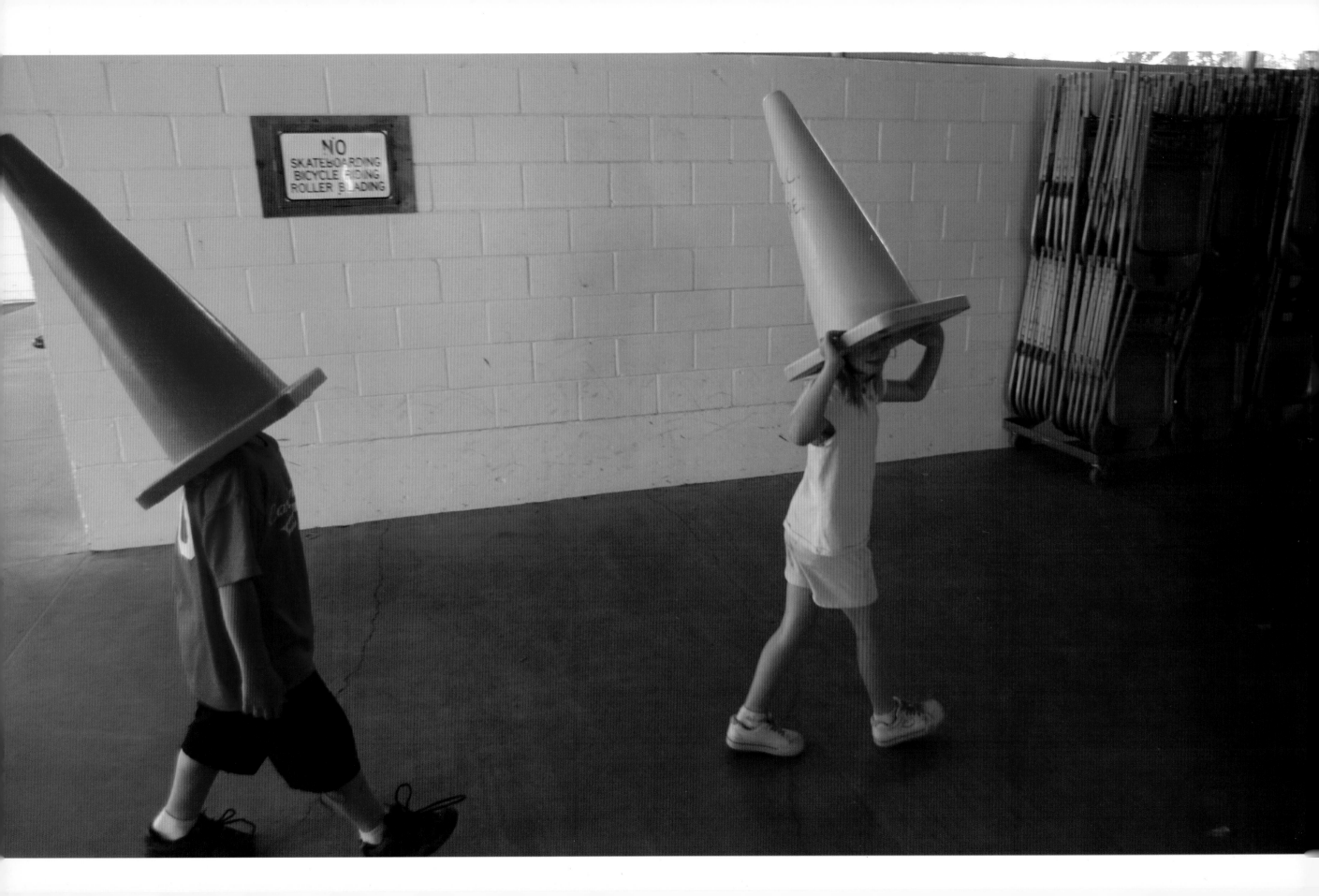

by BOB WOODWARD

Coneheads wander the halls at Amity Creek School

"See no weevils, eat no weevils (yuck!), hear no weevils":
First-graders Quinn Kinzer, Gillian Foxhoven and Tiffany
Brown play at the Tumalo Community School

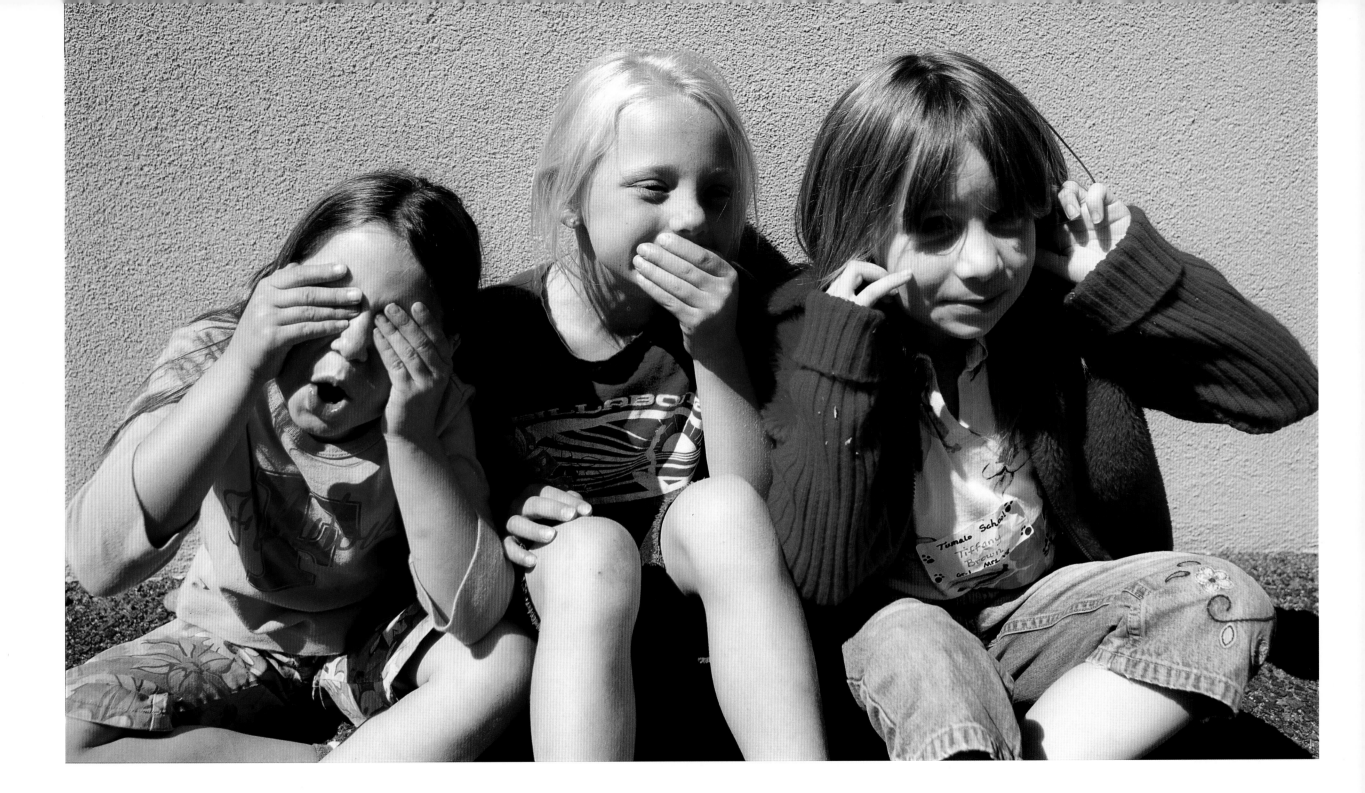

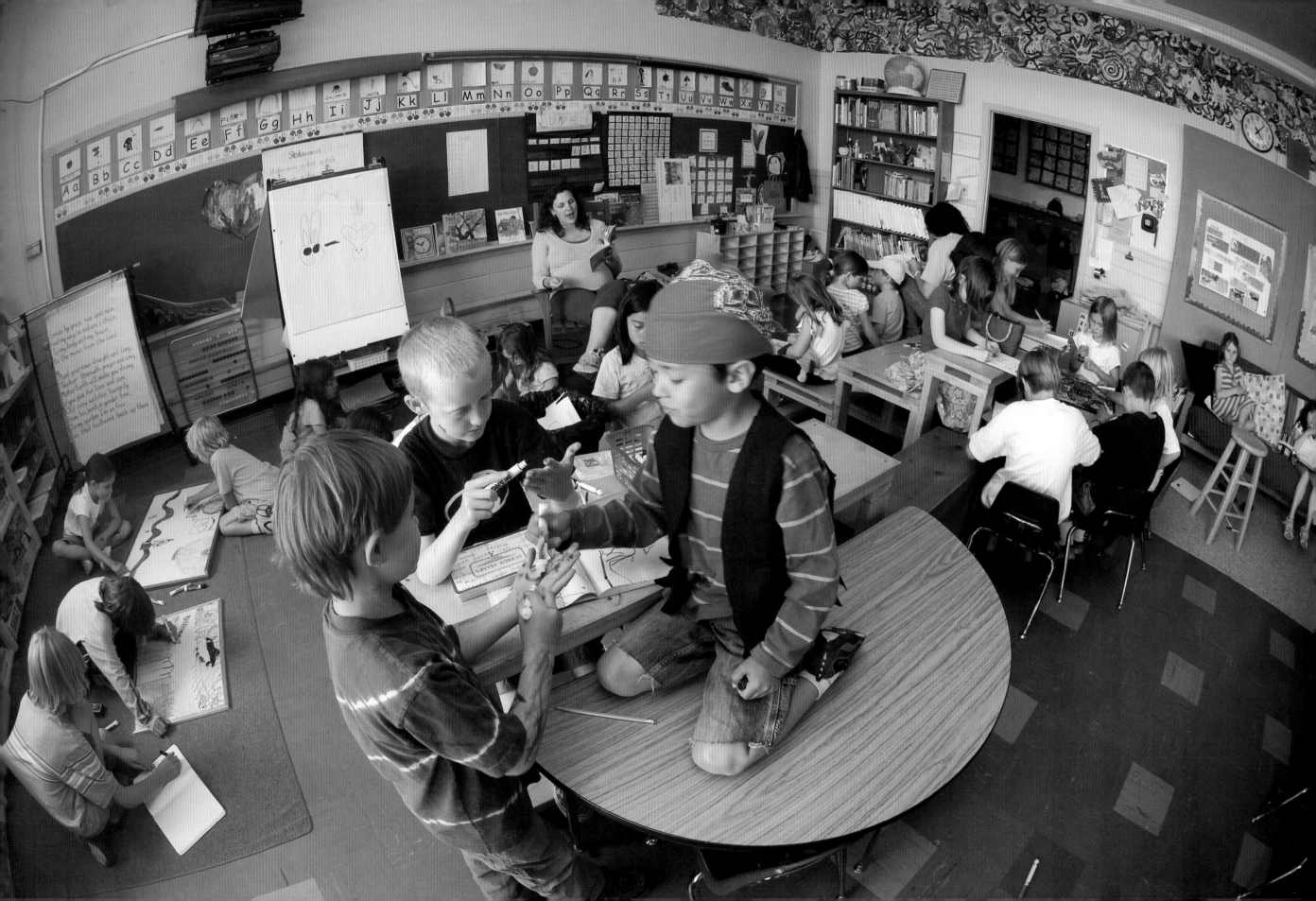

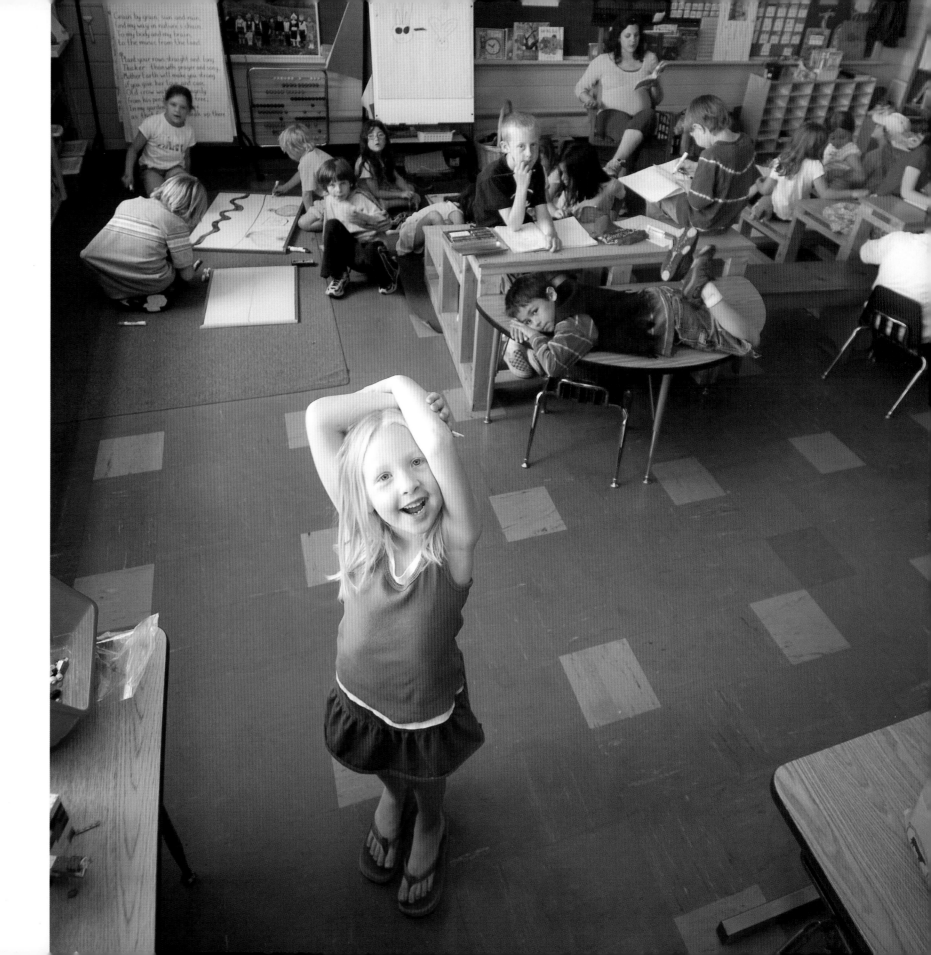

by KEVIN KUBOTA

LEFT:
Kai Kubota (on table) gets creative with friends Cooper Berry (left) and Israel Wallace at Amity Creek School.

RIGHT:
Catria Aldrich launches her modeling career in teacher Lindsey Nightingale's class.

by CAROL STERNKOPF

LEFT:
Alice in Wonderland

RIGHT:
Friends: Isa Riegel, Ana Hoshovsky and Alice McKnight

Emily Brinton of Redmond
holds a scaly friend

by JIM YUSKAVITCH

Brothers Evan and Ezra Gittins—visiting from Aberdeen, Washington—caught their dinners at free-fishing day.

by MARISA CHAPPELL

Wheee! Free spirit Felissica Bergstrom

by MARISA CHAPPELL

Did so? Did *not!*

by PAULA WATTS

One shake, and Javen Hedges is one happy guy

by MARISA CHAPPELL

The kiss

by ROBERT AGLI

Jennifer Banning welcomes Reed Banning to the world.

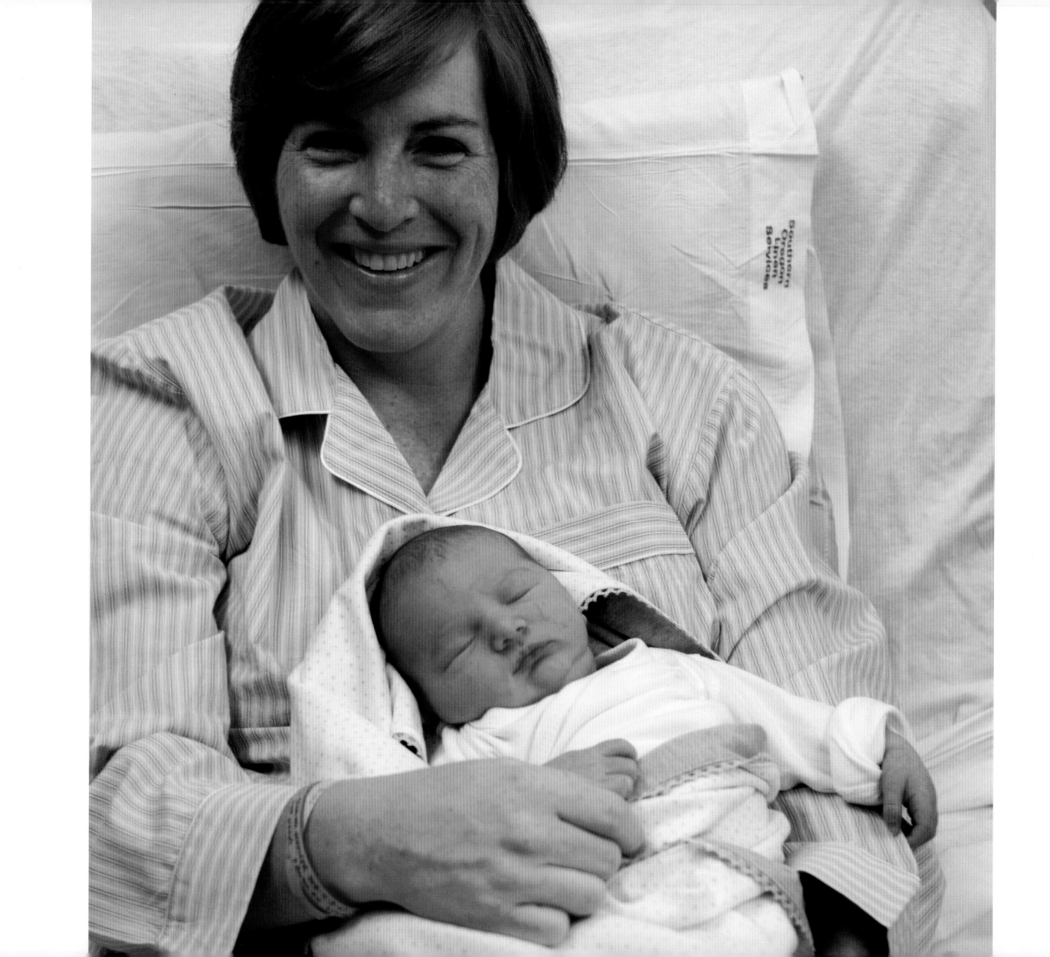

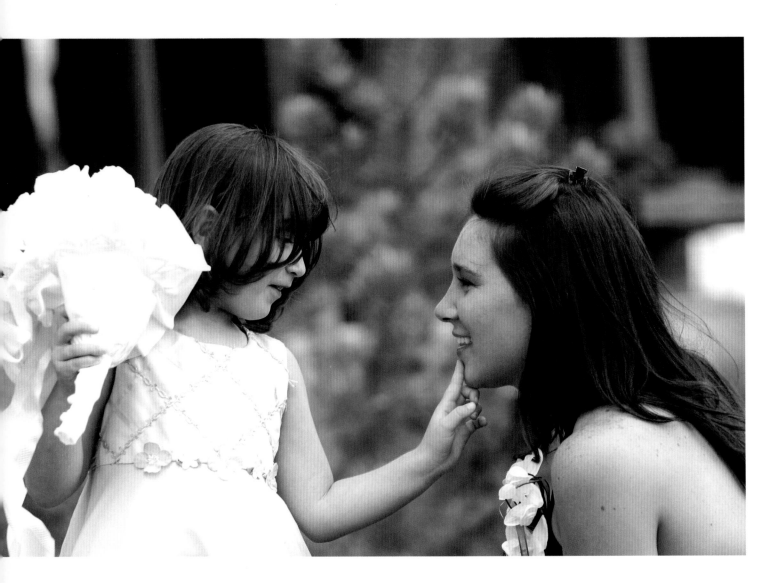

by TODD MARTYN-JONES

LEFT:
A flower girl and bridesmaid at the marriage of Tamara
Okonogi and Steve Jovonovich at Sunriver Resort

RIGHT:
Floral wedding cake

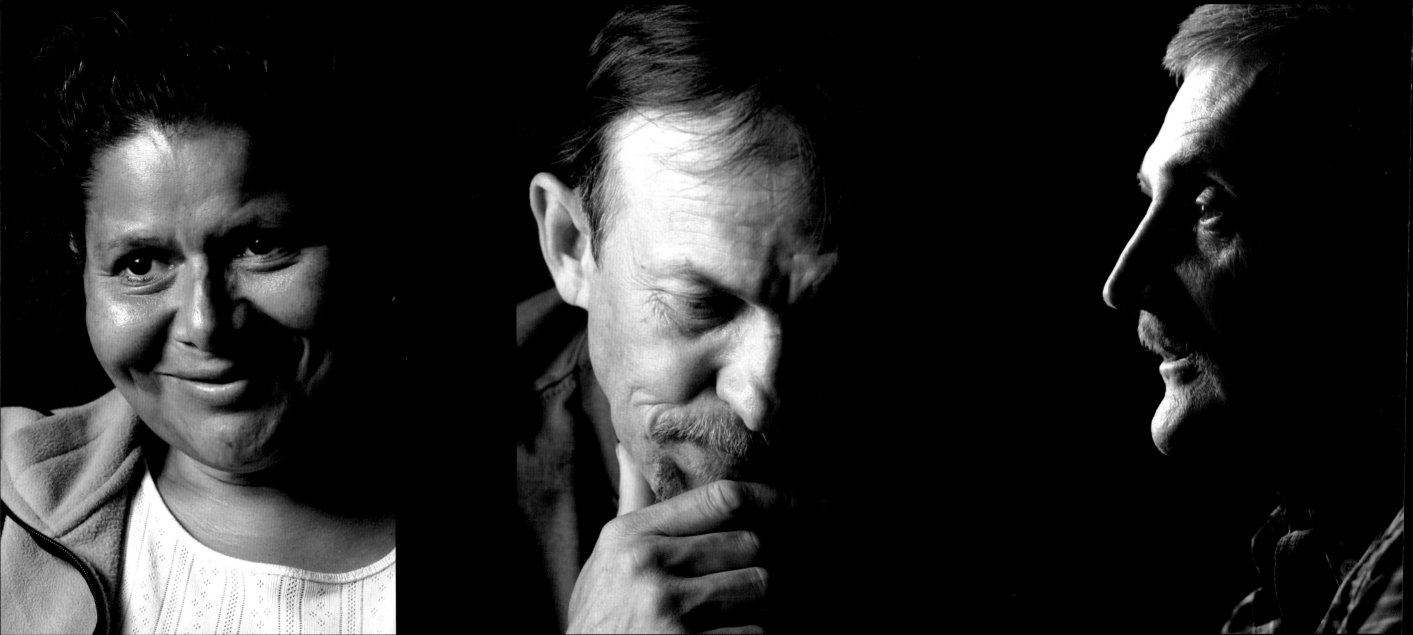

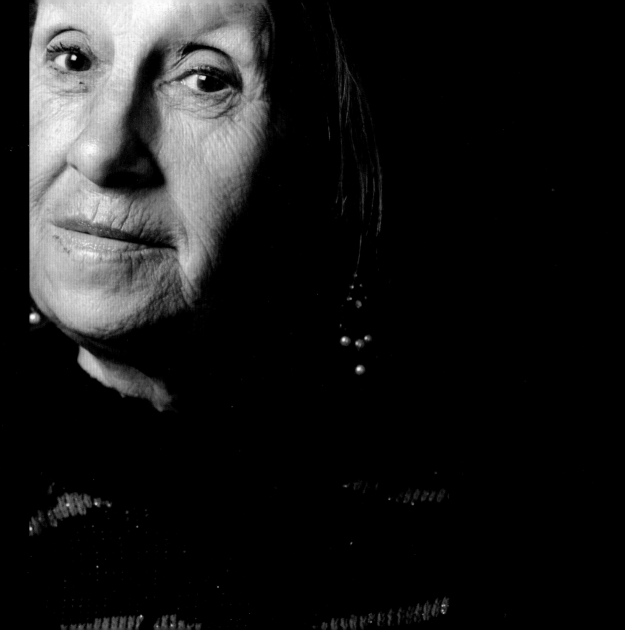

The faces of homelessness

by TOM AND TASHA OWEN

by JIM YUSKAVITCH

Afternoon light, Sisters

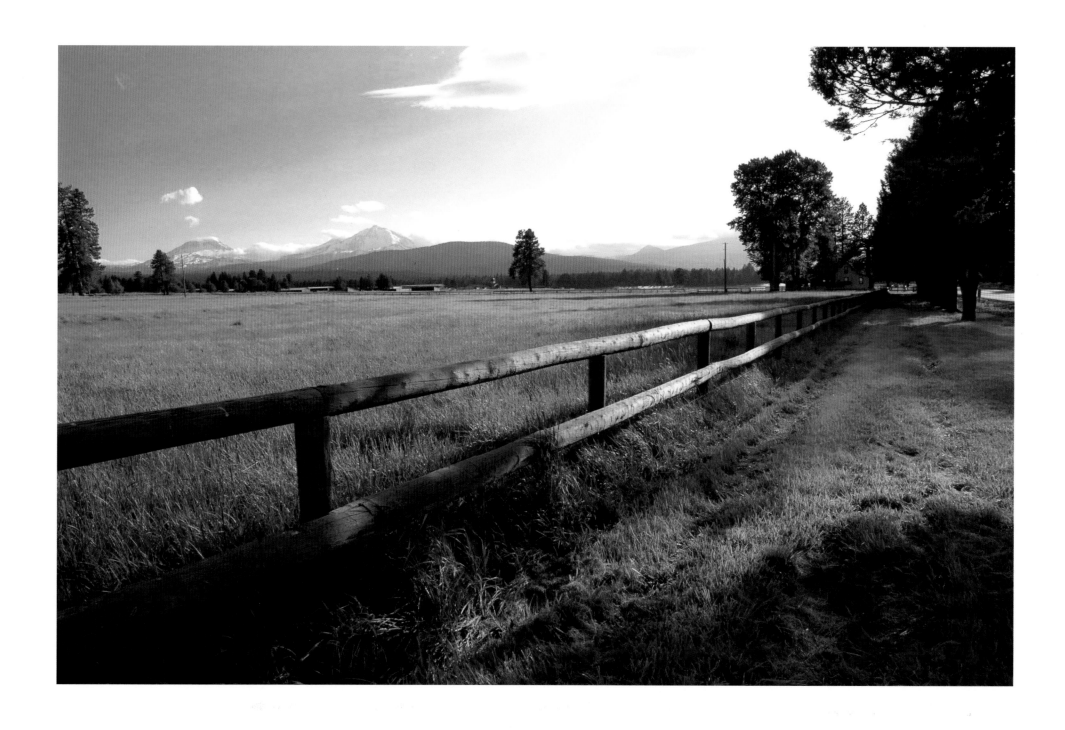

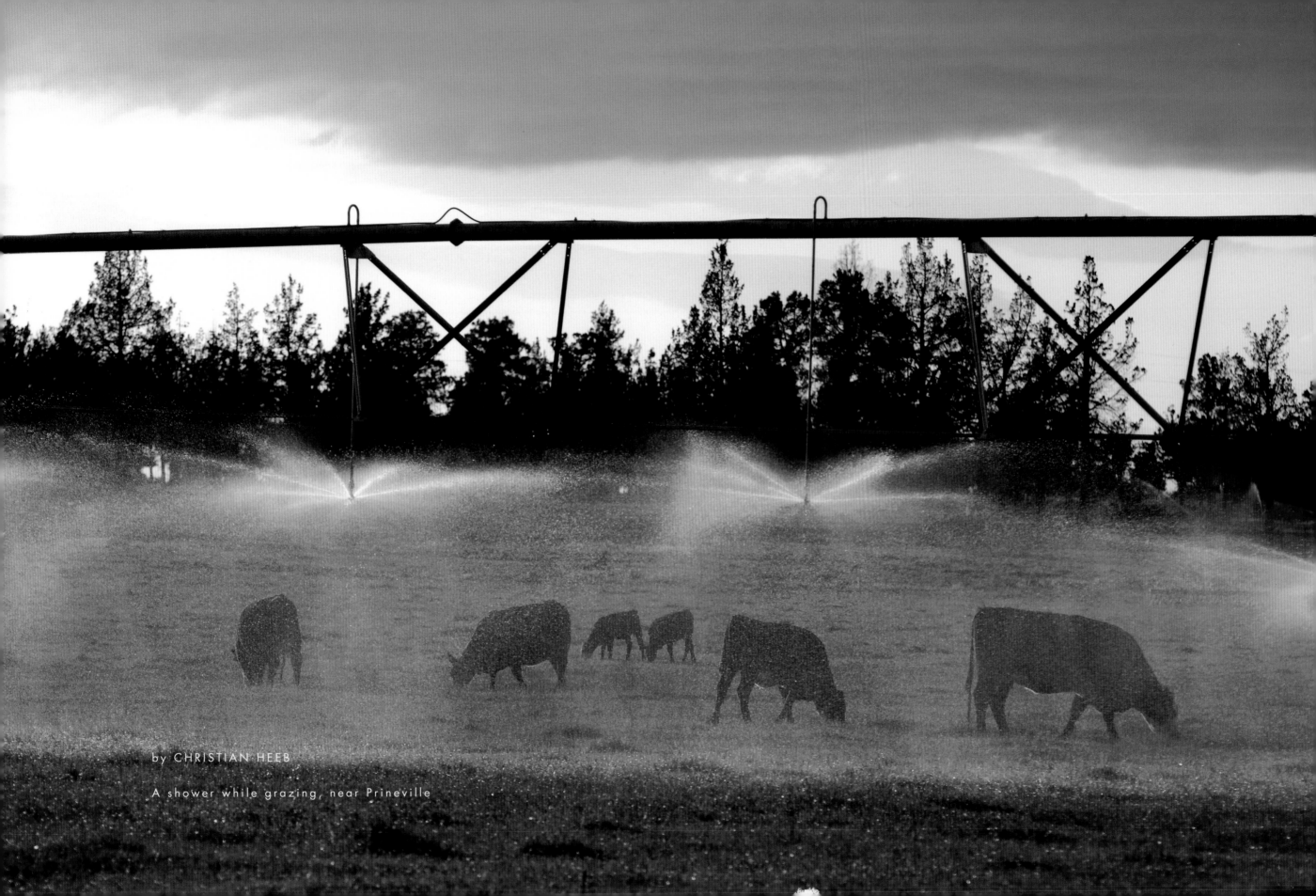

by CHRISTIAN HEEB

A shower while grazing, near Prineville

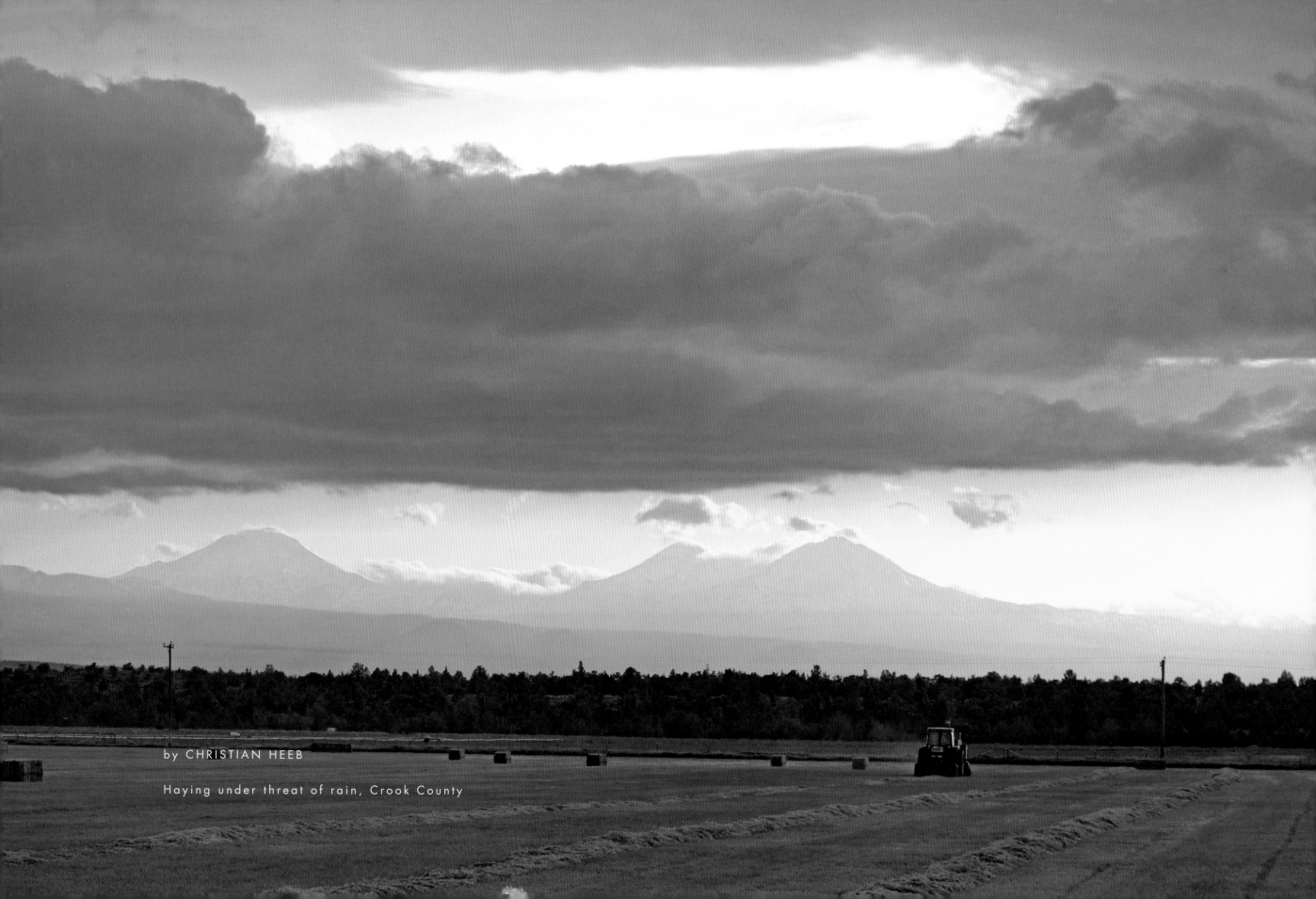

by CHRISTIAN HEEB

Haying under threat of rain, Crook County

by CHRISTIAN HEEB

Water, the lifeblood of Central Oregon

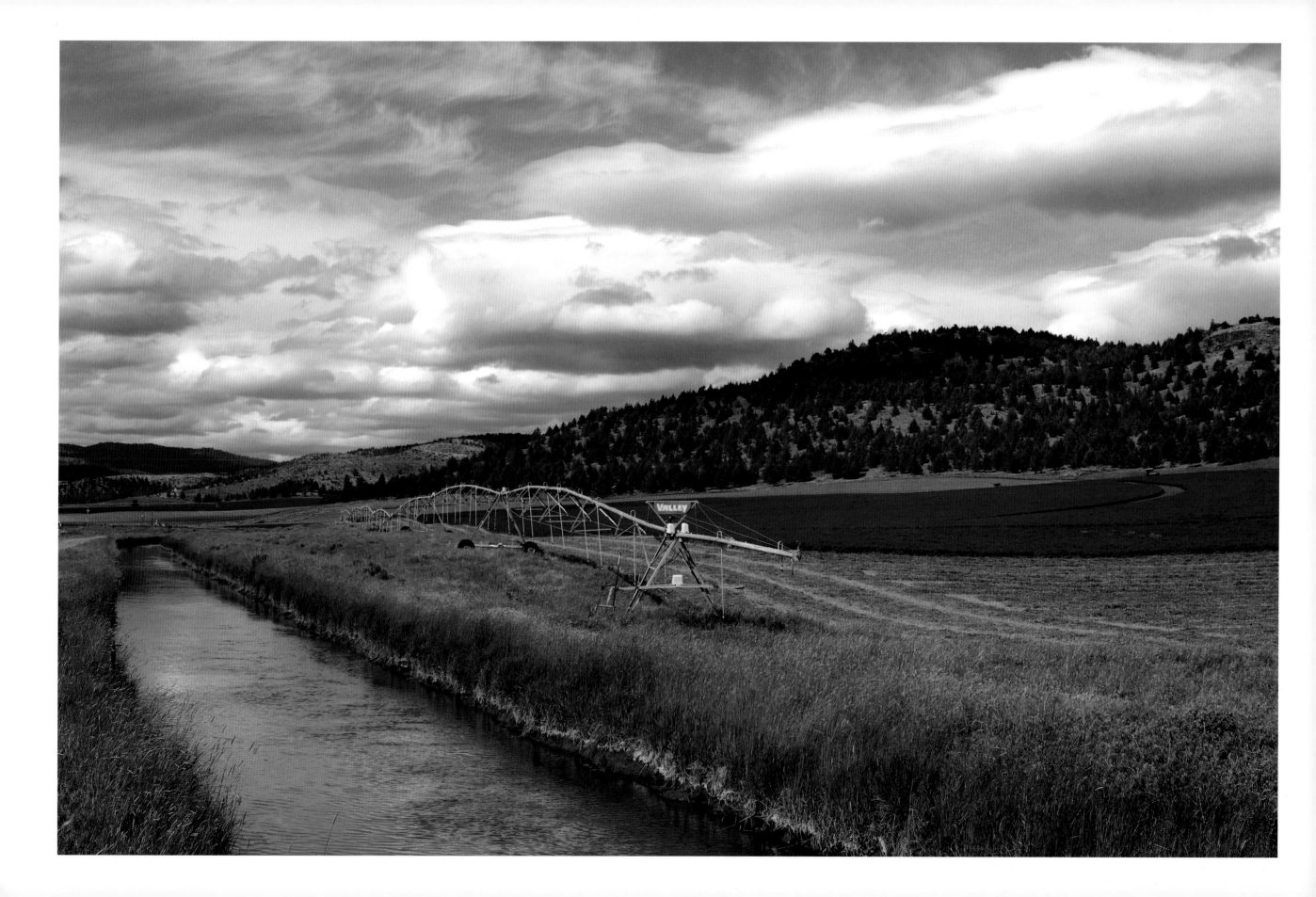

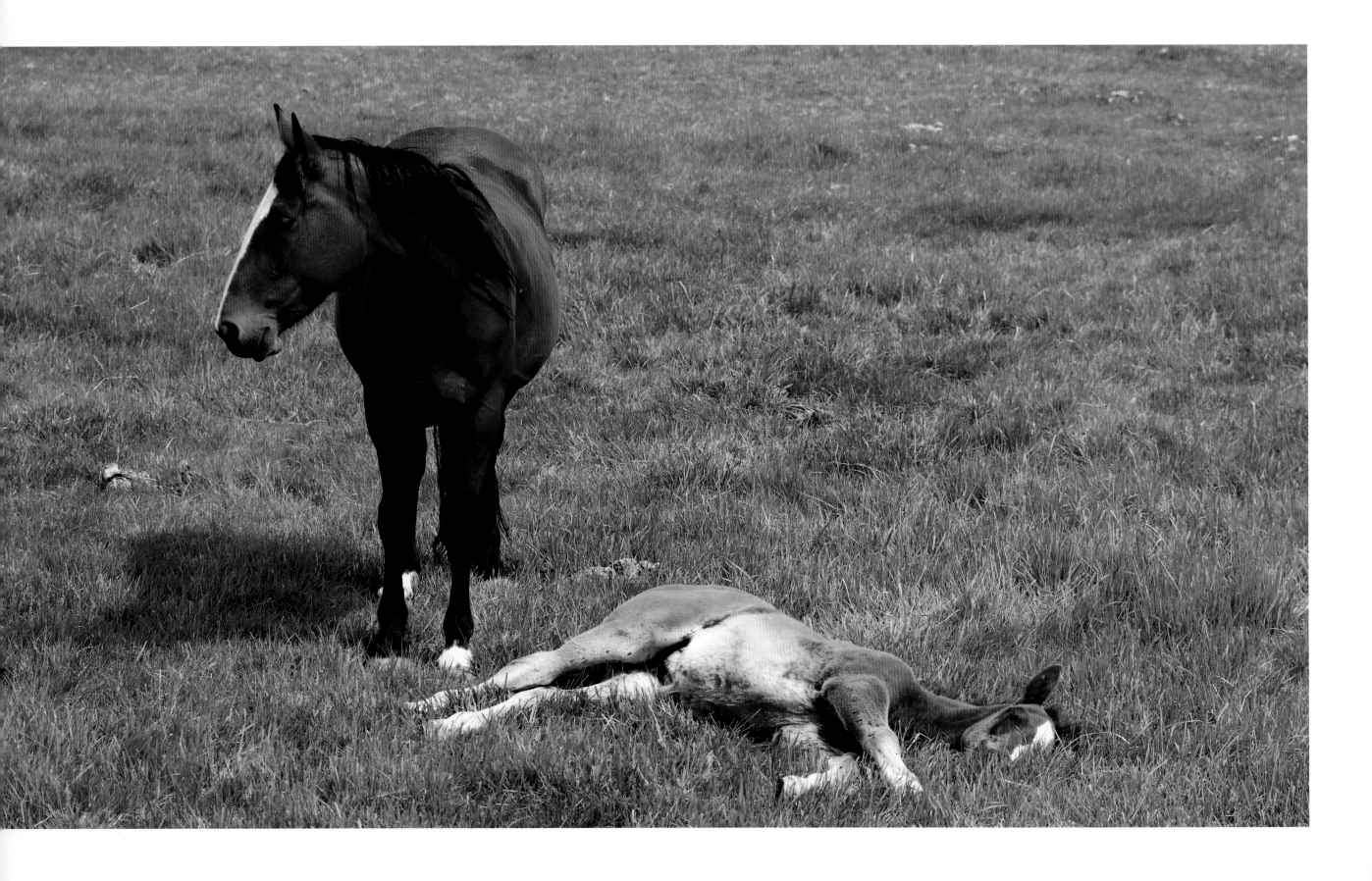

by CHRISTIAN HEEB

Mother and foal, Prineville

by MIKE HOUSKA

Man and machine: John Daniel on his ranch near Tumalo

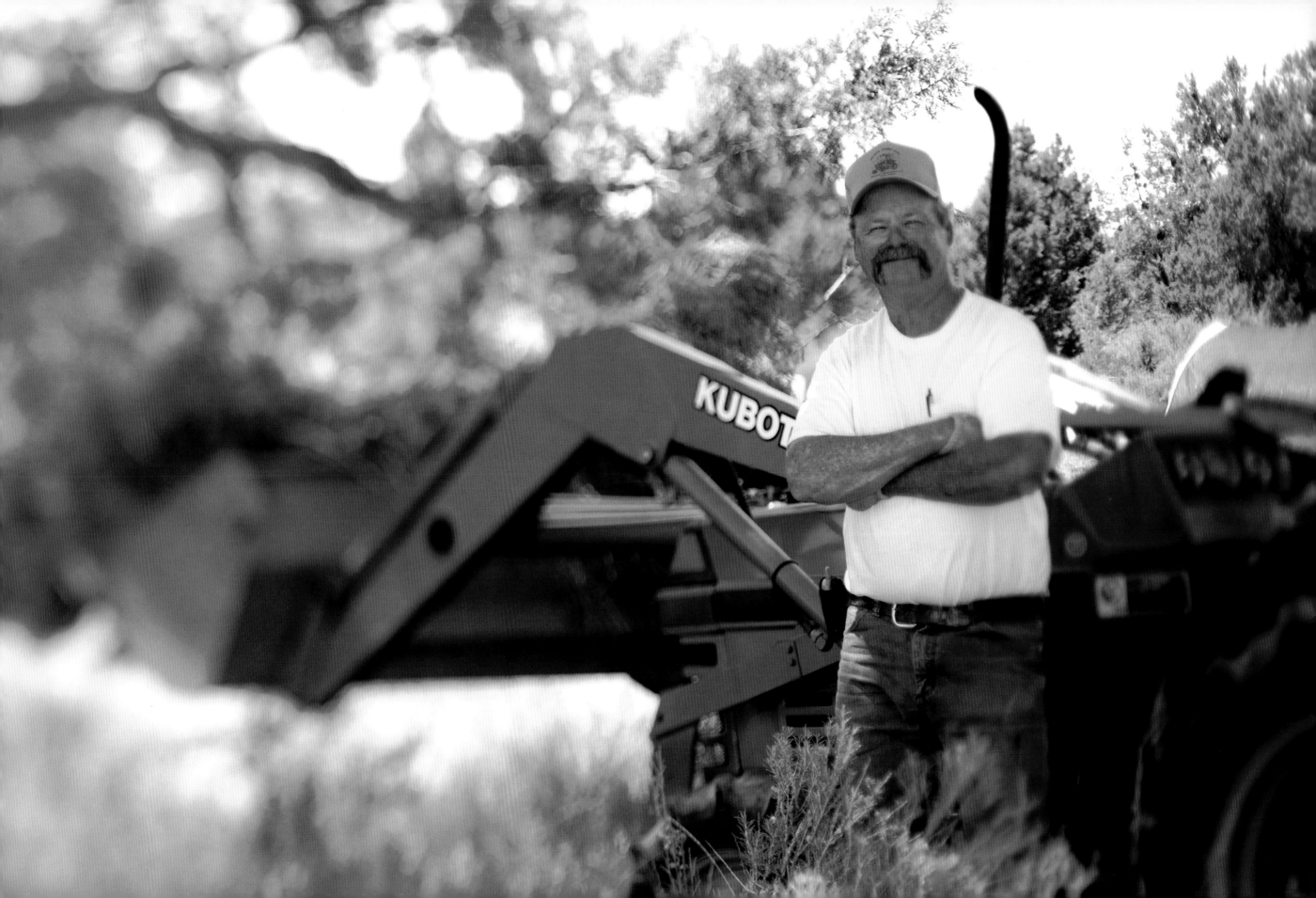

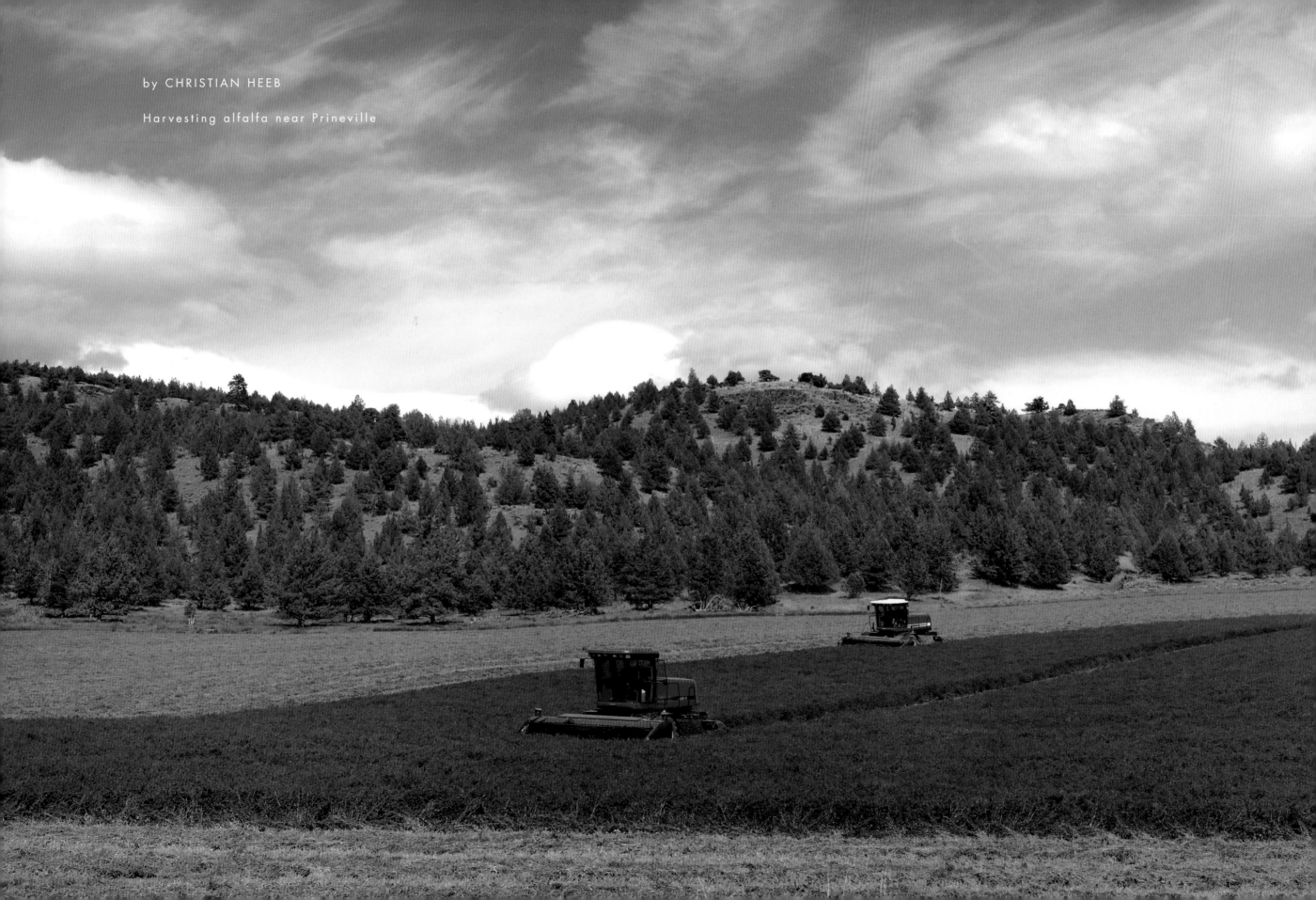

by CHRISTIAN HEEB

Harvesting alfalfa near Prineville

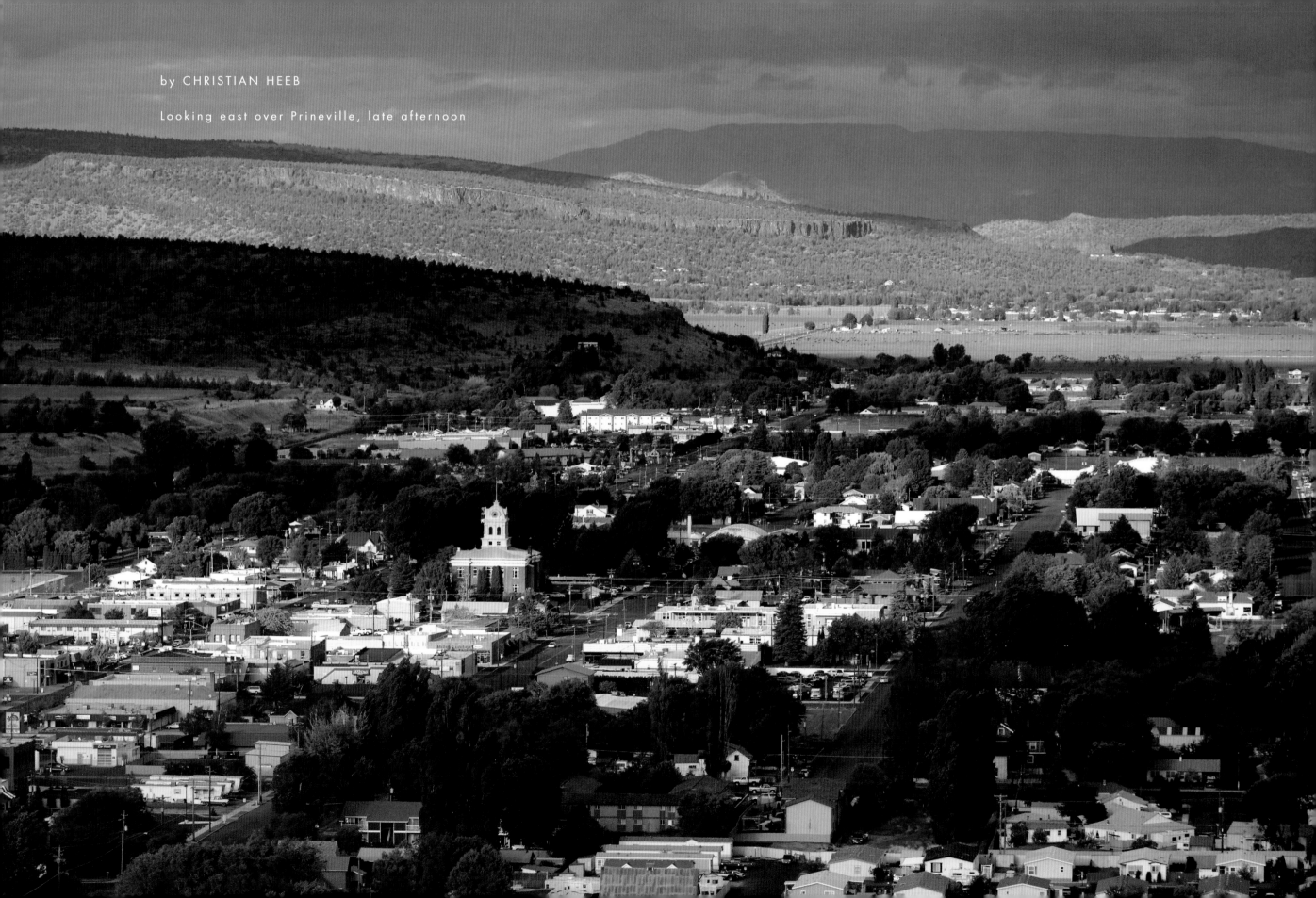

by CHRISTIAN HEEB

Looking east over Prineville, late afternoon

by JIM YUSKAVITCH

Branded

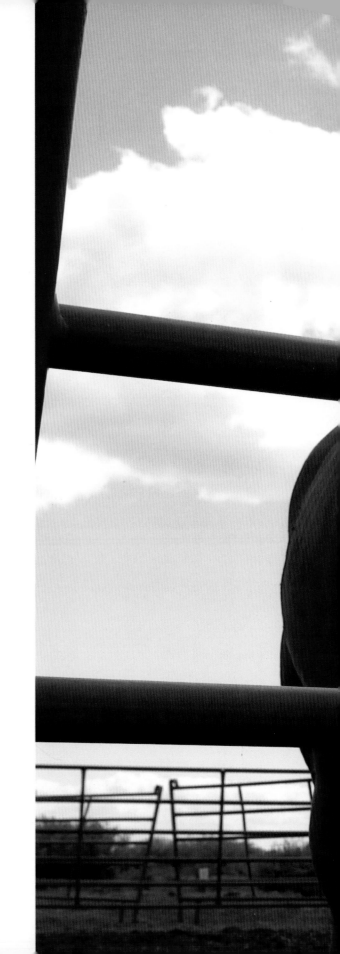

by ZACH SCOTT

Thanks for the snack: Olivia Denton feeds
a new friend at Sunriver Stables

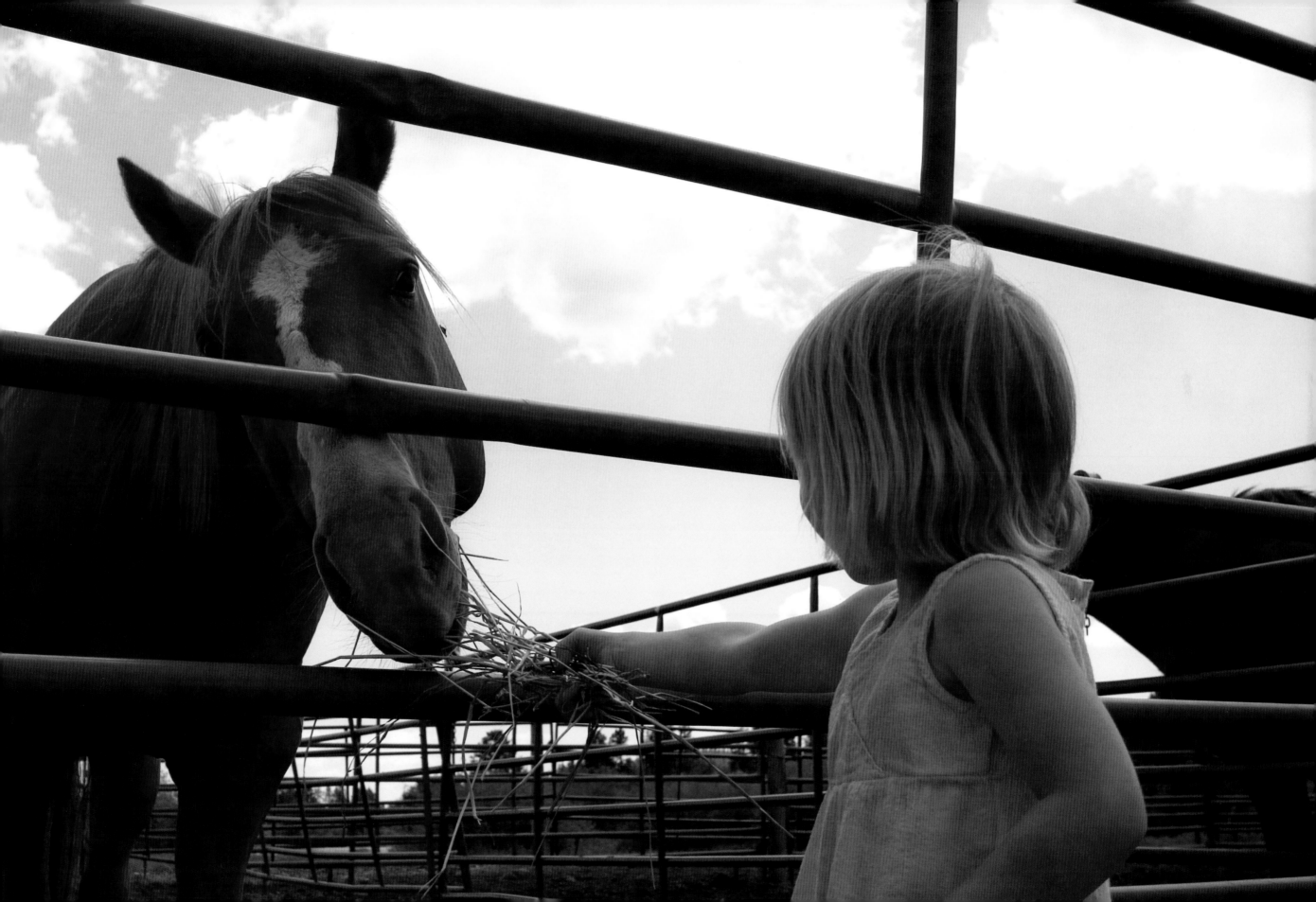

by CHRISTIAN HEEB

Farrier Terry Shelly shoes horses west of Bend

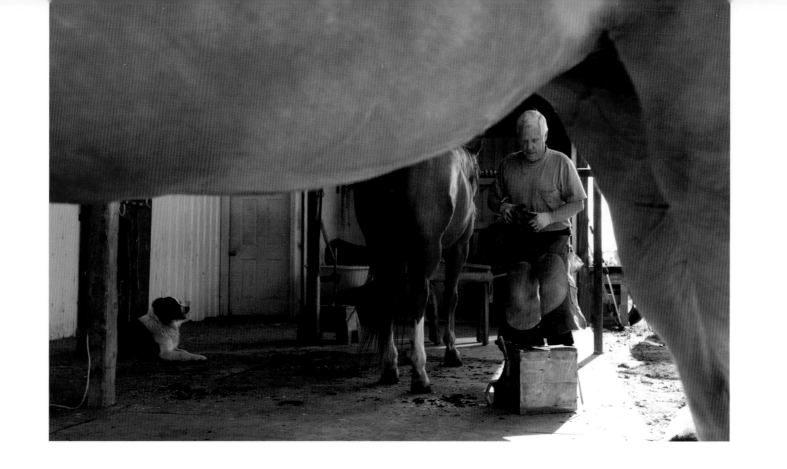
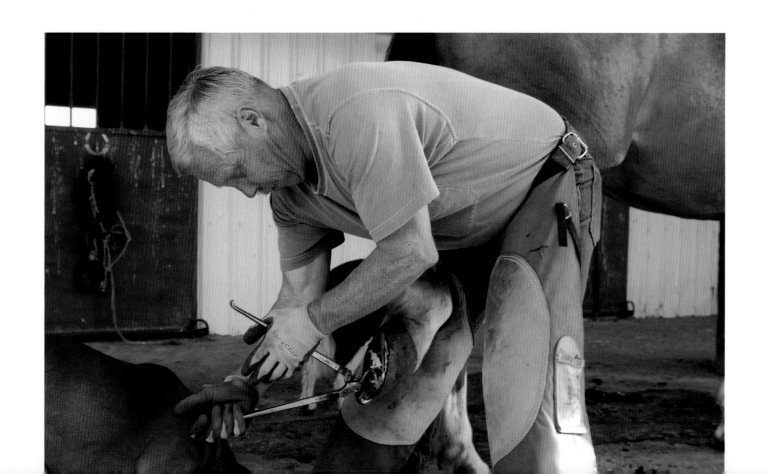

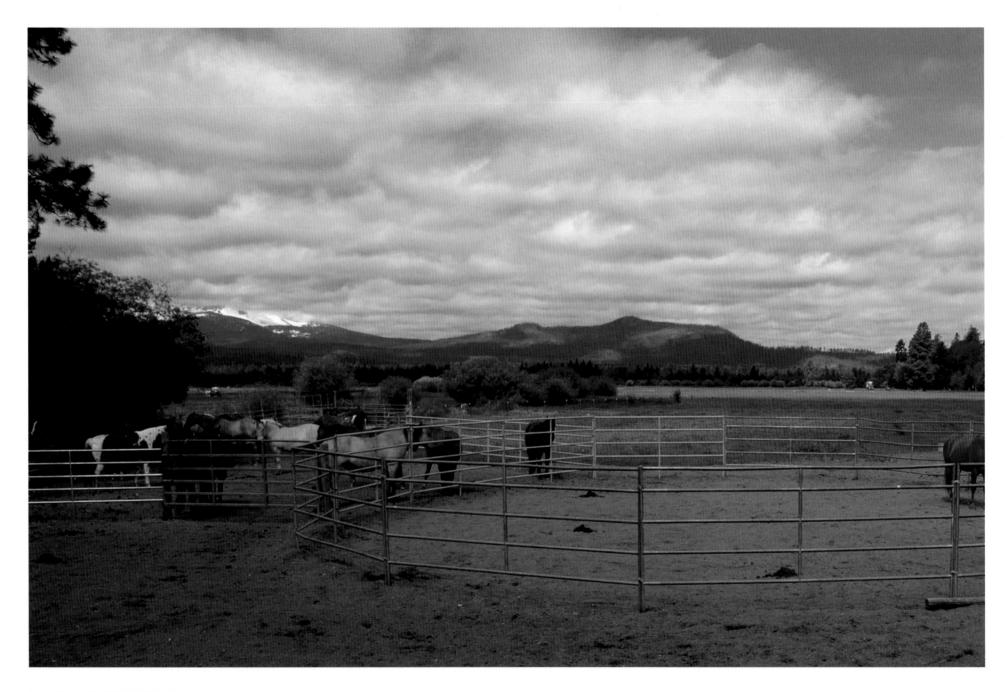

by JIM YUSKAVITCH

Ready to ride, Black Butte Stables, near Sisters

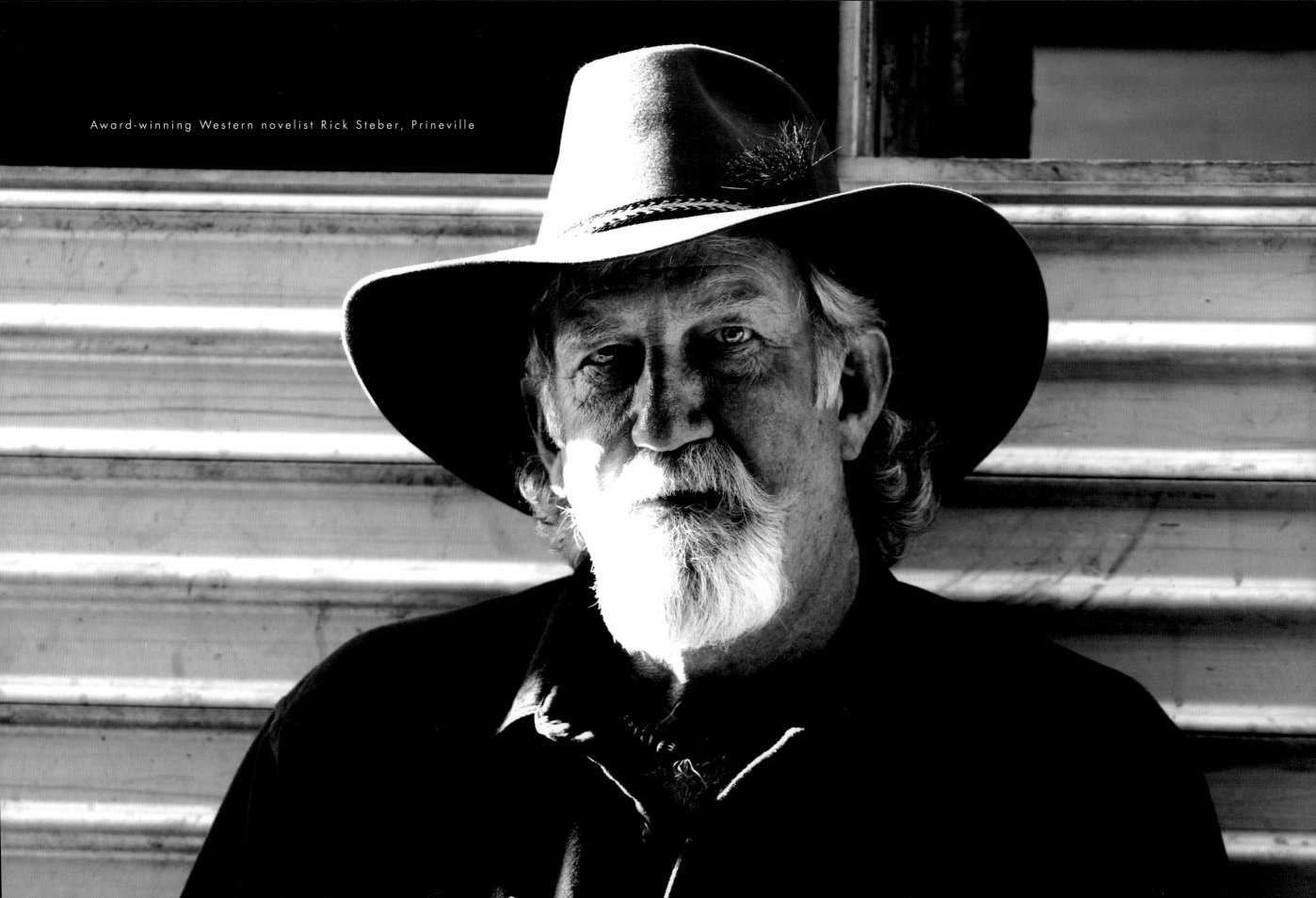

Award-winning Western novelist Rick Steber, Prineville

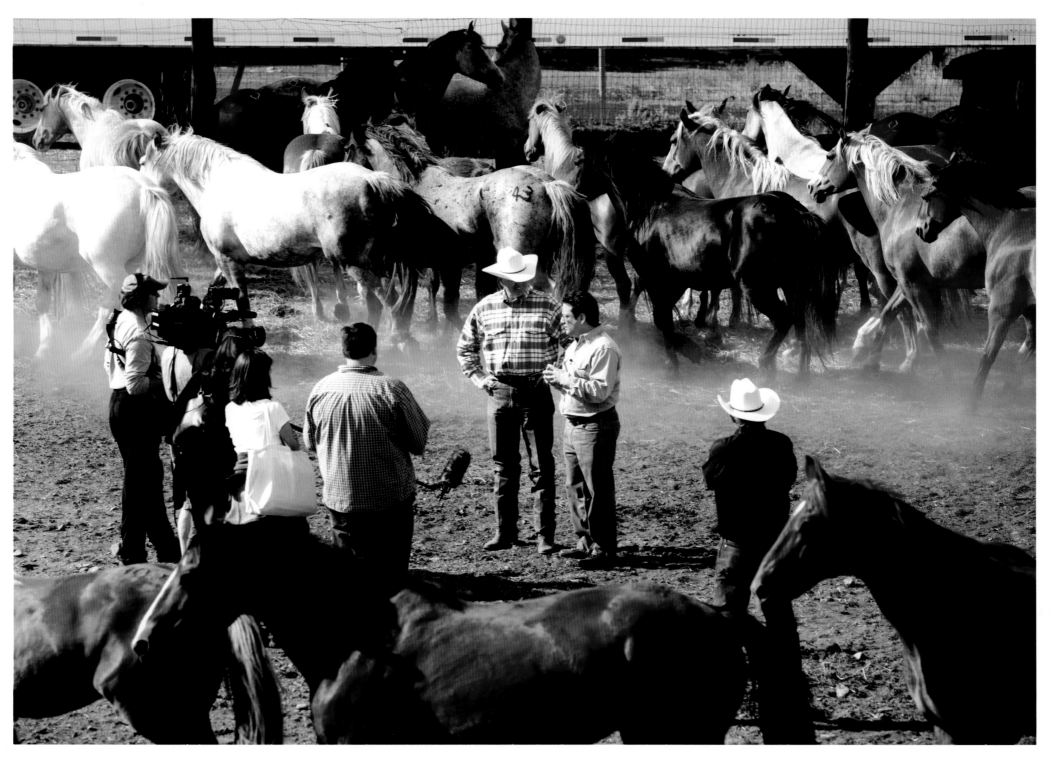

by HADLEY McCANN

A CBS Television crew interviews the buckaroos at the Sisters Rodeo

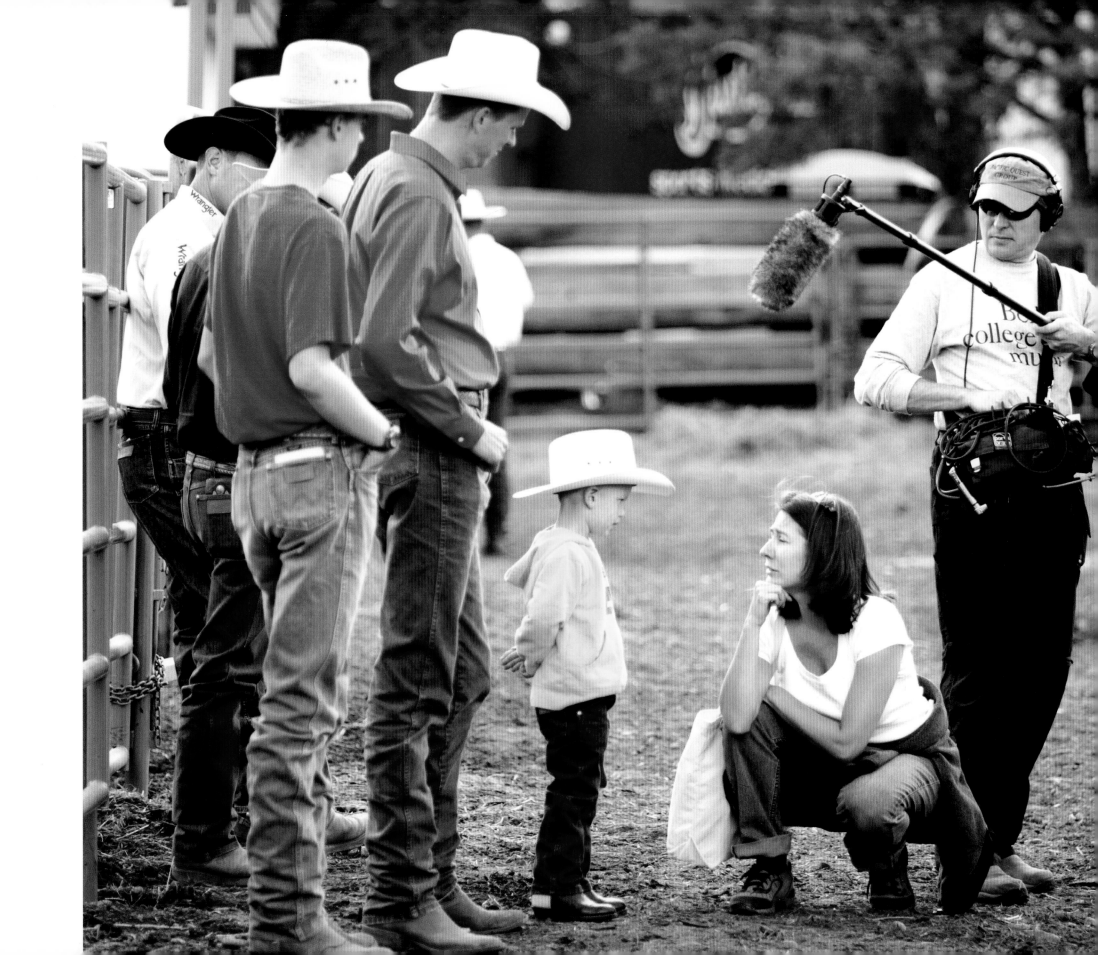

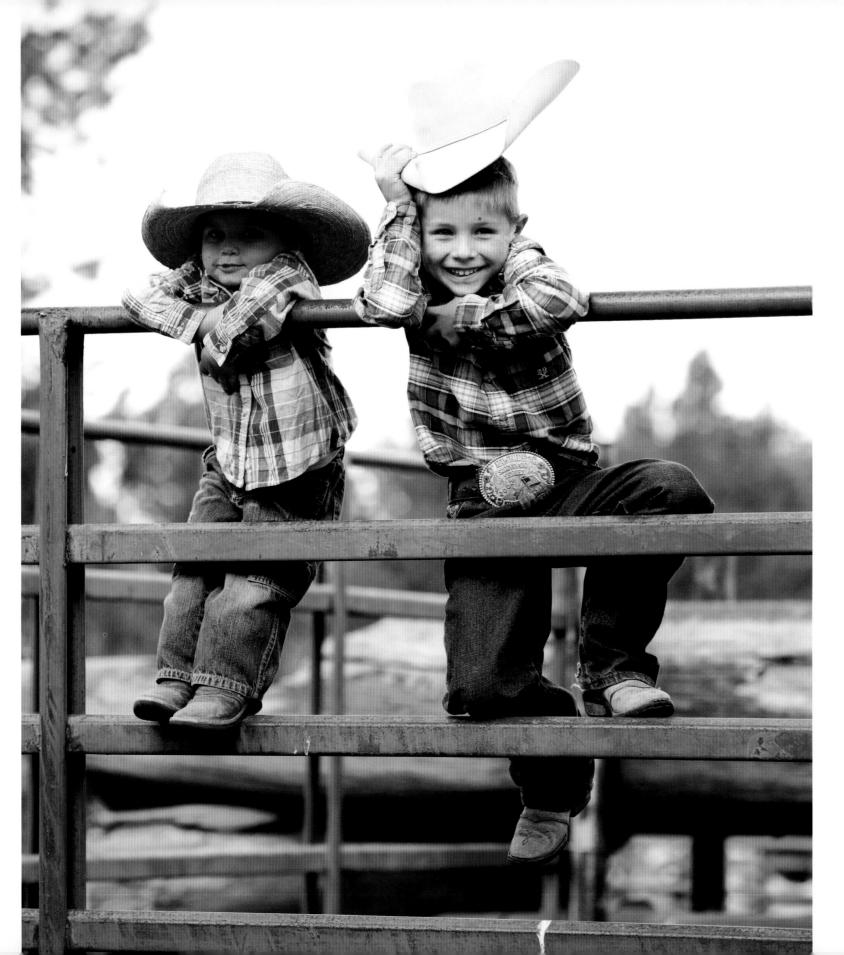

by HADLEY McCANN

LEFT:

Future rodeo stars J.C. and Jaxton Mortensen,
Sisters Rodeo

RIGHT:

Grand Entry, Sisters Rodeo

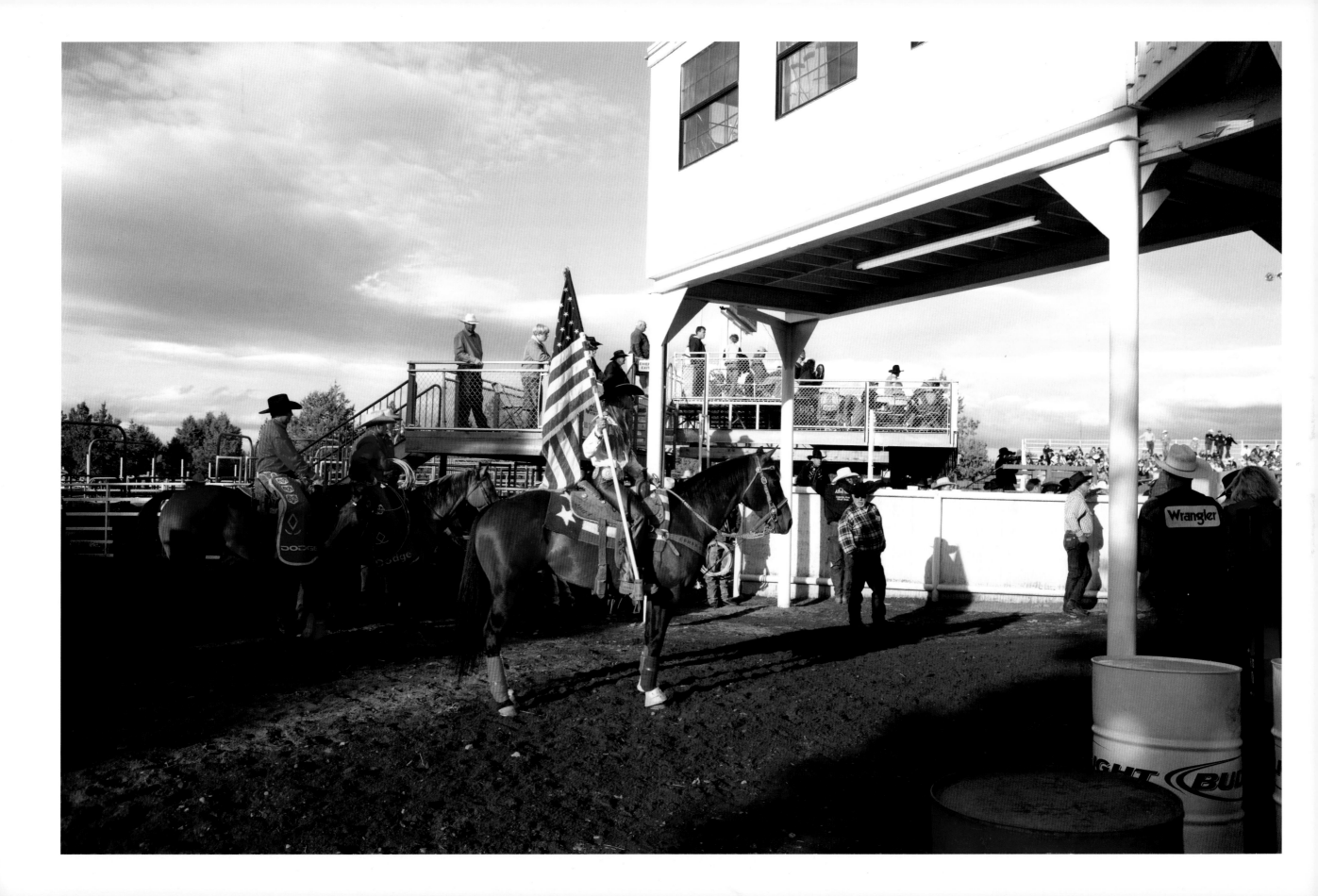

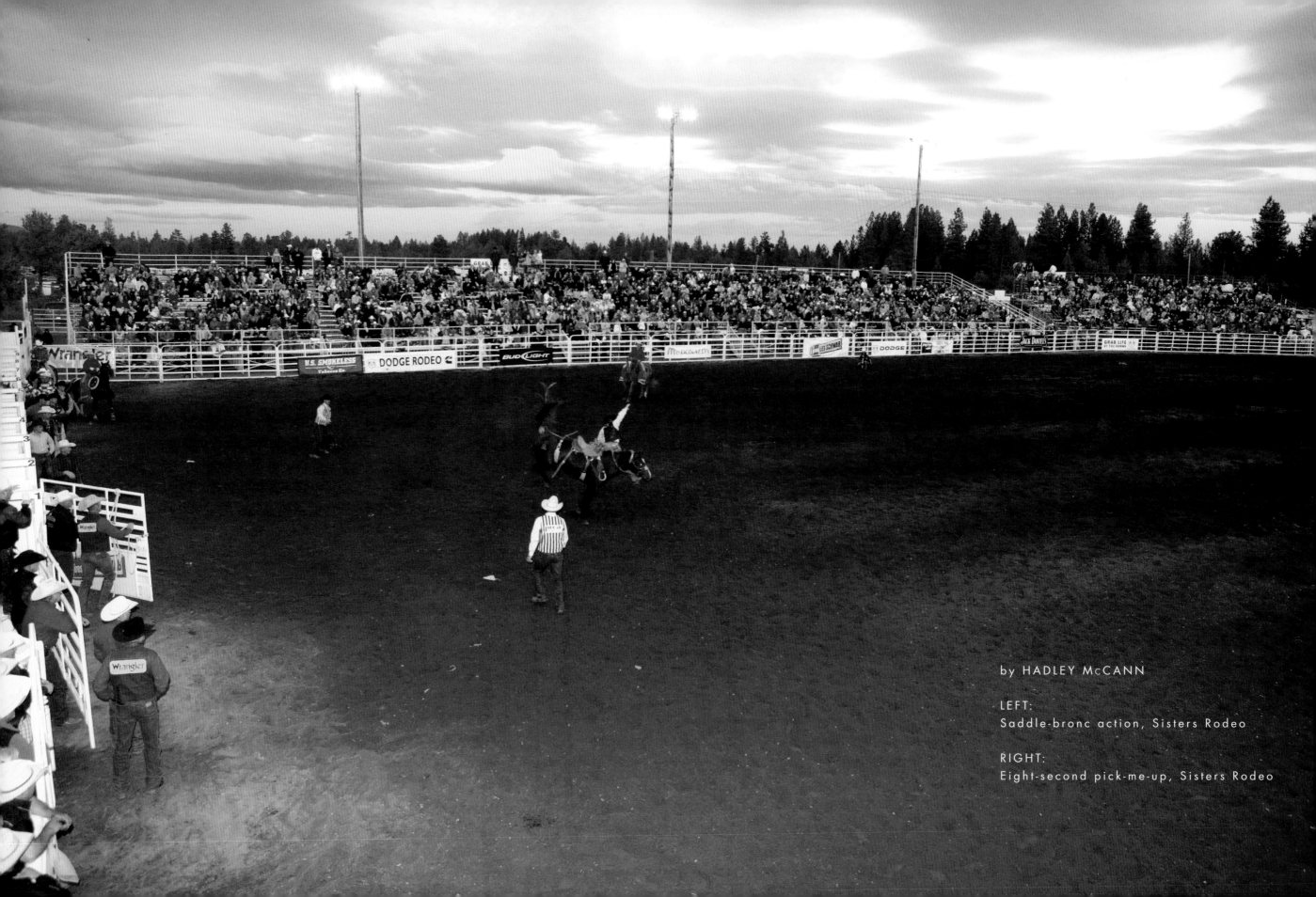

by HADLEY McCANN

LEFT:
Saddle-bronc action, Sisters Rodeo

RIGHT:
Eight-second pick-me-up, Sisters Rodeo

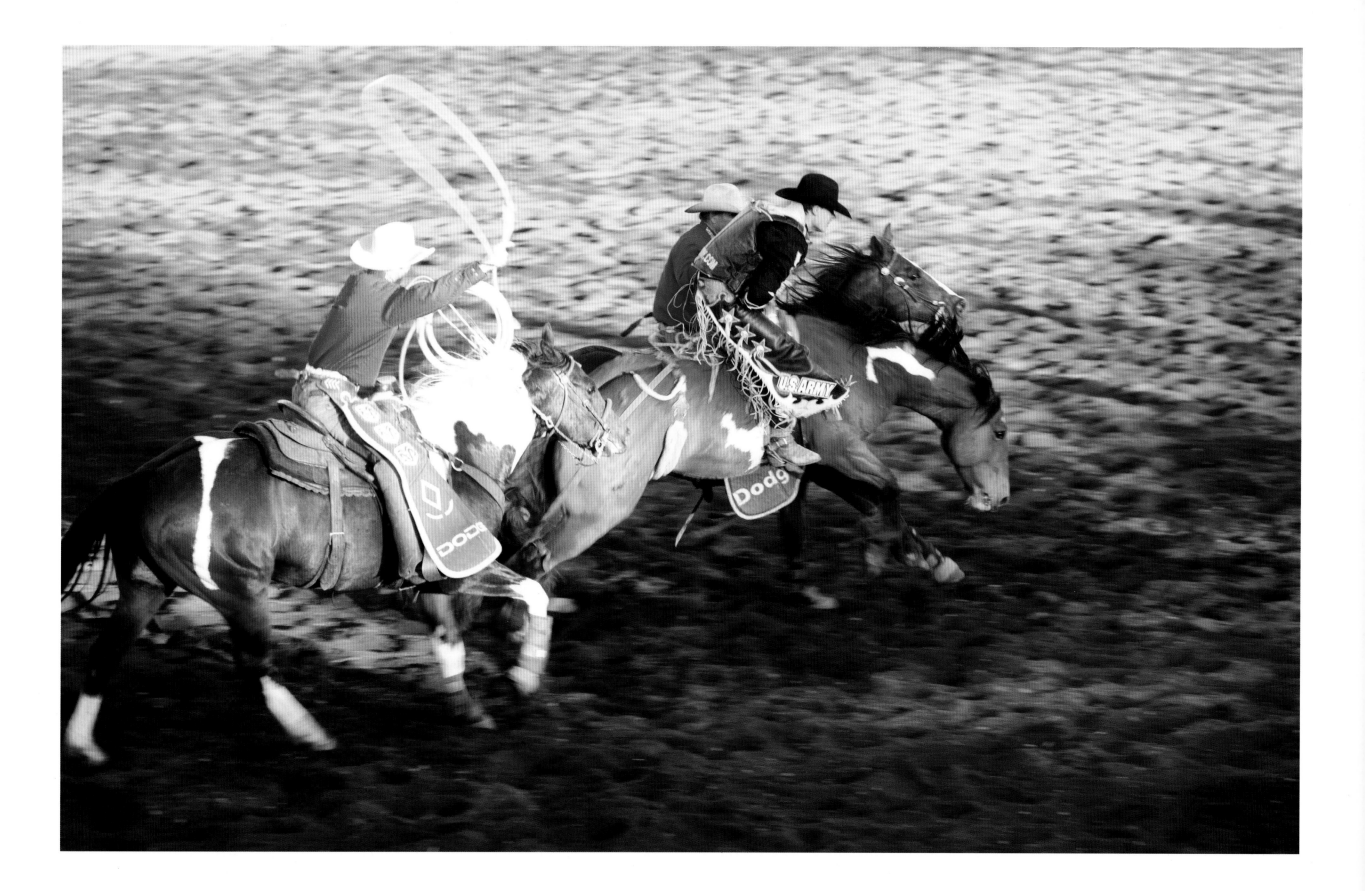

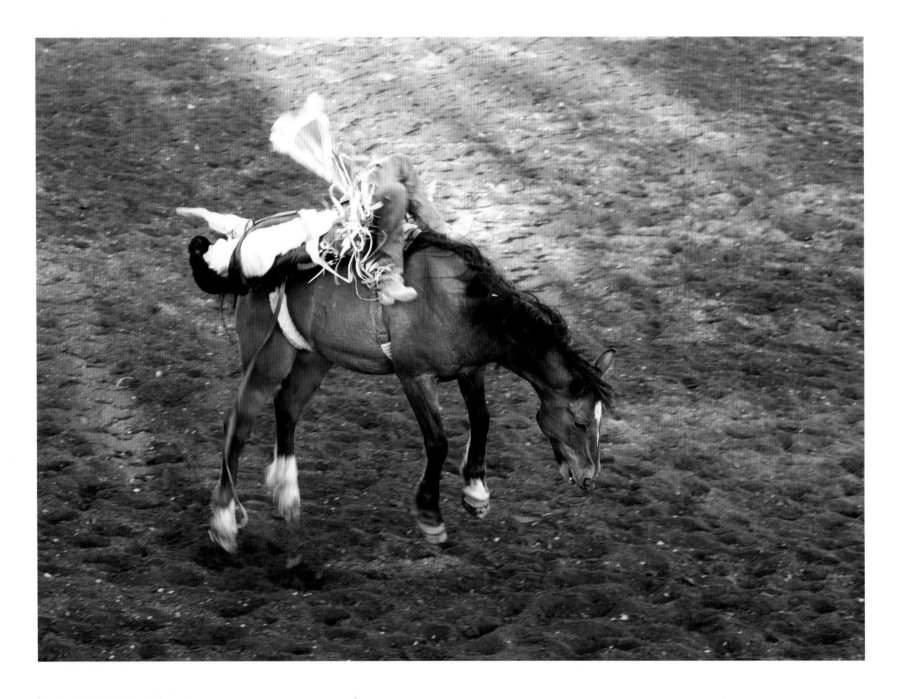

by HADLEY McCANN

Layin' down on the job, Sisters Rodeo

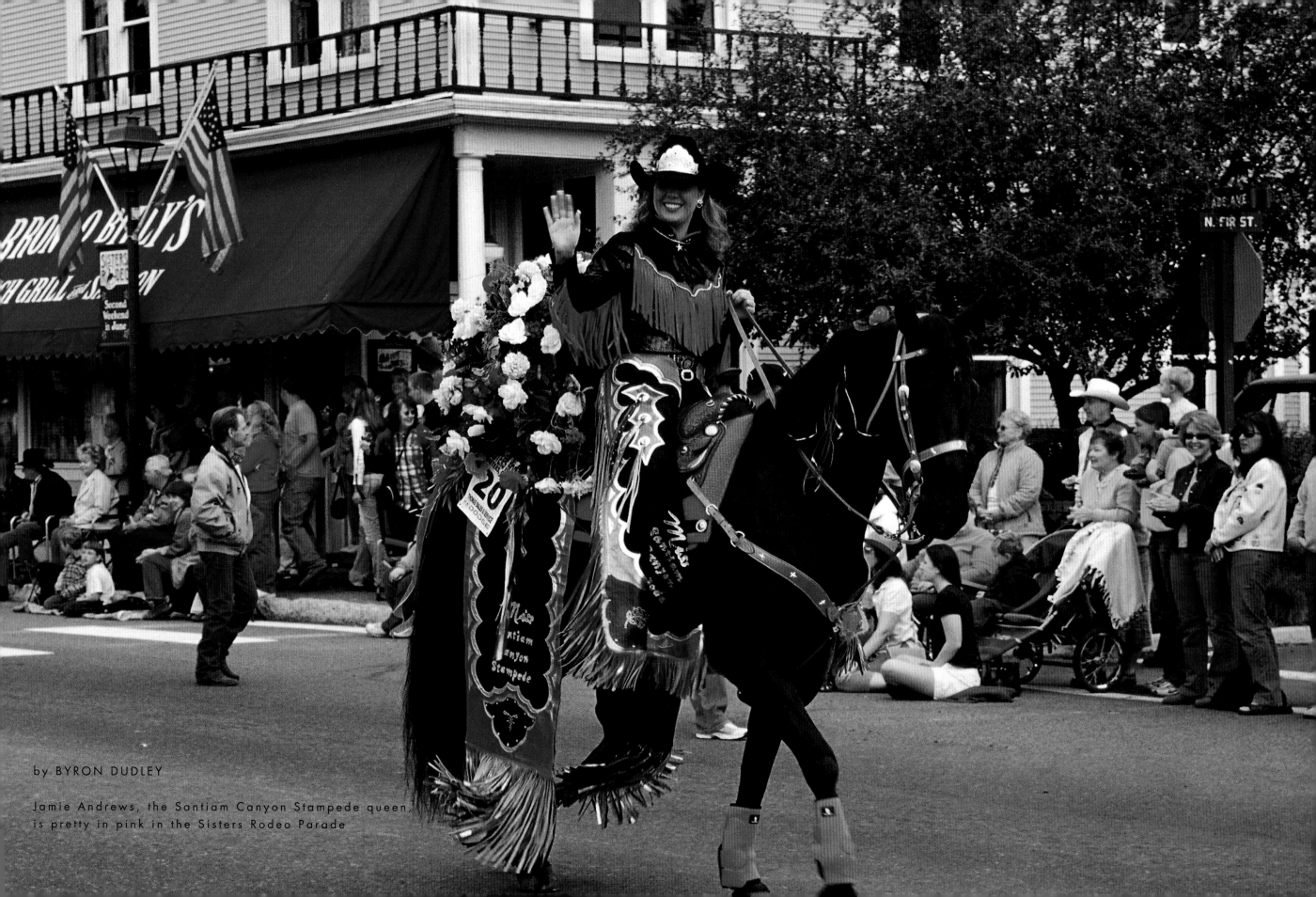

by BYRON DUDLEY

Jamie Andrews, the Santiam Canyon Stampede queen, is pretty in pink in the Sisters Rodeo Parade

by BYRON DUDLEY

Stars and Stripes forever at the Sisters Rodeo Parade

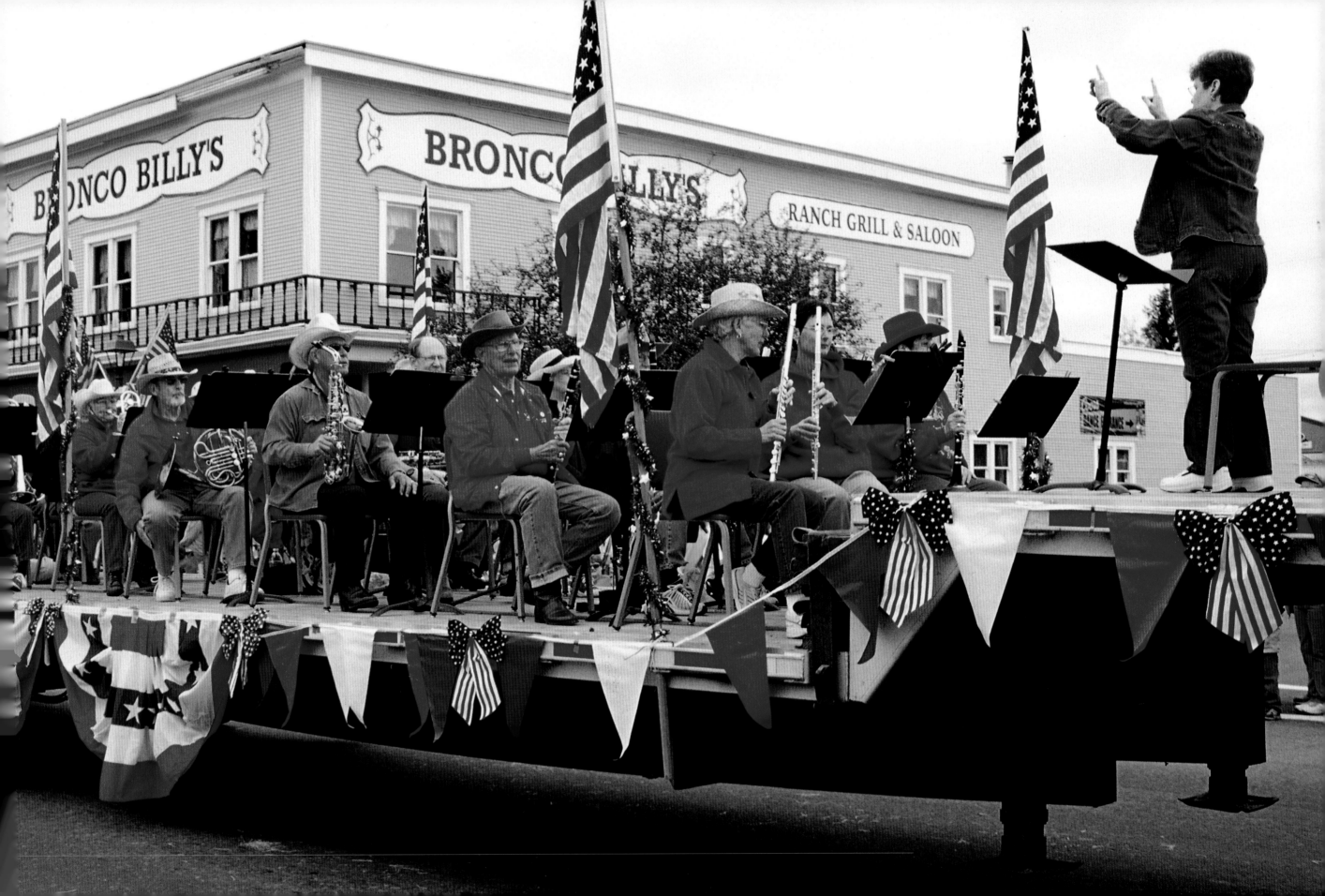

by BYRON DUDLEY

Sisters High School student Kevin Wistrom points to a home that will be
shipped to Mississippi to house Hurricane Katrina victims

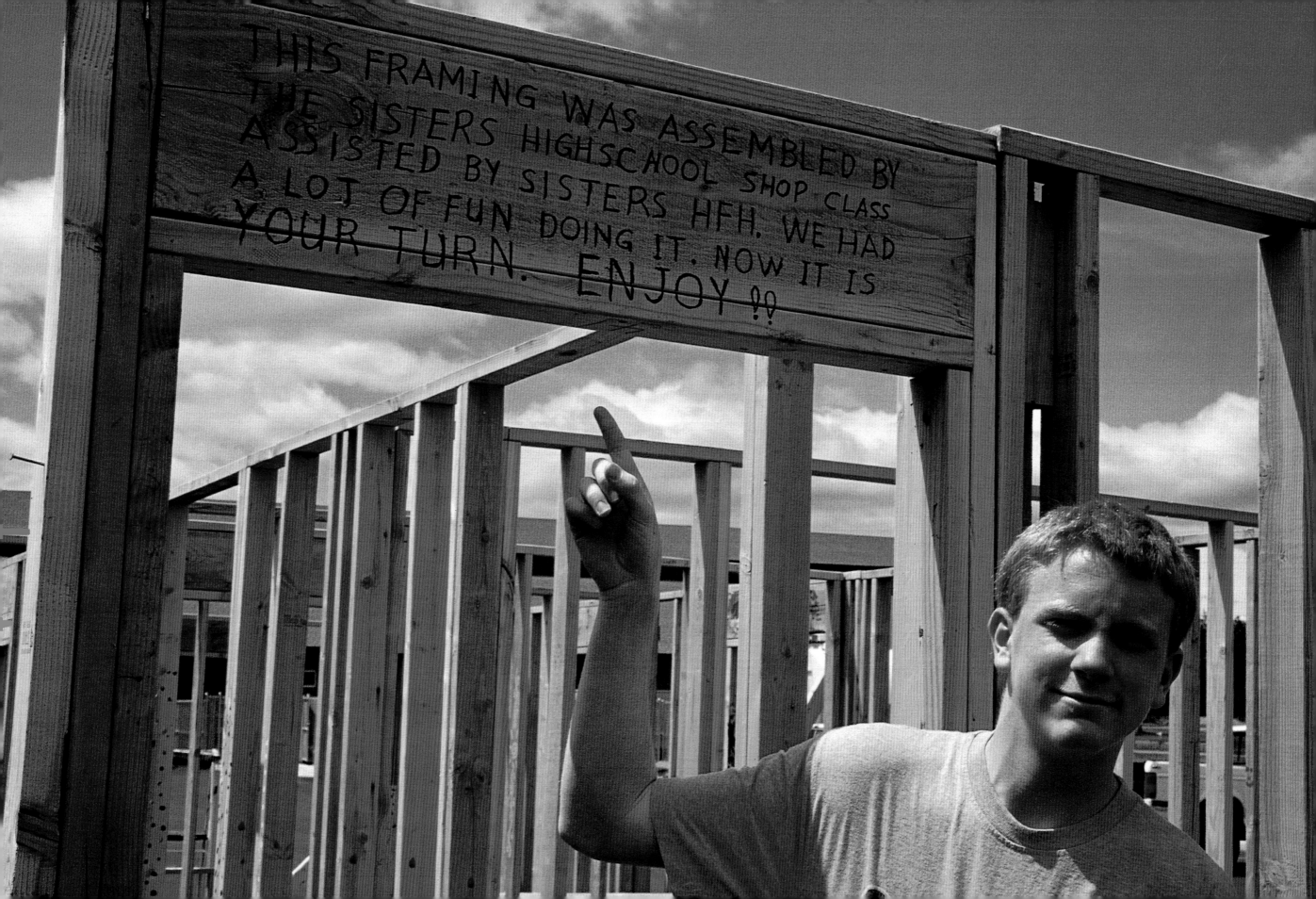

by BYRON DUDLEY

Contractors and students discuss the hurricane-relief project

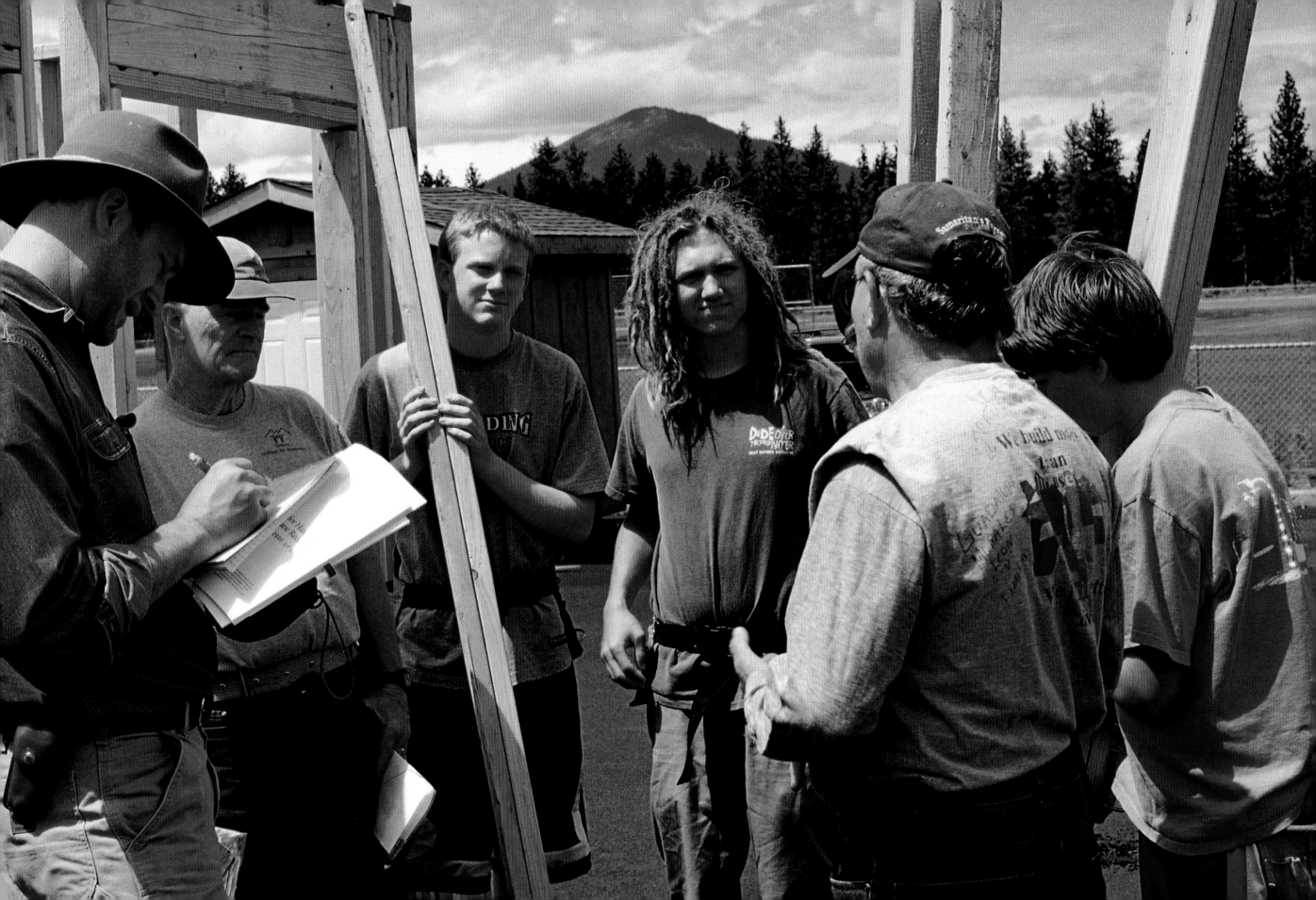

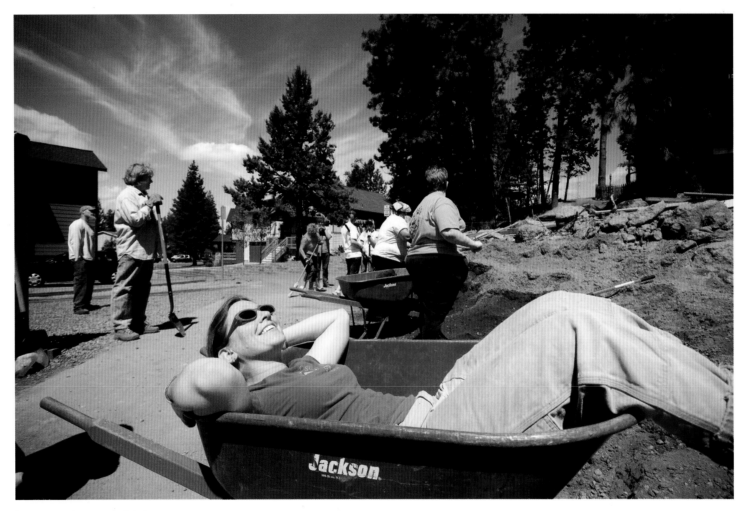

by KEVIN KUBOTA

A wheelbarrow bed lures one woman to snag a few rays during
a rest break from work for Habitat for Humanity in Bend.

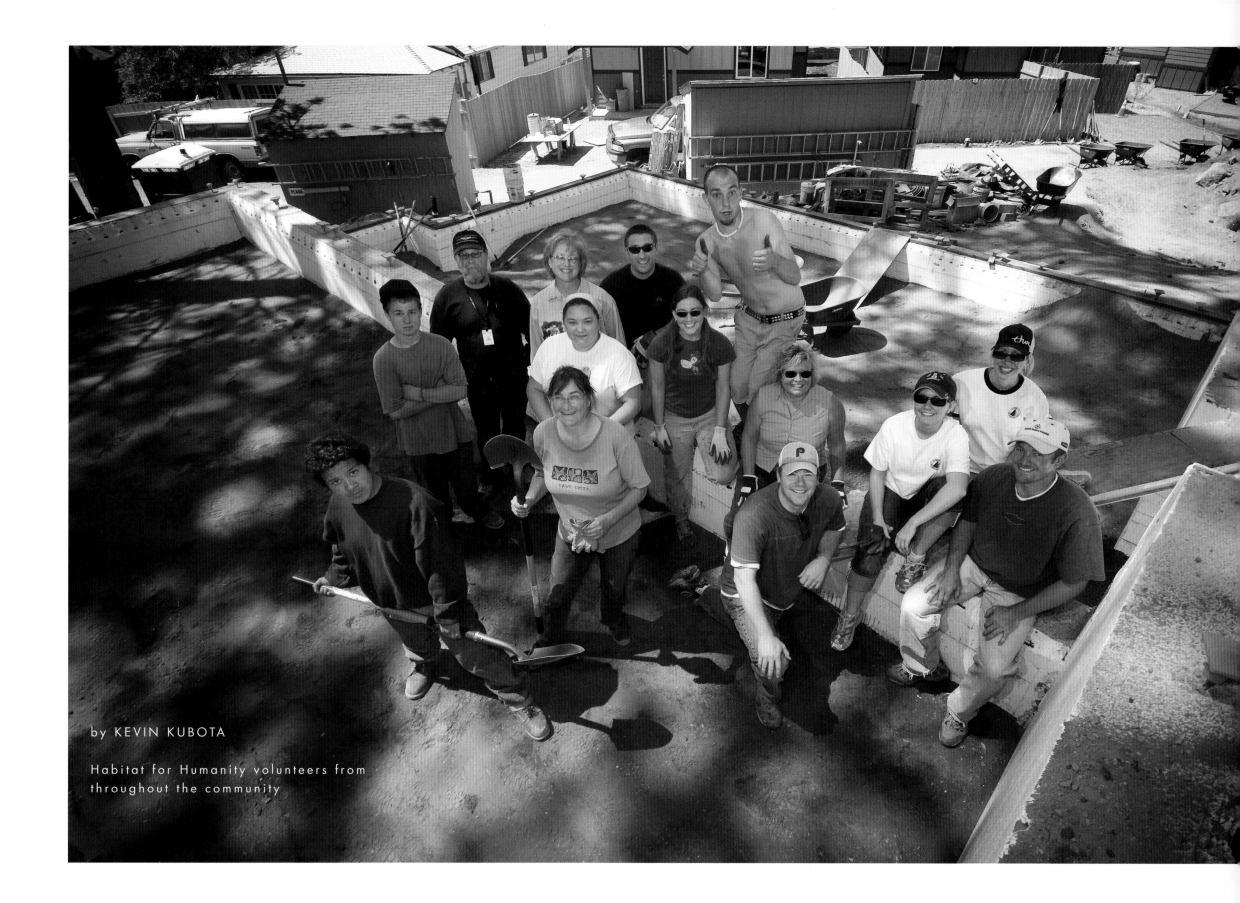

by KEVIN KUBOTA

Habitat for Humanity volunteers from
throughout the community

by BOB WOODWARD

LEFT:
Trail work is a dirty job for volunteer Paul Thomasberg

RIGHT:
Work party, Central Oregon Trail Alliance

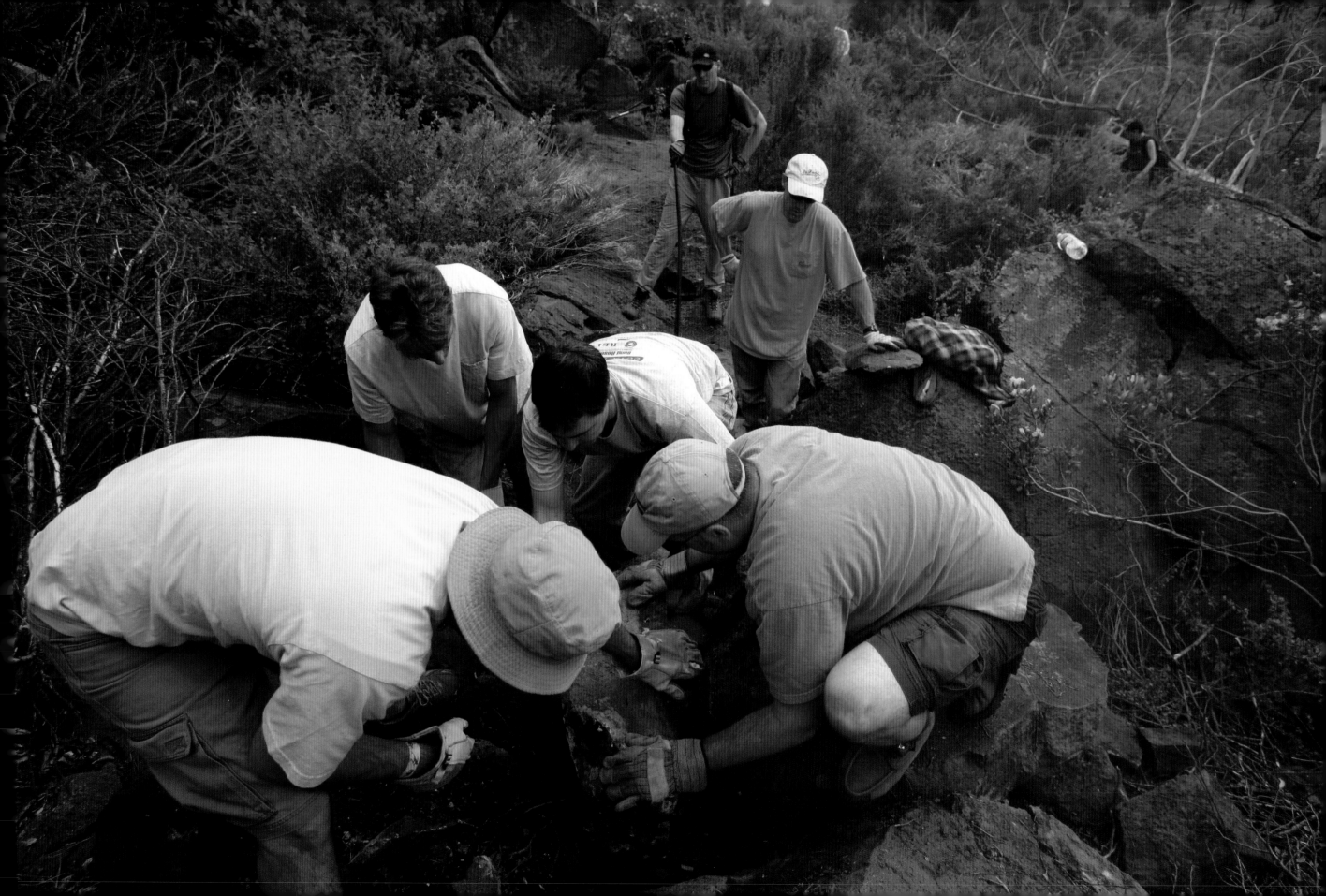

by RIC ERGENBRIGHT

"Take me home!"

by RIC ERGENBRIGHT

Adoption day, Humane Society of Central Oregon

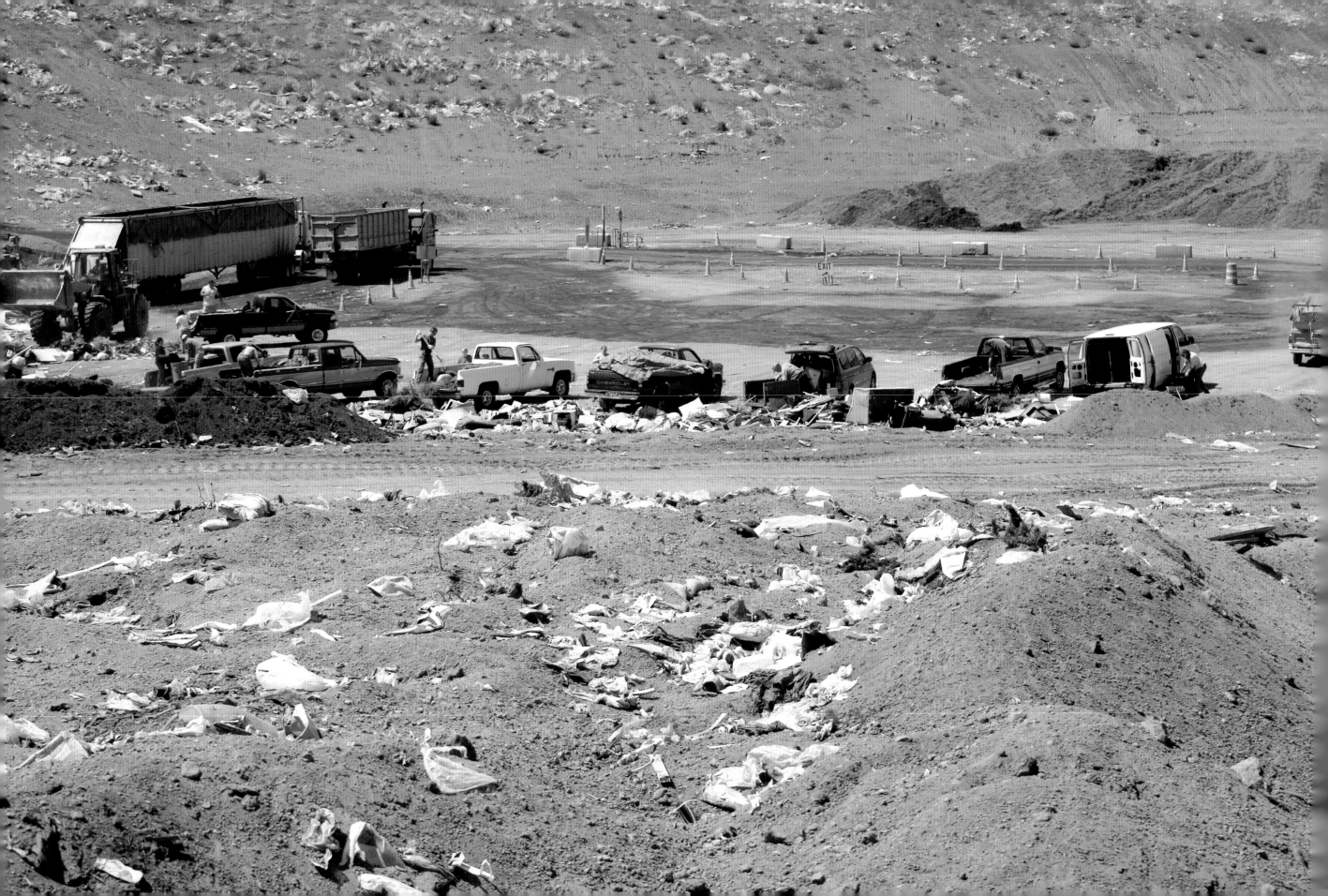

LEFT:

by RIC ERGENBRIGHT
Knott Landfill, Saturday morning

RIGHT:

by ROBERT AGLI
Refuse to lose: Todd Doran
gets ready for an early-morning
garbage run

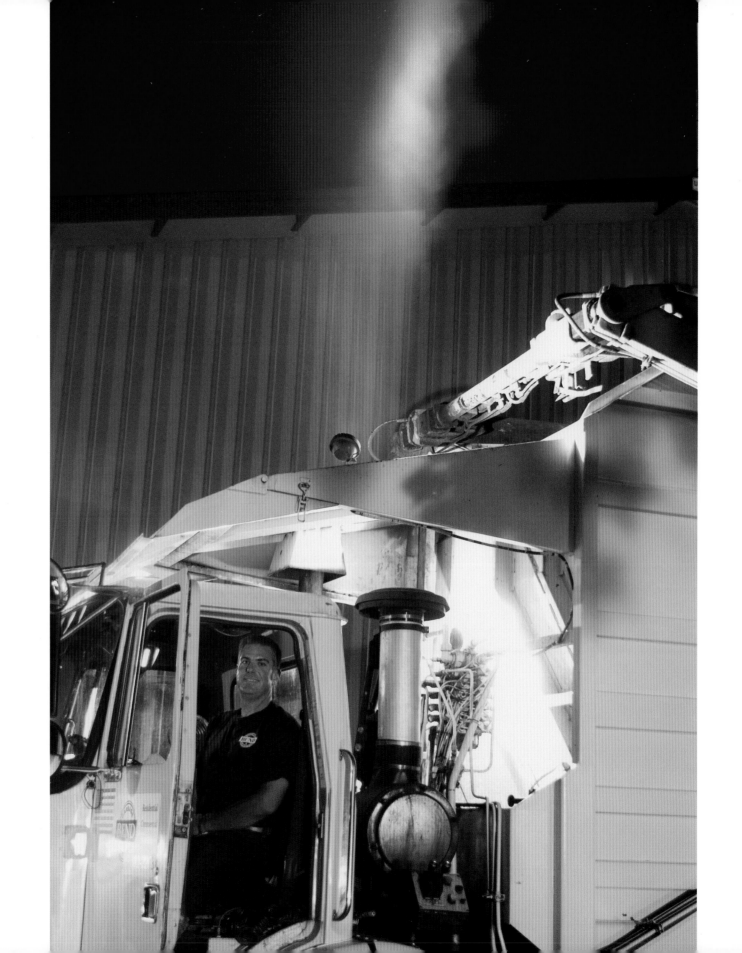

by CAROL STERNKOPF

Graduation day for Bend Senior High School

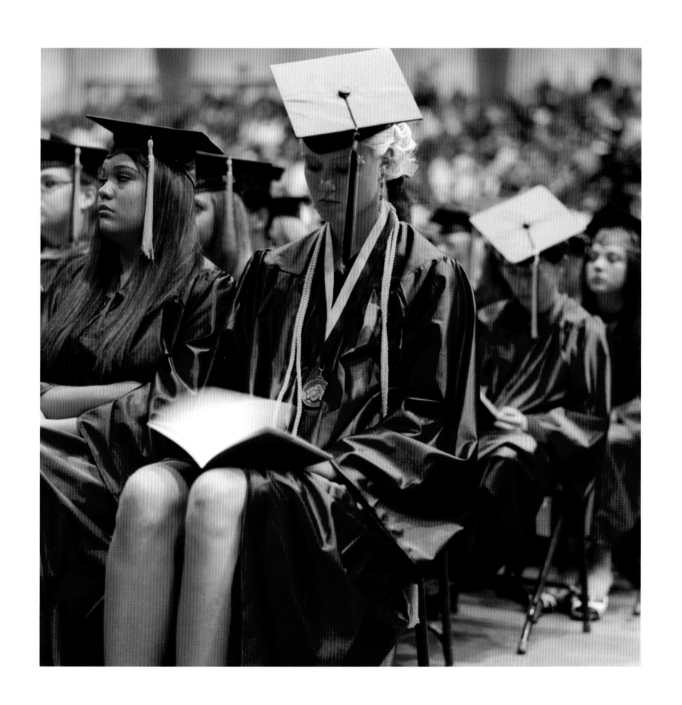

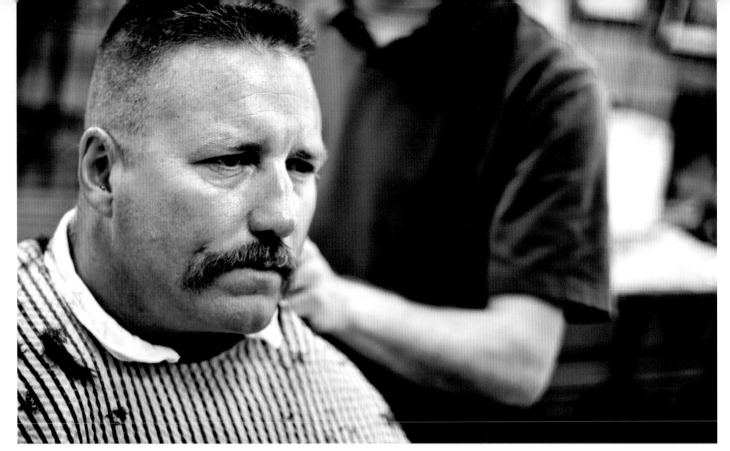

by JEFF KENNEDY

Jeff Hancock gets a flattop, Bond Street Barber Shop

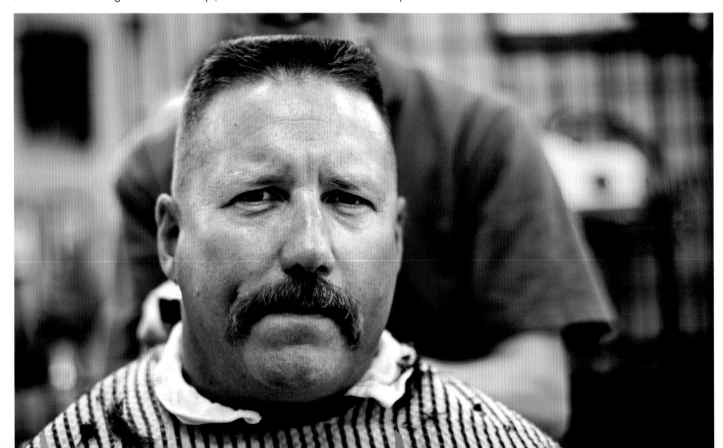

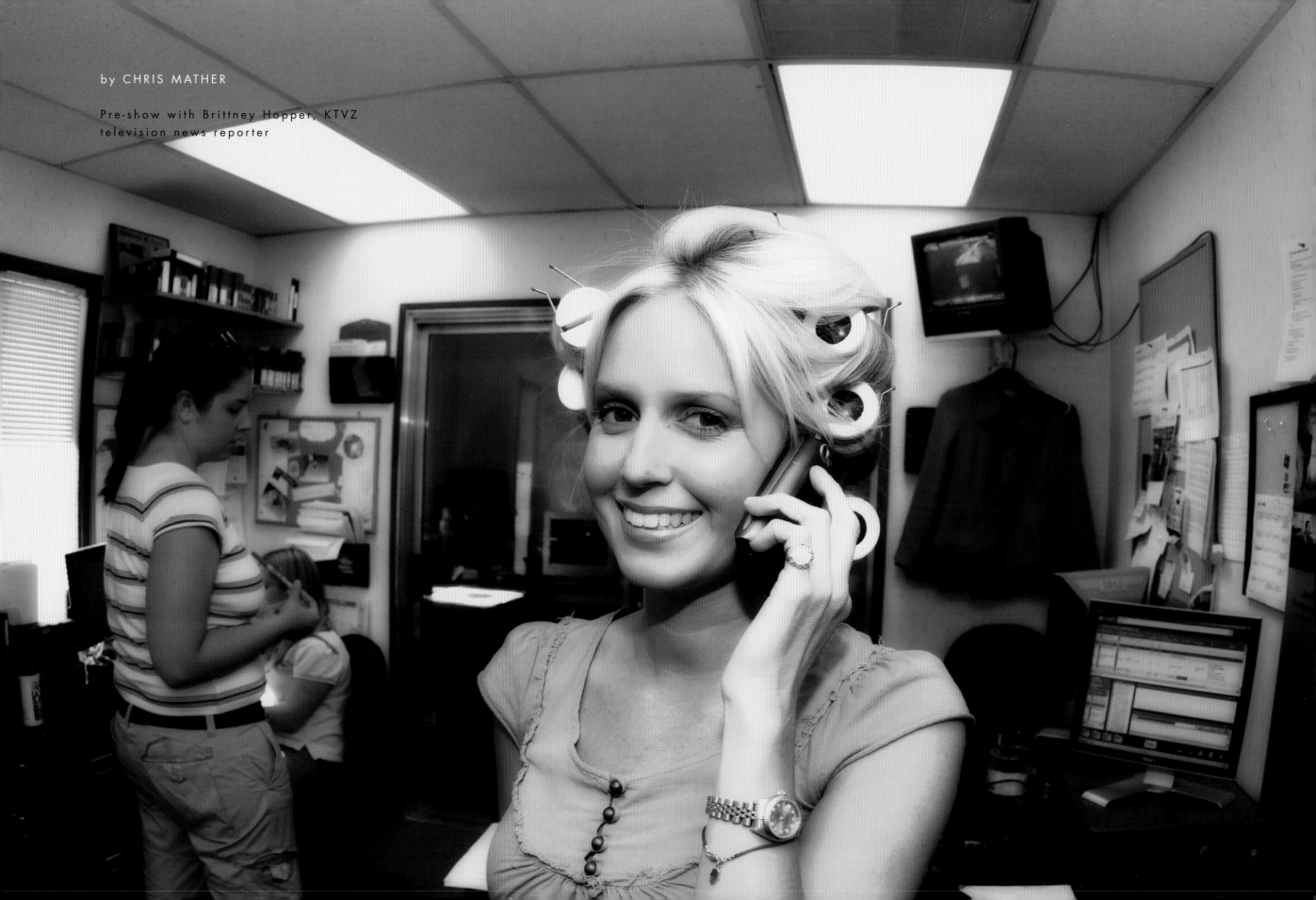

by CHRIS MATHER

Pre-show with Brittney Hopper, KTVZ
television news reporter

by JEFF KENNEDY

The Post Office delivers: Bob Warrenburg on his morning route

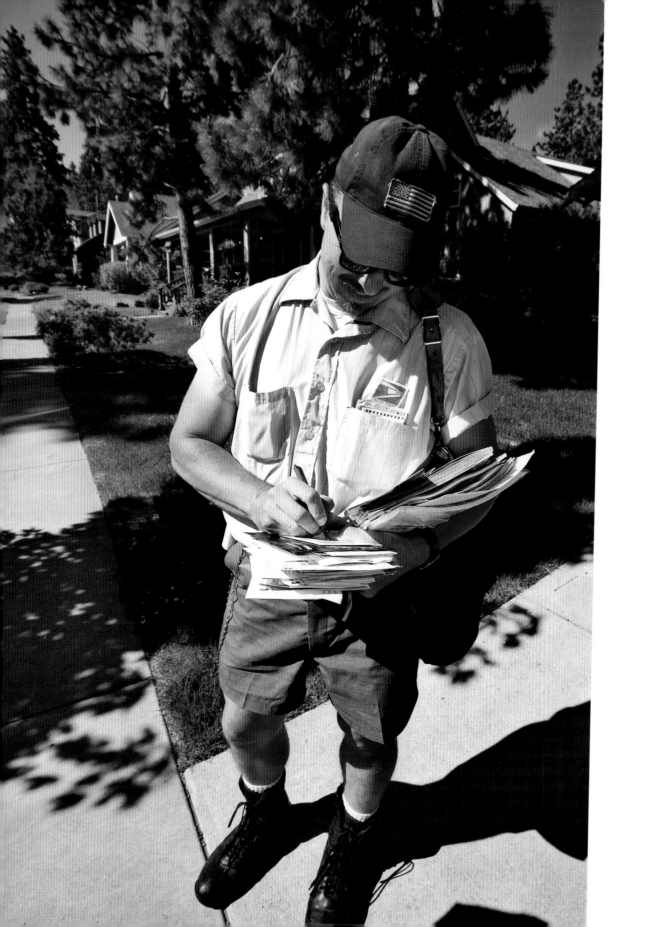
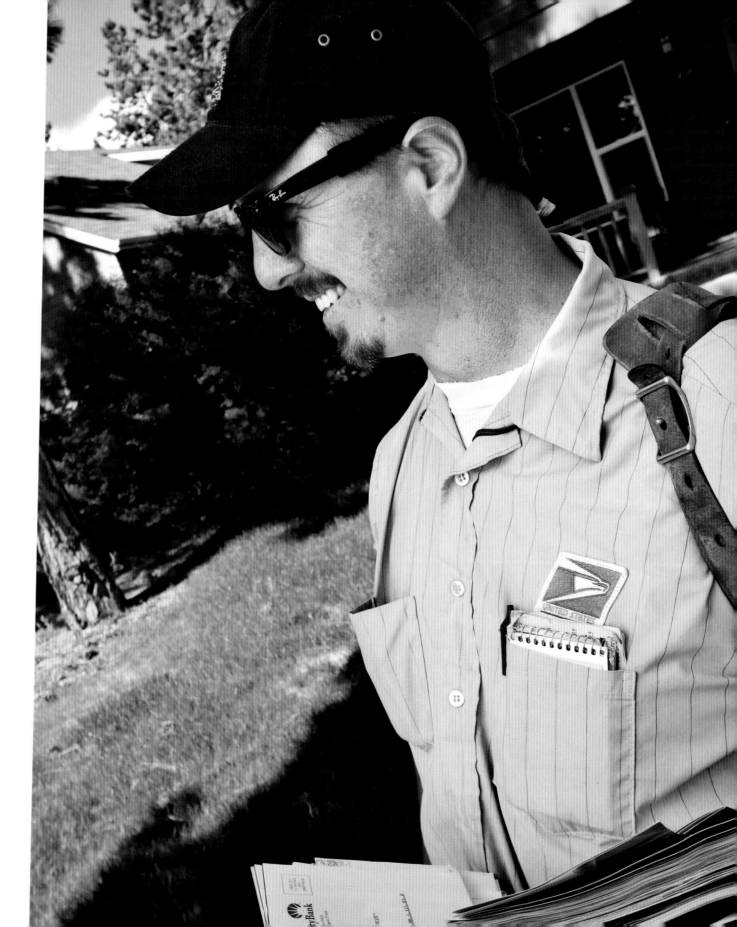

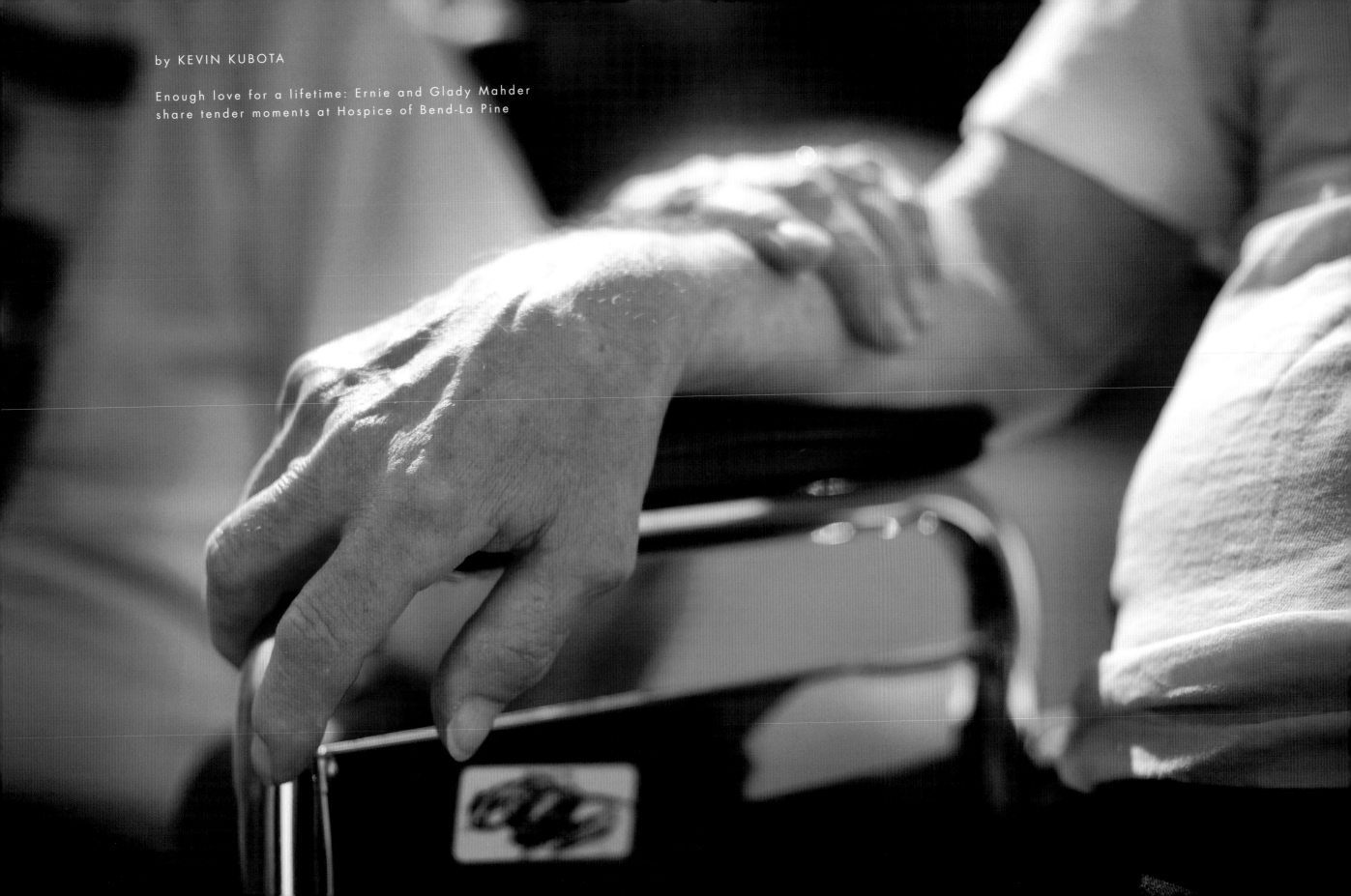

by KEVIN KUBOTA

Enough love for a lifetime: Ernie and Glady Mahder
share tender moments at Hospice of Bend-La Pine

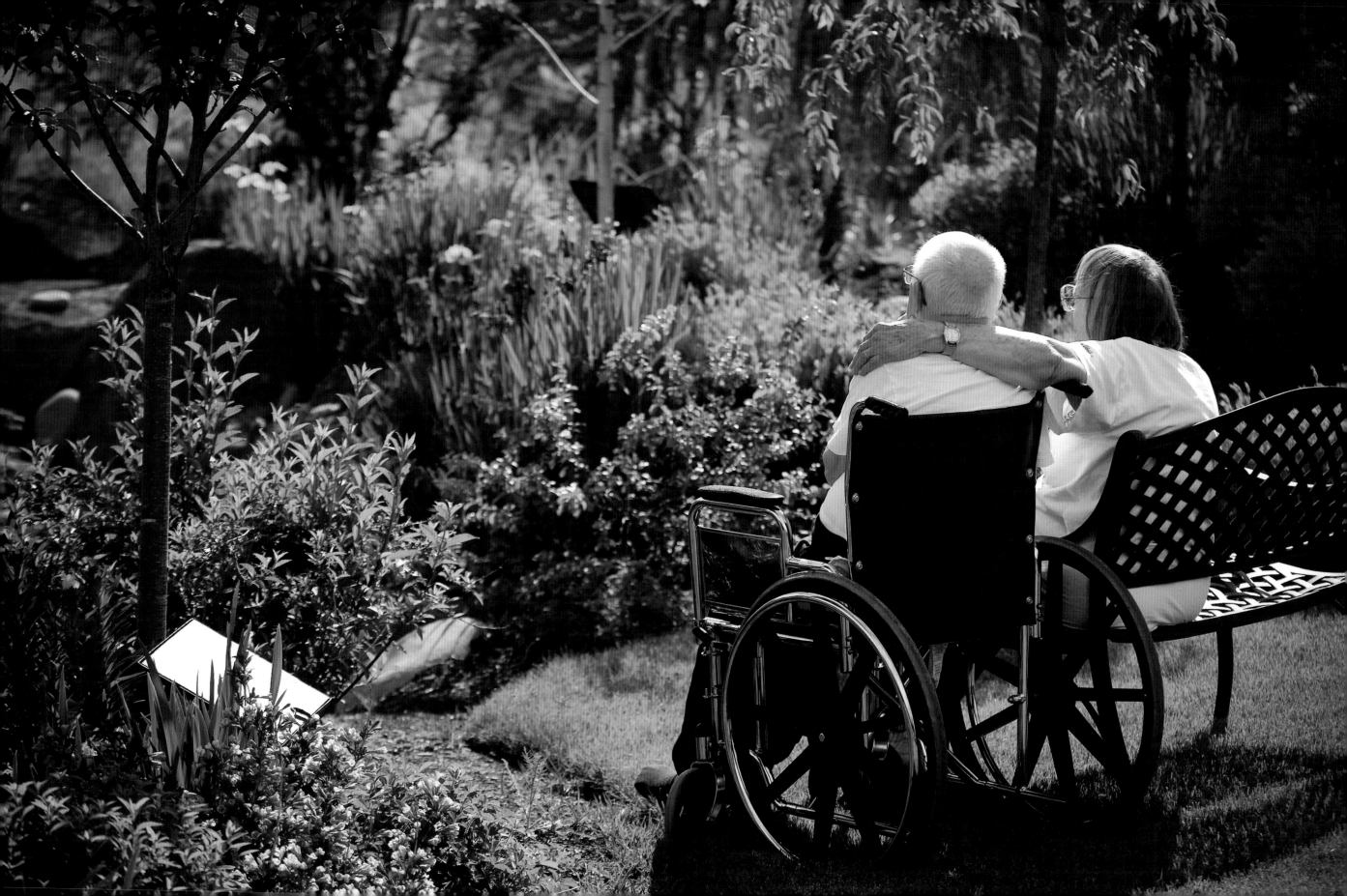

by KEVIN KUBOTA

Deschutes County Sheriff Les Stiles goes cruising on the parkway in his 1964½ Ford Mustang convertible

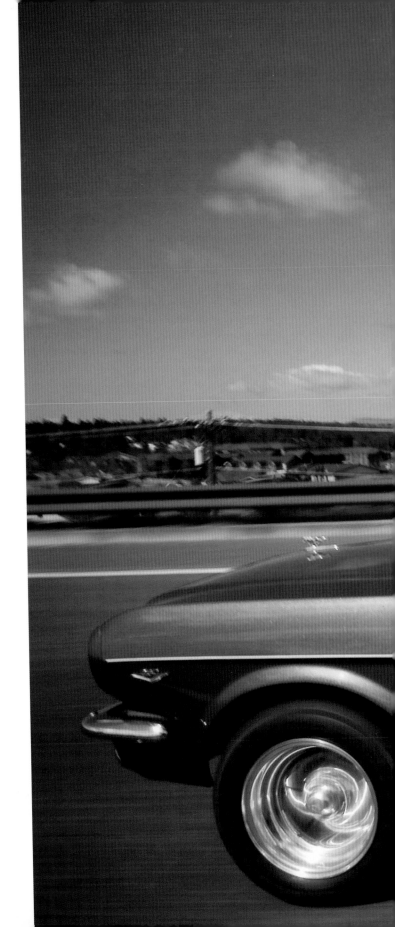

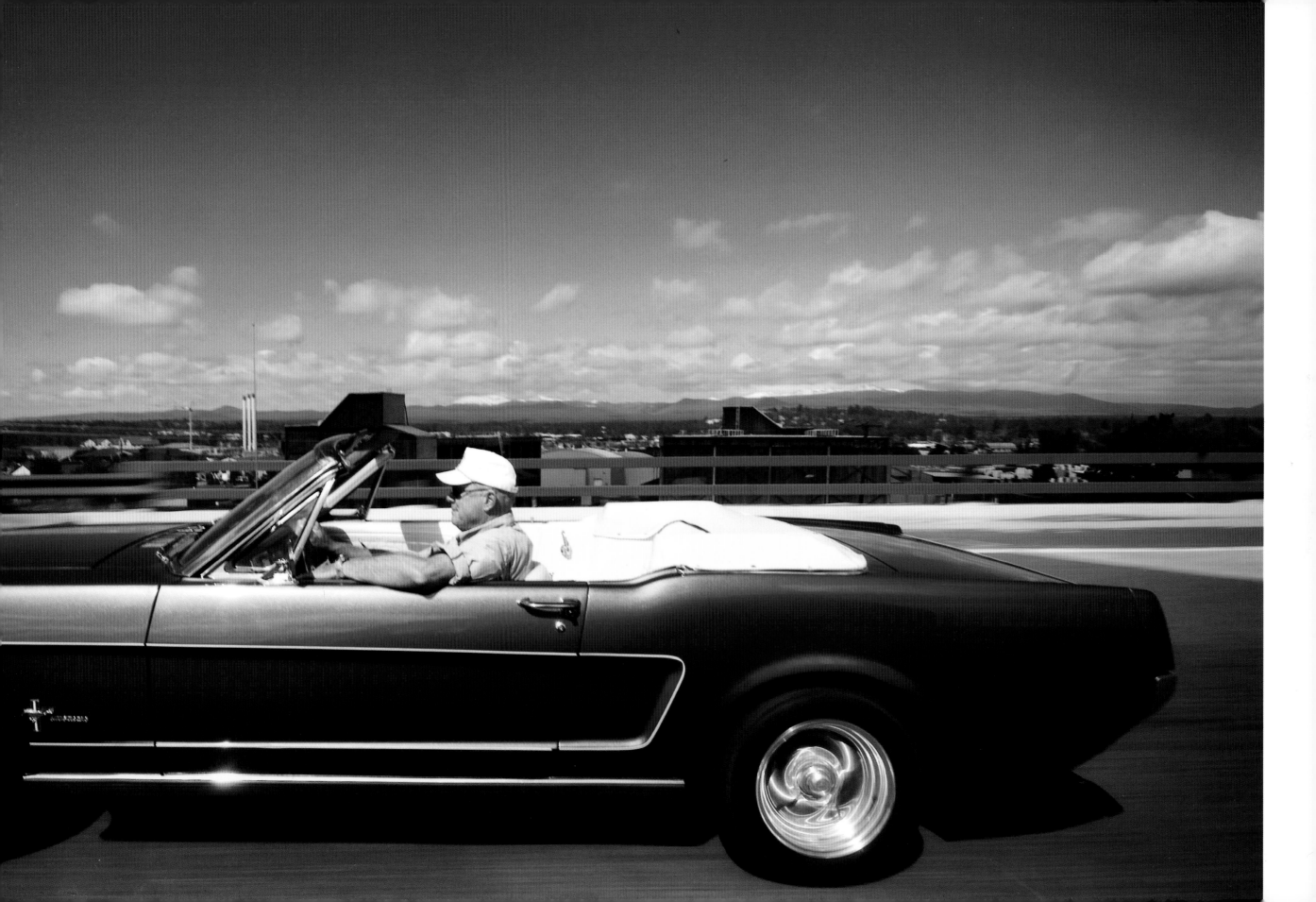

by CHRIS MATHER

Studio interior, KTVZ News Channel 21, Bend

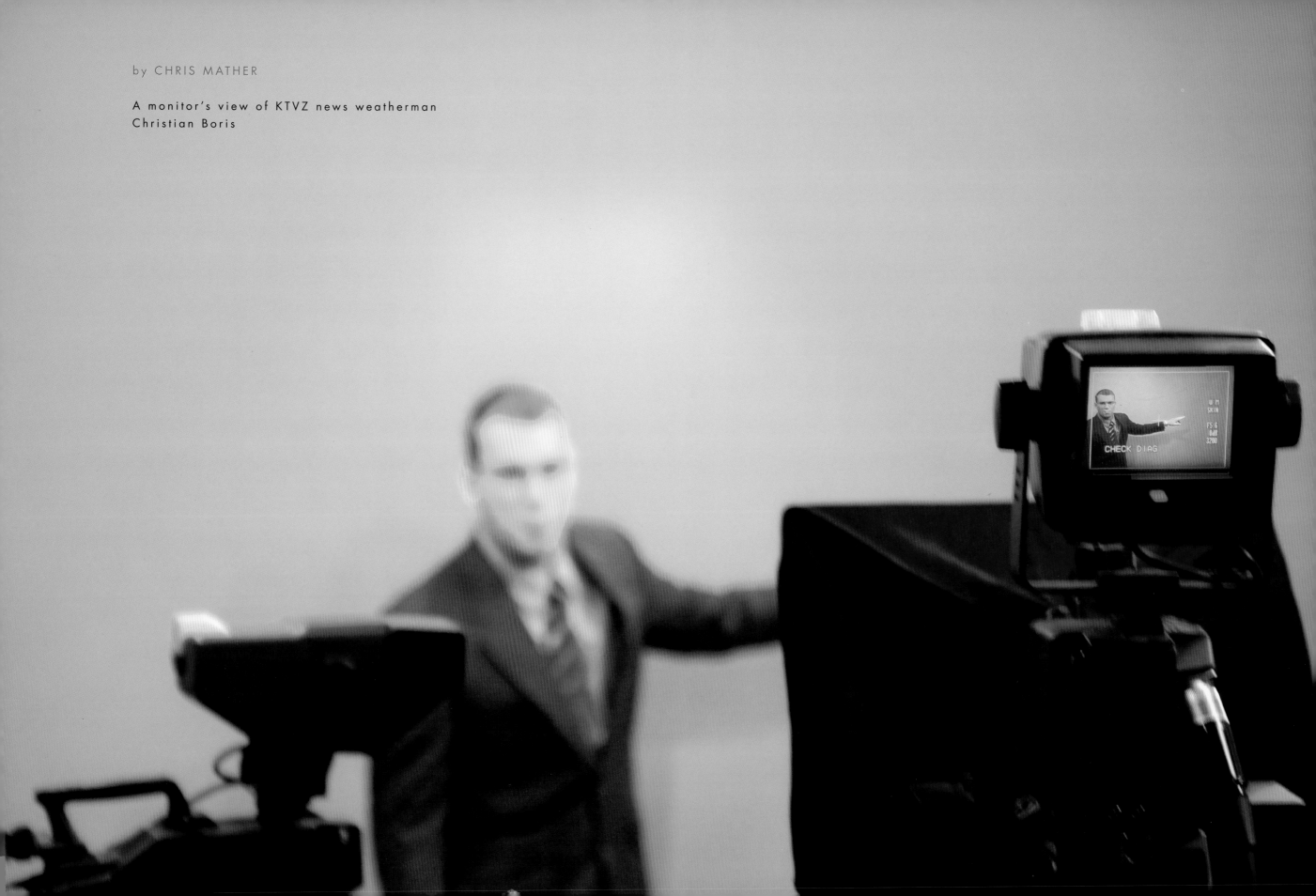

by CHRIS MATHER

A monitor's view of KTVZ news weatherman
Christian Boris

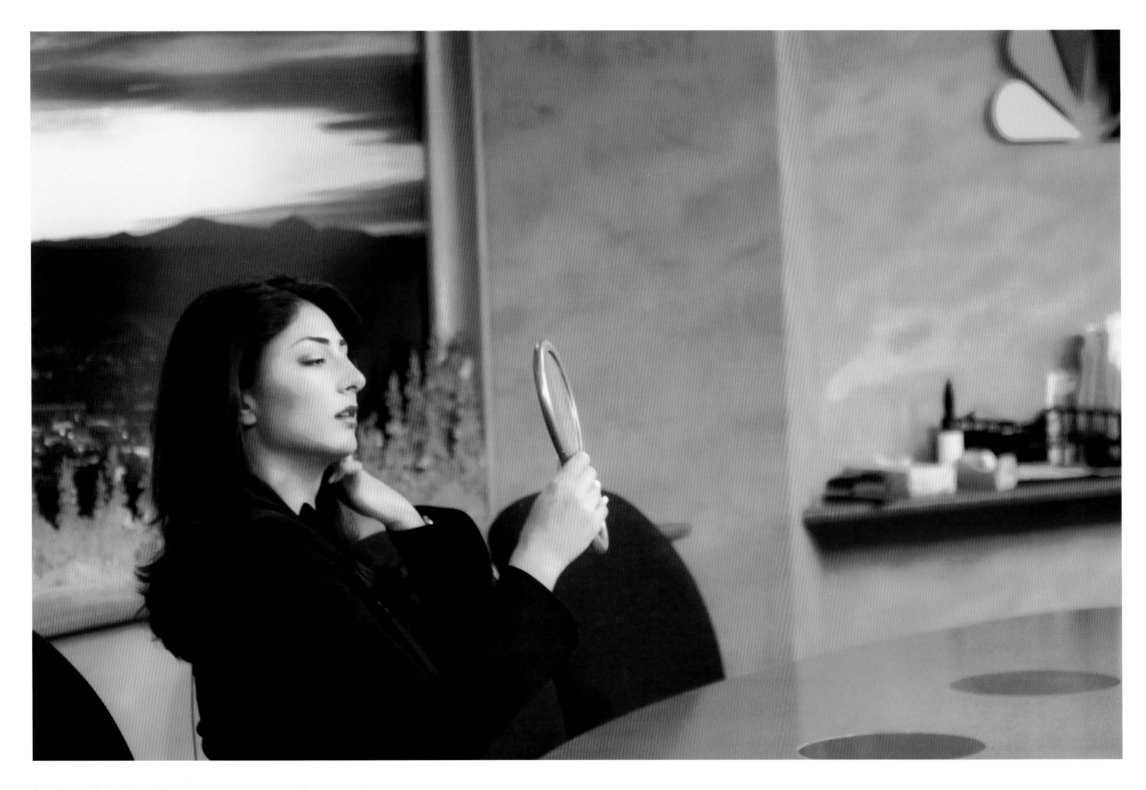

by CHRIS MATHER

KTVZ news anchor Shaliz Koleini gets ready to broadcast in Bend

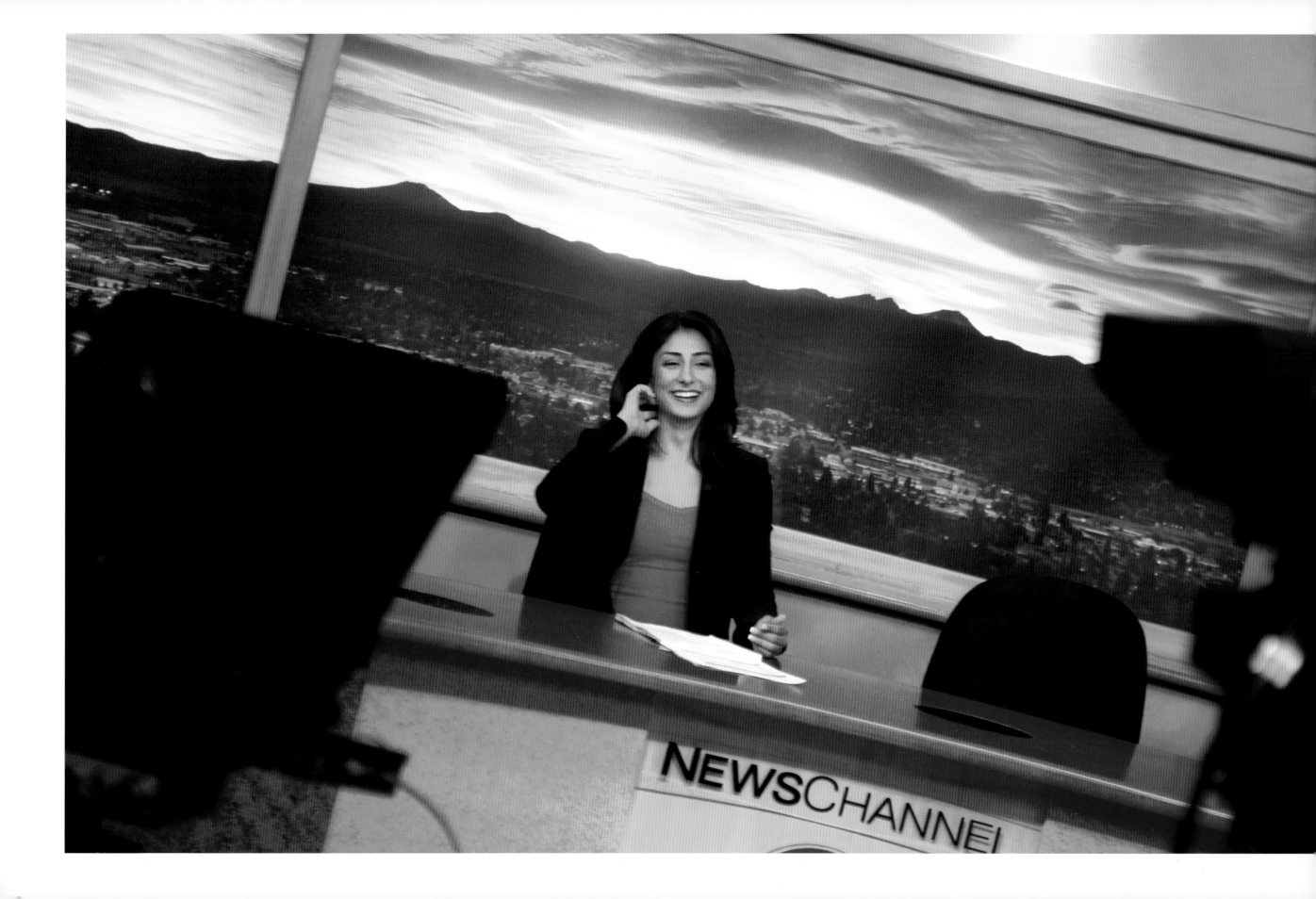

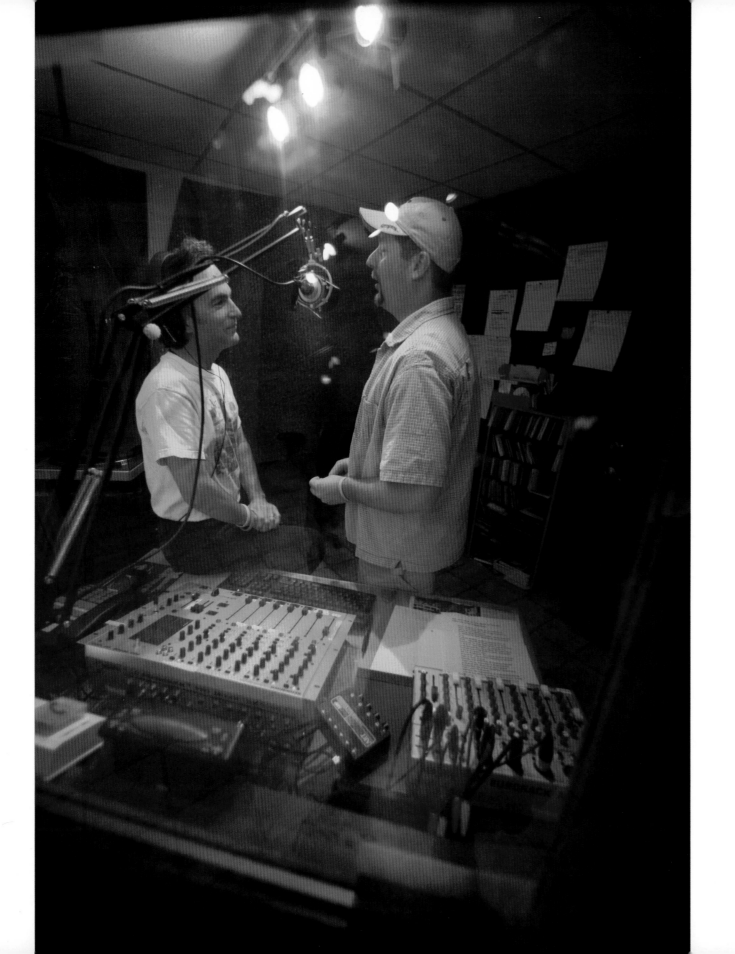

by BOB WOODWARD

LEFT:

Mike Ficher and Jeff "The Mammal"
Duncan broadcast their sports-talk
show live on KPOV Community Radio, Bend

RIGHT:

Opening night, The 2nd Street Theater

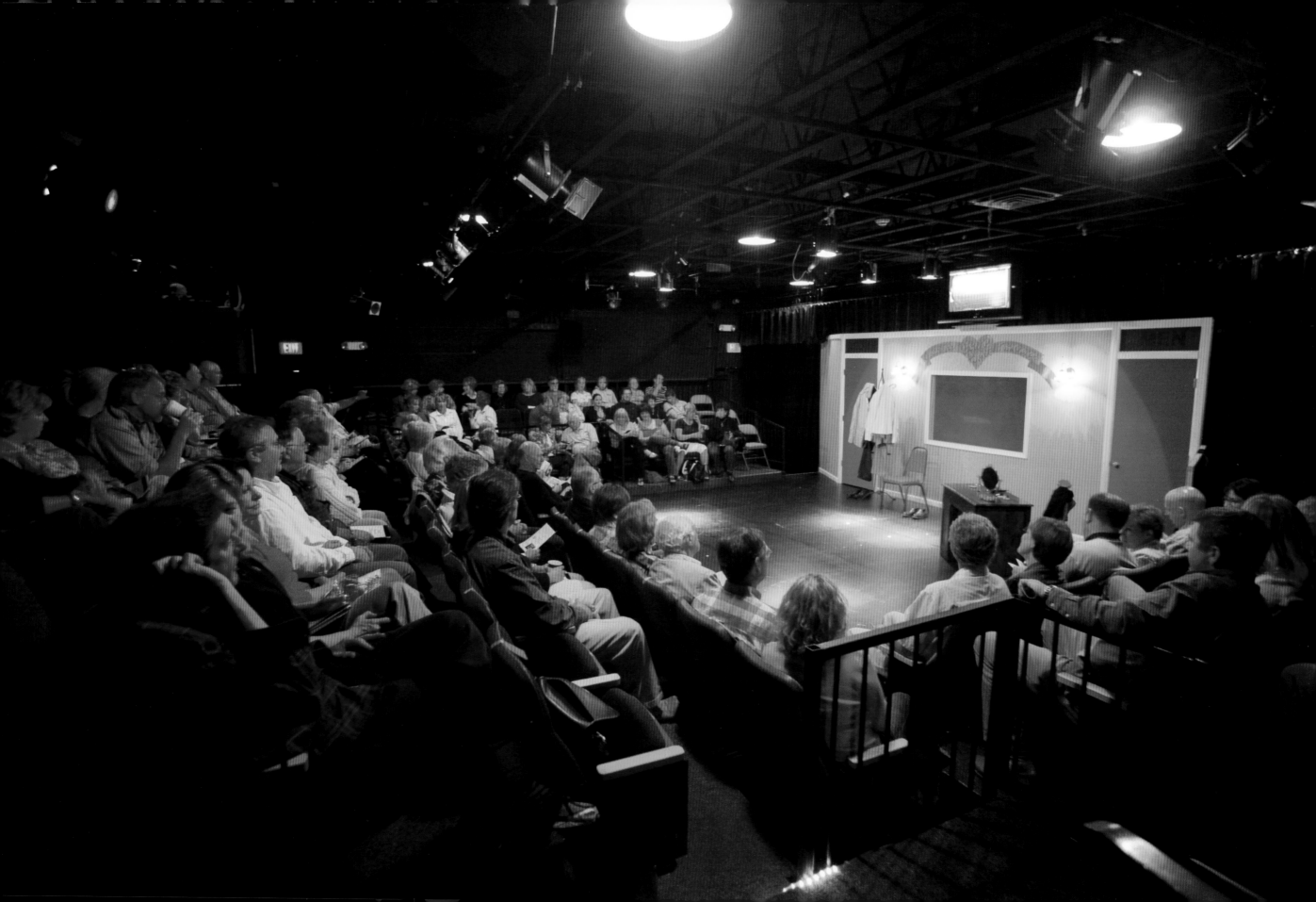

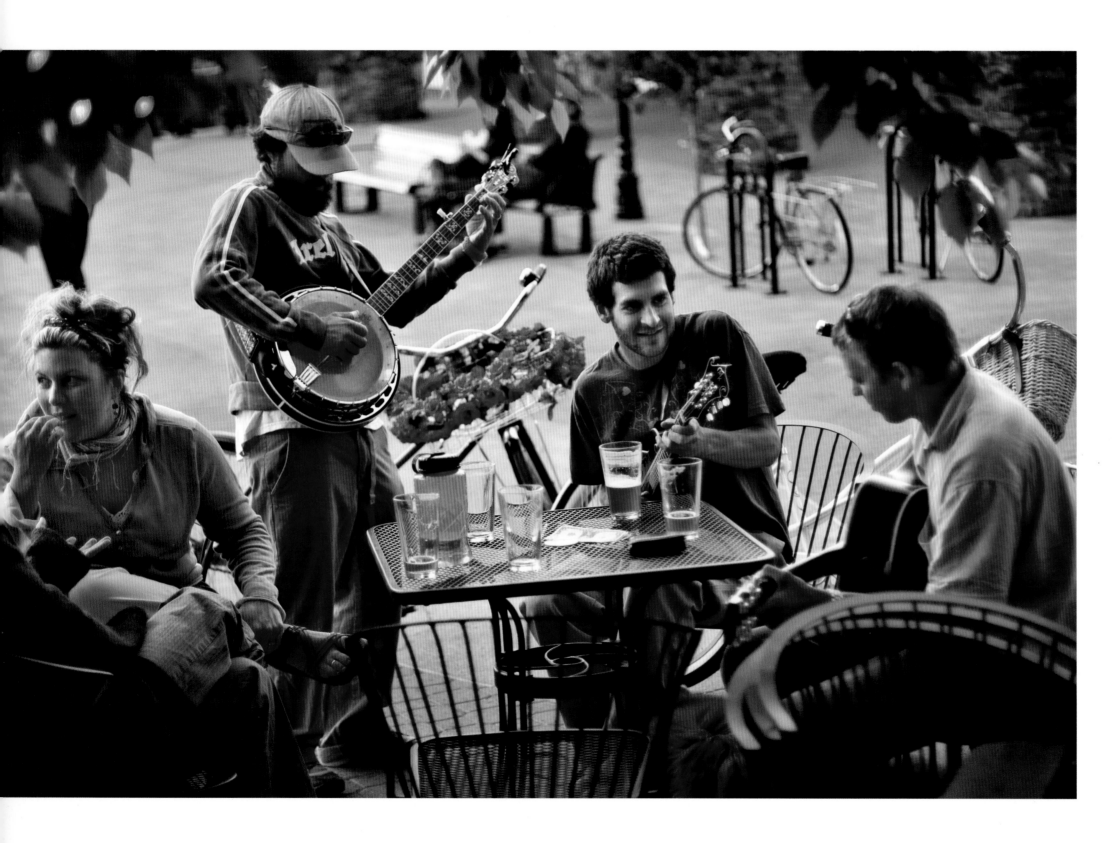

by JEFF KENNEDY

LEFT:
Bluegrass and beers,
Mirror Pond Plaza

RIGHT:
Ethan Ebersol jams with
friends

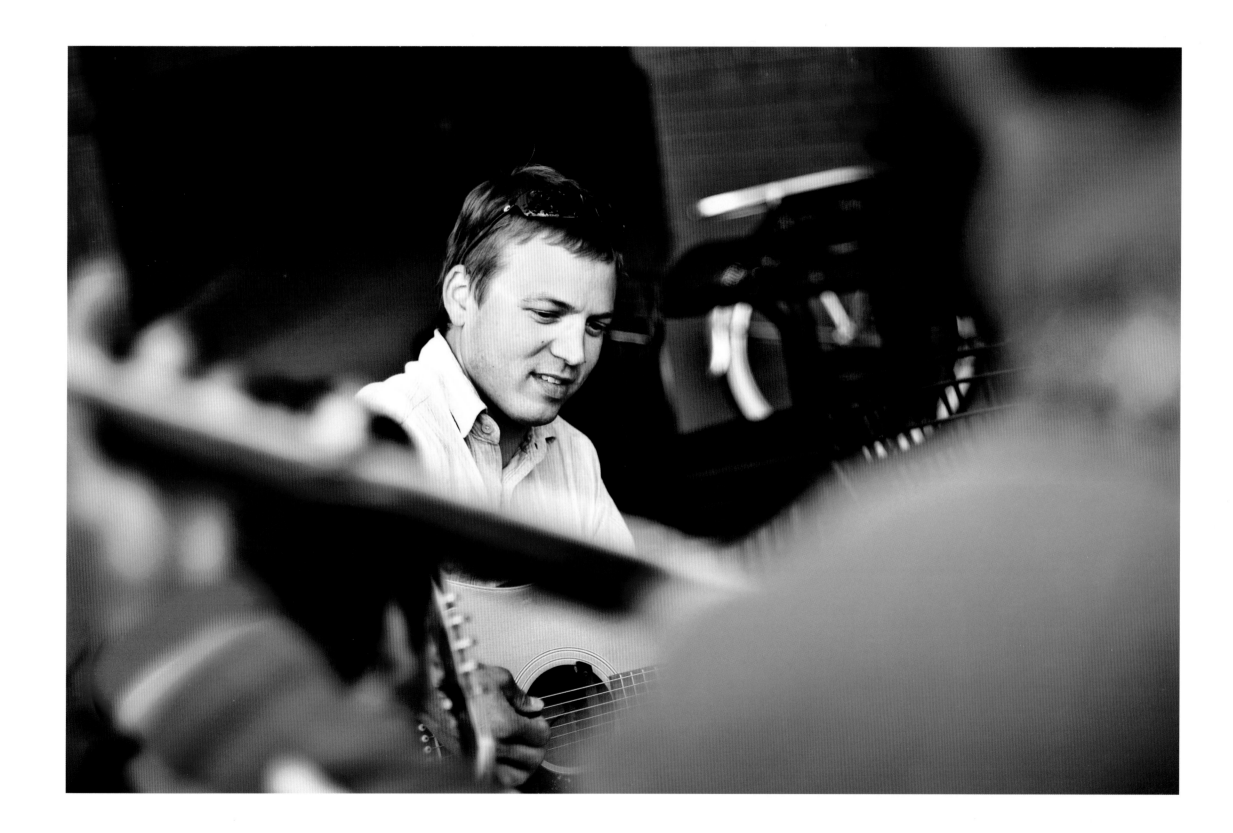

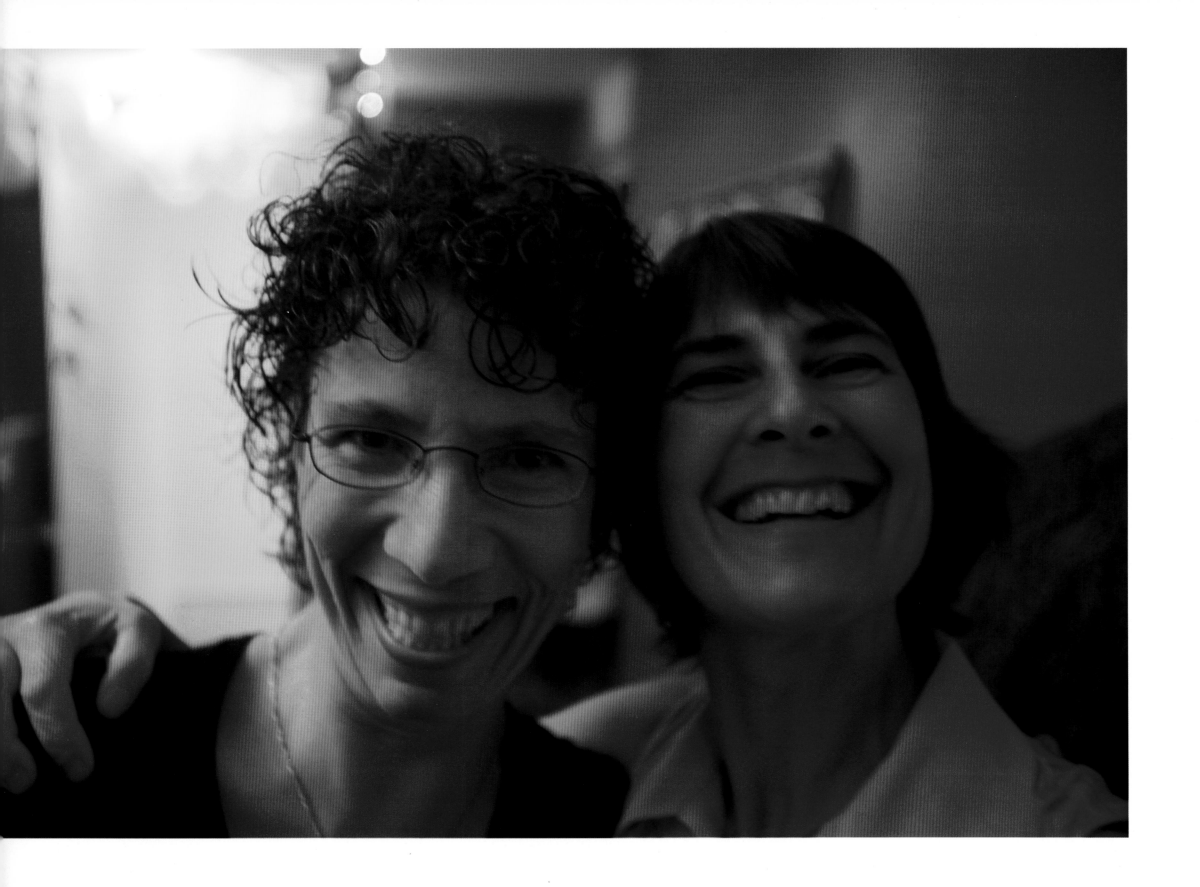

by BOB WOODWARD

LEFT: Tina Meyers and Theresa Jeffries
celebrate together

RIGHT: Joyce Mirelez observes her 50th
birthday at the Midtown Ballroom

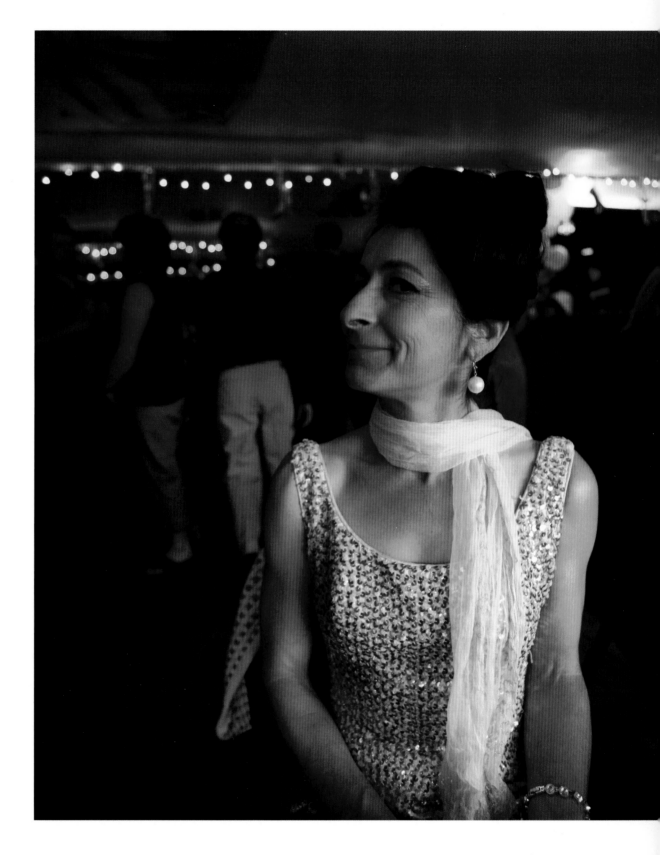

by KAREN CAMMACK

A burger and fries to go:
Sarah Richardson and
Krissa Mattox, Dandy's
Drive-In

by JEFF KENNEDY

Meals on wheels,
Dandy's Drive-In

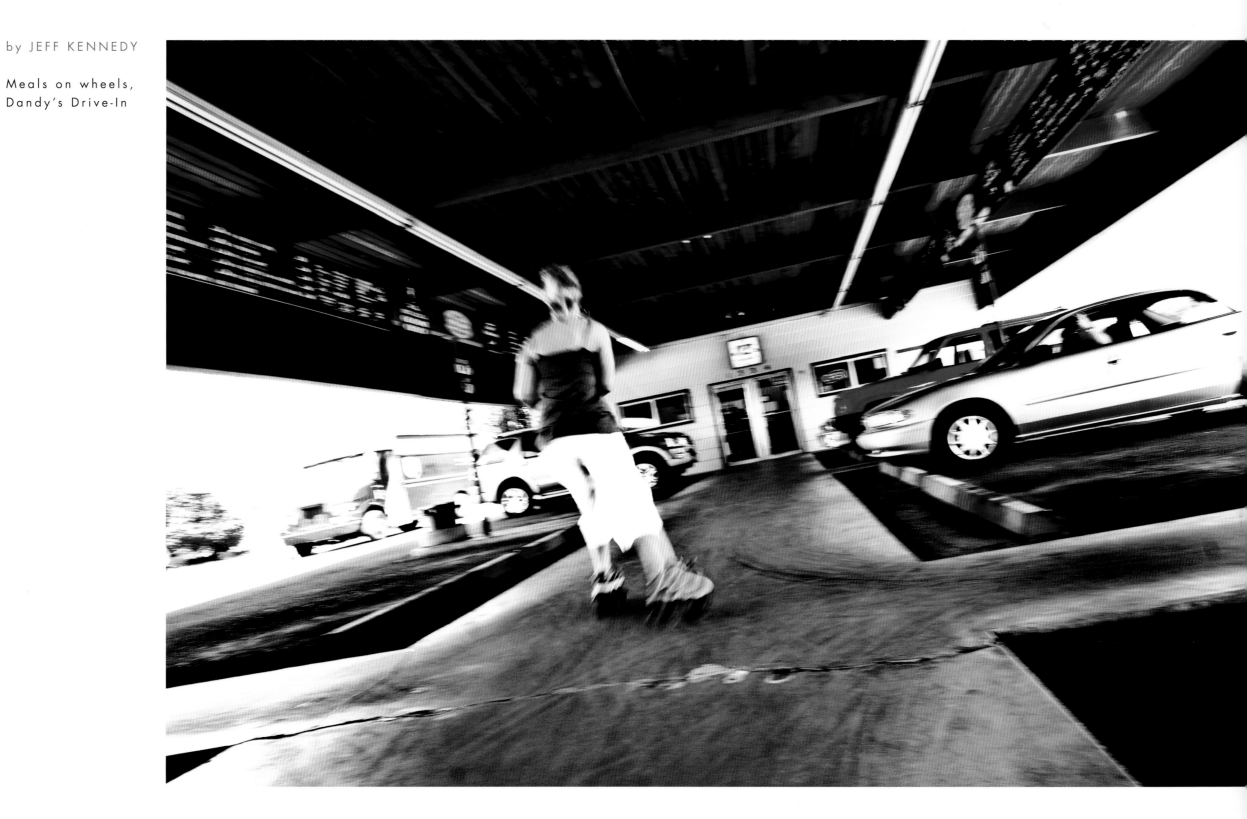

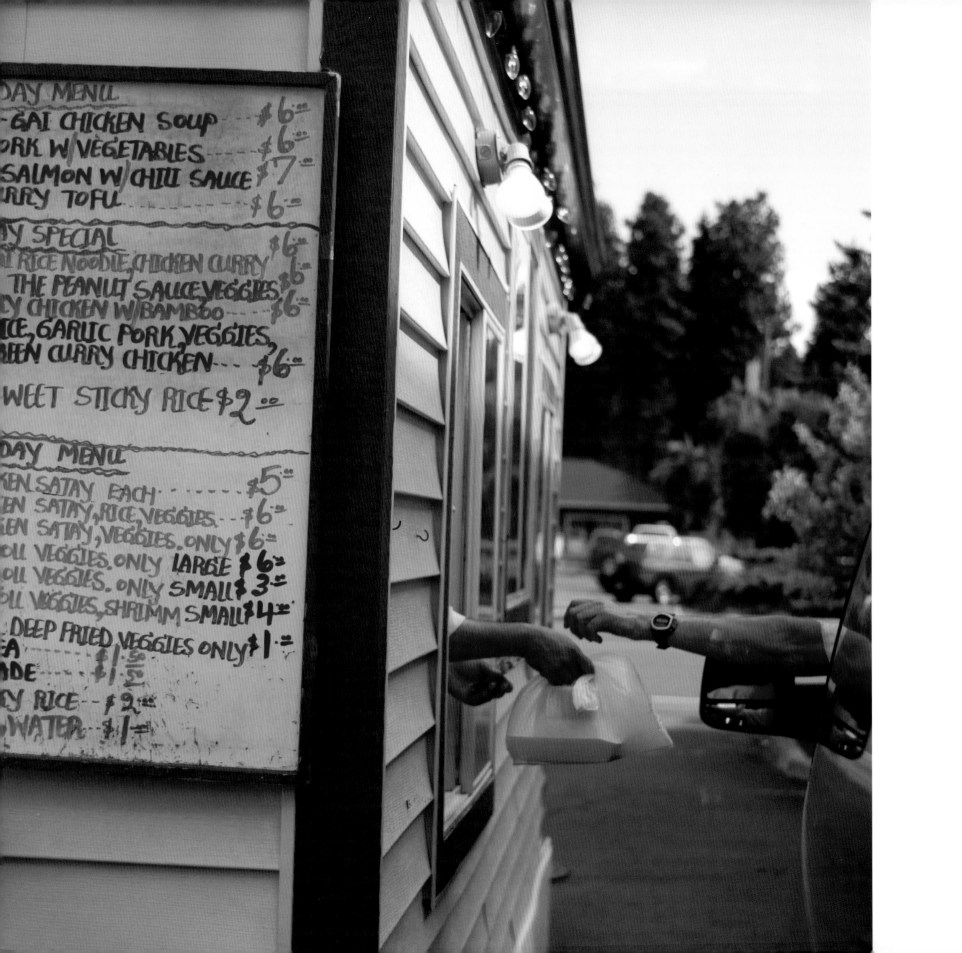

by ROBERT AGLI

LEFT:
"Thai on the fly": A Taste of Thailand
in Bend

RIGHT
Duan Love and Ben Santi

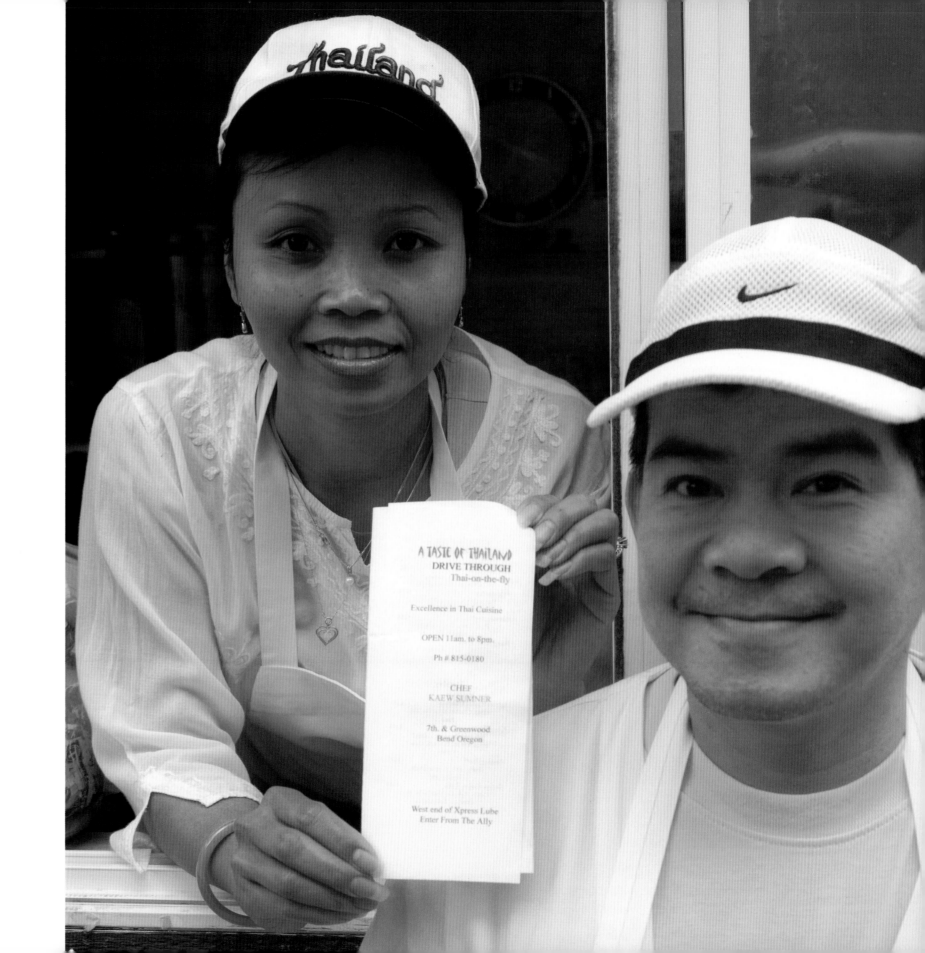

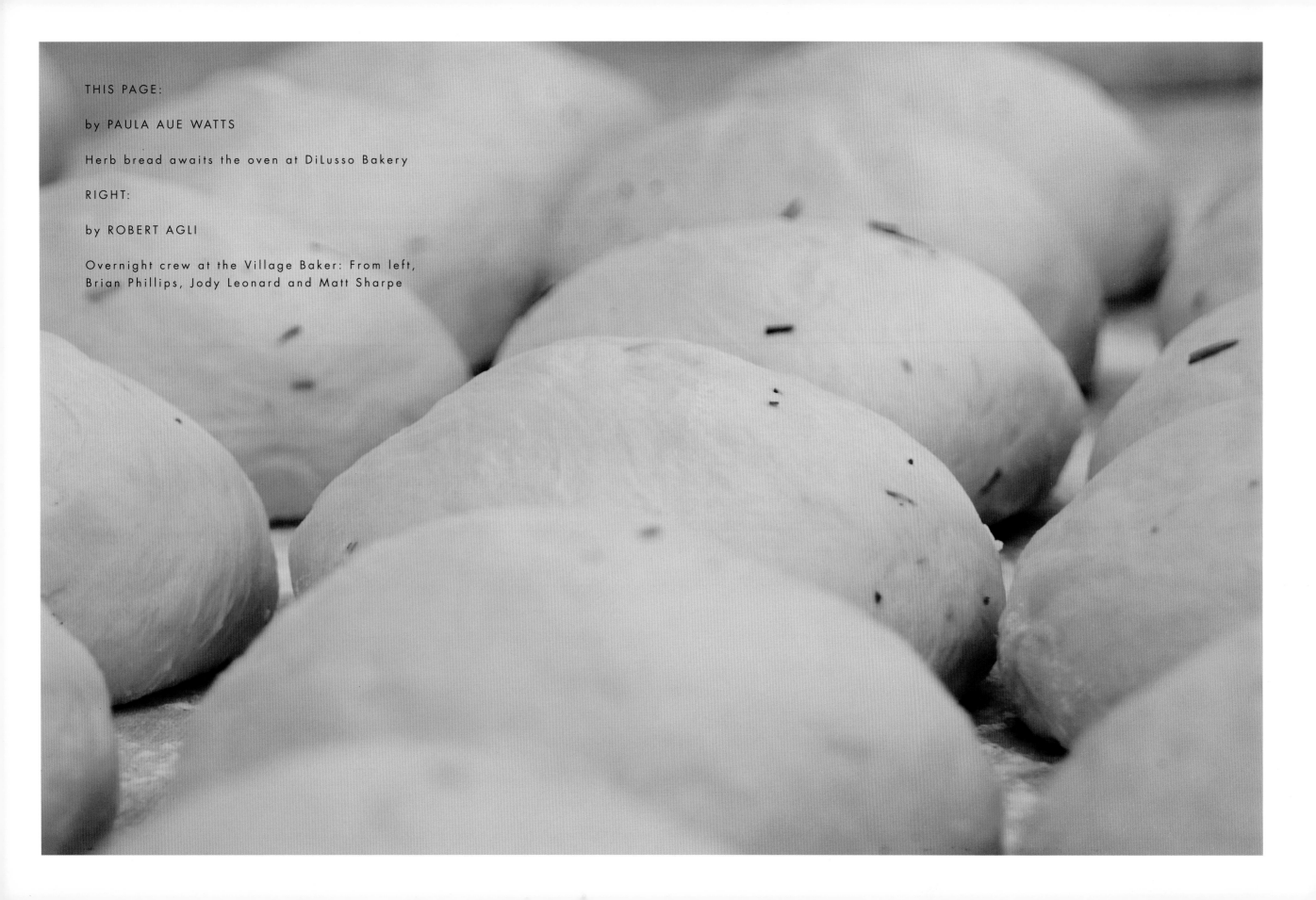

THIS PAGE:

by PAULA AUE WATTS

Herb bread awaits the oven at DiLusso Bakery

RIGHT:

by ROBERT AGLI

Overnight crew at the Village Baker: From left,
Brian Phillips, Jody Leonard and Matt Sharpe

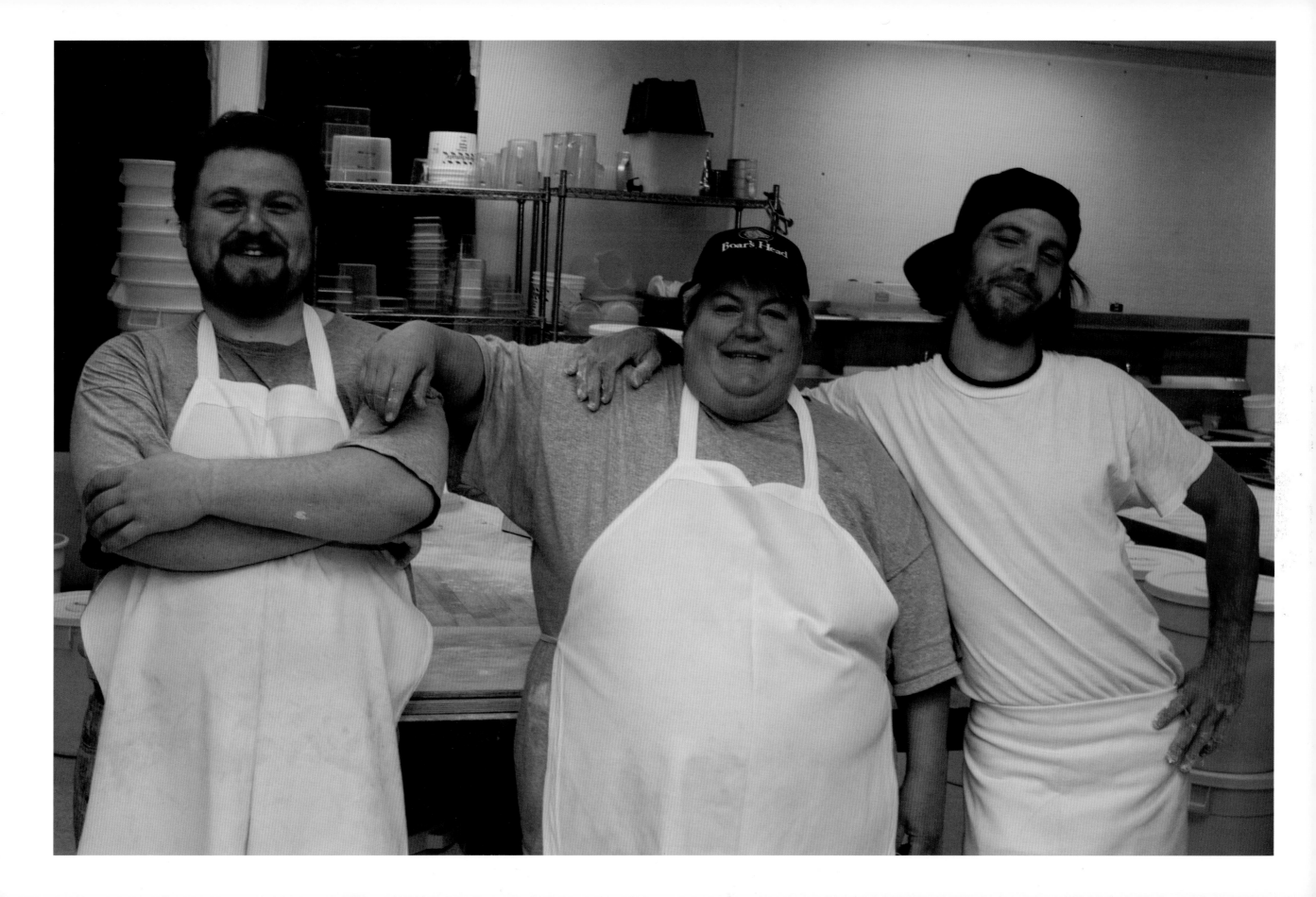

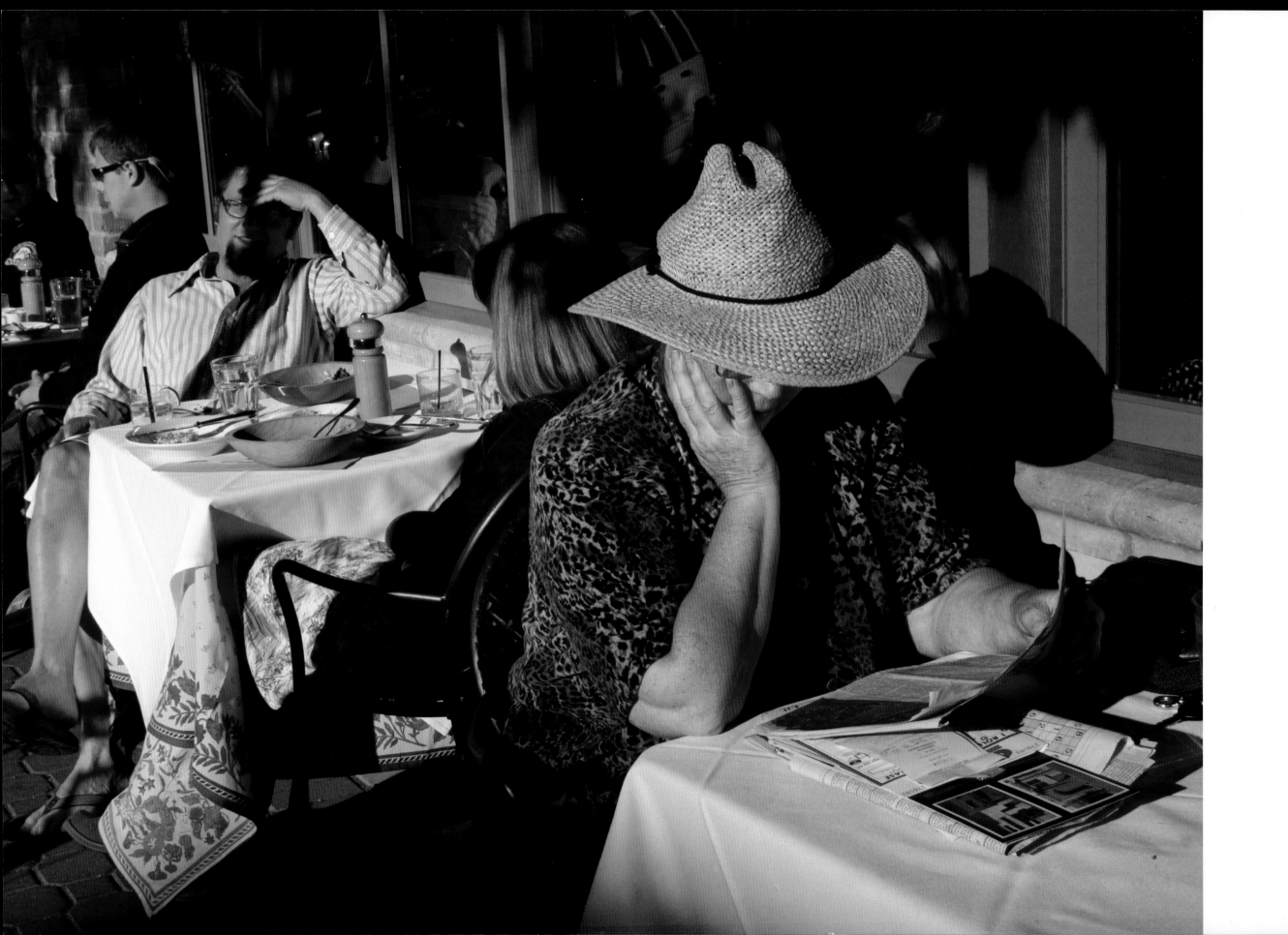

by TIFFANY PAULIN

Outdoor dining, Merenda Restaurant, Wall Street

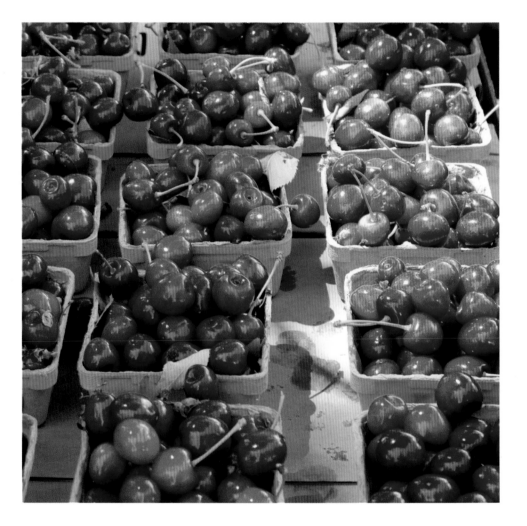

by ROBERT AGLI

Vegetables and fruit at the Farmers' Market

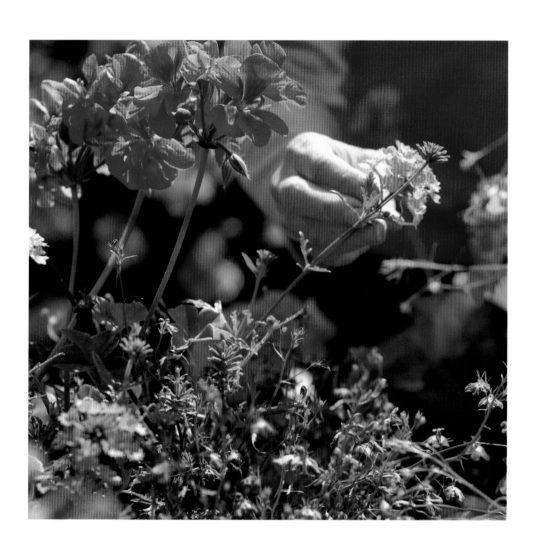

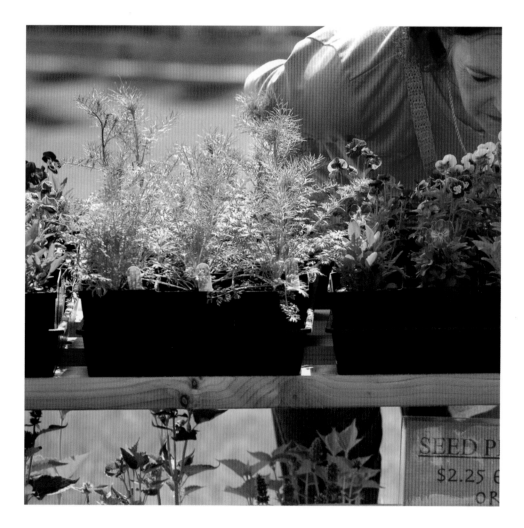

by RIC ERGENBRIGHT

Fresh flowers, Friday Farmers' Market, northeast Bend

by TIFFANY PAULIN

Cook Mehro Eliam takes a break in the alley
behind the Vino Mercato bistro and wine bar

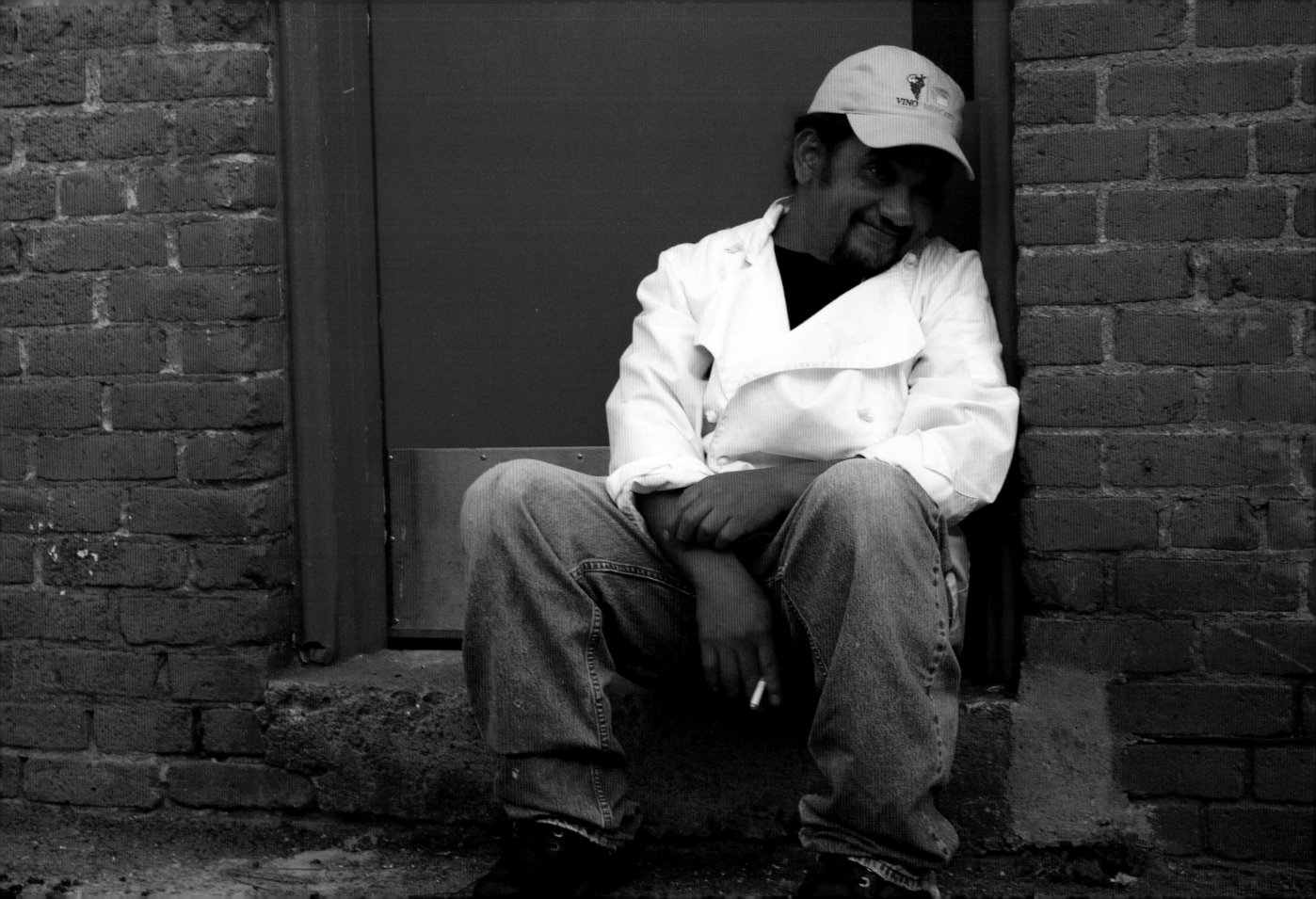

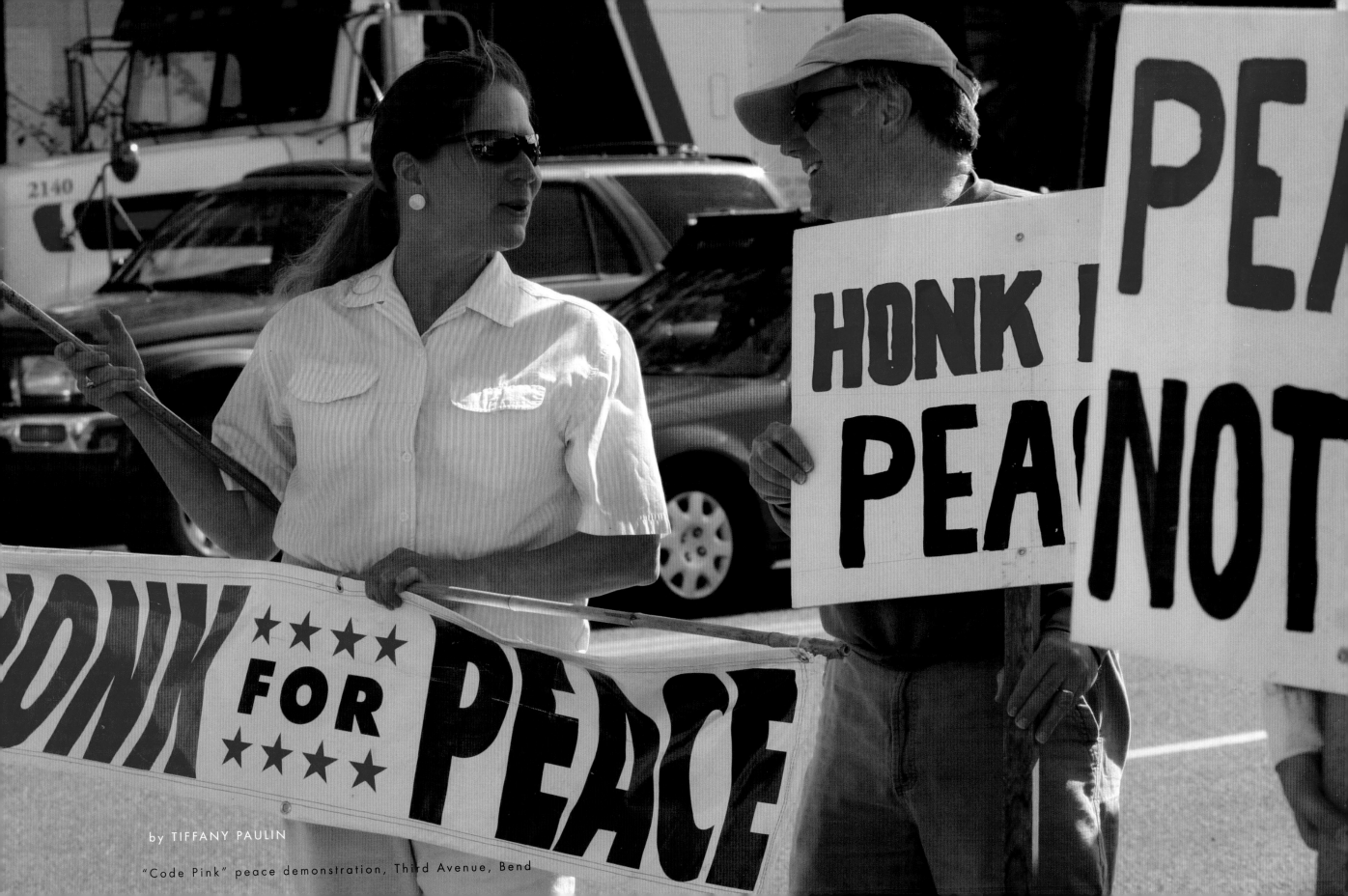

by TIFFANY PAULIN

"Code Pink" peace demonstration, Third Avenue, Bend

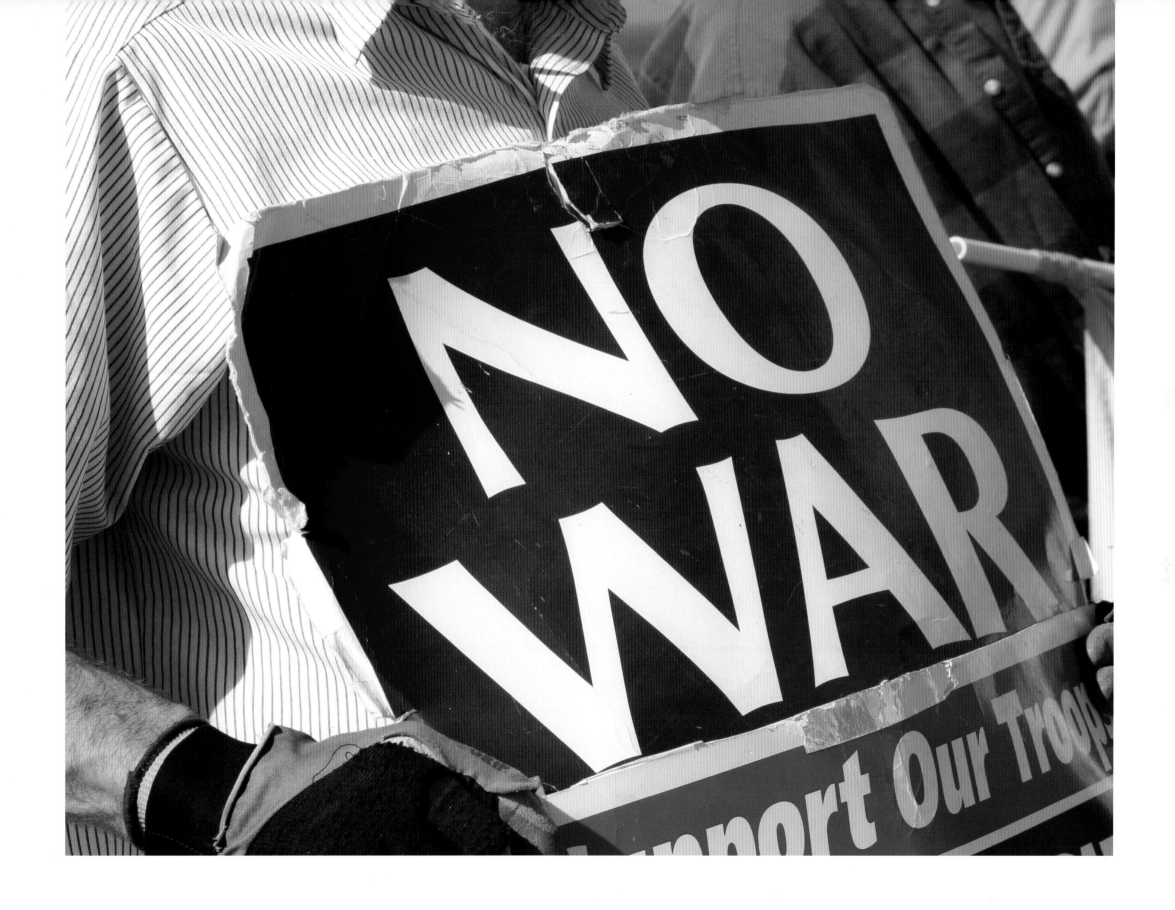

by TIFFANY PAULIN

Officer Kalin Ayhan, Bend Police

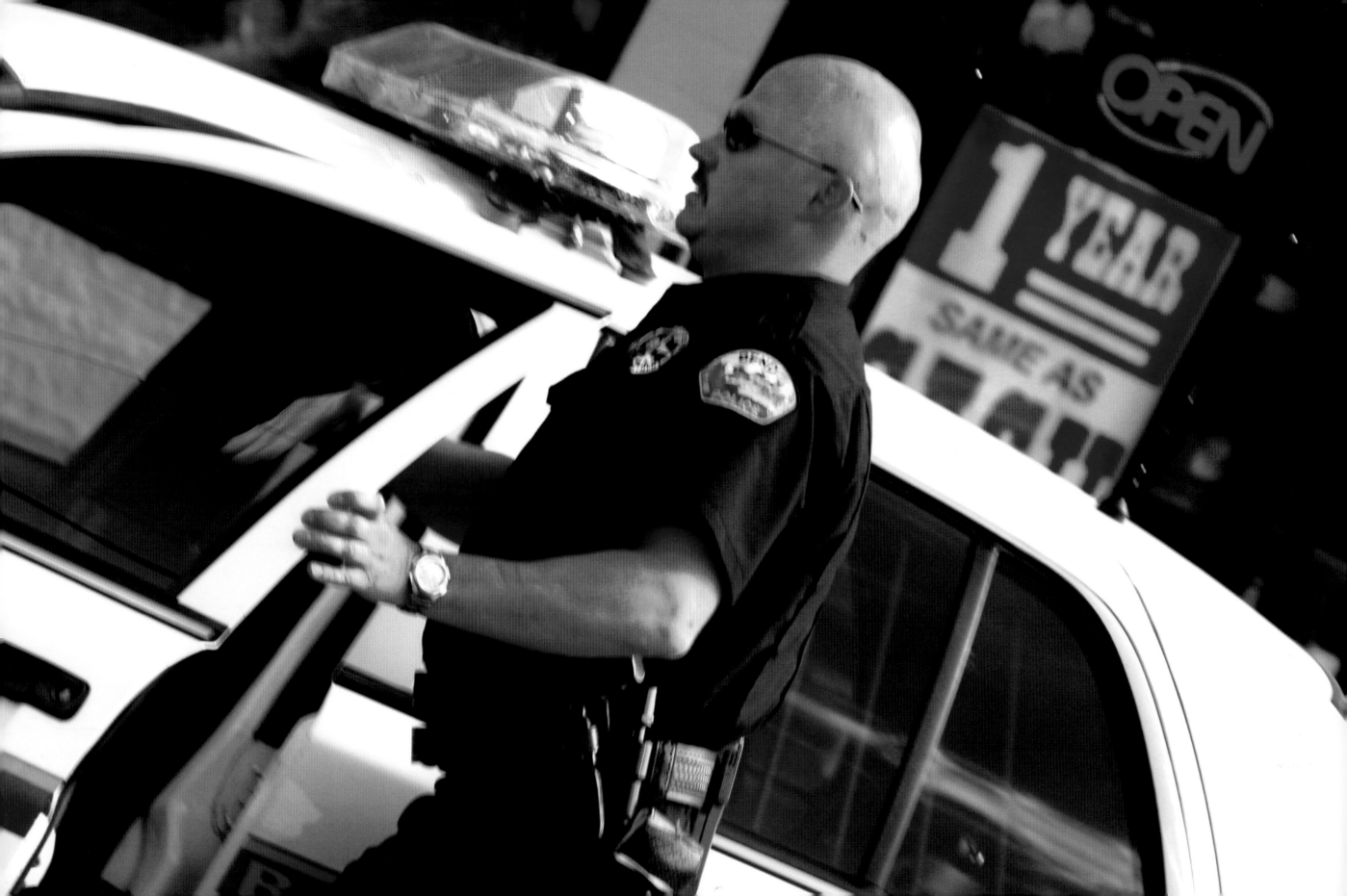

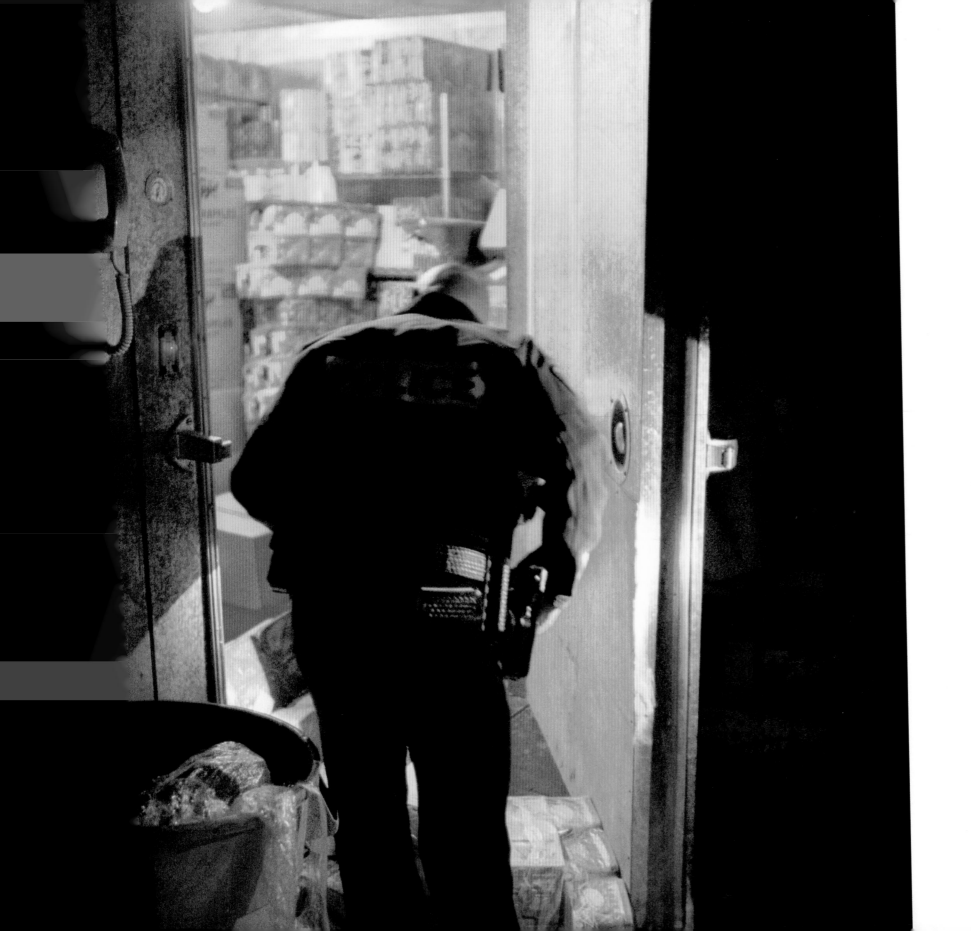

by MARK GAMBA

A routine night for the Bend Police

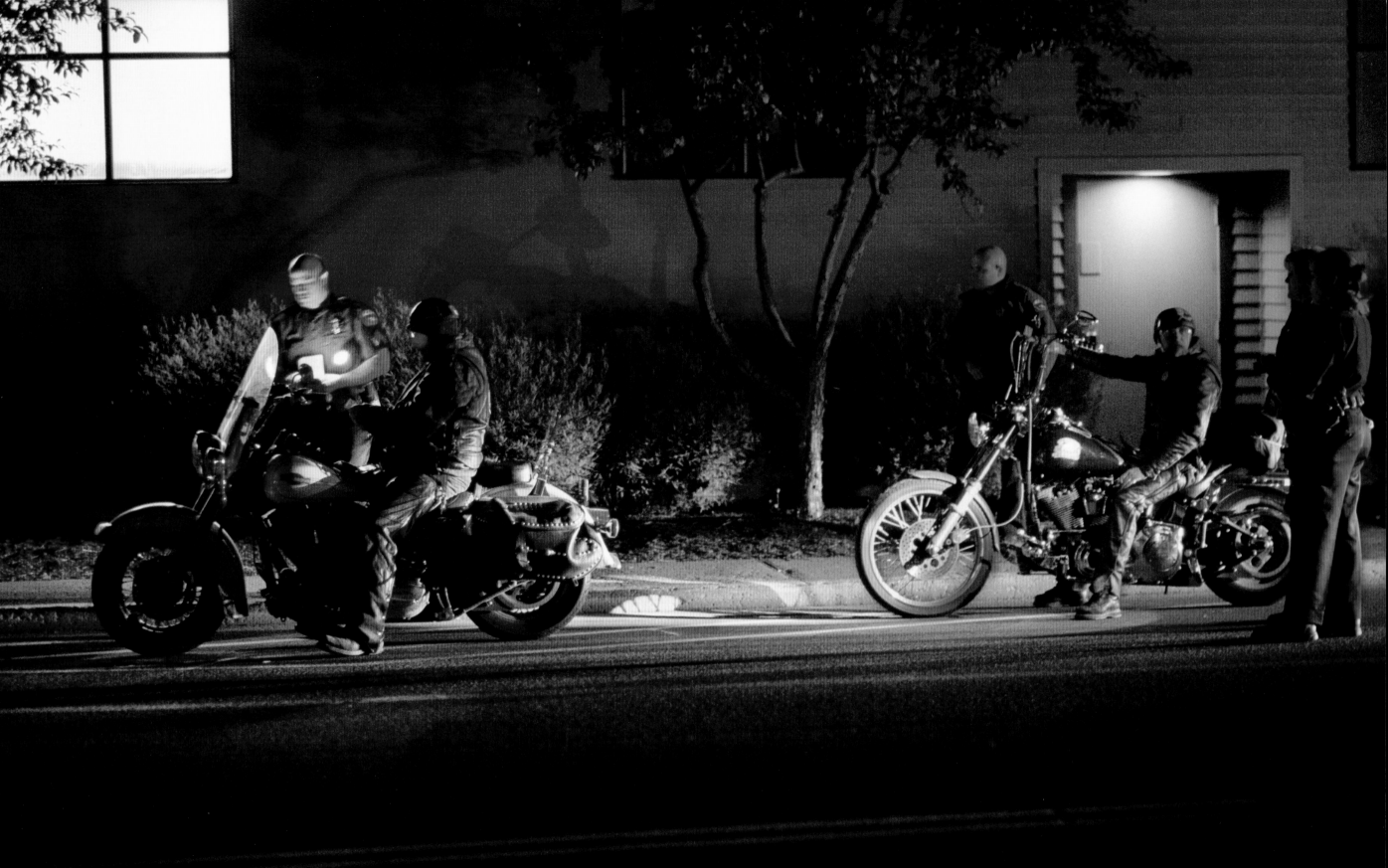

by MARK GAMBA

Officer John Lawrence, Bend Police

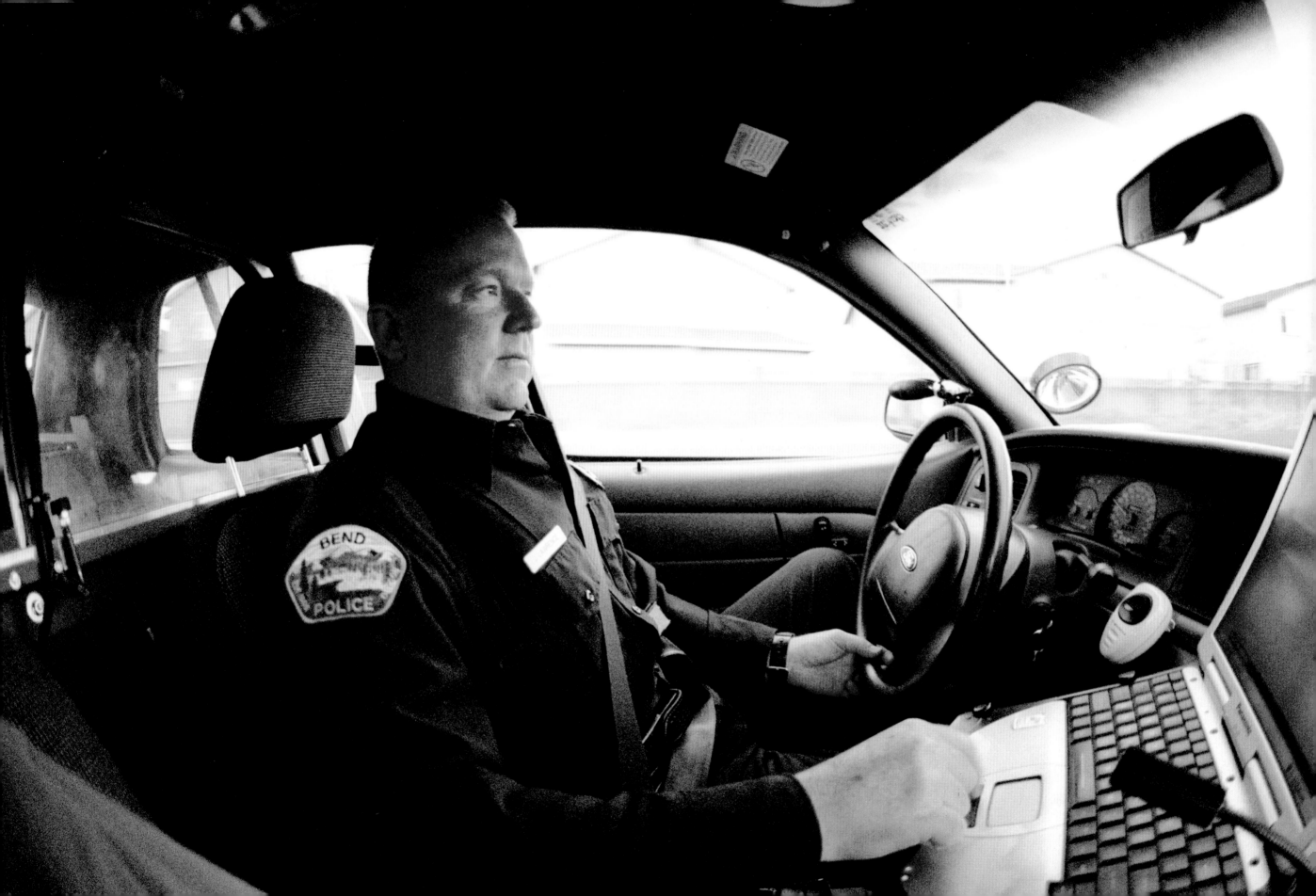

by STEVE TAGUE

LEFT:
Firefighter Mike Ireland pumps iron

RIGHT:
A Bend firefighter trains in a protective
aluminum-fiberglass shield

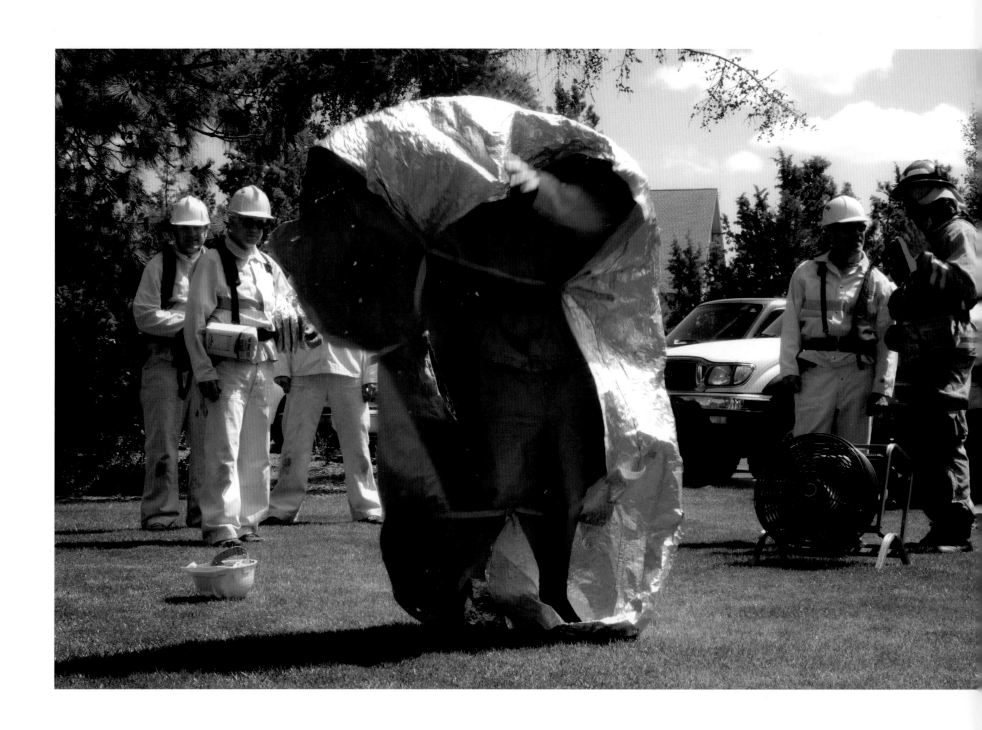

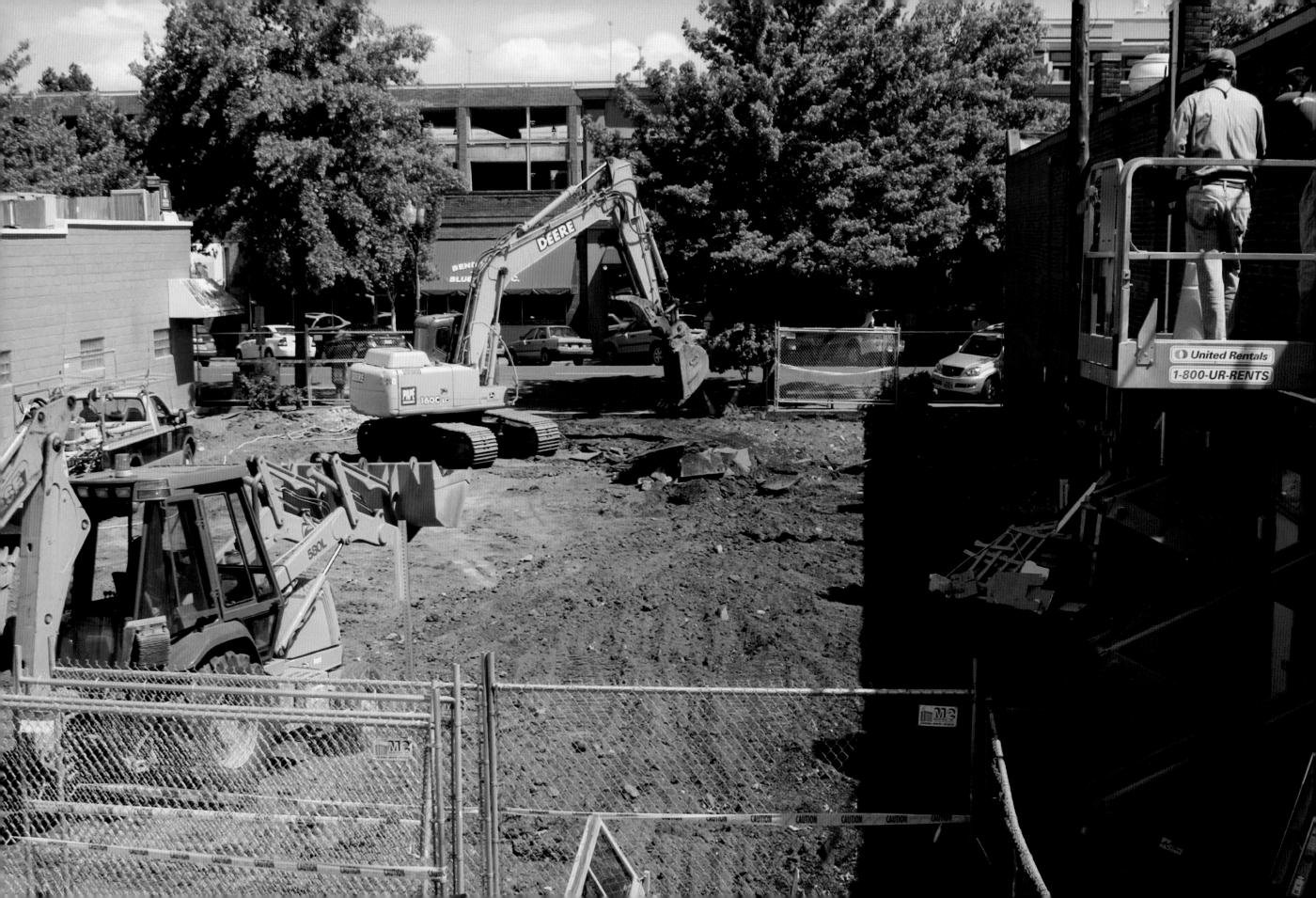

by SIMONE PADDOCK

LEFT:
Making way for growth, Bond Street, Bend

RIGHT:
The new Newport Avenue Bridge, Bend

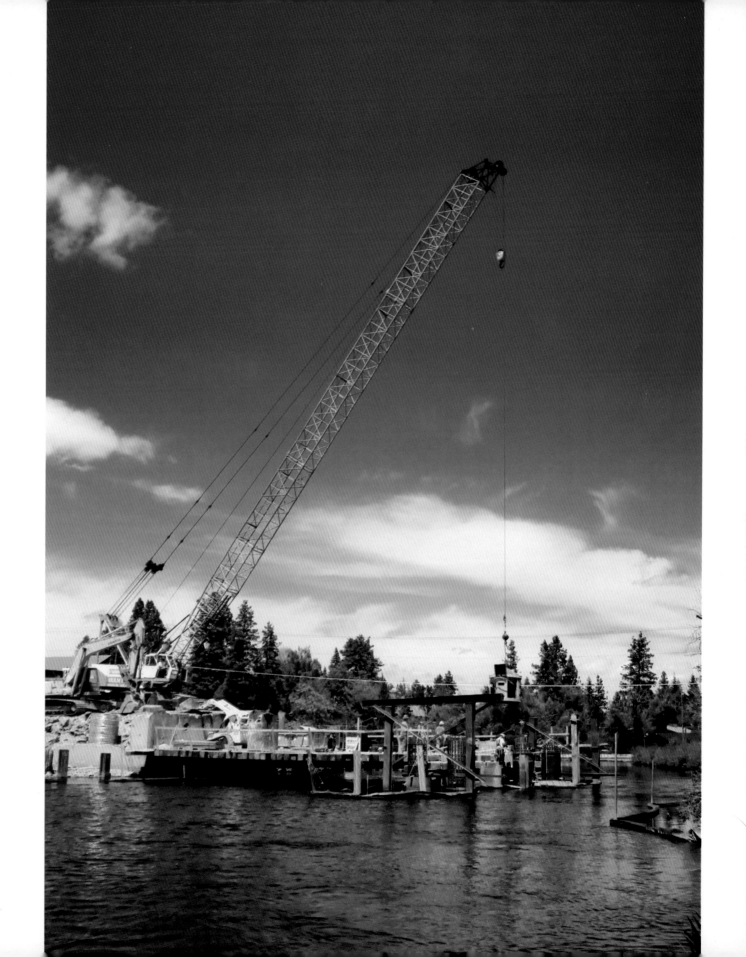

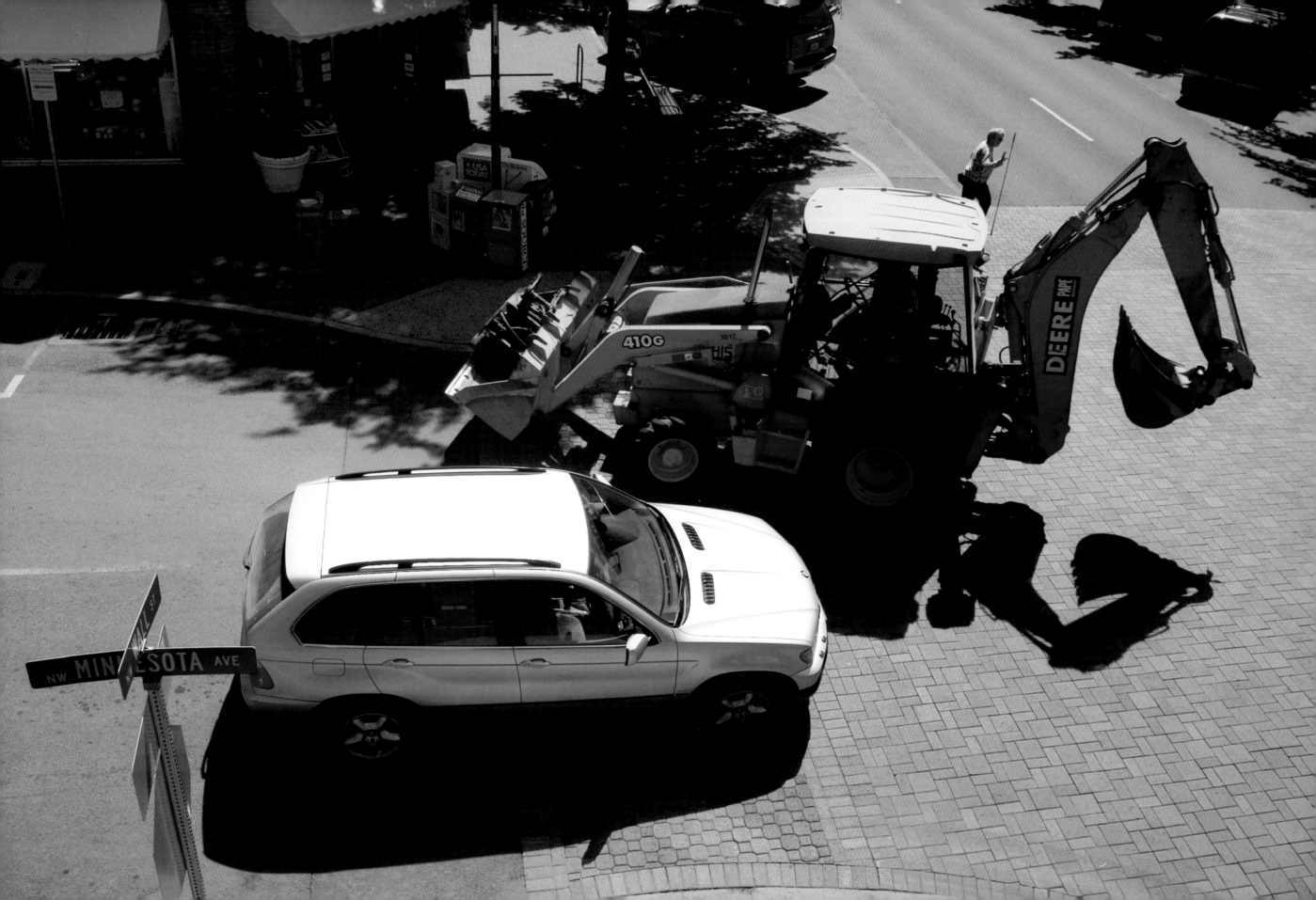

LEFT:

by SIMONE PADDOCK

SUV meets backhoe at Wall Street and Minnesota
Avenue, Bend

RIGHT:

by KEVIN KUBOTA

Aubrey and Brittany Kimble of AB Premier Homes
review plans for a new stage of construction

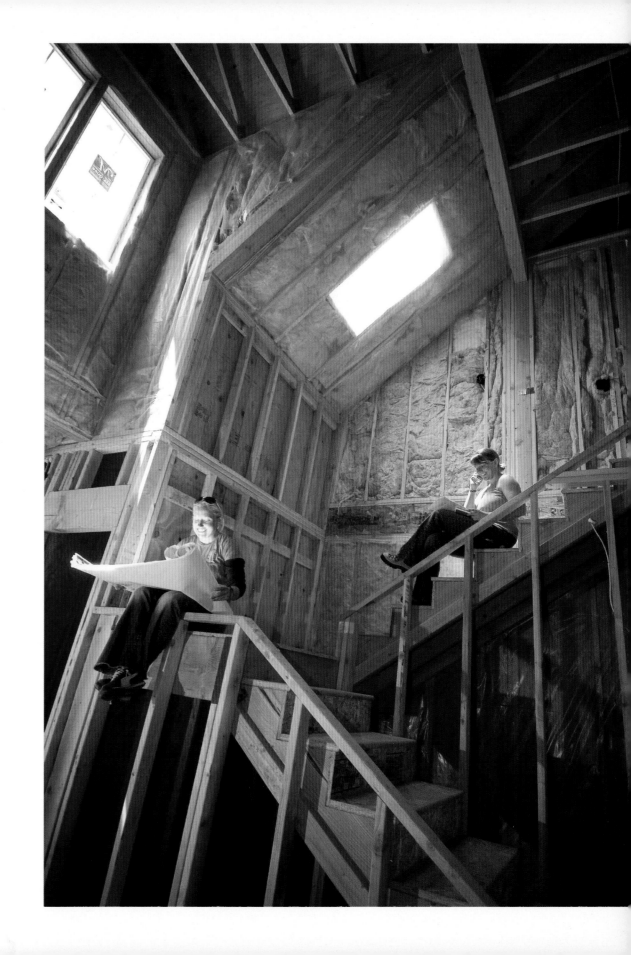

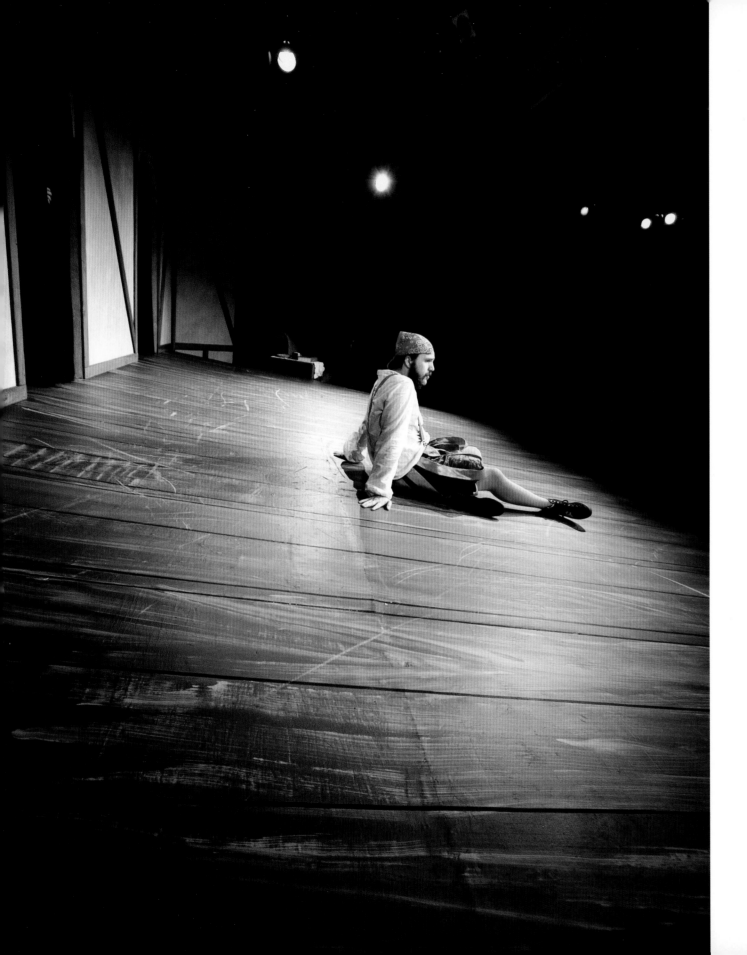

by JEFF KENNEDY

LEFT:
Jared Rasic stretches before a Cascade Theatrical
Company (CTC) performance

RIGHT:
Man in tights, CTC

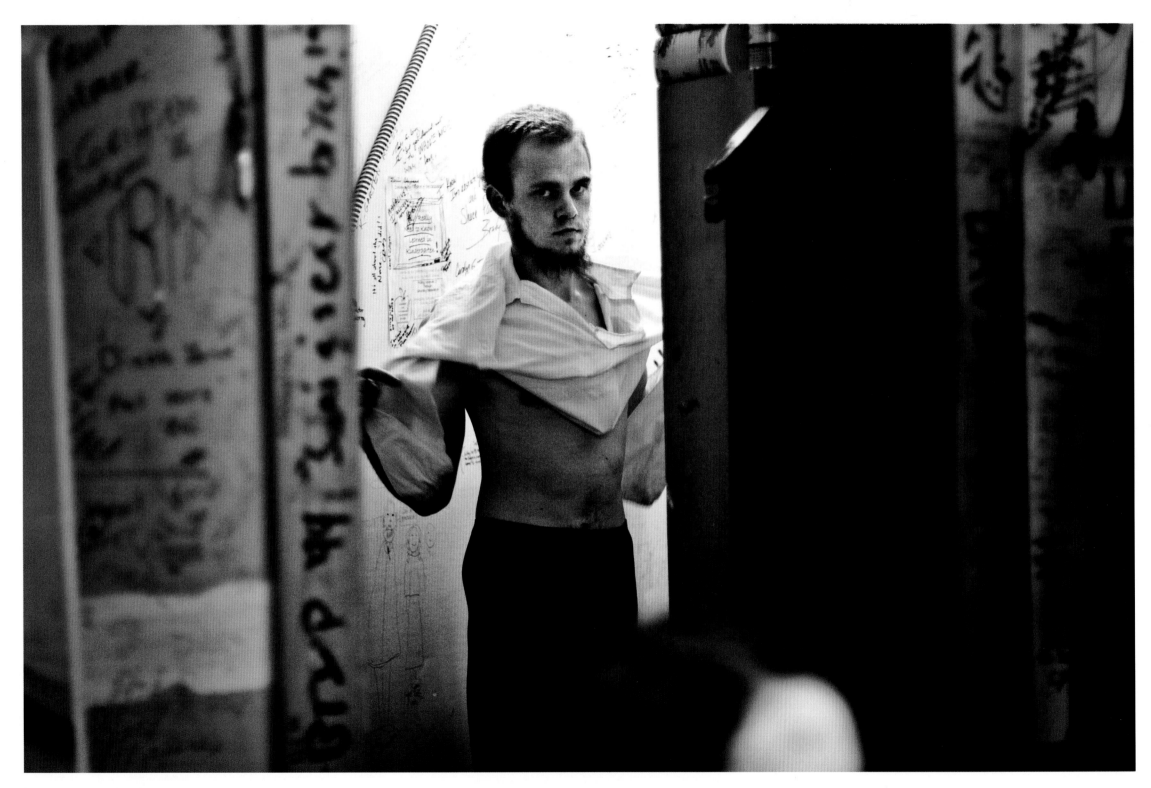

by JEFF KENNEDY

Alastair Jacques dresses at Cascades Theatrical Company, Bend

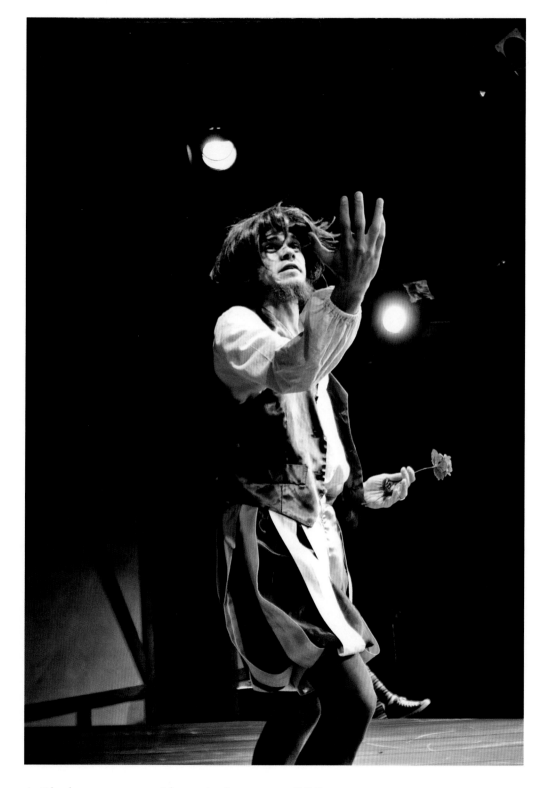

A Shakespearean Alastair Jacques, CTC

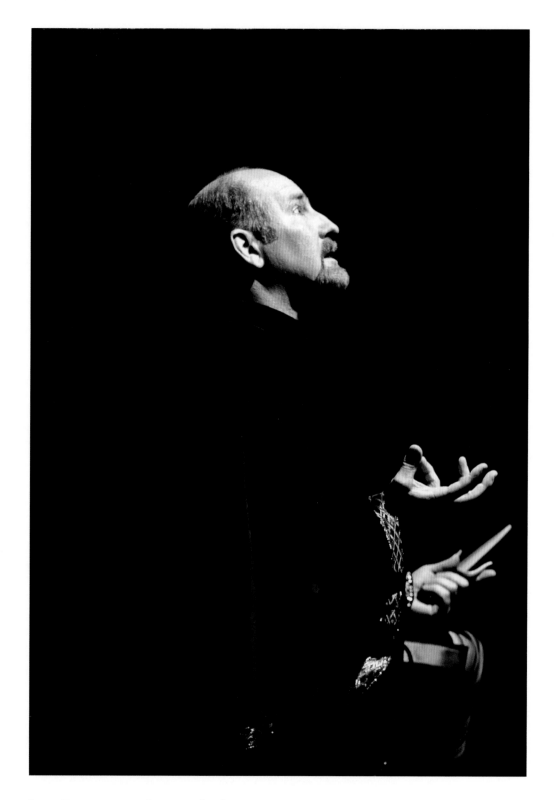

Don Tompos in the spotlight, CTC

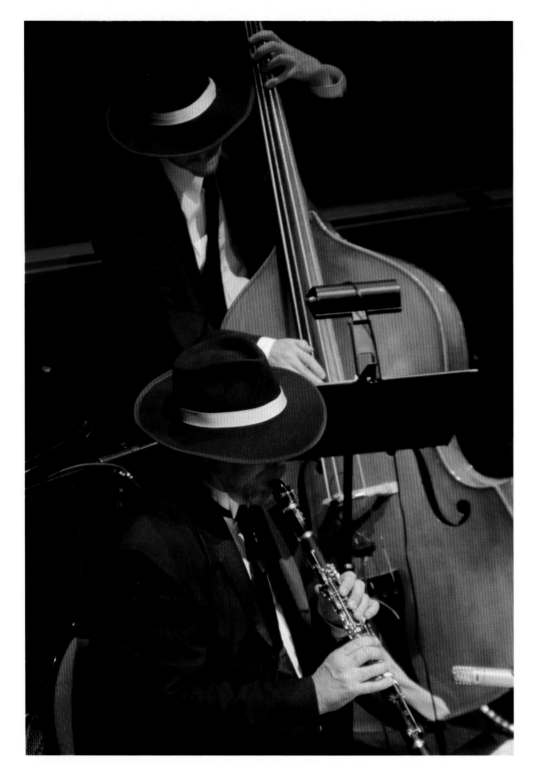

by MARISA CHAPPELL

Pit orchestra, Tower Theatre

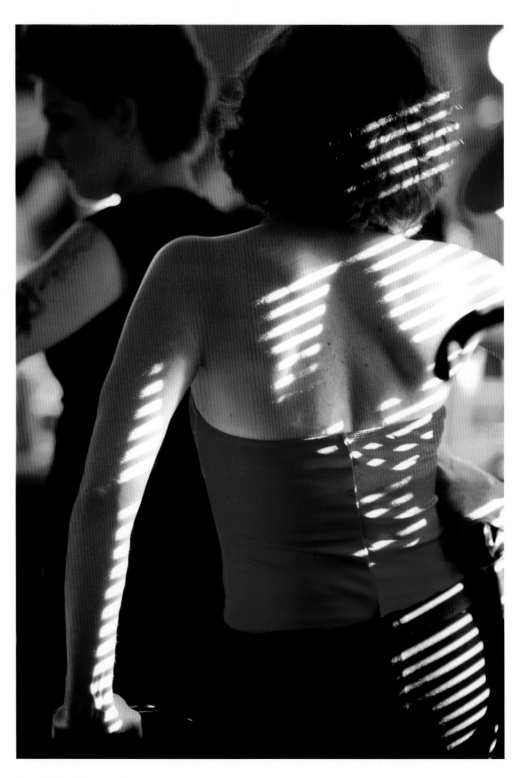

by KEVIN KUBOTA

Backstage, Tower Theatre

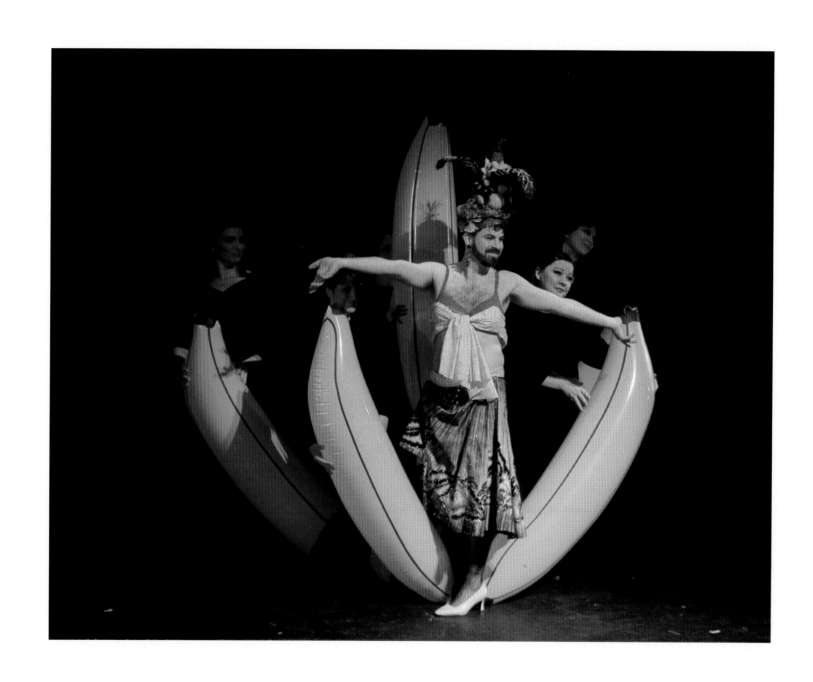

by MARISA CHAPPELL

Gordon Lunde is Carmen
Miranda, Tower Theatre

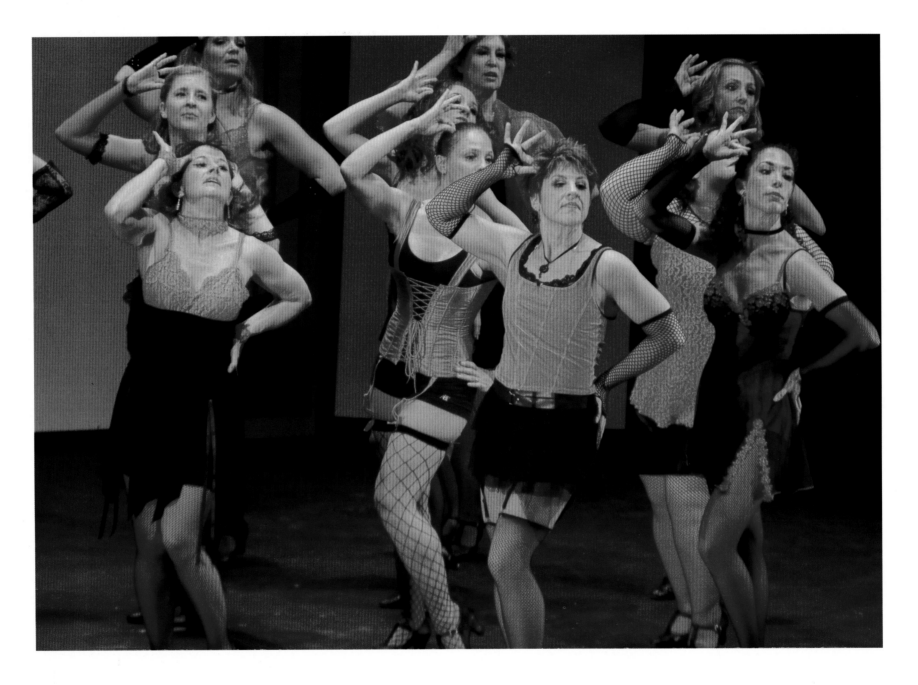

by MARISA CHAPPELL

The Jazz Dance Collective presents "Cabaret, Swing and All That Jazz," Tower Theatre

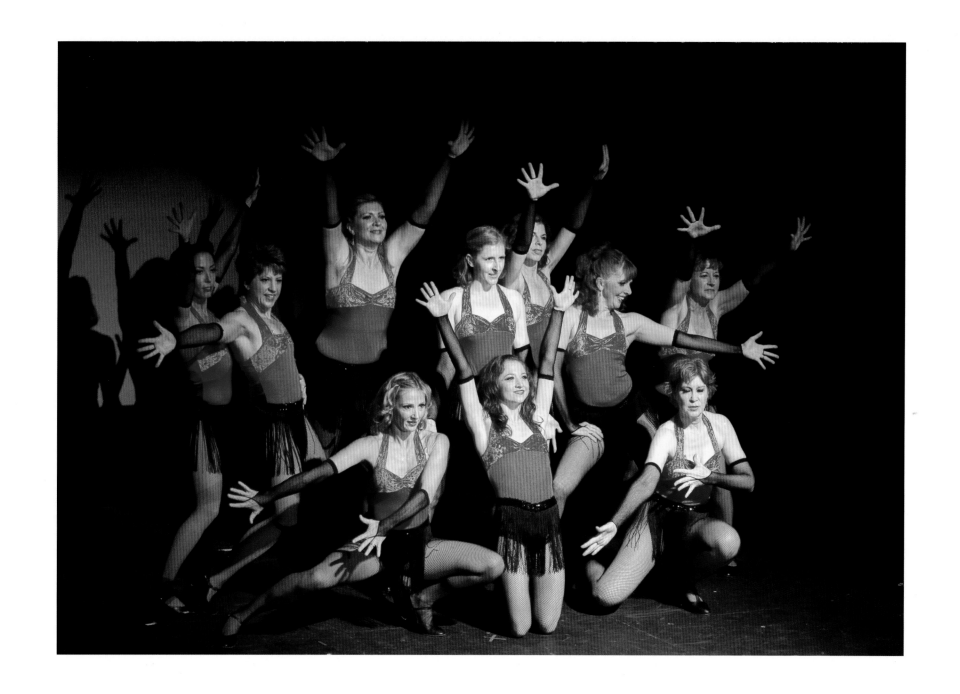

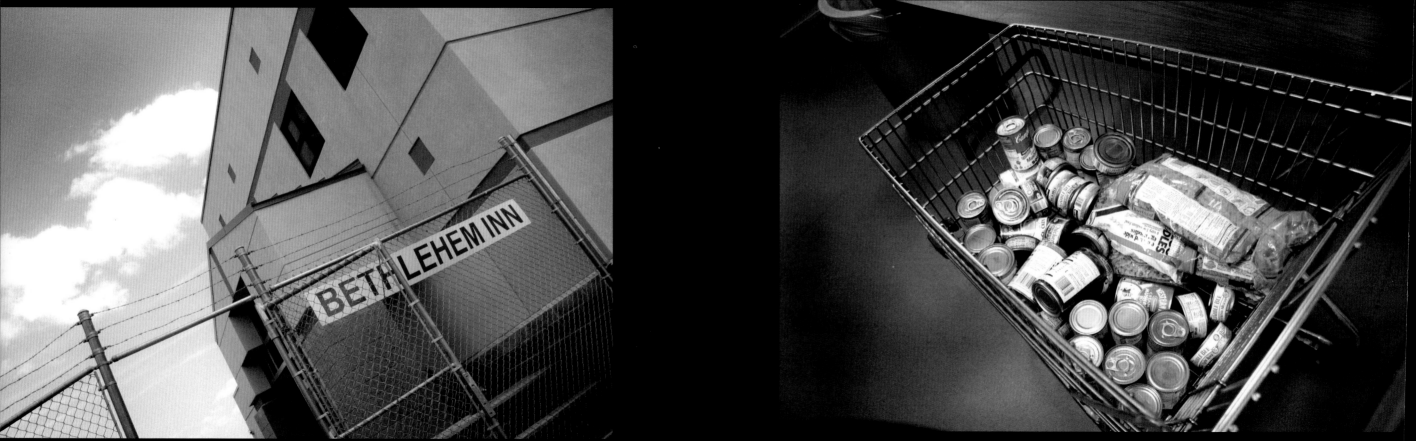

I am a slow walker, but I never walk backwards.
Abraham Lincoln

by TOM AND TASH...

by PAULA AUE WATTS

LEFT:
Pastor Jerry Joubert, Seventh-day Adventist Church, Bend

RIGHT:
Rabbi Jay Shupack, the Jewish Community of Central Oregon

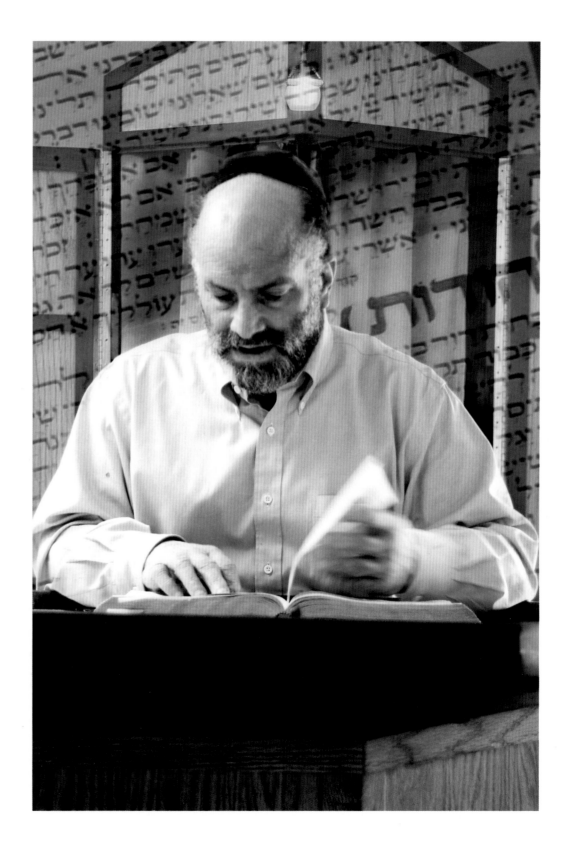

by SIMONE PADDOCK

Alexa Divine, 15, and Geoff Turner, 17, of Bend discover
springtime romance, Drake Park

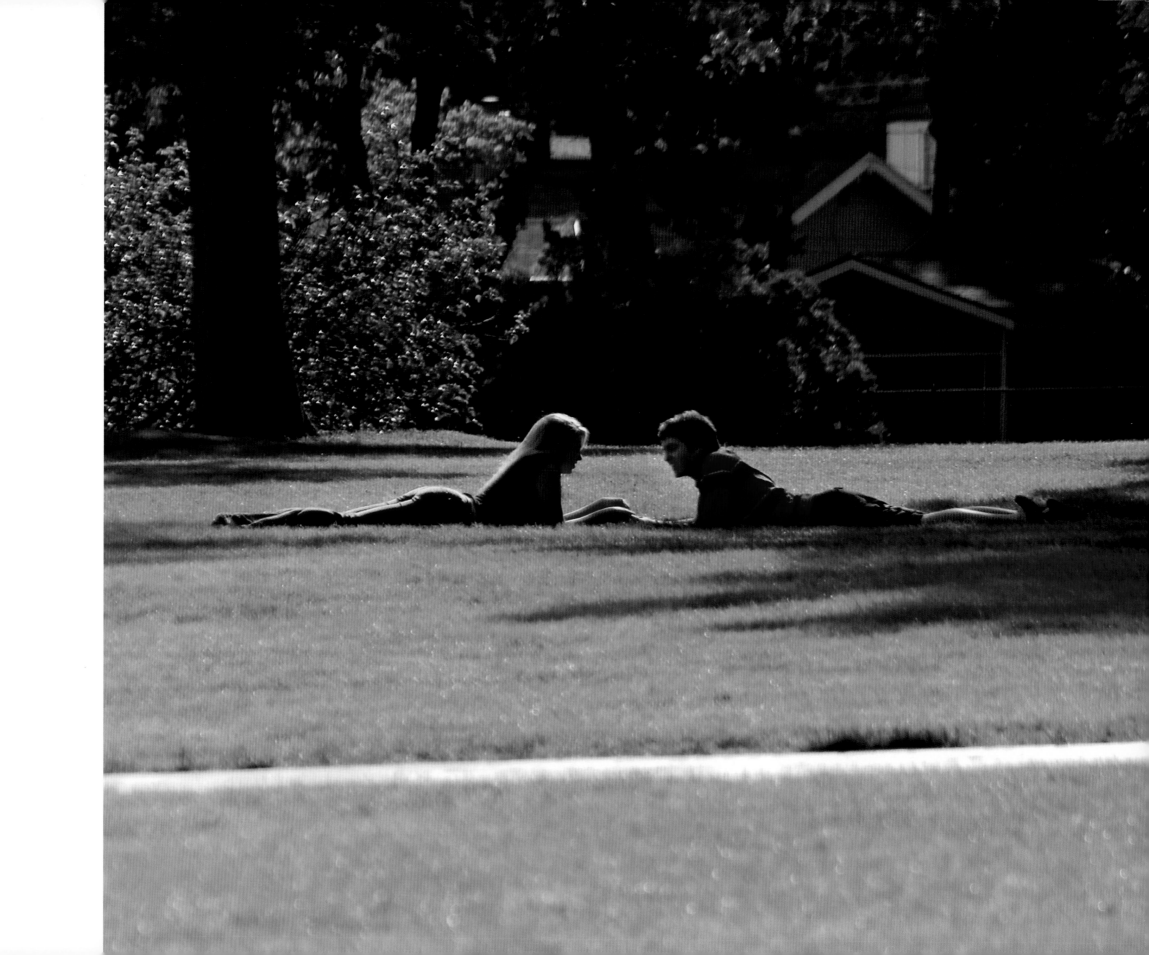

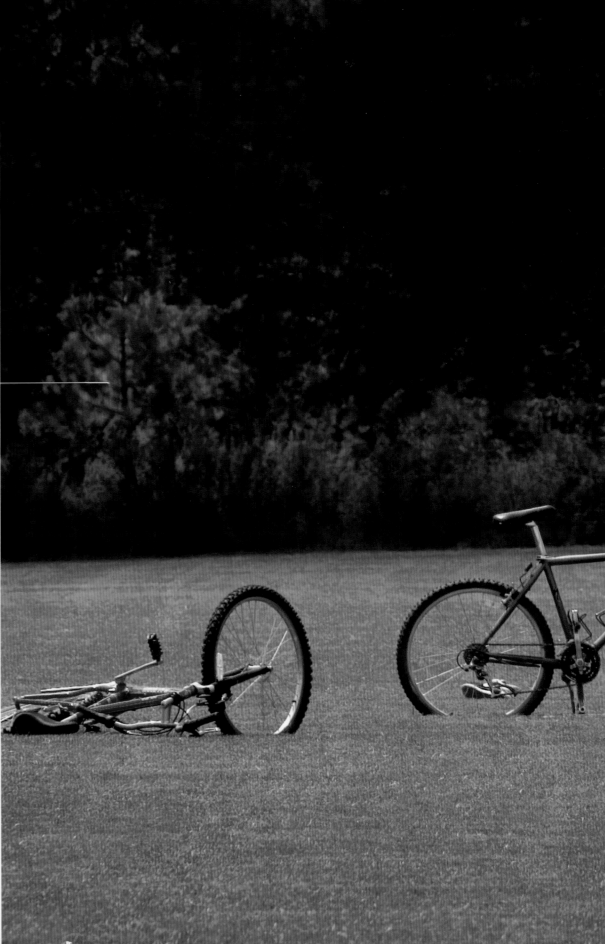

by ZACH SCOTT

Lawn party, Fort Rock Park,
Sunriver

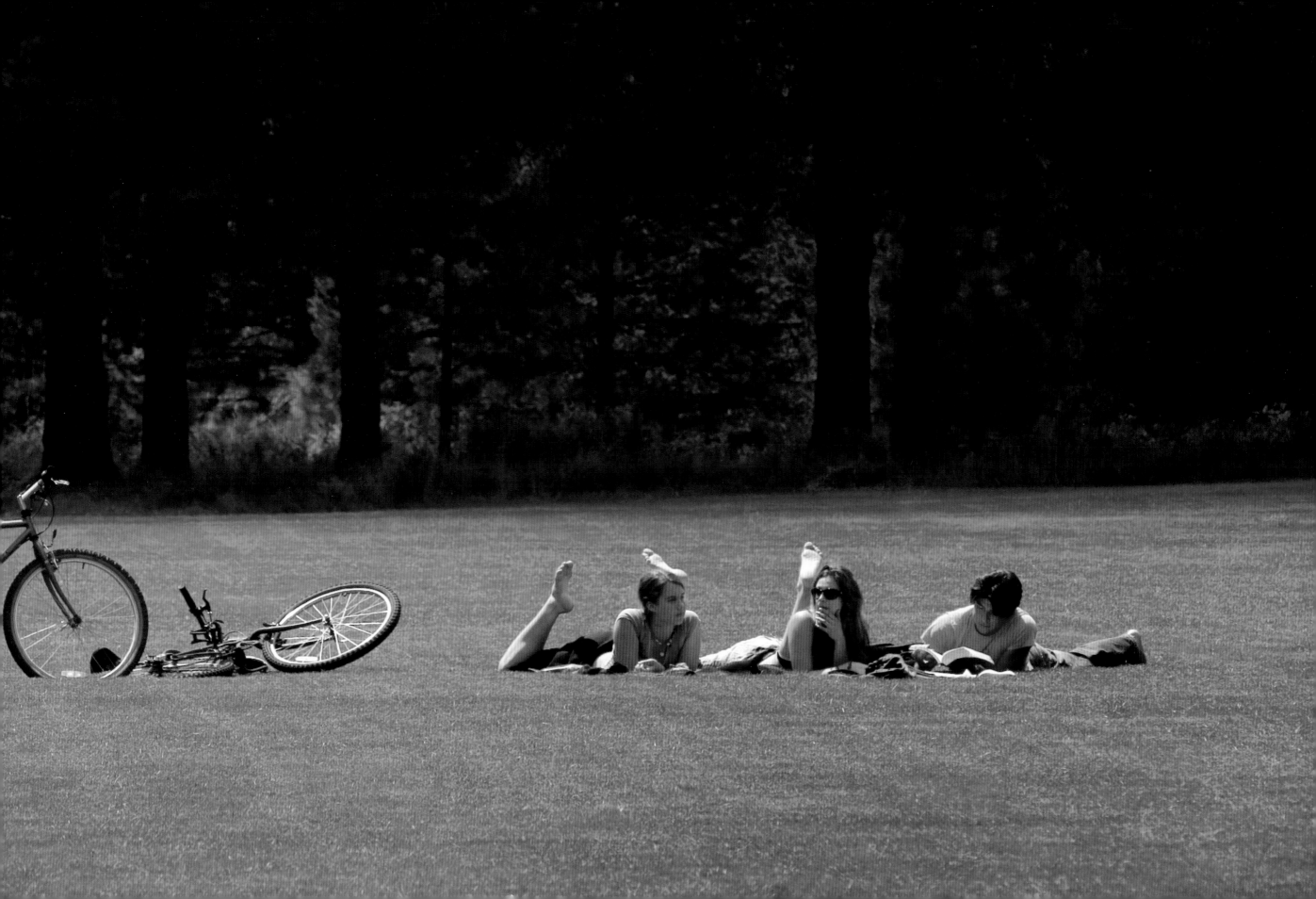

by ZACH SCOTT

Rental canoes, Deschutes River, Sunriver

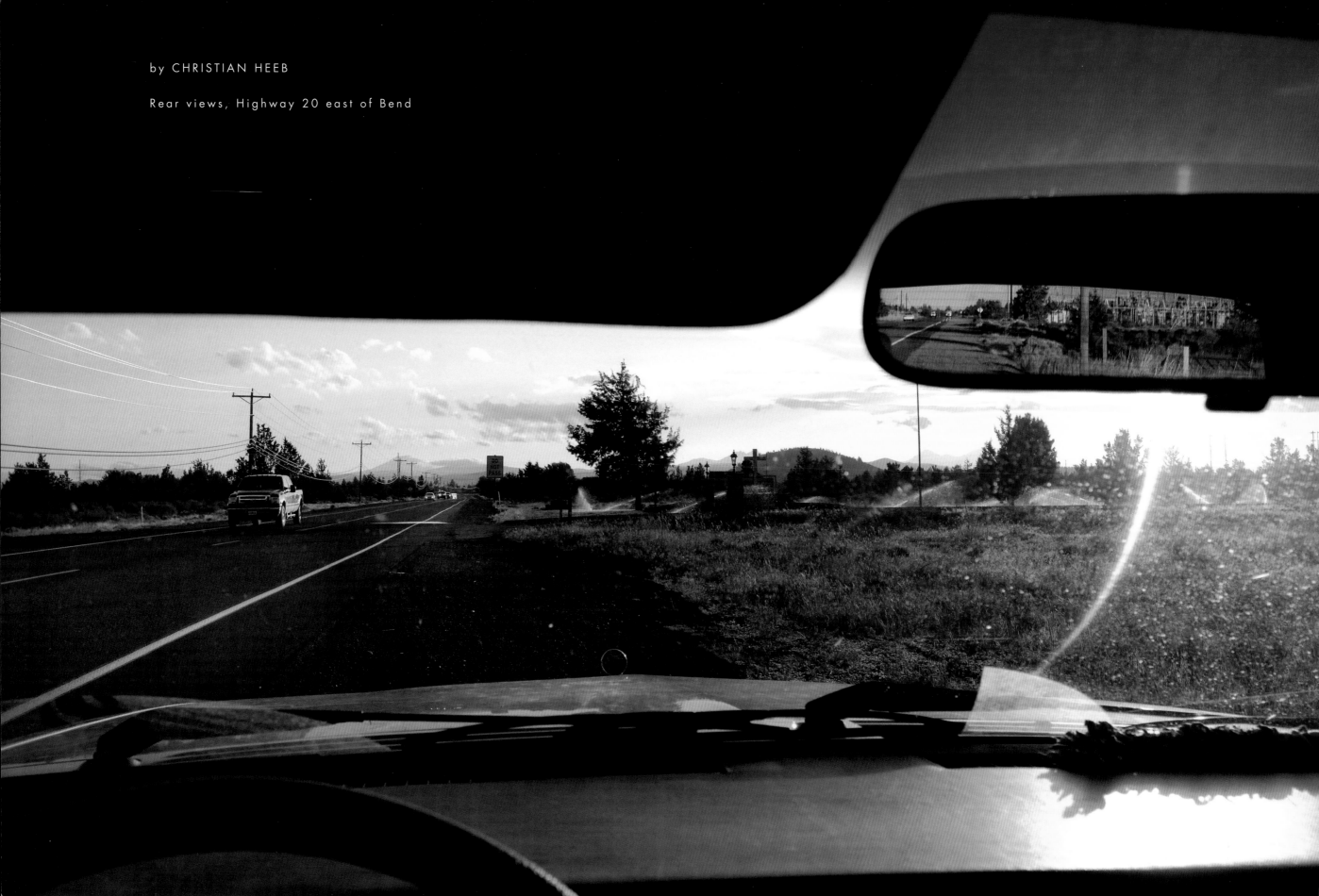

by CHRISTIAN HEEB

Rear views, Highway 20 east of Bend

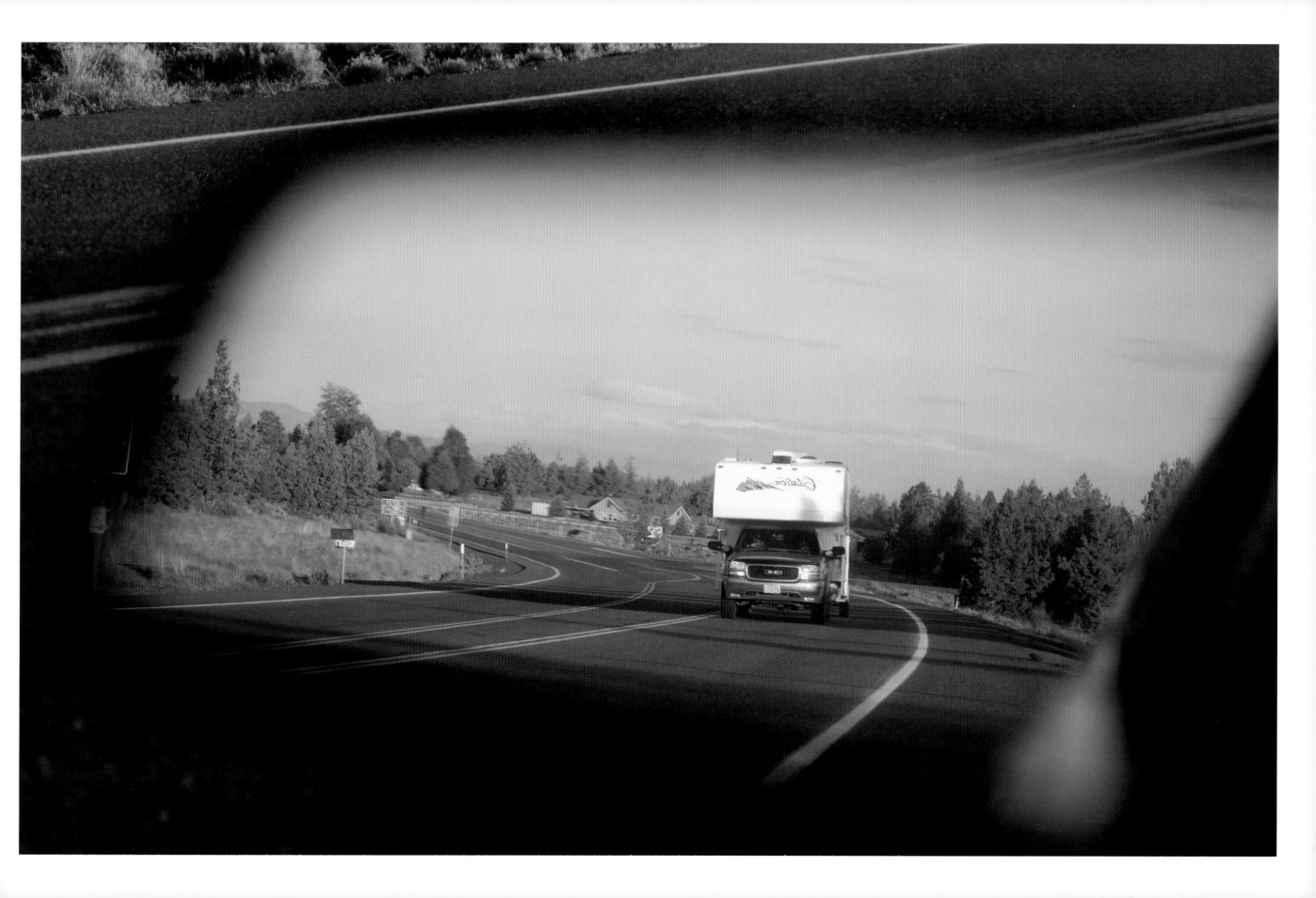

by JULIANNE MEYERS

Spring morning, downtown Redmond

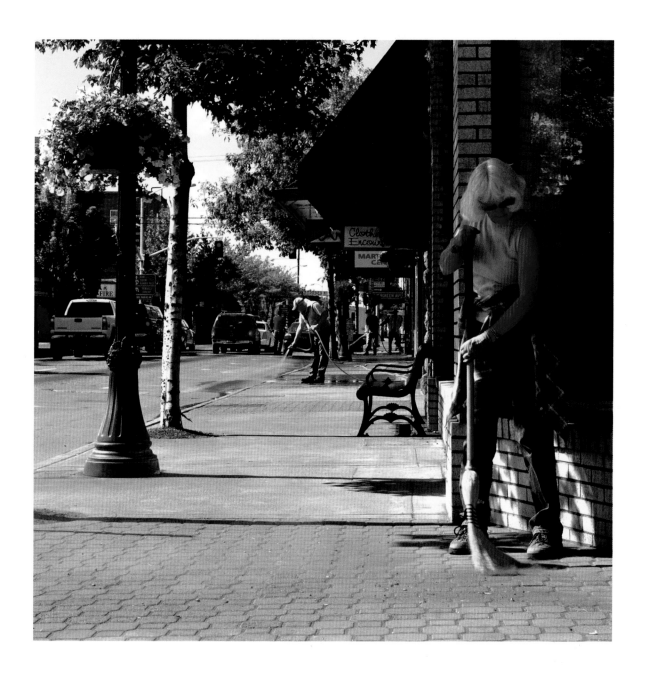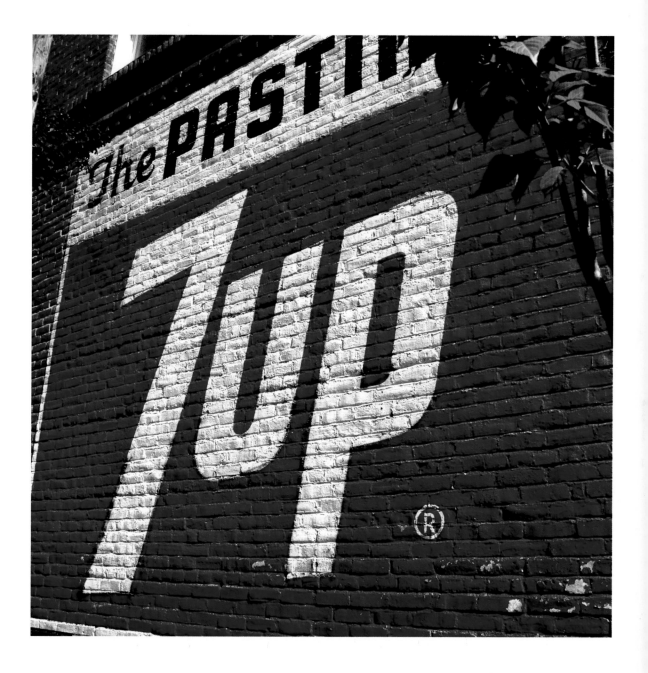

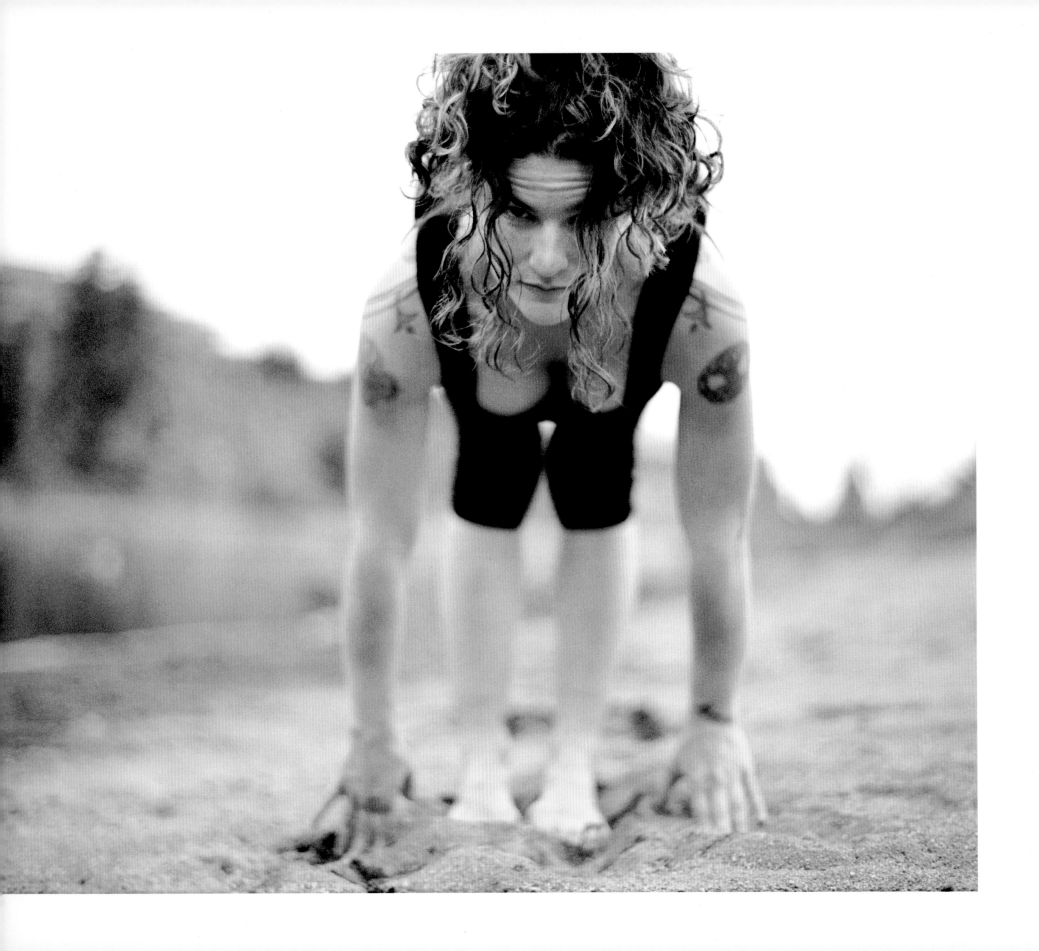

by MARK GAMBA

Bikram yoga student
Heather Tenbroek, Bend

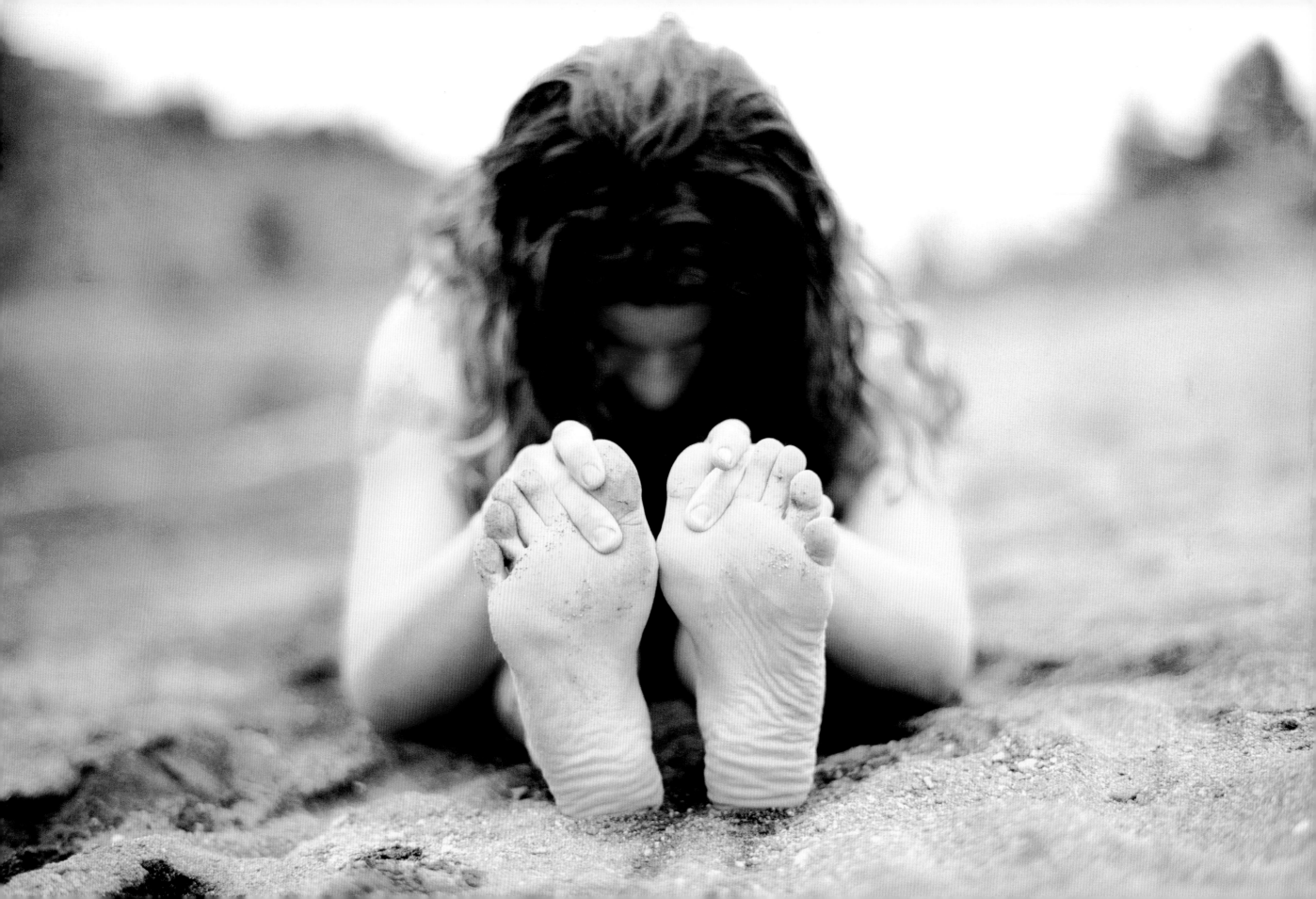

by MIKE HOUSKA

Nostalgia: A boy, a swing, an old cottonwood

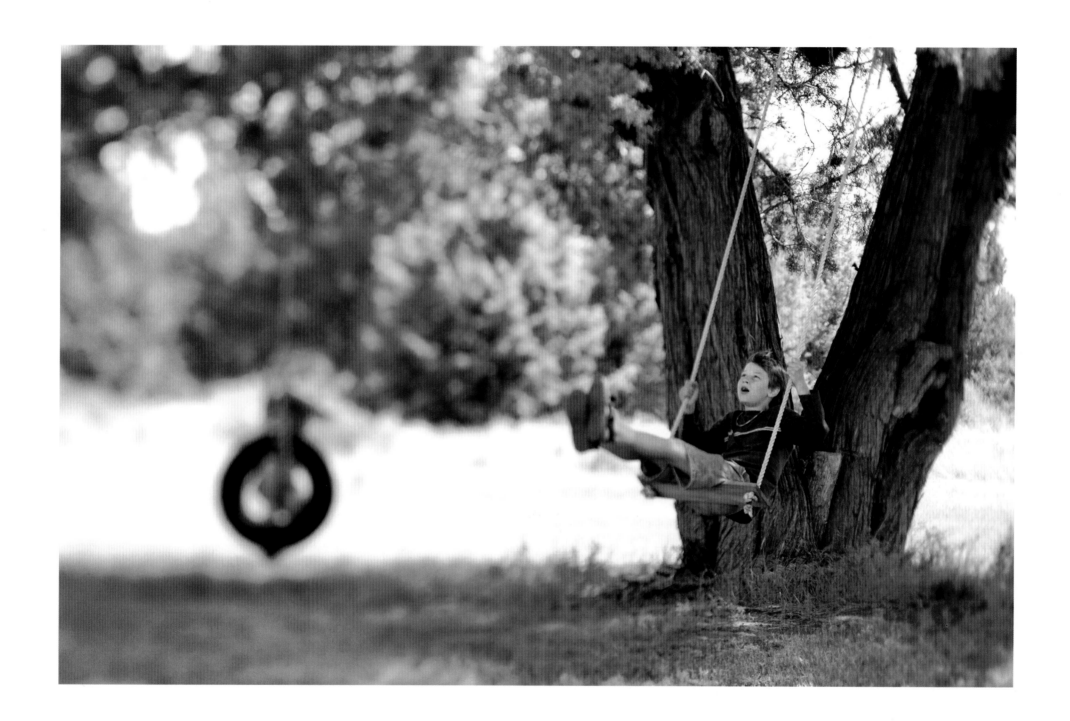

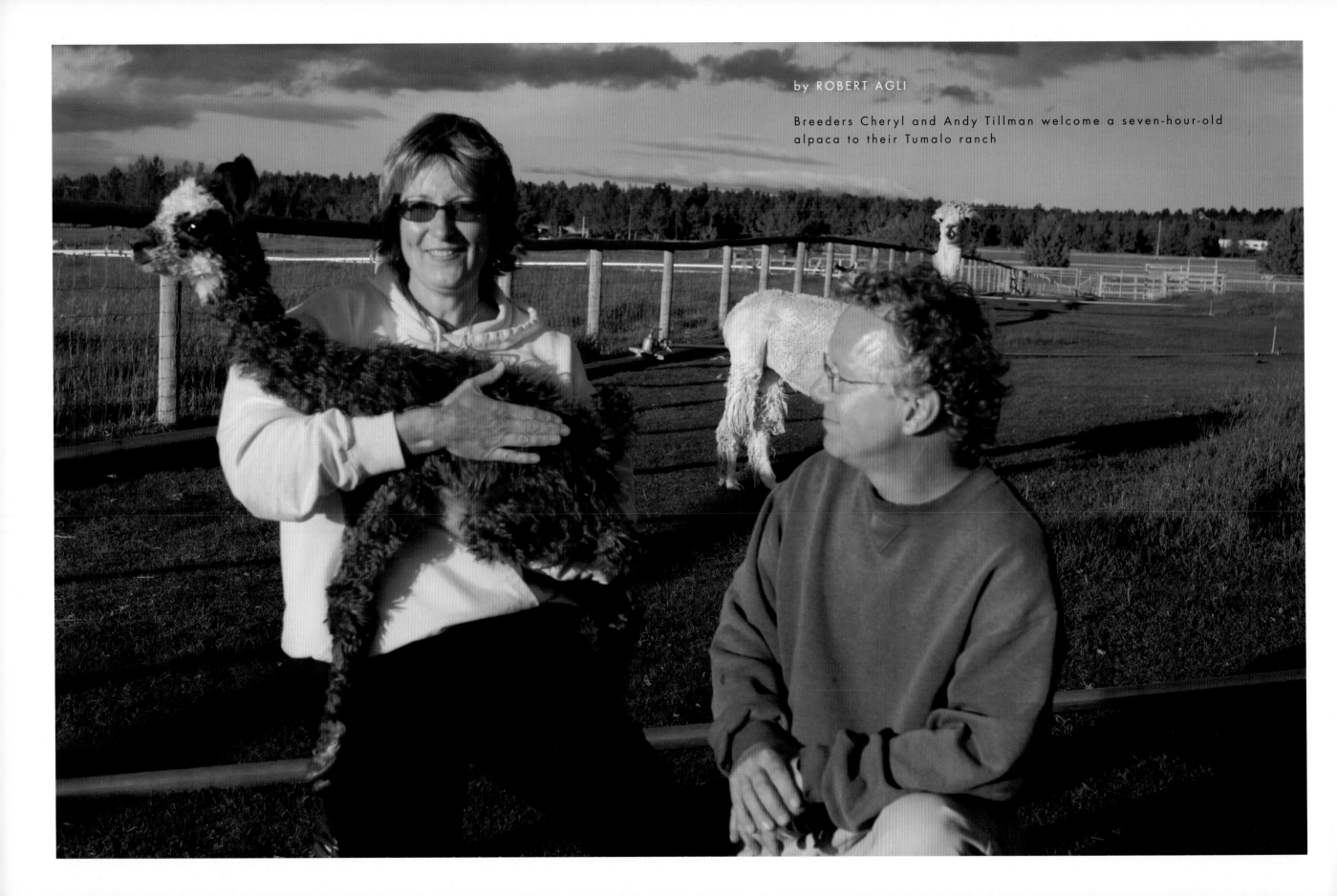

by ROBERT AGLI

Breeders Cheryl and Andy Tillman welcome a seven-hour-old
alpaca to their Tumalo ranch

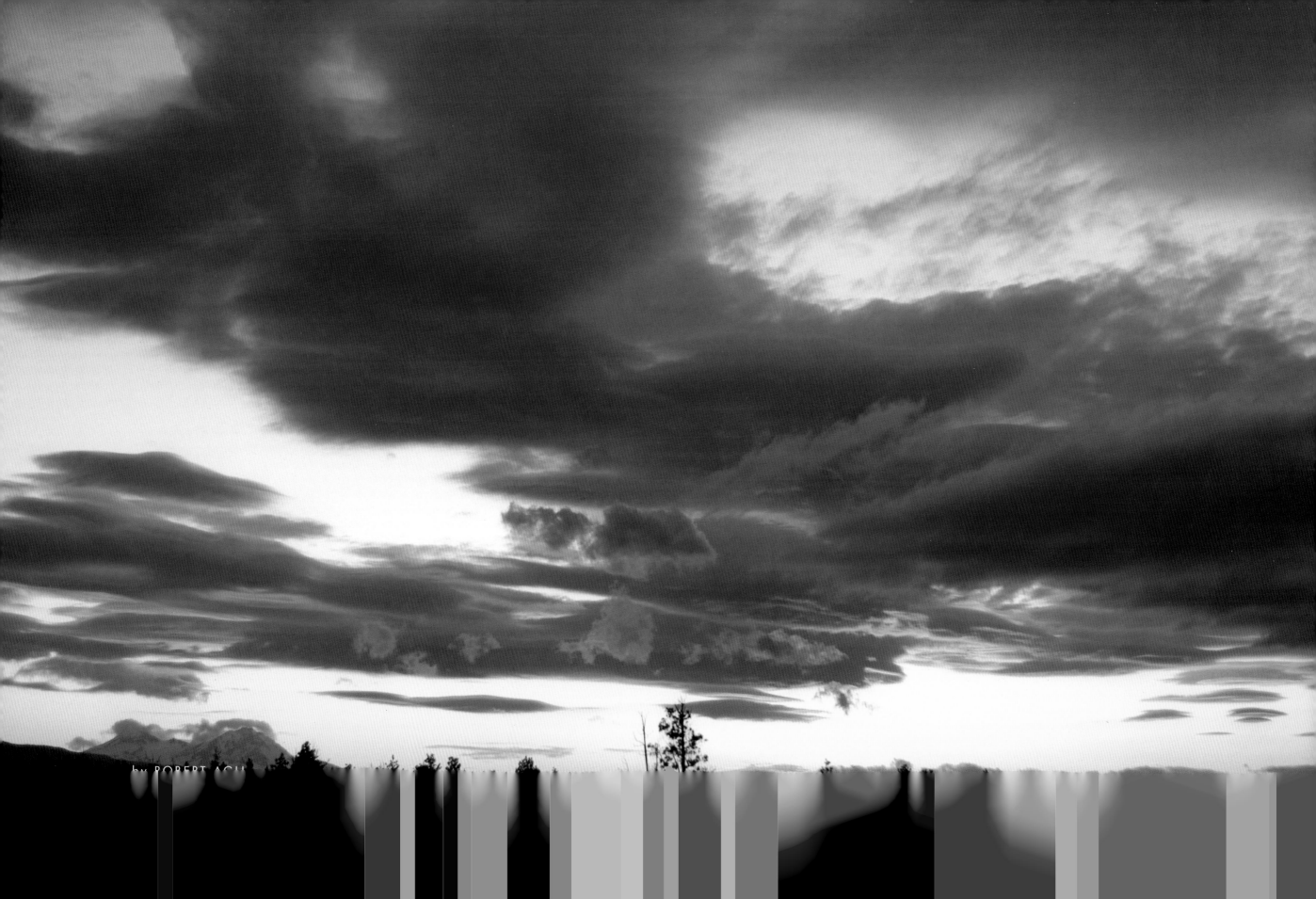

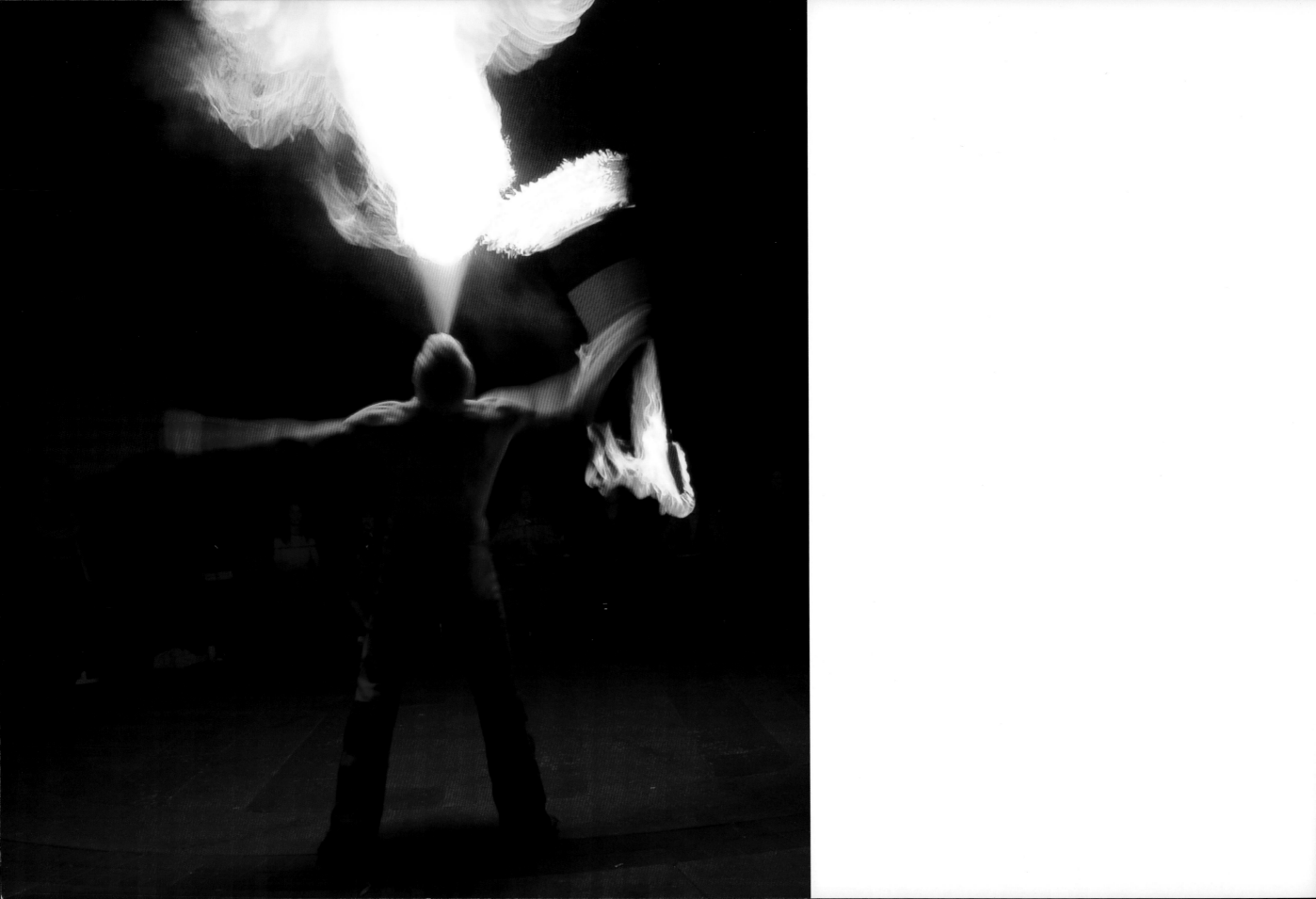

by SIMONE PADDOCK

Fire dancers of FyreFlyte light up the night
on Mirror Pond Plaza

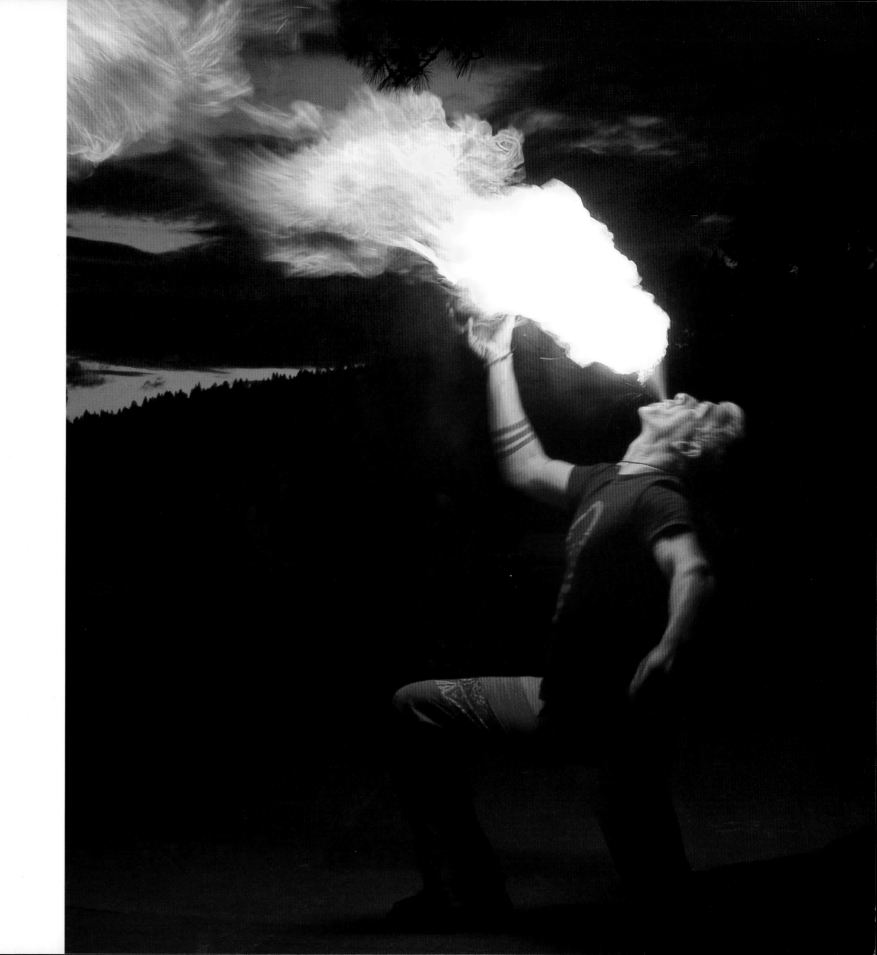

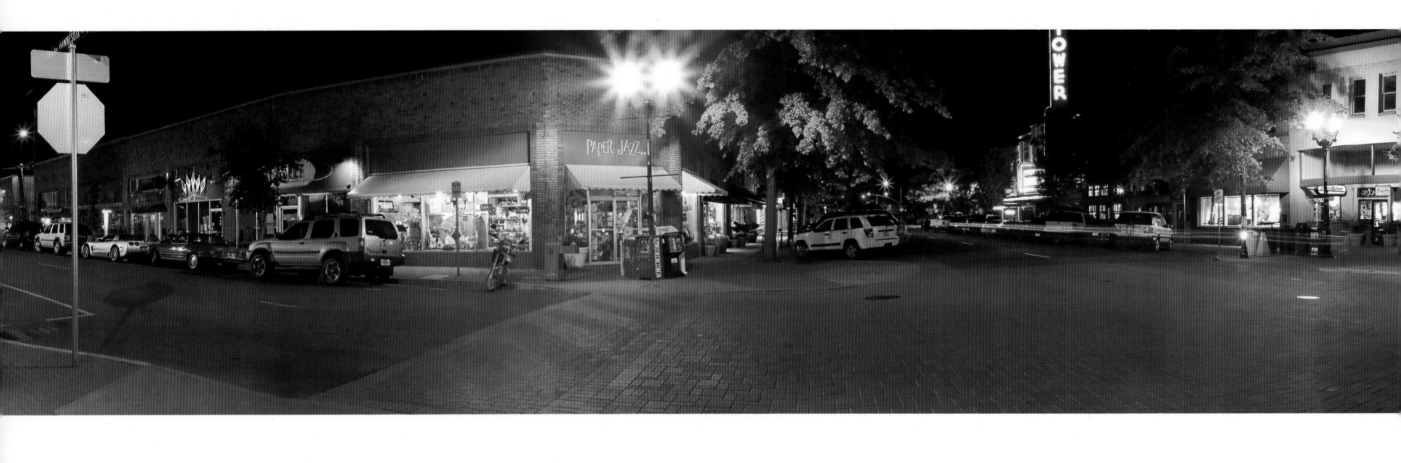

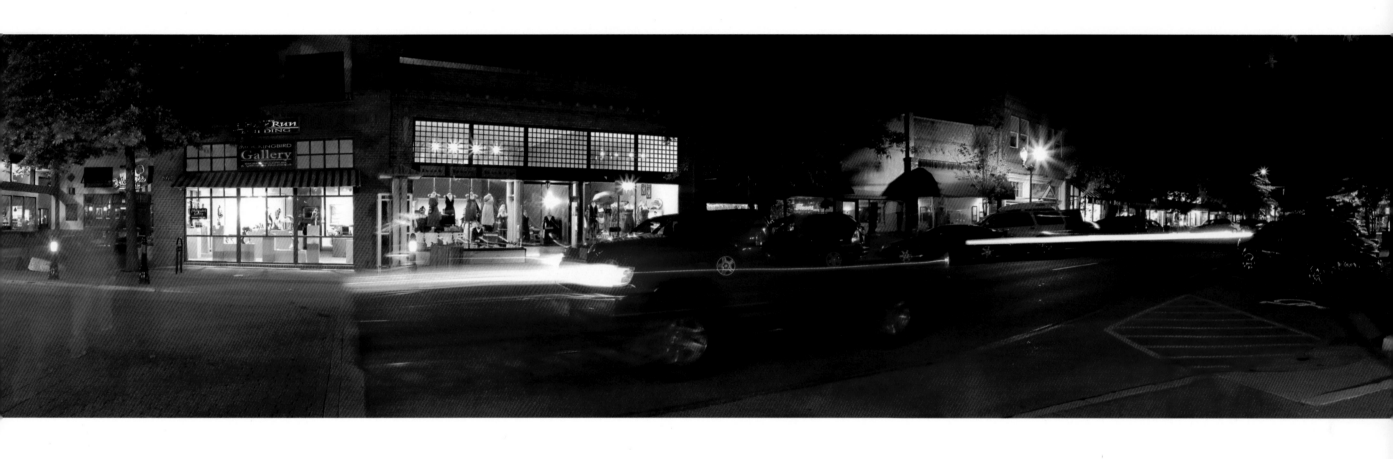

by SIMONE PADDOCK

Wall Street after dark

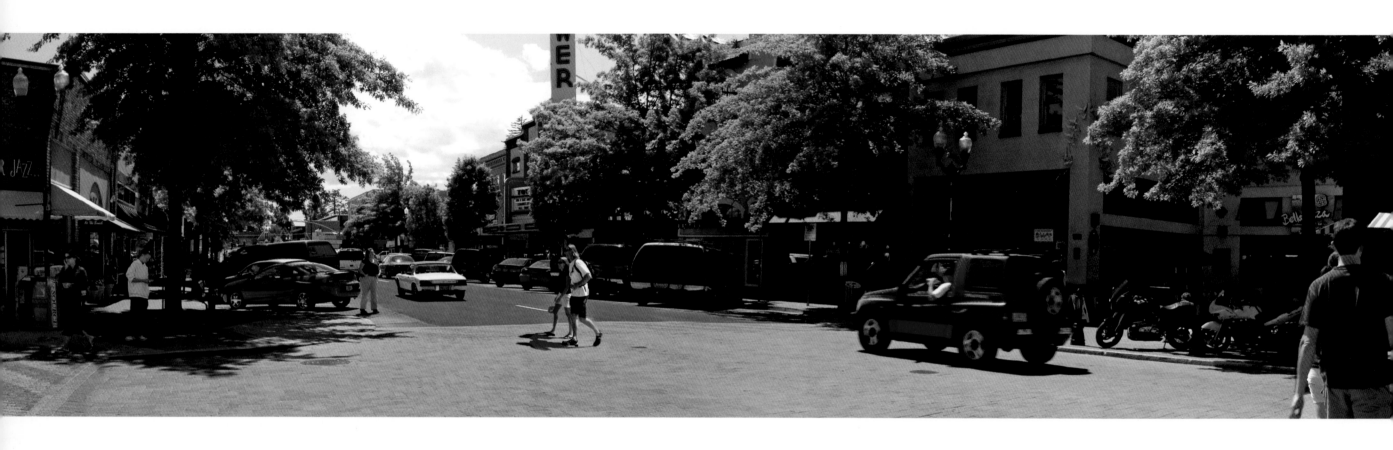

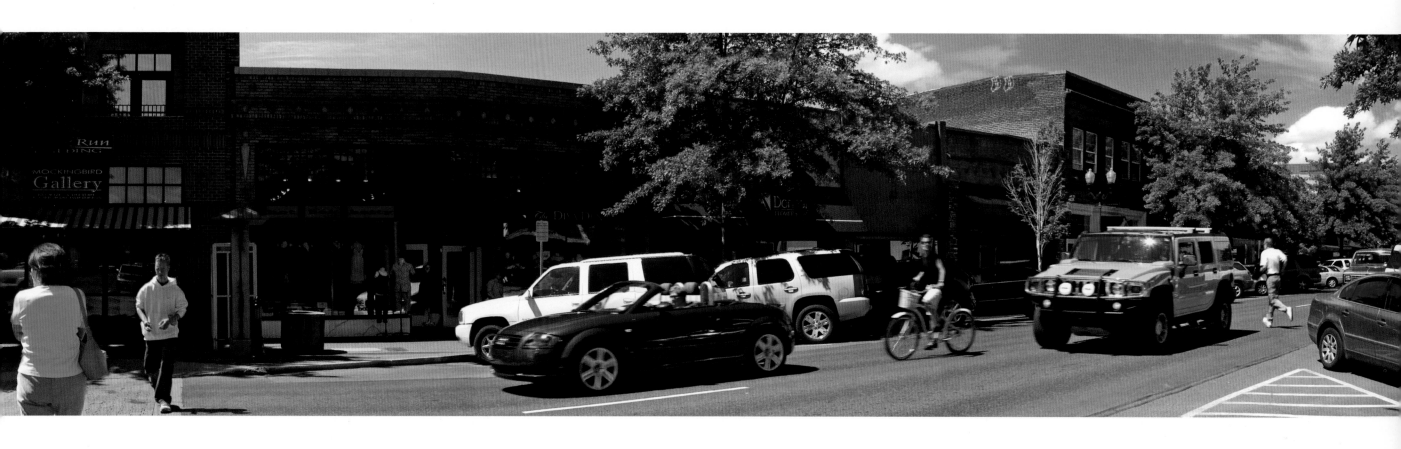

by SIMONE PADDOCK

Wall Street, Bend